Praise for
FALLEN SPORTS H[...]
& CELEBRITY [...]

D0735921

"The stars of sport become figures in public discourses about moralities, lifestyles, and values. This impressive collection, comprising contributors who have been central to the analysis of these processes over many years, is an indispensable guide to the place of the sport hero, celebrated or reviled, in contemporary culture."

—Garry Whannel, Professor of Media Cultures
and Director of the Research Institute for Media Art and Design
at the University of Bedfordshire, UK, and author of *Culture, Politics, and Sport*

"Unlike celebs from other spheres of culture, athletes are also expected to be heroes and role models. This increases the likelihood that they will disappoint fans and fall from favor. The insightful articles in this collection explain the dynamics and consequences of this rise and fall process and help us better understand celebrity culture and the role of sport in society."

—Jay Coakley, Professor Emeritus, University of Colorado,
Colorado Springs, and author of *Sports in Society: Issues and Controversies*

"The breadth, depth, and global reach of these essays compel us to say to our fallen heroes, 'Our nations turn our cynical and forever disappointed eyes from you.' But they also make clear that we will engage in a perpetual quest to create new heroes as we worship one of the most powerful institutions on this planet—sport."

—Mary Jo Kane, Professor of Sport Sociology and Director of the
Tucker Center for Research on Girls & Women in Sport, University of Minnesota

"This collection is a treasure trove of behind-the-scenes stories of many of the world's most famous athletes, their rise, and especially their fall. A diverse set of lively scholars examines the underside of sport celebrities, those stories that seem 'more than we wanted to know' about a star but can't put down. The result is a garden of earthly disasters and delights that will captivate any close observer of sports. Game on!"

—Michael Real, Professor of Communication and Culture,
Royal Roads University, Canada and author of *Super Media* and *Exploring Media Culture*

FALLEN SPORTS HEROES, MEDIA, & CELEBRITY CULTURE

This book is part of the Peter Lang Media and Communication list.
Every volume is peer reviewed and meets
the highest quality standards for content and production.

PETER LANG
New York • Washington, D.C./Baltimore • Bern
Frankfurt • Berlin • Brussels • Vienna • Oxford

FALLEN SPORTS HEROES, MEDIA, & CELEBRITY CULTURE

EDITED BY LAWRENCE A. WENNER

PETER LANG
New York • Washington, D.C./Baltimore • Bern
Frankfurt • Berlin • Brussels • Vienna • Oxford

Library of Congress Cataloging-in-Publication Data

Fallen sports heroes, media, and celebrity culture / edited by Lawrence A. Wenner.
p. cm.
Includes bibliographical references and index.
1. Sports—Social aspects. 2. Sports—Moral and ethical aspects.
3. Athletes—Social conditions. 4. Athletes—Public opinion.
5. Mass media and sports. 6. Fame—Social aspects.
7. Celebrities. I. Wenner, Lawrence A.
GV706.5.F35 306.4'83—dc23 2012016211
ISBN 978-1-4331-1299-7 (hardcover)
ISBN 978-1-4331-1298-0 (paperback)
ISBN 978-1-4539-0850-1 (e-book)

Bibliographic information published by **Die Deutsche Nationalbibliothek**.
Die Deutsche Nationalbibliothek lists this publication in the "Deutsche
Nationalbibliografie"; detailed bibliographic data is available
on the Internet at http://dnb.d-nb.de/.

Cover design by Clear Point Designs

The paper in this book meets the guidelines for permanence and durability
of the Committee on Production Guidelines for Book Longevity
of the Council of Library Resources.

Printed in the United States of America

Table of Contents

Part IV: Fallen Sideline Sports Celebrity

Part V: Afterword

Preface

Lawrence A. Wenner

On the face of it this book is about the fallen sports hero, but it is really about much more, it is about us. As a cultural phenomenon, this is something that has become both ubiquitous and inevitable. At the same time it continues to surprise and disappoint us. For some, the fallen sports hero might seem a small issue. After all, the carnage and collateral damage of sports heroes are insignificant when compared to more important stories that the media cover concerning the main events challenging contemporary lives. Still, we are drawn to the fallen sports hero saga. Like a car crash we are compelled to gaze at while driving past, it captivates us in ways we cannot fully explain. While it is unlikely that we might know the victims, we want to understand how this happened and how bad the damage was. We are, on one hand, simple voyeurs, and on the other, seeking to learn how to avoid a similar fate.

Further complications come into play when encountering the fallen sports hero. Here we confront our sensibilities about the "realities" of living in a uniquely media-infused time. Because the storylines that dot our realities are so constructed by the presses of the marketplace, we are perpetually challenged in our search to distinguish the authentic from artifice. The modern sports hero lies in that chasm. Like a character in a Kris Kristofferson song, the sports hero is "partly truth" and "partly fiction." Ripe with contradiction, this construction presents a captivating conundrum. At a time when many wonder about where all the heroes have gone, ever-ready constructions of the sports hero fill the void. We know that in stretching athletic action to true heroic action, there are many risks. The media machine has many reasons to compound the culture of privilege that comes with elite sports socialization by transforming the athlete to star and celebrity. Still, it would be indelicate for us not to admit that our thirst for heroic narratives in part feeds the media beast.

Even given this, manufactured stardom and celebrity enable the beast to grow. As a result, the sports hero is by definition always teetering at the precipice of heroic authenticity. We understand this not only intuitively, but rationally as our critical selves recognize our complicity in enabling the "auto-

telic" athlete-hero to be transformed into the real deal. That we recognize the strong role that artifice plays in the elevation of the athlete to hero in part explains why such gleeful *schadenfreude* comes into play when the sports hero falls. Yet, for many, penetrating even that which is recognized as artifice can be painful. Thus, when a certain sports hero falls, this can become a personal affront, a metaphor for personal failing. Such dualities of reaction experienced by people over the fallen sports hero in themselves make the phenomenon worthy of study.

Still, there are far more important reasons to study the narrative arc of a sports hero's rise and fall. Through such stories, we learn about our culture's moral contours. On one hand, we learn about those traits that make one great and admirable. On the other, we learn about where our moral fault lines currently stand and how contemporary sensibility poses their negotiation. Further, we learn about ourselves and our capacities for granting a second chance to those we judge worthy of redemption. Thus, stories that tell of heroic rise and fall, along with those about the prospects for redemption, are always about more than the particulars of any one case. Still, it is striking the number of variants that may be seen on the sports hero panorama. In these pages alone, the gamut of what might be considered a "sporting offense" includes not only substance abuse (from performance-enhancing and recreational drugs to alcoholism) and sexual "improprieties" (from bad sexual manners to sexual assault to sex addiction to homophobia to questions over verification of sex), but also routine thuggery (aimed not only at opponents but seen in extracurricular gun play and dogfighting) and questionable politics (demonstrating loyalties ranging from "good" nationalism to "bad").

In each case, we see that the particulars do matter. We learn from both the life history of the athlete and the nature of the offense. We see that both race and gender matter as do the unique abilities of the athlete. In variant ways, these interact with moral stocktaking about the severity of the offense and receptivity to redemption. We also learn about the interlocking ecosystems of big-time sport and big-time media and how they have morphed into one. Through these stories, we learn that the media sports production complex is a self-righting vessel with many inherent conflicts of interest. Willing to throw a few wayward members of its crew overboard to "purify" itself, it will at the same time dole out "homegrown" discipline to those on its crew deemed worthy of saving.

The stories that are told in these pages come from the collected research efforts of a distinguished group of media, sports, and cultural studies scholars from around the globe. Because they have graciously shared their expertise in this volume as a labor of love, I wish to thank them for their contributions.

Taken together, their work breaks new ground in understanding the larger phenomenon of *Fallen Sports Heroes, Media, and Celebrity Culture*. The book's organization aims to help the reader negotiate this terrain. The opening section on *Framing Fallen Sports Celebrity* explores the meaning of the sports hero in an age where media celebrityhood sets the standard, where there is much confusion over real and athletic heroic action, and where the media play an increasingly important role in sorting all this out and determining how athletes fall and who gets a second chance. Part II examines the context of *Fallen Individual Sports Celebrity* by looking at a variety of cases where athletes without loyalties to a team often fall quite alone without the benefit of a team organizational safety net. Part III, by focusing on *Fallen Team Sports Celebrity*, examines how media discourse is colored both by norms of group membership and the limits of the "protections" that it might offer. The set of cases examined in Part IV focuses on the heretofore largely unexamined phenomenon of *Fallen Sideline Sports Celebrity*. Here we learn about what happens when the "leaders" of sports—the coaches that set the standard for athletic performance and the announcers that stand above it all to give sports context—fall into an ethical pothole. Finally, *Fallen Sports Heroes* closes with an Afterword by former champion Ironman triathlete, Scott Tinley, who reflects on why the falling of sports heroes both means so much and hits us so hard.

I join all of the scholars in this volume in hoping that the work showcased here will inspire new thinking about what has become a too regularly occurring phenomenon: the falling of the sports hero. Making our case for this issue having much broader cultural importance than might be thought at first glance would not have been possible without the efforts of many. In particular, I would like to thank Peter Lang Publishing and a very supportive editor, Mary Savigar, who has provided much guidance and has been a joy to work with on this and earlier projects. My work on this project would not have been possible without the support of Loyola Marymount University and the latitude they have granted me in my workload as holder of the Von der Ahe Chair in Communication and Ethics in the College of Communication & Fine Arts and the School of Film & Television. Finally, I would like to thank my wife, Susan Rice, for her help and support in improving all of the work that is seen in this volume. Her grace and encouragement for this project have been much appreciated. She and I continue to share many sporting passions and far more of others. Susan remains my most devoted fan and I remain hers.

Framing Fallen Sports Celebrity

The Fallen Sports Hero in the Age of Mediated Celebrityhood

Lawrence A. Wenner

he•ro | | 'hi(ə)rō| noun (pl. -roes) a person, typically a man, who is admired or idealized for courage, outstanding achievements, or noble qualities. (*New Oxford American Dictionary*, 2009)

The "hero" acts, the athlete performs. (Drucker, 2008, p. 420)

Athletes aren't as gentlemanly as they used to be. I don't like that change. I like the idea of being a role model. It's an honor. (Tiger Woods in G. Smith, 1996, p. 44)

(T)oday's "heroes" are more and more like the prize in the box of Cracker Jacks—we get all fired up anticipating the "greatness" of the prize, only to be sadly disappointed when the prize is much less than we expected. (Watson, 2008, p. 43)

Michael Phelps smokes pot. A-Rod took steroids. What's next? Will U.S. Airways Capt. Chesley "Sully" Sullenberger get busted too? (Rodriguez, 2009, p. A21)

We all know that what goes up must come down. We understand this both intuitively and as a basic law of gravity. Still, when it happens in the course of our lives, to us or those we care about, this often catches us by surprise. Whether we watch in amazement, awe, or fear, the experience is inherently destabilizing. This often hits at a gut level. What we thought to be true turns out not to be the case. There may be a shivering realization that a seemingly solid structure can quickly become a house of cards. As Rowe (1997, p. 204) has observed, when this happens to our heroes, we must face "the 'truth' of scandal."

In the realm of sports heroism, stardom, and celebrity, we increasingly face this truth. The history of sport is littered with scandal. In the early 20th century eyebrows were raised over bribes and fixes in baseball by the Black Sox's "say it ain't so, Joe" Jackson and later Hall of Famers, Ty Cobb and Tris Speaker; boxing champ Jack Dempsey's "loaded glove;" and about whether women track stars, such as German high jumper, Dora Ratjen, and Polish American sprinter, Stella Walsh, were actually female. As the 20th century

closed, the fallen sports hero narrative became common tabloid fodder. Big splash stories included Muhammad Ali's draft evasion; "wife swapping" by Yankees pitchers, Fritz Peterson and Mike Kekich; "Mr. Baseball" Pete Rose's addictive betting; sprinter Ben Johnson's failed Olympic drug tests; football legend O. J. Simpson's spectacular murder trial; boxing champ Mike Tyson's rape conviction and ear biting; skater Tonya Harding's complicity in assaulting her Olympic rival; NBA star Latrell Sprewell choking his coach; and the running of the tabloid table by Australian cricketer, Shane Warne, in stories ranging from bookmaking to failed drug tests and sexual escapades.

The accelerated pace and diversity of these kinds of cases has been seen in the last decade. We have become accustomed to doping and steroid scandals that have plagued cycling's greatest champions, raised questions about track and field's constantly broken records, and put more than a decade of baseball's leading performances, including the sacred ground of its home run records, in jeopardy. But added to this mix are some truly bizarre and puzzling stories that go well beyond "routine" sagas of drug use, assaults, and boorish behavior. More recent times have brought the front page disintegration of iconic golf champion Tiger Woods's life in a cloud of serial affairs; Brazilian soccer star Ronaldo's frolicking with transvestite prostitutes; star quarterback Michael Vick's cluelessness over dogfighting; Dean Richards's role in the fake injury theatrics of Rugby Union's "Bloodgate"; and a parade of wanton gunplay incidents.

There are morals to these stories. Each reveals where a moral line has been crossed, how the moral offender responds, what should be done, and whether a second chance should be given. Such stories, accompanied by those in other quarters of the public sphere, mark a critical ebb and flow of contemporary culture. Tides rise for select individuals as media enable their advancement and naturalize this as common sense. In the sports marketplace, big media and big sports also underwrite the climate of entitlement and invincibility that has become the constant companion of the star athlete. Yet, when sports heroes fall, the media's promotional tendencies that have played an essential role in their rise are largely swept under the carpet as they construct new narratives about individual failings and blame. This book considers how this complicity thrives, in light of our identities with sports heroes, stars, and celebrities. Here we learn how there are many "truths" posed in these morality plays. We negotiate competing truths of sports stars' heroic rise, truths that fuel their celebritization, and truths that explain their fall.

The Hero Conundrum

Living as we do in a postmodern pastiche of simulacra, it is reasonable to ask about what has happened to the authentic. To many, finding something authentic to believe in has become increasingly difficult. In mulling over that loss, many wonder "Where have all the heroes gone?" (cf. Allison & Goethals, 2011; Watson, 2008). Indeed, thinking about what a hero is in contemporary times presents a conundrum. The problems and questions it raises are difficult, puzzling, and confusing.

Even in looking for heroes, it may be less than clear what we are looking for. The media's unrelenting appetite for creating heroes aplenty in the service of promotable narratives only complicates this. Thus, what we are looking for may not be quite what we find. Further, the very notion of a hero is slippery. It is one of those things—as U.S. Supreme Court Justice, Potter Stewart, famously remarked about pornography—that while consensus definition is elusive, we know it when we see it. So while we all think we see heroes, often these are not the same ones, as there are real disagreements over who deserves to be so anointed. Is Kobe Bryant or David Beckham or Caster Semenya deserving of being a hero? Maybe yes. Maybe no. This book considers whether understanding contestation over such terrain may be more valuable in cultural assessments than any firm resolution about what constitutes heroic action.

Still, much thoughtful writing suggests a good deal of agreement about classic accounts of the hero and heroic action. From the first print appearance of the term "hero" in Homer's *Iliad* (Curtius, 1963) to Hannah Arendt's (1958) account in *The Human Condition* come a set of archetypal understandings. As is suggested by the definition framing this chapter, these often default to a male standard (cf. Vande Berg, 1998). Here is the man of action who is the "embodiment of composite ideals" (McGinniss, 1990, p. 16) that feature exceptional competence, character, and courage marked by fortitude, resourcefulness, and noble deeds. As Campbell (1968) suggested, this archetype has had resilient staying power over time and culture and has been commonly embraced in a heroic monomyth that has been narrativized as a journey:

> A hero ventures forth from the world of common day into a region of supernatural wonder: fabulous forces are there encountered and a decisive victory is won: the hero comes back from this mysterious adventure with the power to bestow boons on his fellow man. (p. 30)

Recently, there has been much debate over whether such classic notions have given way. Central to the evaluation is the reality that not many myths contain all of the stages outlined by Campbell. But more telling may be that

increasingly, there are structural tendencies for particular narratives to be routinely featured in the public sphere. Bearing on this, Allison and Goethals (2011), in their landmark study *Heroes: What They Do and Why We Need Them*, provided a ready retort to those who, in asking the question "where have all the heroes gone?" veil the assertion that there is a paucity of contemporary heroes. Their reply is that they have not gone anywhere. Indeed, they find the dominant nonfictional hero named about half of the time is a family member, and when joined by humanitarians, everymen, and underdogs, the contemporary picture of the hero pretty well lines up with McGinniss's "composite ideals." It also lines up with those who do not repeatedly get narrativized in the media. Still, Allison and Goethals (2011, p. 26) noted that nonfictional heroes who are more likely to be narrativized appear to be making steady gains. Of these, sports stars lead the pack, being named over 10% of the time as heroes; they are almost twice as likely to be so named as entertainers or heads of state.

In hypercommodified times, the media has much self-interest in defining public figures as heroic, and this works to make them stars (or at least quasars) and celebrities. Boorstin's (1973, pp. 57, 61) attempt at a dichotomy where the hero is "distinguished by his achievement" and the celebrity is a "human pseudo-event" who is "known for his well-knownness" has long since vaporized, leaving such distinctions to be played out in a grey area along a two-way street. Much of this stems from the media's inherent need to make heroes into celebrities and celebrities into heroes. In today's world, the hero who is not "mediated" risks being just another unheard tree falling. Many argue, as did Strate (1994, p. 16) that "[w]ithout communication, there would be no hero," making the "unsung hero" increasingly impossible.

To the media, the celebritization of heroes has large narrative, and consequently economic, value. Concomitant with this, to be a celebrity is, in a way, not enough. For a celebrity to have substance, and to "add value" for the media machine, some dose of the heroic is helpful to give the star cultural and economic staying power and to help the star avoid being a quickly dimmed quasar. Of course, the contradiction is that celebrity adds value to the heroic while at the same time it necessarily pollutes or dirties it (cf. Wenner, 2007), making the whole prospect seem somehow more artifice than real. Such contradictions and the inherent instabilities over what a hero is or means in contemporary times would likely lead Geertz (1973) to conclude that the hero genre has become "blurred."

The Sports Hero Conundrum

The blurred conundrum that underlies our search for heroes has only been heightened by the rise and domination of the sporting celebrity in our heroic space. Indeed, there may be no one place in culture more in need of a ready supply of heroes than sport. As Allison and Goethals (2011, p. 36) have observed "[i]n the sports world, heroes abound, and more are guaranteed to emerge on the scene every day." Heroes undergird the basic business of sports. This is different, for example, than spheres such as entertainment that, while not immune to using the heroic to enrich celebrity and stardom, are not fundamentally predicated on their stars being heroes even though they may play them in fictionalized roles. Other public spheres, such as the military or politics that feature structural conditions conducive for heroism to emerge, do not share the same voracious daily appetite for heroic narratives. Even if this were not the case, it is hard to imagine a more efficient hero-making machine than the media sport production complex. Drucker (2008, p. 418) argued that because of its unique communicative necessities, "modern sports fosters the illusion that heroes emerge from professional sports; however, these so called 'sports heroes' are actually products of the celebrification of the pro-athlete rather than the creation of a hero."

Without resolving whether the celebrity-chicken or hero-egg comes first, the sports hero presents a unique, truncated variant of a celebrity species within the hero genus (cf. Andrews & Jackson, 2001; Smart, 2005; Whannel, 2002). Archetypal heroes are born when they are thrust into situations for which there can be little preparation. Yet, in a very basic sense this is not possible for the sports hero. Athletic competition—"a rule bound autotelic or self-contained activity" (Drucker, p. 422)—brings a far more limited script of possibilities than does life. Life is not a game. Life matters broadly. And even though who wins and who loses in athletic competition may seem important to many, it is ultimately a performance experienced as leisure spectator activity and enacted in an increasingly professionalized and spectacularized market-place setting. Consequently, anointing the sports hero as true hero may be a cloudy endeavor.

There is little doubt that the notion of the sports hero is rooted in both mythology and romanticism (Crepeau, 1981). Charting this through American literary history, Oriard (1982, p. 26) saw the creation of the athlete-hero as part of a larger and prevalent "hero-making impulse." For Oriard (p. 30) the sports hero is largely a "prowess hero" rather than "ethical hero." This tracks with Allison and Goethal's (2011, p. 200) conclusion that "[a]lthough heroism can be based in either conscience or competence alone, most of the examples

. . . combine both qualities." Indeed, Rowe's (1997, p. 207) characterization that "[t]he heroic mythology of sport is founded on a close matching of the extraordinary physical feats of the sportsperson *in extremis* and the imputed nobility of the performer" implies the central tendency to combine the attributes and for one to implicate the other. This tendency is at the heart of what Harris (1994, p. 13) has called the "athlete-hero dilemma," wherein she argued such inferences from competence to conscience will almost always be hindered by three limitations—"shallowness, flawed complexity, and compartmentalization"—that impede the contemporary athlete's development and moral breadth.

In the end, it may be unreasonable for us to expect the athlete, and even the athlete-hero, to be more than just an athlete, to have a balance of competence and conscience in heroic attributes. Yet in our quest for meaning, we hope for more, and the media feed the notion that extraordinary athletic competence is often undergirded by character and fortitude. Still, as NBA basketball star Charles Barkley's famous remark that he was "no role model" reveals, there may be no inherent connection. The ready shortcomings of the sports star on the conscience or moral dimension of heroism have led many critics such as Williams (2009, p. 13) to caution against the "absurdity of athlete worship" because "the mere fact of being well known is not enough to transform athletes into moral standard bearers."

Because of this, much popular and scholarly writing on the sports hero continues to struggle with fundamental questions about whether the contemporary, celebritized species can meet the test of veridicality for the hero genus. Unfortunately, firm resolution of this necessarily hinges on a blurry distinction embraced in what may be an irresolvable philosophical question: Is athletic heroism based on performance or action? Regardless, the angst that is evident in approaching the conundrum of the sports hero recognizes the limits of athletic heroic action. Related to this are fundamental questions about character building in the context of modern sports as they are played on the media stage. As industrialization unfolded, advocates for using sport as an important tool in toughening the socialization of boys in an increasingly feminized, domestic environment made the case that sports build character. In essence, the argument was that sports help make boys men. But, over the years, the residual shortcomings of this logic have revealed themselves. Thus, in today's climate, we are more likely to hear the insightful joke: we know that sports build character, but we are not sure what kind. Given this, no study of the contemporary sports hero is complete without considering issues of character. Sports not only build character, they reveal it, and what we see may be

good, bad, and/or ugly. As a result, the study of sport and character is necessarily incomplete if we fail to consider why sports heroes fall.

Why Fallen Sports Heroes Matter

There are many reasons why media treatment of the fallen sports hero is important. These stories are diverse, controversial, and compelling. As Rowe (1997, p. 203) noted, each case plots "a familiar, tabloid-lined path between homage and outrage, celebration and vilification, moralism and nihilism." That these stories can be complex, with potentially psychologically troublesome tensions to negotiate, especially for a child who has looked up to a sports hero as a role model, has caused the American Psychiatric Association (APA) ("Fallen sports heroes," n.d.) to offer counseling strategies for parents, teachers, and coaches to employ when a sports hero goes down. Their concerns focus on using the fallen sports hero as a "teaching opportunity" to point out how peer pressure can go awry, why practices (such as performance-enhancing drugs) that create unfairness in competition are wrong, why admitting mistakes and providing apologies are important, how fully modeling behavior after athletes can be problematic, why people should be given second chances, and how there are many other more deserving heroic role models in life than athletes. That the APA offers such tactics reminds us how destabilizing the fallen sports hero can be and points out the elusiveness of moral sensibility when it comes to understanding heroes in the context of sport.

For adults too, consideration of the plight of the fallen sports hero presents a learning opportunity. The "teachers" in this case are largely the media who provide "play-by-play" accounts of who and what went down and what this means. Ironically, this puts a sports press that is better suited to its role as the "toy store" of journalism front and center in the ill-cast role of moral educator. The sports press is like the entertainment and (increasingly, as we learned in the "surprise" of the recent world financial meltdown) business press, in that they all are far more disposed to being cheerleaders for their sectors and stars. Even recognizing the limits of the media's abilities to serve as moral arbiter, each case of the fallen sports hero offers the opportunity to situate meaning in the cultural system that birthed its likelihood.

Unfortunately, even if the sports press could overcome its shortcomings of moral standpoint and the tendency to cheer, it often remains challenged by spotty understanding of the contextual complexities of sports socialization and deviance. Indeed, covering this "beat"—and the regularity of sports stars falling

qualifies it as one—demands more nuanced understandings of youth sport subcultures, institutionalized privileging and sheltering of the elite athlete, and the limits that these may place on development. As a result, much sports coverage of the wayward hero tends to put disproportionate blame on the instrumentalities of the fallen individual. And thus, it is often temptingly easy for the media to encourage the sports system to rid itself of a bad apple and return to the cheerleading role than it is to focus scrutiny on the culture of sports and its role in valorizing it.

While the broad literature on sports socialization and deviance (cf. Atkinson & Young, 2008) recognizes the increasing role the media play in the privileging of elite athletes, many of the more prominent renderings of the big-time fallen athlete place much of the blame in certain quarters of socialization and organizational subculture. This is seen in Jeff Benedict's (Benedict, 1997, 2004; Benedict & Yeager, 1998) triad of portraits of a misogynist jock culture of criminality that he saw as pervasive in big-time college athletics, the NFL, and the NBA. Bolstered by crime reports and rich anecdotal evidence, Benedict made a case for what can go wrong when disadvantaged men are cultivated into a life of privilege that valorizes hypermasculinity. When added to organizational practices that implicitly condone and often explicitly protect offenders, Benedict's portrait revealed a climate of criminal behavior and sexual aggression enabled by what Beverly Smith (1996, p. A11) has called a "'dome of violence' that allows violence to occur in ways that it could not in ordinary society and which also silences anyone who challenges it." But, as Benedict (1997, p. xi) noted about the reception of his work, many see danger in playing the race card in reporting results that "unfavorably serve to perpetuate stereotypes—including those about ethnic and racial groups."

While other analyses of fallen sports stars such as Teitelbaum's (2005, 2010) look more explicitly to the psyche of the athlete in the context of sports socialization, the intersection of race, ethnicity, and hypermasculinity is likely to remain perpetually sensitive in unraveling the cultural meaning of the fallen sports hero. This is especially true, as the work showcased in Ogden and Rosen's (2010) collection, *Fame to Infamy: Race, Sport, and the Fall from Grace* suggested, when questions over morals, sex, and violence take center stage. Nowhere is this more evident than in cultural explanations of why a Black male athlete may fall. Here, as the work of Grainger, Newman, and Andrews (2006) and Leonard (2009, 2010) pointed out, the meaning of the Black male sporting body is almost always paired with predispositions to crime, drugs, and sexual deviance that are stereotyped hallmarks of hip-hop culture.

It is clear that examining the larger topic of this book—*Fallen Sports Heroes, Media, and Celebrity Culture*—will mean that the "media card" will need to be

dealt along with those of race and gender. While there are a number of fine examples of media-sensitive work (cf. Denham, 2004; Foote, 2003; Kennedy, 2000; Markovitz, 2006; Wachs & Dworkin, 1997), perhaps the most insightful and far-ranging is Rowe's (1997) "Apollo Undone," which built on his earlier work (Rowe, 1994) on the falling of "Tragic Magic" Johnson from AIDS. Rowe's work is especially important in that it locates a series of sports scandals in the broader functioning of media in postmodern times. Rowe's (1997, pp. 204–206) study spoke to the uniquely blurry lines of a sporting press that often engages the guilty pleasures of *schadenfreude* and "the moral relativism and ironic detachment of postmodernity" in narrativization that weaves "hard news" with "soft news" and "everyday gossip."

That the media engage moral meaning on such slippery turf, and often with cavalier spirit, means that studies, such as the ones featured in this volume, that attempt to break new ground by taking into account the fullness of the hero-to-villain arc, will encounter many challenges. Meeting that challenge will help us better understand where the moral lines for public figures are drawn in our cultural sand. Beyond this, there are many compelling reasons to put fallen sports heroes, media treatment of them, and our understandings of celebrity culture under the microscope. As Rowe (1997) suggested, these involve weighty questions with broad implications:

> Why and which ways is sport integral to these scandals? What kinds of celebrity are subject to scandal? How do celebrity sports scandals inform political-cultural debates and discourses? These are by no means lightweight questions about ephemeral pseudo-events, because they go to the very heart of the elusive politics of the popular. Each scandal becomes an opportunity to deconstruct and interrogate those social ideologies and structures to which all forms of popular culture are tethered and from which each seeks release. (p. 204)

In lived experience, such opportunities are discrete. As a result, we consider them iteratively, seeing their narratives as unique stories of individual failings. Thus, when an athlete's actions go awry—on the field or off—we tend to blame the actor, rather than the structures and socialization of sport that may have wrought the problem or the forces of media that encourage a certain kind of star "to be born." This book provides an opportunity to look more coherently at the fallen sports hero phenomenon and to understand the roles that both sport and media play in the hero-to-villain arc that has become an inevitable feature of contemporary, celebrity-infused culture. The studies play on a broad cultural field and help us comprehend not only why certain sports heroes fall down and stay down but also why others recover to have their stars shine again another day.

The Fallen Sports Hero Terrain

This book takes us on a unique journey across the fallen sports hero terrain. Featured here is the work of an important group of scholars in sports, media, and cultural studies from around the globe. Each treatment brings a unique vantage point on understanding the rise and fall of the sports star, hero, and celebrity. From the "framing chapters" that open the volume to those that delve into the sometimes sordid details of a notable sporting figure's fall, we are reminded of the remarkable diversity of these moral sagas and their impact on public consciousness. In these treatments, we see that the narratives are not just about sport but about broader issues of character, attribution of blame, the moral sensibilities that guide our judgments, and the conditions under which we may be open to second chances and attempts at redemption. We are provoked to think not only about the differences in the way sporting heroes may be drawn in individual versus team sports, but also about how those who lead and interpret our sports experiences as coaches and announcers uniquely inhabit the moral terrain. The moral crises that these sporting figures face extend well beyond offenses such as doping, performance-enhancing drugs, and cheating to render "un-level" the playing field. They illustrate offenses stemming from a sense of entitlement and self-absorption and provide insight into "arrested development." We learn "what about no" that many in the sports world do not understand.

Building on this chapter's introduction are three essays that help frame our understandings of the fallen sports hero as celebrity, athlete, and media subject and actor. In "Exposing Celebrity Sport," cultural studies theorist Toby Miller evocatively characterizes the rise of cultural celebrity and the moral complexities of sports stardom by examining an early case of a sports hero harmed by his own commodification. Philosopher and ethicist Bill Morgan considers "Athletic Heroic Acts and Living on the Moral Edge" by comparing authentic heroic actions with those of athletes as he speaks to the inherent limitations of media to meaningfully discern differences. The closing chapter of the introductory section features sports communication scholar Bryan Denham who places media coverage of the fallen sports hero into the theoretical contexts of news values and agenda setting. In "From Coverage to Recovery: Mediating the Fallen Sport Celebrity," Denham outlines the processes that media use to cognitively frame and exemplify bad behavior and allow recovery from it that resonate in all the cases featured in this book.

Case studies in the second section consider a wide range of offenses that have brought down heroes in individual sports where the athlete becomes a brand and where responsibilities to team are not featured. Andrew Billings

examines the headline case of how golf great Tiger Woods landed "in the rough" with his marriage and sexual relations and compounded this by mishandling strategies of apologia. Lee Harrington and Kim Schimmel chart the "tides of tennis celebrity" in Andre Agassi's negotiations of image, reconstruction, and confession. Lindsey Meân's study of track star Marion Jones shows the role that gender and race played in the evolution of media framing her first as "Golden Girl" and then as flawed and fraud in her personal relations and drug-aided performance. Becky Beal's story features a different sporting drug prescription, one that has crystal meth meeting Christianity in the unique story of professional skateboarder Christian Hosoi's travails in the "ups and downs of skating vertical." James Cherney and Kurt Lindemann show how media understanding of performance-enhancing drugs may cloud those about the traumatic effects of concussions in explaining the sad story of murder and suicide in the life of professional wrestling icon Chris Benoit. Pirkko Markula and Zoe Avner move from drugs to alcohol in considering the perpetual public soap opera of Finnish ski jumping champion turned popular singer, Matti Nykänen. Alistair John, Toni Bruce, and Steve Jackson explore a different public affront, one that pits the ethics of opportunism against national loyalties in media treatment of New Zealand yachtsman Russell Coutts' negotiation of the international marketplace. The section's closing chapter by Cheryl Cooky and Shari Dworkin explores how media and national identity interplay in struggles over gender verification and maintaining level playing fields for women's sport in a case where South African runner Caster Semenya's star was tarnished.

The book's third section shows how the context of team sport adds complexities to the fallen hero saga. While coaches often observe "there is no 'I' in team," these media narratives clearly remind us that there is one in celebrity and selfish. Michael Giardina and Mar Magnusen examine media sensibilities in the culturally complex case of criminal dogfighting bringing down star quarterback Michael Vick and the complicity of media in his rehabilitation. Kate Lavelle reminds us that "guns are no joke" in media treatment of two complementary cases—featuring the NFL's Plaxico Burress and the NBA's Gilbert Arenas—where understandings about gunplay, Black masculinity and urban culture framed their falls. Mary McDonald and Cheryl Cooky show how race, "sense of place," and a male standard of bad behavior intersect to cast a shadow over media understandings of "shocking behavior" by some WNBA "bad girls." Oliver Rick, Michael Silk, and David Andrews illustrate how media tensions—those pitting marketing communications against press disgruntlement in the case of international globetrotting of soccer mega-celebrity David Beckham—moderate the "liquid" ebb and flow of public

sentiment in a hypercommodified environment. Bill Grantham charts the legal and moral tensions that played out in the illustrious tabloid career of elite Team England and Chelsea centre back John Terry, one that took him from celebrated "Dad of the Year" to an affair with a teammate's wife. Jim McKay and Karen Brooks show how media narratives about "Aussie Rules" football "King," Wayne Carey, that served to normalize a transgressive repeat offender's tendencies to affairs, indecency, violence, and substance abuse can somehow leave room for redemption. David Rowe's intriguing chapter on the dualities of media reception in the ups and downs of the celebritized Indian cricket bowler Harbhajan Singh speaks to the complexities of race and nation in the postcolonial shadow.

Breaking new ground in the fourth section are cases that examine the increasingly heroic and celebritized roles of coaches and broadcast announcers and what happens when these sporting leaders fall. Marie Hardin and Nicole LaVoi consider how wayward women basketball coaches, Rene Portland and Pokey Chatman, received "neo-homophobic" media scrutiny for infractions on very different sides of the "lesbian problem" in women's intercollegiate basketball. Mike Butterworth, in examining three leading college football "coaches gone wild," shows how media tendencies in covering abusive treatment of players are anchored in the moral climate of hegemonic masculinity. Penetrating that climate further, Kevin Young and Michael Atkinson chart how evolving deviant norms in Rugby Union allowed London Harlequins coach, Dean Richards, to soften his mediated fall for having a player fake injury for competitive advantage in the infamous Bloodgate affair. Heather Hundley, in moving the focus from falling coaches to sportscasters, charts how a parade of these stars of sports who "live" by their vocal "swords" often "die" by them as well, courtesy of racist, sexist, and homophobic infractions. Jay Scherer and Lisa McDermott follow by pondering the case of Don Cherry, the often polarizing voice of "Hockey Night in Canada" whose "rock'em sock'em nationalism" shows just how complicated the hero-villain binary can be.

Finally, this book's stocktaking closes with an "inside the bubble" reflection from former Ironman champion, Scott Tinley, whose own performances enabled contemporary fascination with the triathlon. Tinley's candid observations about how our sporting identities are intrinsically linked to our heroes' "thrill of victory" and "agony of defeat" remind us that collectively we are part of the problem. We both enjoy our ride up with our celebritized sports heroes and we seemingly cannot take our eyes (and the press of our slippery moral stocktaking) off them as they fall. Along for the ride, we both wish it could be us and at the same time shudder at the thought.

References

Allison, S. T., & Goethals, G. R. (2011). *Heroes: What they do and why we need them*. New York, NY: Oxford University Press.

Andrews, D. L., & Jackson, S. J. (Eds.). (2001). *Sport stars: The cultural politics of sporting celebrity*. London, UK: Routledge.

Arendt, H. (1958). *The human condition*. Chicago, IL: University of Chicago Press.

Atkinson, M., & Young, K. (2008). *Deviance and social control in sport*. Champaign, IL: Human Kinetics.

Benedict, J. (1997). *Public heroes, private felons: Athletes and crimes against women*. Boston, MA: Northeastern University Press.

Benedict, J. (2004). *Out of bounds: Inside the NBA's culture of rape, violence, and crime*. New York, NY: HarperCollins.

Benedict, J., & Yaeger, D. (1998). *Pros and cons: The criminals who play in the NFL*. New York, NY: Warner Books.

Boorstin, D. J. (1973). *The image: A guide to pseudo-events in America*. New York, NY: Harper & Row.

Campbell, J. (1968). *The hero with a thousand faces* (2nd ed.). Princeton, NJ: Princeton University Press.

Crepeau, R. C. (1981). Sport, heroes and myth. *Journal of Sport and Social Issues, 5*(1), 23–31.

Curtius, E. R. (1963). *European literature and the Latin Middle Ages*. New York, NY: Harper & Row.

Denham, B. E. (2004). Hero or hypocrite?: United States and international media portrayals of Carl Lewis amid revelations of a positive drug test. *International Review for the Sociology of Sport, 39*(2), 167–185.

Drucker, S. J. (2008). The mediated sports hero. In S. J. Drucker & G. Gumpert (Eds.), *Heroes in a global world* (pp. 415–432). Cresskill, NJ: Hampton Press.

Fallen sports heroes. (n.d.). American Psychiatric Association. Retrieved from http://www.healthyminds.org/More-Info-For/Athletes/Fallen-sports-heroes.aspx

Foote, S. (2003). Making sport of Tonya: Class performance and social punishment. *Journal of Sport and Social Issues, 27*(1), 3–17.

Geertz, C. (1973). *The interpretation of cultures: Selected essays*. New York, NY: Basic Books.

Grainger, A., Newman, J. I., & Andrews, D. L. (2006). Sport, the media, and the construction of race. In A. A. Raney & J. Bryant (Eds.), *Handbook of sports and media* (pp. 482–505). Mahwah, NJ: Lawrence Erlbaum.

Harris, J. (1994). *Athletes and the American hero dilemma*. Champaign, IL: Human Kinetics.

Kennedy, E. (2000). Bad boys and gentlemen: Gendered narrative in televised sport. *International Review for the Sociology of Sport, 35*(1), 59–73.

Leonard, D. J. (2009). It's gotta be the body: Race, commodity, and surveillance of contemporary Black athletes. *Studies in Symbolic Interaction, 33*, 165–190.

Leonard, D. J. (2010). Jumping the gun: Sporting cultures and the criminalization of Black masculinity. *Journal of Sport and Social Issues, 34*(2), 252–262.

Markovitz, J. (2006). Anatomy of a spectacle: Race, gender, and memory in the Kobe Bryant rape case. *Sociology of Sport Journal, 23*(4), 396–418.

McGinniss, J. (1990). *Heroes.* New York, NY: Simon & Schuster.

New Oxford American Dictionary (Version 2.1.3 (80.4)). (2009). Cupertino, CA: Apple.

Ogden, D. C., & Rosen, J. N. (Eds.). (2010). *Fame to infamy: Race, sport, and the fall from grace.* Jackson, MS: University Press of Mississippi.

Oriard, M. (1982). *Dreaming of heroes: American sports fiction, 1868–1980.* Chicago, IL: Nelson-Hall.

Rodriguez, G. (2009, February 16). Our need for heroes, flaws and all. *Los Angeles Times*, p. A21.

Rowe, D. (1994). Accommodating bodies: Celebrity, sexuality, and 'tragic Magic.' *Journal of Sport and Social Issues, 18*(1), 6–26.

Rowe, D. (1997). Apollo undone: The sports scandal. In J. Lull & S. Hinerman (Eds.), *Media scandals: Morality and desire in the popular culture marketplace* (pp. 203–221). New York, NY: Columbia University Press.

Smart, B. (2005). *The sport star: Modern sport and the cultural economy of sporting celebrity.* London, UK: Sage.

Smith, B. (1996, July 17). Abuse prevalent in sport, survey indicates. *The Globe and Mail*, pp. A11–A12.

Smith, G. (1996, December 23). The chosen one. *Sports Illustrated*, 28–52.

Strate, L. (1994). Heroes: A communication perspective. In S. J. Drucker & R. S. Cathcart (Eds.), *American heroes in a media age* (pp. 15–23). Cresskill, NJ: Hampton Press.

Teitelbaum, S. H. (2005). *Sports heroes, fallen idols.* Lincoln, NE: University of Nebraska Press.

Teitelbaum, S. H. (2010). *Athletes who indulge their dark side: Sex, drugs, and cover-ups.* Santa Barbara, CA: Praeger.

Vande Berg, L. (1998). The sports hero meets mediated celebrityhood. In L. A. Wenner (Ed.), *MediaSport* (pp. 134–153). London, UK: Routledge.

Wachs, F. L., & Dworkin, S. L. (1997). 'There's no such thing as a gay hero': Sexual identity and media framing of HIV-positive athletes. *Journal of Sport and Social Issues, 21*(4), 327–347.

Watson, D. R. (2008, January/February). Where have all the heroes gone? *Debt 3, 23*(1), 42–43.

Wenner, L. A. (2007). Towards a dirty theory of narrative ethics: Prolegomenon on media, sport and commodity value. *International Journal of Media and Cultural Politics, 3*(2), 111–129.

Whannel, G. (2002). *Media sport stars: Masculinities and moralities.* London, UK: Routledge.

Williams, A. (2009, December 17–23). The absurdity of athlete worship. *New York Amsterdam News*, p. 13.

Exposing Celebrity Sports

Toby Miller

"Get fit, get hot, start sooner, last longer, look cool, be loved. It's summer, so strip down!" Incitements to invigilate the body are everywhere, brokered through sporting heroes and heroines who function as models of desire. Sports and celebrity jumble together. They cannot be kept apart because they live cheek by cheek, torso by torso, boot by boot.

The paradox at the heart of sports, its simultaneously transcendent and imprisoning qualities and its astonishing capacity to allegorize, is most obvious and perhaps most transformative in the field of celebrity culture. With the advent of consumer capitalism and postmodern culture, the body has become an increasingly visible *locus* of desire. The manipulation of appearance through fashion codes, bodily adornment, calculated nutrition, and physical condition- ing has changed the clothes we wear, the desires we feel, the exercises we do, and the images we consume.

Sporting bodies are powerful symbols because they are embossed with signs of free will, self-control, health, productivity, and transcendence. Hence the almost inevitable code-switching between good and bad conduct among athletes: high-performance dietary supplements versus illegal drugs, sexual display in advertisements as opposed to extramarital affairs in private, club loyalty and disloyalty, or any other oscillation between and within written and unwritten rules that classify the good and the bad. The body is the currency of sports, and its passions and its unreliability mark it out for disappointment and excess as much as fulfillment and success. That ontology connects the concerns of this book to wider issues of celebrity.

Cultural Celebrity

The idea of cultural celebrity has been with us since the first portraits of writers and painters in 12th century Europe, which marketed their subjects to potential sponsors—a precapitalist commodification of authorship. In the 17th century, portraits became methods of instruction. Depictions of the daily life

of royalty modeled rituals for courtiers. Some time later (this is my hyper-abbreviated history of European art and society) democracy and capitalism invented the idea of publicity as a means of transferring esteem and legitimacy from the court and religion to upwardly mobile businessmen, whose legitimacy did not derive from their family backgrounds or from superstition (cf. Briggs & Burke 2003, pp. 11, 41; Elias, 1994; Gamson, 1994; Marshall, 1997).

Hence contemporary debates over celebrities and authenticity: their transhistorical as opposed to ephemeral value, their authentic versus manufactured qualities, and their public and private lives—in other words, the full catastrophe (and pleasure) of a *nouveau riche* that promotes itself and instructs others. Sports stars are part of the pantheon of celebrities who are constituted as models for emulation, displacing the traditional role of sovereign royalty as symbols of higher conduct. They form a labor aristocracy.

Sports Celebrity

The major sporting star is a stranger who is paradoxically part of daily life, a key myth and symbol of gender, race, and happiness, reified by capitalistic, sexual, and cultural processes that fabricate personal qualities and social signs as resources for commerce, art, and fantasy. Athletes are perfect celebrities. We know almost too much about them, most notably what they look like *in extremis*: dirty, sweaty, teary, demoralized, undressed, furious, joyous, unguarded, unconscious, and otherwise injured. Like ourselves when vomiting or coming. Our assumption of omniscience flows from their visibility, "liveness," repetition, and discourse. Athletes' vulnerabilities and victories grow all too apparent, magnified with each replay and diagnosis.

At the same time, we know less about stars than we imagine. Who is the real Wayne Rooney? Is he the diminished footballer who visits prostitutes, pays a hundred pounds for a packet of cigarettes, and watches his hair float down the plughole, never to return, while sex workers are calling him Shrek behind his back? Or is he the dynamic player and dedicated post-hair graft husband of Coleen? Who is Michael Vick? Is he the gormless gambler who derives pleasure from public brutality towards animals? Or is he misunderstood? We are told by the head of the Southeastern Virginia Arts Association that "[p]eople talk about Michael Vick as a convicted felon, well so was Jesus Christ yet . . . we all recognize him today as lord and savior" (dEstries, 2011, para. 1).

The Value of Sports Celebrity

Despite these contradictions, because celebrities lead their lives in the public eye, it is fondly assumed that the public knows who they really are. This tendency is subsidized and commodified—even governed—by a tabloid media joy that derives in seemingly equal measure from celebration and condemnation, as photo shoots of big weddings are supplanted by paparazzi shots of big waistlines. It is a coefficient of the desire of sponsors to pay sizeable sums to associate their products with sporting stars, based on a deal about lifestyle that contractually favors reliability and decency but finds those qualities hard to separate from headlines and excess. By 2005, U.S. celebrity endorsements were said to amount to over a billion dollars in corporate expenditure, based on the assumption that audiences hope to transfer qualities from stars onto themselves by purchasing commodities. Marketing mavens call this "associative learning" (Thrall et al., 2008; Till et al., 2008) in their adoption of psy-function *clichés* for corporate ends.

Again, this has profound historical precedents. Consider the nexus between male athletes and leadership in premodern Greece. Xenophon, Socrates, and Diogenes believed that triumph in sex and sports could lead to failure unless accompanied by regular examination of one's conscience and physical training. Carefully modulated desire in both spheres became a sign of the ability to govern, so Aristotle and Plato favored regular flirtations with excess, as tests as well as pleasures. The capacity of young men to move into positions of social responsibility was judged by charioteering and man-management, because their ability to win sporting dramas was akin to dealing with sexually predatory older males. Each success showed fitness not only physically, but managerially (Miller, 2001).

Exposing the Celebrity Athlete

Inevitably, however, things go wrong with a system based on tests of desire, flirtation, denial, and physicality. People fail and so do institutions. Perhaps the key precedent in the modern era that illustrates this inevitable tension is the U.S. case of *Burton v. Crowell Pub. Co.* from 1936, in which the Second Circuit Court of Appeals for the Southern District of New York heard a previously dismissed action. The plaintiff, Crawford Burton, complained that an image published by the defendant made him look "physically deformed and mentally perverted," as well as "guilty of indecent exposure." The court found the defendant had a case of libel and slander to answer, even though

the "trivial ridicule" that might descend on Burton was "patently an optical illusion" as part of an advertisement in which he had consented to appear (for US$500, according to a rather disdainful *Harvard Crimson* student newspaper (Poo, 1937).

The image in question? Photographs of Burton in an advertisement (available at http://www.periodpaper.com/media/catalog/product/cache/1/image /8022f01105bea4edf676ba39d5976c14/S/E/SEP4_733_1.JPG) for Camel cigarettes had appeared in such periodicals as the *Saturday Evening Post, Popular Mechanics, Liberty Magazine, Collier's,* and *Popular Science.* Burton, a renowned jockey and stockbroker, was quoted as endorsing Camels for their calming, restorative effect after "a crowded business day." This annotation accompanied two images. The first, which did not excite legal action, depicted Burton post-race in his riding attire, holding cigarette, whip, and cap, with "Get a lift with a Camel" as the caption. It represented him after the little death, the race-finish when it is time for all good jockeys and horses to draw deep breaths. Problems arose with the other picture (captioned "When you feel 'all in'"). Burton is shown in the less dramatic, more regulatory ritual of the weigh-in. Carrying his saddle, he has one hand under the cantle and the other beneath the pommel. The seat is about a foot below his waist, and the line formed by a loose girth appears to connect him to it. Herein lies the problem: it looks like an exposed and available penis.

Time magazine ("Press: Camel Jockey," 1937) described the background to the case thus:

> An advertising sensation of 1934 was the color photograph of Gentleman Jockey Crawford Burton, twice winner of the dangerous Maryland Hunt Cup, posing in his racing silks as an endorser of Camel cigarets' [sic] recuperative power. By a horrible mischance, the photograph of Mr. Burton, holding his saddle and girth, reproduced in such a manner that to a prurient or imaginative eye it appeared to show Mr. Burton indecently exposed as only a man could be exposed.
>
> When Crawford Burton, who is a stockbroker when not riding, showed up the next day at the New York Stock Exchange, he found that its notoriously prurient members had so chosen to interpret his picture. When Mr. Burton entered the Exchange smoking room, he said that scores of brokers began to brandish copies of *Collier's* (one of the first publications to receive and print the advertisement) and set up such a gibbering that he could execute no orders, went home to seclude himself for days.

In the terminology of Circuit Judge Learned Hand, "the photograph becomes grotesque, monstrous, and obscene; and the legends, which without undue violence can be made to match, reinforce the ribald interpretation. That is the libel." He was struck by the picture's "lewd deformity."

Burton had posed for the photographs but had not been shown the outcome. His counsel claimed that the image meant he could be regarded "as guilty of indecent exposure and as being a person physically deformed and mentally perverted" (*Burton v. Crowell*, 1936, p. 154). The case continues to be read today, and its arguments about the jockey losing legitimacy in the public eye still resonate. In an Equal Opportunities Commission Case (*Oates v. Discovery Zone*, 1996, p. 1205) it was regrettable that the Commission believed the decision in the case turned on comparing the appellant Burton to a "gorilla."

The case has another side. Even before the judgment was handed down—and not because of the Camel-penis connection—the National Steeplechase and Hunt Association had announced that a ten-dollar fine would be levied on jockeys smoking in their silks. Once Burton's advertisement appeared, it was decided that the act of smoking itself should lead to a ban, as James Thurber noted in *The New Yorker* (Kinkead, Smith, & Thurber, 1934).

Conclusion: The Complexities of Celebrity Sports

As per that case, the celebrity sports star is a complex mix of marketing methods, social signs, national emblems, products of capitalism and individualism, and objects of personal and collective consumption, with desire and control in a necessarily unsteady relationship. Each tendency imbricates the public with the private and publicity with intimacy. The space for errors is literally boundless, as wide as the distance between winners and nonstarters in a steeplechase.

Athletes become celebrities when their social and private lives grow more important than their professional qualities. They represent the times more generally because they provide stereotypes of success, power, and beauty. As figures of consumption and emulation, they incarnate dramatic roles and fashions. In addition, they show us the limitations and promises of an age. Above all, each celebrity "es una imagen; pero no una imagen natural" [is an image; but not a natural image]. What matters is: "la transformación del icono ideográfico en icono normative" [the transformation of an ideographic icon into a normative one], a process whereby photographs and other reproductions become public historical documents about success and tragedy (Bueno, 2002, p. 2).

It is easy to mock a fascination with celebrity culture. Moving away from sports, consider the questions asked only a short while ago about U.S. obsessions with minor celebrities: should we care when "octomom" Nadya Suleman

gives birth to a lot of children or a Mouseketeer (Britney Spears) gets a bad haircut? We could ridicule engagement with such topics and suggest it would be better to study Iran's nuclear warhead capability or Israel's theocratic racial state. Or we could list some of the issues that such tabloid tales represent: life as a single parent; the ethics and experience of fertility treatments; eating disorders; and romantic disappointment. Are these so unimportant? Thinking back to Rooney and Vick, the issues their stories raise—about masculinity, the sex industries, and animal cruelty—are also far from trivial.

It is easy to lament popular interest in the transgressions of sporting figures, to read them as symptoms of a culture of triviality that fails to address major questions of the day—or indeed to read the scandals themselves as symptoms. The history is more clouded and complex than such facile analyses will allow, and the value of investigating human life as a social sign infinitely more valuable. Hence the importance of the book you hold in your hands.

References

Briggs, A., & Burke, P. (2003). *A social history of the media: From Gutenberg to the Internet.* Cambridge, UK: Polity Press.

Bueno, G. (2002). La canonización de Marilyn Monroe. *El Catoblepas, 9,* 2.

Burton v. Crowell Pub. Co., 82 F.2D 154 (2nd Cir. 1936).

dEstries, M. (2011, March 1). Michael Vick now being compared to Jesus Christ. *Ecorazzi.* Retrieved from http://www.ecorazzi.com/2011/03/01/michael-vick-now-being-compared-to-jesus-christ

Elias, N. (1994). *The civilizing process: The history of manners and state formation and civilization* (E. Jephcott, Trans.). Oxford, UK: Blackwell.

Gamson, J. (1994). *Claims to fame: Celebrity in contemporary America.* Berkeley, CA: University of California Press.

Kinkead, E., Smith, G. B., & Thurber, J. (1934, August 25). Comment. *The New Yorker.* Retrieved from http://archives.newyorker.com/?i=1934-08-25#folio=011

Marshall, P. D. (1997). *Celebrity and power: Fame in contemporary culture.* Minneapolis, MN: University of Minnesota Press.

Miller, T. (2001). *Sportsex.* Philadelphia, PA: Temple University Press.

Oates v. Discovery Zone 96 F.7D 1205 (7th Cir. 1996).

Poo, W. (1937, January 13). Off key. *The Harvard Crimson.* Retrieved at http://www.thecrimson.com/article/1937/1/13/off-key-pcrawford-burton-the-so-called/?print=1

Press: Camel jockey. (1937, January 18). *Time.* Retrieved from http://www.time.com/time/magazine/article/0,9171,770495,00.html

Thrall, A. T., Lollio-Fakhreddine, J., Berent, J., Donnelly, L., Herrin, W., Paquette, Z., . . . Wyatt, A. (2008). Star power: Celebrity advocacy and the evolution of the public sphere. *International Journal of Press/Politics, 13*(4), 362–385.

Till, B. D., Stanley, S. M., & Priluck, R. (2008). Classical conditioning and celebrity endorsers: An examination of belongingness and resistance to extinction. *Psychology & Marketing,* 25(2),179–196.

Athletic Heroic Acts and Living on the Moral Edge

William J. Morgan

Athletic heroism is a kind of decisive, no-holds barred action that contrasts markedly with the cautious, safe, and secure lives contemporary human beings seem—by design—to live. Our penchant to play it safe and to make sure that we satisfy our egoistic needs and interests while eschewing involvement in any larger venture that transcends those needs and interests explains why many social critics consider our age to be a decidedly unheroic one, lacking in passion and a higher sense of purpose. On the other hand, our great admiration for heroes both on and off the field suggests we are not as far gone as such critics suggest, as we are uplifted, if not awestruck, by the remarkable things heroes do. But of late, we are just as often morally troubled by heroes who fail us. This chapter considers the interplay between our ambivalence about athletic heroes and their choices to live on the moral edge.

What Is Heroic Action?

In trying to assess what counts as heroic action, I recount a paradigmatic event that received much press coverage in January 2007, the heroic status of which is beyond dispute. The main features of that event help understand how it received that status. In a Manhattan subway, Cameron Hollopeter, a young film student, suffered a convulsive fit and fell backwards off a subway platform to the tracks below. Wesley Autrey, a middle-aged construction worker, observed the event from further back on the platform. Without the slightest hesitation he jumped to the tracks and just as the lights of a southbound train appeared, proceeded to push Hollopeter down into a one-foot trough between the rails by lying on top of him. The train conductor applied the brakes immediately but was unable to stop the train before five of its cars screeched over the top of the two men, missing them by inches. Hearing terrified cries from the onlookers above, Autrey yelled that they were both okay and asked

for someone to tell his two young daughters—left behind on the subway platform—that their father was fine. The onlookers clapped spontaneously and thunderously while shouting to one another about the remarkable event just witnessed.

Indisputably, Autrey's actions rise to the level of the heroic. While surely paradigmatic, his actions fall into a special class of heroic acts as they called on him to risk his life. By contrast, athletic instances of heroism seldom (with the exception of some "extreme" sports) rise to this level, not requiring such extreme altruism or risk. As a paradigmatic example of heroic action, there are several overlapping features in Autrey's acts that illumine what kinds of action, athletic and otherwise, qualify as genuinely heroic ones.

The first thing to note is the decisiveness of Autrey's actions—he showed no trace of hesitancy or ambivalence. They were decisive because he was able to size up the situation and settle on a course of action in an instant. The short time he had to act influenced the decisiveness of his response, but the timeliness of his response was also crucial to its heroic quality. Another important sense in which Autrey's actions proved decisive is that they were unmistakably effective, determining whether someone lived rather than died. That Autrey's actions made this big difference further showcases their impressive decisiveness, and thus their heroic quality. By contrast, actions which we mortals take (whether voting for a political candidate, working for the betterment of others, or just trying to be a better person) seem to rarely make a difference in the lives of others or even our own.

The second notable feature of Autrey's actions is that despite their decisiveness and consequential effects, he was responding to events not entirely within his control. What he did was not in itself "out of control" in the sense used to describe someone who acts impulsively or in an addictive manner (i.e.,in nonintentional or nonpurposive ways). His actions were self-determined and purposive, but they were also responses to the situation he encountered. As a hero he was able to do these remarkable, self-directed things only because the stimulus came from a force outside of himself (Dreyfus & Kelly, 2011).

What makes these actions heroic, then, is not that they were at Autrey's exclusive beck and call, but that he was neither controlled nor otherwise rendered powerless by these outside forces—as addicts and compulsive eaters typically are. Rather, he was able to respond and meet them head on. For all the resoluteness and effectiveness of his actions, they were dictated by factors over which he had no control. Thus, no one can simply decide (in the sense of aim and plan) to be a hero. Rather, events must conspire to create just the

right conditions to make heroic action possible, and only if one is up, as Autrey was, to the challenge presented.

Yet a third important feature of Autrey's actions is the practical intelligence informing them. The thoughtfulness of heroic acts like this one—the amount of thinking that goes into them and makes them so effective—is often forgotten because they are not deliberate acts. It is only if we mistakenly run together deliberative reflection with thinking as such, however, that we will be misled into characterizing heroic acts as those that "have left the domain of thought altogether" (Dreyfus & Kelly, 2011, p. 9). That heroic acts are not, and could not be the product of deliberation is a given. There is no time to deliberate first and then to act when one is pressed to respond in a decisive and consequential way to an ongoing and dynamic situation. In such tension-packed moments, there is not only no time but no need to decide first what to do. That is because heroes like Autrey possess a heightened awareness of their surroundings, which, importantly, includes already knowing the right thing to do to resolve the situation. Because heroes are not vexed or otherwise unsure about what needs to be done, deliberation is not needed. They differ only in degree from other thoughtful persons, who, though they may not be capable of acting heroically, are similarly aware, in a lesser sense, of their surroundings and respond accordingly: the passerby who suddenly sees an elderly couple struggling to lift heavy luggage up stairs and, without pausing, lends assistance (Watson, 2004).

In this and Autrey's case, deliberation is superfluous because both immediately recognized what the situation demanded in the way of an appropriate response. But for all that, they did not just respond blindly, rashly, or in a foolhardy way that made a bad situation worse, but rather in a thoughtful way that made the situation better. This is practical intelligence at work, even if it does not involve "deciding" what needs to be done. It also does not involve the calculative weighing of benefits and costs that many automatically engage in when we are mulling over whether to undertake some venture. But to insist that "deciding" and instrumental reasoning exhaust what passes for practical intelligence, for being thoughtful, is a conceit we can do without, because if we accept this conceit then even fewer of us will be able to act heroically, let alone recognize heroes in our midst.

The fourth and last feature of Autrey's actions relevant to the heroic is that they are highly prized by all concerned—both by those directly affected and those learning of them after the fact. This explains why media characterizations of such actions are so important to their reception as heroic. Autrey's actions were considered worthy of acclaim because they touched on what we believe is valuable and meaningful in living. In contrast, the no less decisive,

effective, and intelligent actions a gang member might take to avenge a comrade's death in a street fight are seen as anything but heroic. Unlike the hero, the gang member's actions are not considered worthy of our acclaim because they speak to what is base rather than noble in the human spirit.

While other features of Autrey's actions could also be analyzed, the four features discussed here are the most salient and have special relevance forconsidering heroic actions in the athletic domain.

Athletic Heroic Action

This section analyzes heroic actions in sport, and considers why, notwithstanding their positive moral valence, we may find them morally tenuous if not morally suspect. The following example of a paradigmatic case of athletic heroic action sets the stage.

This example comes from the late writer David Foster Wallace (2006), who described a forehand winner hit by Swiss tennis player, Roger Federer, against his American opponent, Andre Agassi, in the fourth set of the 2005 U.S. Open finals. Writing in *The New York Times Magazine*, Wallace dubbed the intricately executed actions captured in his description as a "Federer Moment." Wallace began his account as Agassi had hit a scorching forehand deep to Federer's backhand and caught the Swiss player moving wrongly to the center line. Wallace continued:

> Federer . . . somehow instantly reverses thrust and sort of skip[s] backward three or four steps, impossibly fast, to hit a forehand out of his backhand corner, all his weight moving backward, and the forehand is a topspin screamer down the line past Agassi at net . . . and lands exactly in the deuce corner of Agassi's side a winner. (2006, pp. 1–2)

Wallace described spectators erupting into rapturous applause at Federer's recovery and amazing forehand winner. Recounting and replying to color commentator John McEnroe's incredulous question—"How do you hit a winner from that position?"—Wallace noted that "given Agassi's position and world-class quickness, Federer had to send the ball down a two-inch pipe of space in order to pass him, with no setup time and none of his weight behind the shot. It was impossible. It was like something out of 'The Matrix'" (p. 2).

All four of the features identified earlier as necessary conditions of heroic action are present in Wallace's description of Federer's actions. What is missing in his description is the life and death scenario played out in the Autrey example, which showcased it as one important species of heroic action. But Wallace's account of Federer's athletic prowess offered the player's actions as an equally important but significantly different species of heroism. They both

fall under the genus of heroic action, with each one providing a vivid picture of larger-than-life humans pulling off larger-than-life feats that the rest of us can only marvel at (but scarcely replicate except in our imaginations). That a noted writer like Wallace portrayed Federer's tennis in such heroic terms and that he was published in *The New York Times* augments the plausibility of comparing Federer's actions to Autrey's, a connection that might otherwise appear strained.

Featuring on-the-court, rather than off-the-court, exploits of an athlete like Federer draws attention to sport as an arena for the expression of human nobility—a characteristic of heroic actions. Doing so, however, significantly brackets from consideration some of the most noteworthy sports heroes whose heroism has as much to do with off-the-playing-field actions as those on the field. Arthur Ashe and Roberto Clemente come to mind because of their noteworthy accomplishments in sports and in larger life. Ashe's heroism was evident in his work with inner city youth and on behalf of AIDS (that eventually claimed his life) victims. Clemente's heroism appeared in humanitarian work on behalf of his native Puerto Rico, which led to his death in a plane crash while delivering supplies to his homeland. By taking this internal vantage point on athletic heroism, no slight is intended against athletes like Ashe and Clemente, whose heroic acts deserve their own special treatment. Rather, the focus here is on heroic acts occurring within athletic competition.

The case for Federer's athletic heroism is fairly straightforward, as his on-court actions match those of Autrey in important respects. They are equally decisive, unbidden in certain important ways, practically intelligent, and highly esteemed by the sporting public. Moreover, given the prominence of sports in modern life, his actions are esteemed by a large segment of the general public as well, and importantly, by sports media eager to hype and normalize uplifting athletic stories as a counter to those about the dark side of sports.

To say that Federer's actions were decisive seems obvious, both with regard to their timeliness and their effectiveness. Part of the reason why is the way that tennis and all sports are internally constructed. Most important in this respect are the rules of sports, allowing them to function as relatively autonomous affairs governed by clear and ideal (fair) standards with respect to their goals and to standards of excellence appropriate to them. This is why sports are not plagued by what Lasch (1979, p. 181) referred to as "the normal confusions of everyday life" that make it difficult to determine what it is we are attempting to accomplish in our lives (be content, healthy, happy, well-off financially) and whether we have or have not accomplished what we set out to do (clear conditions of what counts as success or failure).

The artificial boundaries such rules put in play also establish the agonistic struggle that is a signature feature of sports. The rule-based actions and interactions occurring in a sport like tennis, to which its participants voluntarily subscribe, are all contrived. This is why the intense competitive interchange between Agassi and Federer that prompted the latter's heroism was quite intentional, while in the subway example, the heroism was unwittingly provoked by the involuntary actions of the film student. The timeliness and difference-making character of Federer's performance were, importantly, artifacts of the rule-structured environment in which he and Agassi operated, one in which both could unambiguously see the point of each other's responses and counter-responses and act in a clearheaded and robust manner. In sports, as opposed to everyday life, generating heroic moments of this agonistic kind is an important aspect of the game, and what goes on within the protected venues occurs because of the agency of the participants rather than happenstance.

Because sports heroism is ginned up partly by the rule-governed structure doesn't mean that athletes enjoy complete control over their destiny (heroic or not). That is because while sports are contrived social settings, they are not scripted ones. The same rules that frame sports and give them a clear and distinct purpose as well as a protected space for athletes to perform, also open up a wide range of possible actions, interactions, and countless permutations that defy control, despite the efforts of coaches and others. Because sports are not scripted affairs, much that occurs depends on unplanned and unforeseen contingencies—no athlete, even a Federer, can manufacture a heroic moment. No matter how well prepared, he must contend with events on the court over which he has limited control, forcing him to make choices, initiate actions, and react to the dynamic, competitive situation he has willingly embraced. Borgmann (1992) noted:

> there is no way of predicting or controlling what will happen. No one can produce or guarantee the flow of a game. It unfolds and reveals itself in the playing. It inspires grace and despair, it provokes heroics and failure. . . . It is always greater than the individuals it unites.(p. 135)

Even within the carefully calibrated world of sports, therefore, genuine heroism is a rare occurrence, only slightly less rare than in everyday life.

The practical intelligence of Federer's heroic movements on court is another notable aspect of his performance. It is not the quality of his decisions that matters, for sports provide few opportunities for "deciding" to do anything, instead placing a premium on rapid-fire responding in the moment. Rather, the qualitative grasp he has on relevant actions occurring is key. As Lasch (1979, p. 181) bluntly wrote, "Like sex, drugs, and drink, [sports] oblit-

erate awareness of everyday reality, but they do this not by dimming awareness but by raising it to a new intensity of concentration."

John McPhee noticed the same quality when chronicling the remarkable basketball court sense of former NBA player (and former Senator) Bill Bradley. "During a game," McPhee wrote, "Bradley's eyes are always a glaze of panoptic attention, for a basketball player needs to look at everything, focusing on nothing, until the last moment of commitment" (as quoted in Dreyfus & Kelly, 2011, p. 10). It was this same "panoptic attention" and focus that accounted for Federer's court sense.

As in the Autrey example, Bradley's and Federer's actions, although products of neither deliberation nor the weighing of alternative courses of action (and of costs and benefits),were neither blind nor foolhardy but intelligently on point. The practical intelligence intrinsic to athletic heroism teaches us the limitations of "deciding" and "instrumental weighing," as exemplified by the tragic example of major league second baseman Chuck Knoblauch. One of baseball's best infield players, Knoblauch in 1999 suddenly and inexplicably was unable to accurately make the short throw from second to first. One of his errant throws hit a fan in the stands (Dreyfus & Kelly, 2011, pp. 79–80). The harder he tried to regain accuracy by mentally rehearsing his throwing motion and tinkering with mechanics, the worse his accuracy became. What Knoblauch had lost in field sense and practical mastery of the game—he could no longer execute even a simple throw—could not be compensated for by reverting to a more deliberative, calculative mode of thinking and acting. His very deliberate and explicit efforts were the wrong remedy, blocking rather than enabling the practical intelligence stored away in his "panoptic" feel for the game that until 1999 served him well.

The fourth and final feature necessary to consider an action heroic—to be judged by others to be valuable—is evident in Wallace's enthusiastic treatment of Federer's besting of Agassi. Our local sports pages are full of praise for Federer-like athletic exploits. Adulation is freely and enthusiastically given by media (and many sectors of society) to high-performing athletes. They are often recipients of lavish praise about their exploits because of the important expressive function sports play in society. This can be traced in part to sports' grip on our culture and to athletes' unparalleled capacity to gather surprisingly large numbers of fans and followers.

Sports' impressive "gathering" capacity is matched by their equally impressive "focusing" capacity. Sports have the capacity to "focus" crowds' attention on the heroic qualities of athleticism in a way that can infuse our lives with larger importance and cultural meaning (Dreyfus & Kelly, 2011). Heidegger called any social artifact or practice that performed this gathering and focusing

function a work of art, which he claimed "gives to things their look and to men their outlook on themselves" (1971, p. 43). In ancient Greece, he opined, it was the Greek temple housing their divinities that played a key role in most of ancient Greek life. The temple-dwelling divinities played this gathering/focusing/expressive role and helped citizens understand themselves and what they regarded as meaningful about their lives.

In modern times, it has been the arts in general (literature, music, fine art) and theater in particular that typically performed this function. But today, as Barthes (2007, p. 57) noted, sports and sports media have largely taken over this expressive function: "At certain periods, in certain societies, the theater has had a major social function: it collected the entire city within a shared experience: the knowledge of its own passions. Today it is sport that in its way performs this function. Except the city has . . . [become] a country."

Fallen Athletes and the Media

If sports and the sports media do play this important expressive role in our culture—revealing those features of our lives that are heroic and deserving of our highest esteem—then such acts of athletic heroism must necessarily operate close to the edge of what we regard as morally and aesthetically praiseworthy. So close is this at times that they lose their heroic stature and are rebuked by the media in eager exploitation. Sports—through their "gathering" and "focusing" capacity—play such a key expressive role in culture that we place disproportionate value on their importance, leaving their moral and aesthetic status always open to challenge.

Because there is no shortage of media attention given to sports, what they express about us as a people, and, specifically, what they say about our sense of the heroic, sports are always a site of contestation. Consequently, what has constituted heroic athletic action in one context or time is not guaranteed to pass muster in another, as the history of sports reveals. In some cases, certain instances of heroism have been dismissed as anachronistic and quietly removed from the category, while in others, they have been openly repudiated and forcefully banished from the heroic.

To illustrate this point in a way that addresses our moral doubts about certain forms of athletic "heroism," two elements of athletic success, and therefore, athletic heroism, loom large. The first, a contentious issue in the history of modern sports from the beginning, concerns how strenuously one should strive for athletic glory. At the turn of the twentieth century, when the amateur conception of sport still dominated, the answer to this question was

unequivocally "not too strenuously." The idea that sports was not a serious enough human affair to justify supreme effort extended both to training and competition. To be an athletic hero required demonstrating suitable restraint in one's actions—an athlete should try to win but should do so in a certain insouciant way that showed sports were not the "end all, be all." This explains, for example, why rather than dispensing praise, the British press excoriated the surprisingly dominant American track and field athletes in the 1906 Olympic Games for being "better athletes than sportsmen" (Dyreson, 1998, p. 138). The Americans tried too hard to win.

During the next decade, this quaint view was directly challenged by a burgeoning professional conception of sports in which achieving athletic success/heroism required one's total effort. This clash between the amateur and professional conceptions of the athletic hero was depicted in the film, *Chariots of Fire*, released in 1981, about the 1924 Olympics. One of the main characters, the sprinter Harold Abrahams, is severely reprimanded by his Cambridge dons (and many fellow athletes) for hiring a professional coach. He is criticized for following the coach's "expert" advice to improve his chances for winning by hurling himself headfirst at the finish line tape rather than, as convention demanded, breasting it in an upright position. Abrahams replied, "You know gentlemen, you yearn for victory just as I do. But achieved with the effortlessness of the gods. Yours are the archaic values of the prep school playground I believe in the relentless pursuit of athletic excellence" (Weatherby, 1981, pp. 91-92). For Abrahams and his like-minded professional compatriots, the British media's outrage at the success of winning-focused American athletes in the 1906 Games was viewed as sour grapes. In their contrary view, parroted by the press following professional sports, the better sportsmen could only be the better, winning, athletes.

Abrahams's relentless pursuit of excellence quickly became the norm for judging the heroic quality of athletic actions. But echoes of this earlier tension could be observed in the decades immediately following over such issues as specialization versus all-around athletic competence, and on technological advances in equipment. These historically shifting and heated debates in the public and media spheres reflected the differing ways people construed athletic heroism, and, therefore, whether certain athletic actions called for our esteem, our indifference (actions now viewed as prosaic rather than heroic), or our contempt.

Today athletic specialization is no longer considered a barrier to athletic heroism but a necessary prerequisite, as achieving extraordinary results can scarcely be accomplished any other way, notwithstanding baseball purists who disdain specialization by designated hitters. Technological improvements in

athletic equipment have become uncontroversial as well except in select cases like recently outlawed "slime" suits in swimming. But the same cannot be said for the undeniably important second prerequisite for athletic success and heroism: the matter of talent.

To be an athletic hero requires executing extraordinary athletic feats beyond the reach of most people. Athletic heroes may all be genetic outliers: they are, of course, much more than that, but the "much more" depends on their having first won the genetic lottery. In the past, this has been an uncontroversial part of athletic achievement because it was thought to be unalterable. Good genes were considered something a person was born with (or without), rather than something that could be manipulated and improved upon. But this picture began to change when athletes' surgical procedures began to look less like repair jobs and more like major, performance-enhancing, reconstruction jobs. A notable example is major league pitcher, Tommy John, who became a much better pitcher after undergoing extensive surgery on his arm than he had been before. The picture changed even more dramatically when performance-enhancing drugs became common in the 1960s. Today, advances in genetic engineering raise the specter that manufacturing athletic talent may overtake "practice makes perfect."

The prospect of the surgical, chemical, and genetic boosting of natural talent raises deep and troubling questions about athletic agency that are central to the changing conceptions of athletic heroism and of athletic success. These questions concern whether we think such modes of performance enhancement diminish players' status as agents *qua* athletes. Should such improvements in performance be credited not to the athletes but to the surgeons, pharmacists, and genetic engineers that are responsible for it? Do we fear that athletes will be turned into super agents responsible for everything taking place, such that, as Sandel provocatively put it, "Today when a basketball player misses a rebound, his coach can blame him for being out of position. Tomorrow, the coach may blame him for being too short" (2007, p. 87).

On the first interpretation, enhanced athletes have no real agency to speak of and thus cannot be counted as genuine heroes. On the second, athletes have too much agency to be considered heroes, because what we now regard as extraordinary achievement in sports (only the talented few are capable of such achievement) will become, rather than heroic, quite ordinary and prosaic. Talent will no longer be a limiting factor, and the athletic test as presently structured will not be much of a test for souped-up athletes.

Conclusion

Where does this latter set of complications lead? How the media handle them will largely determine whether high-performing athletes will continue to be accorded hero status. In the case of a Federer, his standing as a hero looks secure. But in the cases of baseball sluggers like McGwire and Sosa, the media have already delivered their verdict—these players no longer belong on our cultural pedestals. Similar verdicts have come to giants such as Lance Armstrong who have allegedly used chemical advantage to fuel success. Indeed, the media, taking stock of today's "un-leveling" of the playing field, ensure that notable athletic achievement is interrogated to assess whether it was accomplished "cleanly."

Such suspicions may be justified since athletes who take this chemical route can be accused of cheating. Yet for those who do not want their heroes transformed into drug-advantaged competitors, the press seemingly has acted more like executioners than impartial judges. The media often underplay the less compelling story that success or failure in sports is related to who wins or loses the genetic lottery. Focusing on this would make the athletic meritocracy they promote and which grounds their determinations of who warrants public adulation or rebuke look more like an athletic hereditary caste.

The media's role in identifying and making sense of sports heroes is an important focus of this book. How the media make sense of the infractions leading to an athletic hero falling from grace is also important in shaping how we think about sports. These are notably complex questions. Even thinking about the drug issue and how it plays into many sagas of the fallen athletic heroes can be challenging for a sports press better equipped to describe the big play and heroic deeds. In helping us think about the falling of the McGwires and Sosas and Armstrongs, the press will have much to sort out about drugs and what role they play in assessing heroism. If they continue to look the other way, to not explain the intricacies of drug testing and ways in which drug tests can be scammed, and to avoid discussing the routine practice of readying injured athletes with analgesic drugs, our understanding of heroes falling through drugs will not be complete.

Drugs, of course, are only one way that our athletic heroes fall. These diverse stories, seen in the chapters that lie ahead, present different challenges for the press. Ripped from the tabloids, these stories are about our heroes' transgressions. For the press, such stories bring short-term gain and long-term pain as these infractions sully the purity of sport and the attractiveness of its heroes as media product. These tales of sex, guns, and bad behaviors are not

just stories of our heroes going down, they are stories about where our moral lines are drawn. One wonders whether the sports press is up to the task.

References

Barthes, R. (2007). *What is sport?* New Haven, CT: Yale University Press.

Borgmann, A. (1992). *Crossing the postmodern divide*. Chicago, IL: University ofChicago Press.

Dreyfus, H., & Kelly, S. (2011). *All things shining: Reading the Western classics to find meaning in a secular age*. New York, NY: Free Press.

Dyreson, M. (1998). *Making the American team: Sport, culture, and the Olympic experience*. Urbana, IL: University of Illinois Press.

Heidegger, M. (1971). *Poetry, language, thought*. New York, NY: Harper & Row.

Lasch, C. (1979). *The culture of narcissism: American life in an age of diminishing expectations*. New York, NY: Warner Books.

Sandel, M. (2007). *The case against perfection: Ethics in the age of genetic engineering*. Cambridge, MA: Harvard University Press.

Wallace, D. F. (2006, August 20). Federer as religious experience.*The New York Times Play Magazine*. Retrieved from http://www.nytimes.com/2006/08/20/sports/playmagazine/20federer.html

Watson, G. (2004). *Agency and answerability: Selected essays*. New York, NY: Oxford University Press.

Weatherby, W. J. (1981). *Chariots of fire*. New York, NY: Dell.

From Coverage to Recovery: Mediating the Fallen Sports Celebrity

Bryan E. Denham

Since the emergence of the penny press more than 180 years ago, reports of scandalous acts have captivated news audiences. Sensationalized accounts of cheating spouses and violent outbursts have helped to increase newspaper and magazine sales, boost the ratings of television news programs and, more recently, provide Internet users with seemingly endless amounts of schadenfreude. Indeed, salacious news has effectively conditioned mass audiences to take pleasure in the misfortunes of others, resulting in a popular culture that celebrates humiliation and public ridicule. Because amateur and professional sports play a significant role in popular culture, athletes who engage in scandalous behavior often find themselves the subjects of media onslaughts, challenging even the craftiest of image-restoration specialists.

This chapter examines how the mass media portray fallen sports heroes yet also provide the exposure for those same individuals to restore their respective images. The chapter begins by addressing basic news values. It then reviews theoretical frameworks in agenda setting (McCombs, 2004), framing and attribution (Heider, 1958; Iyengar, 1991), and exemplification (Zillmann, 1999), before covering work in crisis communication and image restoration (Allen & Caillouet, 1994; Benoit, 1997; Coombs, 2007). As the chapter stresses, because episodic news texts tend to be grounded in dominant conceptions of moral behavior, news audiences generally blame individuals for their predicaments, attributing embarrassing situations to shortcomings of character and to an absence of values and personal ethics (see Denham, 2008). Yet, when athletes acknowledge their behavior and offer public apologies, media feature stories of redemption, extending the basic narrative of right versus wrong, moral versus immoral.

Covering the Fallen Sports Celebrity

News values

To gain a sense of why the mass media feature scandal-driven news stories as often and as prominently as they do, one should first become familiar with basic news values. These are the fundamental characteristics of news, and those who decide whether events warrant press coverage look for the presence of at least one of these elements. As an example, news directors and editors consider events relevant based on the *proximity* of those events to news audiences (i.e., "The closer to home, the bigger the story"). Reports also emerge based on their *timeliness*, with recent events tending to receive priority over older occurrences. In the Internet age, timeliness has become especially critical as a news value, as literally thousands of news organizations and independent news blogs compete with one another to break stories. Related to timeliness is *currency*, with ongoing issues receiving sustained coverage in the press. In recent years, news organizations have reported on the use of performance-enhancing drugs (PEDs) by athletes competing in baseball, football, and cycling, among other sports, and when new allegations emerge, they become part of a broader, cheating-to-get-ahead narrative.

Perhaps more than ever, events are considered newsworthy when they contain elements of *celebrity*, especially when famous individuals find themselves entangled in a *bizarre* set of events. As an example, in 2009, when professional golfer Tiger Woods wrecked his sport utility vehicle (SUV) near his home in Orlando, Florida, news companies began reporting the event immediately. The wreck had occurred in dramatic fashion, at 2:30 A.M., and over the next 48 hours, journalists kept news audiences informed (and entertained) as new details emerged. Here was the most famous golfer in the world apparently attempting to escape the wrath of his spouse, who had become infuriated by reports of his extramarital affairs. Through "Reality TV," television viewers had grown accustomed to domestic squabbles, and now a famous athlete had been caught cheating. Woods and his indiscretions moved quickly to the top of the news agenda, sending the golfer on a lengthy hiatus from his sport and tarnishing his image among his fans and among those who had paid Woods large sums of money to endorse products and services. The moral capital he had established through his sport and clean-cut image had vanished overnight.

Theories of media content and effects

Agenda setting. In communication research, agenda-setting theory suggests that while mass media may not tell audiences exactly what to think, they often tell them what to think *about*, when the issues at hand do not otherwise obtrude into their lives (McCombs, 2004). For instance, without news agencies covering the Tiger Woods SUV accident, few people would have known it ever occurred. Similarly, without the press bringing issues to light, news audiences may be left unaware of athletes who receive improper gifts from college "boosters" or who lose millions of dollars through gambling addictions. Through their reporting, the mass media transfer object salience, or perceived importance, to mass audiences. From a cognitive standpoint, agenda setting suggests that certain issues become more accessible in memory when they have been the focus of media attention (Scheufele & Tewksbury, 2007). Of the many items that could be the focus, only some contain sufficient news value, which allows the items to move past media gatekeepers and into the public consciousness.

In the profit-driven news industry, items that reach the public tend to be steeped in drama and lend themselves to basic narratives of right and wrong. When, in 2007, professional football player Michael Vick stood accused of animal cruelty amid an investigation into dog fighting, news audiences reacted with anger and dismay, appearing to crave additional news of justice being dispensed. In the absence of news reports, audiences would have known little, if anything, about Vick and dog fighting more generally. Moreover, with scholars having demonstrated links between mass and interpersonal communication (Vu & Gehrau, 2010; Yang & Stone, 2003), members of the news audience may have shared reactions and opinions on the events with one another. Indeed, news reports have the capacity to stimulate interpersonal communication, with people using the reactions of others as a barometer for their own responses to controversial issues.

In addition to *first-level*, agenda-setting effects, mass media have the capacity to transfer or attribute salience, effectively telling audiences *how* to think about objects in the news (McCombs, 2004). By stressing certain object attributes, media actors help to define the story for those unfamiliar with its central components. As an example of *second-level* agenda-setting, journalists who report on labor disputes in professional sports can choose to emphasize any number of issue attributes, resulting in news audiences blaming multimillionaire athletes for greedy behavior or blaming the leagues and team owners for paying athletes less than what the market dictates. Are professional athletes prima donnas who do not appreciate their good fortune, or are they talented individuals who wealthy executives commodify to become even wealthier?

Journalists make choices about which attributes to emphasize in news reports, with news audiences then drawing conclusions based on those attributes.

Framing and attribution. Although scholars continue to debate their similarity (see Scheufele & Tewksbury, 2007), second-level agenda-setting processes resemble those associated with issue framing. Describing the latter, Entman (1993) posited that

> To frame is to select some aspects of a perceived reality and make them more salient in a communicating text, in such a way as to promote a particular problem definition, causal interpretation, moral evaluation, and/or treatment recommendation for the item described. (p. 52)

Again, mass media stand to define news events for mass audiences, and if one conceives of these events as social constructions, the potential influence of the media becomes apparent. How a media report is framed will determine, to some extent, how mass audiences think about the issue at hand (Price & Tewksbury, 1996).

When considering processes in framing, it is important to recognize that frames apply not only to the structure and content of media reports but also to individual cognitions. As Goffmann (1974) explained, frames are devices that allow audience members to "locate, perceive, identify and label" occurrences of information (p. 21). Cognitive frames relate to what psychologists term *schemata*, which can be understood as the mental shortcuts individuals take to make sense of their surroundings. Heider (1958) proposed attribution theory as a means of explaining how individuals make sense of the social world, and Hindman (1999) noted later that

> an individual will attribute the event to some constant condition. In particular, individuals conclude that events are caused either by traits internal to the actor—such as abilities, motives, or personality—or circumstances external to the actor—such as the specific situation or environment. (p. 501)

These processes tie into framing research conducted by Iyengar (1991), who observed that individuals make sense of news reports through attributions of responsibility; that is, in reasoning about issues and events, members of the news audience tend to assign responsibility to either the individual(s) involved or to broader social considerations.

Importantly, as research in "attribution error" (Ross, 1977) has revealed, individuals are often biased in their judgment, attributing the behavior of others to internal considerations (e.g., shortcomings of character, arrogance, irresponsibility), while attributing their own behavior to external circumstances (e.g., lack of expressly stated rules, overcrowded conditions). Attribu-

tion error is significant to the discussion of fallen sports celebrities for, as Iyengar (1991) noted, news events tend to be framed largely in episodic (versus thematic) terms. Episodic frames focus on concrete events while thematic frames explore issues in greater depth. Of the two, episodic frames lend themselves most to drama, human interest and, perhaps most importantly, blame. An episode might involve an athlete accused of assaulting someone in a nightclub, with the news stressing that the athlete was belligerent and intoxicated. News audiences may in turn attribute the incident to irresponsibility on the part of the athlete who, the audience members may reason, believed that his fame and fortune would solve any and all problems. Attribution error would suggest that, had a given news audience member been involved in the same incident, he or she may have quickly attributed the alleged assault to poor security or to the behavior of others.

Cognitive frames can be shaped by media reports that repeatedly link certain behaviors, abilities, and propensities with certain groups. Research in the sociology of sports, for example, has found that Black male athletes tend to be characterized, or "mediated," as oversexed and potentially violent individuals (see Davis & Harris, 1998, pp. 157–165), with Latino athletes considered hot-tempered and, by extension, emotional and unpredictable (Hoose, 1989). When characterizations by race and ethnicity do not vary—that is, when athletes of certain races are described based on long-held behavioral assumptions—then media audiences begin to expect patterns of behavior to emerge based on "mediated realities" (Nimmo & Combs, 1990).

Additionally, in situations that lead audience members to experience anger or moral outrage, the very emotions that audience members experience stand to serve as frames. As Nabi (2003) argued, emotions stand to promote selective processing of information: "This perspective . . . places the receiver in a central role in the framing process by recognizing that once evoked, emotions dominate people's perspectives and drive subsequent cognitive efforts, including message processing and decision making" (p. 242). Thus, for news audiences, factual information about an event may become linked with a certain emotion, deepening the impact of the event and helping to solidify expectations and attributions of responsibility.

Exemplification. Journalists tell stories steeped in drama, and in some cases, news narratives link otherwise independent events to one another, creating "troubling trends" and "new scourges" in the process. Exemplification involves aggregating case descriptions to imply the presence of a trend (Zillmann, 1999), triggering emotional reactions among news audiences by identifying supposed moral failures. Zillmann explained the process:

Narratives, as a rule, leap from event to event, irrespective of the events' locality and position in time. More important here, narration aggregates events that exhibit sufficient phenomenal similarity to warrant their being classified as manifestations of the same kind. Such grouping implies that each and every grouped event, to the extent that it shares all essential attributes with the remaining grouped events, is capable of representing the group at large—meaning, that it is capable of providing reliable information about all other events in this group and thus about the group itself. (p. 74)

One might apply exemplification theory to a May 1998 *Sports Illustrated* article, "The Muscle Murders," in which author William Nack attempted to link a series of homicides to the pastime of bodybuilding. He began by telling the story of former Mr. Universe, Bertil Fox, who had shot to death his former fiancée and her mother on the small island of St. Kitts in 1997. The author then discussed two California bodybuilders, one of whom had stabbed and killed his girlfriend in 1993, and another who had shot and killed his estranged girlfriend and her closest friend in 1983. Nack then moved to a 1995 case in which the wife of a competitive bodybuilder had shot him dead, before covering another 1995 event in which two bodybuilders had gotten into a fight outside a gym, leaving one of the two dead with a ruptured aorta. Finally, Nack wrote of a former competitive bodybuilder who had shot and killed the owner of an Atlanta strip club in 1993. In his article, Nack made the fair point that, in the elite ranks, bodybuilding is a cult activity whose participants often live on the edge. Yet, a cautious reader might seek to differentiate those who killed from those who *were* killed, also differentiating crimes of passion from those committed in cold blood. The reader might consider the 15-year window of events, the geography of the crimes, the ages of the aggressors and the victims, and whether the bodybuilders involved were active or were no longer competing when the crimes occurred. Clearly, the events could not be directly substituted for one another.

As Zillmann (1999) explained, events that appear to constitute a danger-ous pattern often have few elements in common and the circumstances sur-rounding their respective occurrences may differ dramatically. To illustrate, one might construct a dramatic narrative involving football players instead of bodybuilders, beginning with the 1994 murders of Nicole Brown Simpson and her friend, Ronald Goldman. In this case, a criminal court acquitted O. J. Simpson of murder, but a civil court subsequently found him liable for the wrongful deaths of the deceased. In 1995, a court sentenced Los Angeles Ram Daryl Henley to 20 years in prison for drug trafficking, and he received 21 additional years after he attempted to hire a hit man to kill the sentencing judge and a witness. In 1999, Rae Carruth of the Carolina Panthers took part in the murder of a woman he had been dating. Advancing to 2009, a mistress

of Tennessee Titans quarterback Steve McNair gunned down the athlete before committing suicide. In April 2011, Miami Dolphin Brandon Marshall and Denver Bronco Jason Hunter were stabbed in separate domestic incidents, with both recovering from their wounds. Are these stories as similar to one another as the bodybuilding stories were? If so, sports journalists might present the stories as elements of a disturbing trend, even though the stories' differences exceed their similarities.

Exemplification relates to the subject of fallen sports celebrities in that individuals can be situated within any number of dramatic occurrences given a limited set of facts. Conversely, those who do not fit a narrative may be left out even when they share as many similar attributes as those included in the story. The problem, of course, is that episodes may not reflect empirical realities but nevertheless imply a behavioral trend. In fact, through sheer repetition in the press, time periods have become known by issues brought to light through media reports (i.e., the "steroid era" or the "cocaine years"). Was drug use really more prevalent during these purported "eras," or did the media construct the eras based on what seemingly stood to reason, given the high-profile athletes caught using PEDs and other illicit substances?

(Re)covering the Fallen Sports Celebrity

Having discussed the processes through which mass media construct dramatic narratives about athletes falling from grace, the chapter now examines how athletes attempt to restore their respective images through mass communication. Scholarly literature in crisis communication helps to elucidate these processes, which apply to both individuals and organizations. Crises, in general, create "information voids" (Coombs, 2007), and stakeholders must scramble to define events as quickly as possible. When high-profile athletes get in trouble with the law or experience some type of personal adversity, the athletes and their agents must move quickly, as the media will not hesitate to fill the void (i.e., report the news) based on a limited set of facts. Coombs explained:

> Nature abhors a vacuum. Any information void will be filled somehow by someone. The media have deadlines, so they are driven to fill the information void quickly. . . . If the crisis team does not supply the initial crisis information to the media, some other groups will, and they may be ill informed, misinformed, or motivated to harm the organization. (2007, p. 129)

Reviewing scholarship in crisis response and image restoration (Allen & Caillouet, 1994; Benoit, 1997), Coombs (2007) proposed four "postures"

taken by organizations: denial, diminishment, rebuilding, and bolstering. Within these organizational postures, which one can readily apply to individual athletes, 10 strategies emerge, each of which informs the manner in which athletes may succeed or not succeed in responding to adversity. As this section of the chapter reveals, athletes often make poor choices in attempting to preserve or restore their respective images, and in some cases, they dig themselves deeper into the information void to which Coombs referred.

The first type of posture, denial, contains three strategies: attacking the accuser, denial, and scapegoating (Coombs, 2007, p. 140). For examples of these strategies, one can look to the responses of athletes named in *The Mitchell Report*, a 409-page document released in December 2007. Major League Baseball Commissioner Bud Selig had asked former U.S. Senator George Mitchell to conduct an investigation of steroid use in professional baseball, and of the many players accused in the report of using PEDs, few were as prominent as New York Yankees pitcher Roger Clemens, whose name appeared 82 times. Brian McNamee, who had worked as a strength coach for Clemens, told investigators he had personally injected the pitcher with steroids (see Thompson, Vinton, O'Keeffe, & Red, 2009), but attacking the accuser, Clemens's attorney, Rusty Hardin, said McNamee was "troubled and unreliable." Clemens denied steroid use outright during a January 2008 episode of *60 Minutes*, and in February 2008, Clemens testified before Congress and denied using PEDs. However, in August 2010, a federal grand jury indicted Clemens on obstruction of Congress and perjury charges. Journalists subsequently offered an indictment of their own, having been used by Clemens to profess his innocence in the face of PED allegations. For Clemens, attacking the accuser and denying the allegations did not get the job done.

San Francisco Giant Barry Bonds, caught up in a steroid scandal with Bay Area Laboratory Co-operative (BALCO) in California (see Fainaru-Wada & Williams, 2006), used a scapegoat strategy in alleging that he had been misinformed about the contents of syringes used to inject PEDs. Bonds claimed that had he known the syringes contained PEDs and not flaxseed oil, he never would have permitted the injections. In general, media audiences do not respond favorably to scapegoating, as such a practice may be perceived as a mask for an unwillingness to offer a straight answer. Additionally, from the standpoint of image restoration, both Bonds and Roger Clemens had alienated sports journalists, and when steroid allegations emerged, few in the press came to their rescue. Rather, journalists appeared to "pile on" and keep the stories in the news for as long as possible.

The second type of posture, diminishment, contains strategies that allow individuals to excuse or justify an embarrassing event. Coombs (2007) noted

that in excusing an action or a behavior, an individual might claim that he or she had no choice in the matter. As an example, a professional athlete caught using PEDs might argue that drug use in sports is pervasive, and for every athlete who takes the moral high ground and does not enhance performance with chemical substances, hundreds of others will gladly step in, leaving the athlete out of a job. In reporting the news, media personnel can cite those who agree with the athlete, or they can quote those who moralize about sports and the athletes who participate in them. Sources define the news for mass audiences (Sigal, 1973), and the choices journalists make in this regard will impact audience perceptions.

Those who viewed the 2006 FIFA World Cup final between France and Italy may recall a physical altercation that took place between French star Zinedine Zidane and Italy defender Marco Materazzi culminating with Zidane head butting Materazzi and sending the Italian player to the turf. Zidane received an immediate red card and was sent off, with television announcers offering scathing criticism of his behavior. But as Denham and Desormeaux (2008) observed, Materazzi may have made crude remarks about Zidane's sister, provoking the French forward, and as the story unfolded, some journalists began to characterize the head butt as justified, given the circumstances. Specifically, journalists working for prominent news outlets in Ireland appeared more sympathetic to Zidane than did journalists in England and Scotland. Did the French star commit a flagrant foul or did he defend the honor of his sister against crude remarks?

The third type of posture, rebuilding, contains strategies grounded in compensation and apologia (Coombs, 2007). In addition to basic cash payments, compensation sometimes takes the form of donations to charity. Such donations serve as gestures of goodwill, not just among individuals but also among organizations. As an example, when the U.S. government began to hold hearings about PED use in Major League Baseball, the league quickly agreed to help fund public-service announcements about the dangers of anabolic steroids. An athlete arrested for drunk driving may offer a public apology for his behavior and make a monetary donation to an organization such as Mothers Against Drunk Driving (MADD).

Of the image-restoration strategies athletes employ, few tend to be as successful as taking ownership of an event or a behavior, accepting responsibility, and seeking to make amends. Tiger Woods offered a public apology for his extramarital affairs, and even though critics found his communication stoic and perhaps overly rehearsed, the golfer nevertheless owned up to his behavior. No one forced him to make the choices he did, and he accepted the responsibility for what had occurred. Woods also sought counseling for a

possible sexual addiction, moving the story from one of selfishness and irresponsibility to one involving a possible psychological condition.

Apologizing offers a segue to the fourth type of posture, bolstering, which includes three strategies: reminding audiences about previous good works and positive contributions, ingratiating oneself to stakeholders, and suggesting that the organization or individual is also a victim of bad actors. Michael Vick angered many people with his involvement in dog fighting, especially members of People for the Ethical Treatment of Animals (PETA), some of whom may never forgive Vick for his actions. In his defense, however, Vick can at least remind PETA members and others that he served his sentence in prison, paying his debt to society. Many people involved in crimes do not serve a single day in prison, and Vick served 19 months at the federal prison in Leavenworth, Kansas. He finished his 23-month sentence under house arrest and went bankrupt as a result of actions and legal costs. In a sense, Vick ingratiated himself to the Philadelphia Eagles by thanking the organization for giving him a second chance in the National Football League.

Finally, in terms of the victim strategy, both Major League Baseball and the National Football League have, at certain points, identified the sporting culture in the United States as the reason athletes feel compelled to use PEDs. Fans expect to witness incredible athletic feats, league representatives contend, and athletes feel compelled to consistently demonstrate those feats, lest they be replaced by better personnel. In some cases, league officials point to antidrug programs that have been instituted, assuring sports journalists and their audiences that they have taken steps to fight PED use in sports. League officials remind audiences that few entities have a greater interest in keeping sports "clean" than they do, and that reports of PED use taint the credibility of the respective sports and everyone involved. Alas, once a fan bears witness to a 500-foot home run, others tend to pale in comparison, and the 500-footer becomes the standard for greatness. The fans, themselves, play a significant role in setting that standard.

Conclusion

This chapter began by reviewing basic news values, noting how media gatekeepers evaluate potential news items based on considerations such as proximity, timeliness, currency, celebrity, and bizarre circumstances. While news audiences have always enjoyed learning about the private lives of celebrities, the Internet has accelerated the speed at which salacious information spreads among mass audiences. High-profile athletes are

ensconced in the celebrity culture of the United States, and when they act irresponsibly or selfishly, reporters do not hesitate in calling attention to them. Indeed, "mainstream" news organizations have found it difficult to dismiss gossip and schadenfreude, given the commercial success of tabloids such as the *National Enquirer*, which actually broke the Tiger Woods story.

Agenda-setting theory suggests that while mass media may not tell news audiences exactly what to think, they do tell them what to think about. This theory becomes especially important at the second level, which suggests that in stressing certain attributes of stories, the media can effectively tell people how to think about issues and events. As research in framing has revealed, members of the news audience indeed tend to follow news frames in reasoning about issues. They do so through attributions of responsibility, and when news reports focus heavily on concrete events—and embarrassing events at that—then audiences begin to attribute much of what they see to the shortcomings of those who appear in the news. Social psychologists have explained this tendency through attribution error, which suggests that individuals tend to attribute their own behavior to what is going on around them, while attributing the behavior of others to internal factors. Thus, the professional baseball player who uses PEDs is considered a moral failure, as opposed to being thought of as an athlete competing in a sporting culture that privileges the kinds of incredible feats that PED use makes possible.

Regarding image restoration, of the many strategies athletes employ, a basic apology tends to resonate with audiences. On occasions when someone is truly innocent, a denial strategy may be appropriate, but as athletes such as Roger Clemens and Barry Bonds have learned, lying to journalists is generally a bad idea, as it only motivates them to dig deeper for a story. Failing to tell the truth keeps the story alive, and while it may be painful or embarrassing to offer a public apology or admission of guilt, doing so puts that dimension of the story to rest, allowing the athletes to focus on the future instead of attempting to manipulate the past.

References

Allen, M. W., & Caillouet, R. H. (1994). Legitimation endeavors: Impression management strategies used by an organization in crisis. *Communication Monographs, 61*(1), 44–62.

Benoit, W. L. (1997). Image repair discourse and crisis communication. *Public Relations Review, 23*(2), 177–186.

Coombs, W. T. (2007). *Ongoing crisis communication: Planning, managing, and responding* (2nd ed.). Thousand Oaks, CA: Sage.

Davis, L. R., & Harris, O. (1998). Race and ethnicity in US sports media. In L. A. Wenner

(Ed.), *MediaSport* (pp. 154–169). London, UK: Routledge.

Denham, B. E. (2008). Calling out the heavy hitters: What the use of performance-enhancing drugs in professional baseball reveals about the politics and mass communication of sport. *International Journal of Sport Communication, 1*(1), 3–16.

Denham, B., & Desormeaux, M. (2008). Headlining the head-butt: Zinedine Zidane/Marco Materazzi portrayals in prominent English, Irish and Scottish newspapers. *Media, Culture & Society, 30*(3), 375–392.

Entman, R. M. (1993). Framing: Toward a clarification of a fractured paradigm. *Journal of Communication, 43*(4), 51–58.

Fainaru-Wada, M., & Williams, L. (2006). *Game of shadows: Barry Bonds, BALCO, and the steroids scandal that rocked professional sports*. New York, NY: Gotham Books.

Goffmann, E. (1974). *Frame analysis: An essay on the organization of experience*. Boston, MA: Northeastern University Press.

Heider, F. A. (1958). *The psychology of interpersonal relations*. New York, NY: Wiley.

Hindman, E. B. (1999). 'Lynch-mob journalism' vs. 'compelling human drama': Editorial responses to coverage of the pretrial phase of the O. J. Simpson case. *Journalism & Mass Communication Quarterly, 76*(3), 499–515.

Hoose, P. M. (1989). *Necessities: Racial barriers in American sports*. New York, NY: Random House.

Iyengar, S. (1991). *Is anyone responsible? How television frames political issues*. Chicago, IL: University of Chicago Press.

McCombs, M. (2004). Setting the agenda: The mass media and public opinion. Cambridge: Polity.

Nabi, R. L. (2003). Exploring the framing effects of emotion: Do discrete emotions differentially influence information accessibility, information seeking, and policy preference? *Communication Research, 30*(2), 224–247.

Nack, W. (1998, May 18). The muscle murders—When a former Mr. Universe was arrested for double homicide last year, he became only the latest on a list of accused murderers among hard-core bodybuilders. *Sports Illustrated, 88*(20), pp. 96–103.

Nimmo, D., & Combs, J. E. (1990). *Mediated political realities* (2nd edition). New York, NY: Longman.

Price, V., & Tewksbury, D. (1996). News values and public opinion: A theoretical account of media priming and framing. *Progress in Communication Sciences, 13*, 173–212. Norwood, NJ: Ablex.

Ross, L. (1977). The intuitive psychologist and his shortcomings: Distortions in the attribution process. In L. Berkowitz (Ed.), *Advances in experimental social psychology* (Vol. 10, pp. 173–220). New York, NY: Academic Press.

Scheufele, D. A., & Tewksbury, D. (2007). Framing, agenda setting, and priming: The evolution of three media effects models. *Journal of Communication, 57*(1), 9–20.

Sigal, L. (1973). *Reporters and officials: The organization and politics of newsmaking*. Lexington, MA: D.C. Heath.

Thompson, T., Vinton, N., O'Keeffe, M., & Red, C. (2009). *American icon: The fall of Roger Clemens and the rise of steroids in America's pastime*. New York, NY: Knopf.

Vu, H. N. N., & Gehrau, V. (2010). Agenda diffusion: An integrated model of agenda setting

and interpersonal communication. *Journalism & Mass Communication Quarterly, 87*(1), 100–116.

Yang, J., & Stone, G. (2003). The powerful role of interpersonal communication in agenda setting. *Mass Communication & Society, 6*(1), 57–74.

Zillmann, D. (1999). Exemplification theory: Judging the whole by some of its parts. *Media Psychology, 1*(1), 69–94.

Fallen Individual Sports Celebrity

Tiger Woods Lands in the Rough: Golf, Apologia, and the Heroic Limits of Privacy

Andrew C. Billings

> I knew what I was doing was wrong, but thought only about myself and thought I could get away with whatever I wanted to. . . . I had worked hard. Money and fame made me believe I was entitled. (Woods, 2010)

> Cause we all just wanna be big rock stars/Livin' in hilltop houses driving fifteen cars. (Nickelback, 2007)

One result of living in an age of niche media (see Anderson, 2006) has been the diminished status of the "celebrity" role. Even people who "star" on shows viewed by less than 1% of American households find themselves on the covers of major magazines. Much of the public is chattering away about pseudo-celebrities that clutter the media space. Located within this increasingly diminished sense of celebrity wattage came the November 2009 story of über-athlete and über-celebrity Tiger Woods. At first, the details came in a trickle. An SUV accident. A broken window. A less-than-coherent Woods. Then, facts, rumors, and falsehoods blended into the story. Which was which? No one could be sure. It became clear that Tiger had been unfaithful to his wife, Elin Nordegren, and that the sheer number of indiscretions was shockingly high to most people, particularly when considering Woods's epic "Q" rating (a measure of his advertising and marketability options; see Elliott, 2010) and disciplined public persona.

Ultimately, the public was left to witness a hero who had fallen perhaps more epically and precipitously than any other modern athlete. The persona everyone knew to be Tiger Woods before November 2009 would now do battle with the persona splashed on tabloids and gossip-based television shows. This chapter will outline the rise, fall, and attempted restoration of golf's greatest personality, ultimately drawing a conclusion as to which persona rose to the surface.

Tiger the Ferocious

There is only one Tiger Woods. No story is like his and no personality parallels appropriately to the life he has lived. Debuting to the masses on *The Michael Douglas Show* at age 2, Eldrick "Tiger" Woods seemed destined for superstardom. Most of this inevitability came from his superior play, winning 21 amateur championships before turning pro at age 20, but a measureable portion of his appeal also came from his unique background (see Rosaforte, 1997). Tiger Woods's ethnic heritage is so diverse (see Houck, 2006) that he ultimately claimed to be "Cablinasian," a mixture of his Caucasian, Black, Indian, and Asian backgrounds (Nordlinger, 2001). His skills and tremendous appeal were on full display when he won his first major championship, a stunning 12-shot coronation at the Masters in 1997. Author John Feinstein (1998) regarded Woods as the "first coming," and Tiger lived up to the immense hype, securing 14 major championships (second only to Jack Nicklaus's 18 majors) by the age of 32. In mid-2009, Woods became sports' first "Billion Dollar Man," including a wide range of endorsements and properties along with the millions won directly on the PGA Tour (Eldridge, 2010). He had won massively (securing the 2000 U.S. Open at Pebble Beach by a record 15 shots) and enigmatically (outdueling Rocco Mediate in a 2008 U.S. Open playoff with a leg in desperate need of major knee reconstruction). On top of it all, Woods had perhaps the most finely honed image in all of sport—distant, perhaps, but larger than life and seemingly laden with a heavy dose of integrity.

Tiger the Arrogant

Then it happened. If there were ever an instance in which "pride goeth before a fall," Tiger Woods's late 2009 car accident was the embodiment. The evening after Thanksgiving, Woods was leaving his neighborhood when he hit a hedge, then a fire hydrant, and then a tree. Nordegren reportedly used a golf club to get Woods out of the car. Woods paid a $164 ticket and then asked for privacy.

The reports of infidelity followed almost immediately and escalated at an alarming rate. What began as a single extramarital affair became three, and then 10, and then what the media would describe as "countless" indiscretions (MacFarlane, 2010, p. 53). One report later listed his marital infidelities at a staggering 120 different women (Martinez, 2010). There were porn stars, Perkins coffee shop waitresses, neighbors, and beauty queens. The reports

were diverse, widespread, constant, and ultimately devastating to Tiger Woods and his family, friends, sponsors, and supporters. It was clear Woods's life—public and private—would never be the same again.

Tiger the Beleaguered

Two major communicative methods for the public analysis of image restoration and apologia (related, yet not identical concepts) come from the work of Benoit (1995, 1997, 2000) and Ware and Linkugel (1973). Benoit has applied a five-step structure to image restoration for corporations and individuals, ranging from Tylenol (with cyanide-laced pills found in 1982), to Exxon (with an epic oil spill in 1989), to actor Hugh Grant (following his arrest for soliciting a prostitute in 1995). He outlines five stages that frequently occur: (a) denial, (b) evasion of responsibility, (c) reduction of offensiveness, (d) assurance of corrective action, and (e) mortification. In a similar vein, Ware and Linkugel (1973) identified four stages involved in public apologia: (a) denial, (b) bolstering, (c) differentiation, and (d) transcendence. These methods still hold true in 2010, but it is clear that with new media, the manners in which they unfold vary greatly.

Relating back to Tiger Woods's troubles, all these stages probably took place, but the early, methodological tenets likely played out at home, rather than in a public forum. Later reports informed us that Tiger attempted to label many of his relationships as platonic (a denial mechanism) and also attempted to use his stellar, public celebrity (which before the incident was enviable to all known figures short of Oprah Winfrey and Nelson Mandela). Most significant about the framing of Tiger's troubles was both the speed and magnitude with which the information was released. There was little time to respond to each accusation (as thousands of media reports surfaced daily). There was no way for Woods to even attempt to separate truth from fact (Woods could not possibly deny affairs with select women without inadvertently confirming rumors of relationships with a dozen others). Likely recognizing this, Woods opted to stay silent during a media frenzy unmatched for any modern celebrity for a personal (as opposed to a legal) offence. He would have to immediately move the media narrative to the later stages of image restoration—an assurance of corrective action.

The need for Woods to move the narrative frame makes the media handling of the Woods scandal particularly intriguing. Clearly, the appropriate corrective and mortification steps would occur, but would the media believe the corrective steps would be sufficient public punishment? It was clear that

Woods had to endure what would be termed a "public flogging" (Porpora, 2010); there was also little doubt that both the sporting and celebrity cultures would need Tiger Woods to return, whether the motivations were to reinvigorate the PGA Tour or simply to complete the celebrity restoration narrative which the public has come to expect. While Tiger Woods's personal recovery timeline was likely far different, the media timeline that drove the narrative highlighted a handful of major events that later appeared resonant based on measures of public sentiment:

1. November 27, 2009: Car crash near Woods's home.
2. January 20, 2010: Tiger Woods reported to be in sex rehabilitation.
3. February 19, 2010: First public, oral statement regarding incident.
4. March 17, 2010: Announces return to golf.
5. April 7, 2010: Nike advertisement, "Father."
6. August 23, 2010: Divorce finalized with Elin Nordegren.
7. November 29, 2010: Set media offerings, including *Newsweek* editorial.

At least four prominent timelines were all unfolding in this one-year period. First, there was Woods's personal timeline, which was almost exclusively kept private. There was undoubtedly much to work out in the private arena, which likely included admissions of blame, attempts at reconciliation with his wife, and promises to become a better person. Second, there were the media timelines outlined above. This series of events could be more or less numerous depending on what one considers to be resonant in the media, yet what is most important is that this timeline becomes the yin-yang relationship to the first one—the public attempts at image restoration that may or may not have dovetailed with the private ones. Third, there is a golf world timeline. This cannot be dismissed as superfluous as each of golf's four "majors" along with October's Ryder Cup offered an opportunity for success and the inevitable redemption stories that would accommodate a victory. Finally, there is a societal timeline—embracing broad, public sensibilities about Woods. This was the subject of many media reports and also was influenced by other media revelations over the course of the year. It also, perhaps, provides the most direct insight into what would drive the ultimate judgment of the persona, celebrity, and person known as Eldrick "Tiger" Woods. These four timelines overlap and intermingle in complex ways to showcase the stages of public opinion over the course of the 12 months following the accident.

Stage #1: Demanding answers

At first, media outlets were not sure how to report the car accident and issues surrounding it. Thus, the initial questions included "public vs. private" and "legal vs. moral." As one newspaper outlet offered just one day later:

> Maybe there is a simple explanation of how Woods ended up hitting a fire hydrant and then a tree at that time of the morning, how he ended up in the hospital even though he wasn't going fast enough in a Cadillac SUV to have his air bags deploy. . . . We sure don't have it yet. . . . You always hear that these are private matters. Well no, they're not, actually, not once police reports are filed and you read and hear that charges might be "pending." No, they're not private when it's the richest and most famous athlete in the world, one who has made billions by being a public figure. (Lupica, 2009, p. 48)

A lack of information coming from Tiger Woods and his associates was resulting in a frenzy of rumors that could not all be verified or even seen as possible, given their frequently contradictory nature. From the start, a firestorm ignited. Some media outlets tried to withhold judgment and keep some sense of journalistic integrity, but the story had "gone viral" in spaces not regulated by traditional notions of journalistic ethics—social and tabloid media leading the way. Much of the debate within the print media centered on how what was "fair" to report was somehow different when a person is not just a celebrity, but also an über-celebrity like Woods. As Le Batard (2009) wrote on Thanksgiving weekend:

> Not all of [it] can be true, obviously, but who cares? Truth is one of the many things that gets trampled today when boring facts can't keep up with the media's need to feed instantly and the public's appetite to be fed faster than that. . . . I don't pretend to know what is and isn't true here. What I do know is that Woods is too famous to have any kind of accident quietly. (p. A1)

As one can sense from the two previous excerpts, major media outlets were tacitly saying: (a) "We'll stick with you for a little while longer, Tiger," and (b) "But we better get some answers."

Stage #2: Circus atmosphere

Once the mistresses started to funnel into the limelight, sides were chosen. Hartley-Brewer (2009) argued that

> While Tiger licks his wounds, it's Elin Woods who is coming out of this as the heroine of the hour. Tiger may have lost his godlike status but his wife has been elevated to a feminist icon as St. Elin, the Patron Saint of Wronged Wives Everywhere. (p. 39)

Tiger was subject to several months of seemingly inexhaustible jokes about his being a cad. Late-night hosts fanned the fire, with people such as Jay Leno offering, "A new study found that casual sex does not lead to lower self-esteem. It does, however, wreck your marriage, your Escalade. . . ."

Virtually anything about Woods's life appeared to be fair game simply because of the magnitude of the indiscretions. The public had witnessed public shamings or mockings of celebrities before and seemed to feel nothing was truly out of bounds because (a) the number of mistresses warranted it, (b) the extent of Woods's celebrity demanded it, and (c) the previously squeaky-clean image of Woods required it. Some stories happen in one huge information spill; this story slowly dripped in a way that only escalated the frenzy. Endorsements were dropped, rumors of nude pictures of both Woods and his mistresses surfaced, revealing text messages were released. The scandal had reached epic proportions, and the narrative within this "circus" stage necessitated questions about how much worse it would get and, more interestingly, the conversation changed from *when* Tiger would recover to *if* he ever would. Wilbon (2009) wrote:

> Certainly he isn't the first athlete to be defeated by the temptation that is infidelity, but it seems possible now he could be the first to be undone by indiscretion. We now have one whale of a sports story. . . . The toll of more than a dozen women going public to say they've had sex with Tiger has unnerved him in a way that no opponent, no eight-foot putt, ever has. . . . Since every day seems to be worse than the day before, it's quite possible there are worse days to come. . . . The Woods scandal is being treated like nothing we've ever seen. And Woods is now set to pay for it, perhaps dearly. (p. D1)

Then, in January, came the report that simultaneously offered the ultimate Tiger Woods jokes while also indicating an initial step toward recovery: Woods had entered a clinic in Mississippi for sex addiction rehabilitation. Late-night television hosts, who did not imagine there could be an escalation of the jokes surrounding Tiger Woods, found ample opportunity to mock this development, with presumed motivations ranging from attending the clinic to save his marriage, to restore his public image, or to simply escape from the media spotlight. This was the most overt attempt at something resembling Benoit's (1995, 1997, 2000) "assurance of corrective action," but media outlets largely were not ready to move to this stage. While print publications offered some measured coverage on the nature and stark realities of sex addiction, including a differentiation between being a sex addict and just liking sex (see Berman, 2010), the majority reported on his six-week stint in sex rehab with a mix of humor and resentment over his privileged status at the clinic. Some reported that Woods was simply going through the motions and causing a

disruption at rehab, demanding $100,000 in renovations for his cabin and frequently opting not to attend rehabilitation meetings (Mangan, 2010). Sexual rehabilitation may have been Tiger's first gambit at publicly assuring corrective action, but it was not his first successful one.

Stage #3: Remorse detecting

More overt attempts at image restoration occurred on February 19, 2010 when Woods—nearly three months after the accident—finally spoke publicly at an event at Sawgrass Players Club. The 14-minute scripted oration was, as expected, met with mixed reviews. The media focus was on two issues: (a) whether the content of the speech "hit the right notes," and (b) whether Woods's delivery of the speech indicated genuine or, conversely, performed remorse. The majority of media outlets regarded the content of the speech as covering the necessary areas for public remorse. Some felt Woods lacked detail (as, for instance, one was still left to wonder what happened the night of the accident), but many concurred that Woods was right to attempt to keep private issues from the mainstream media. However, the more revealing analyses were of Woods's delivery. Some outlets employed body language expert testimony to conclude that Tiger successfully employed the three S's: "sincerity in the service of survival" (McShane & Schapiro, 2010, p. 5). Tinley (2010, para. 4) assessed the "performance" by claiming that "Tiger Woods played the role as well as he could. Like a great film script, the audience had become involved in the narrative. His problem became our problem. But too bad for Tiger that this genre has been over-produced."

The major revelations receiving commentary from his February 19 address were that (a) he referenced Buddhism over any newfound reliance on Christianity, and (b) he gave no timetable for his return to golf, noting that he "didn't rule out" that it could happen in the year 2010. However, the most common reading was that this was a heartfelt apology, with Woods stating that:

> I know I have bitterly disappointed all of you. I have made you question who I am and how I could have done the things I did. I'm embarrassed that I have put you in this position. For all that I have done, I am so sorry. I have a lot to atone for. (ESPN.com, 2010)

Some were satisfied, others were not. Little movement was found within the extreme ends of the discussion about Woods, but those in the middle largely regarded the event as another item to check off of a predetermined celebrity apology tour (Tinley, 2010), shifting the discussion from "when will Woods speak with the media?" to "when will he return to competitive golf?"

Stage #4: The return

A month later, on March 17, Woods issued a statement indicating that he was ready to return to golf, and the Masters tournament—just a few weeks away—appeared to be the most logical. The timing of the announcement was immediately questioned as it conflicted with the World Golf Championship Match Play Tournament, which also happened to have a sponsor (Accenture) that had recently dropped Woods. Reason (2010, p. 11) opined: "Will he never learn? The news that Woods has chosen Augusta for his comeback will also confirm his title as golf's Mr. Selfish . . . the players will now be even angrier." Some also questioned whether returning at one of golf's Majors was a good idea (rather than two weeks earlier at a local tournament at Bay Hill), ultimately coming to the conclusion that "the fortress that is Augusta National provides plenty of sanctuary. TMZ can't rent a home along the fairway as it could have at Bay Hill" (Gola, 2010a, p. 62).

The gradual build to the event steadily grew to epic proportions. CBS News and Sports President, Sean McManus, called it "one of the biggest media events of the last decade . . . rivaling even the Obama inauguration" (as cited in Jonsson, 2010, n.p.). Yet, for anyone who thought Woods's return was designed first and foremost for avoidance, they were to be at least partially mistaken. On the eve of the Masters tournament, Nike released an ad entitled, "Father," which offered a voiceover from a deceased Earl Woods and a simple shot of Tiger Woods listening to the advice. The ad was short and relatively simple, ending with Tiger's father stating, "I want to find out what your thinking was. I want to find out what your feelings are. And did you learn anything?" The invocation of Tiger's father was designed to jointly evoke sympathy and again, apologia. People who were more skeptical saw it as a way for Nike to attempt to rehabilitate their own paired image with Woods in hope of financial gain. Most of all, it was designed to offer a new beginning to Woods's career. When Woods tied for 4th place after such a long layoff, most reporters were impressed and believed Woods would be back and would be as good or better than ever once the final bits of rust were removed. Of course, that simply was not to be.

Stage #5: Tumult on the tour

Tiger's 2010 golf season was one of near misses and resounding failures. Woods failed to win a tournament all year. He remained relevant at times (offering a flair of brilliance in the third round of the U.S. Open before falling back to a 4th place tie on Sunday), while also experiencing career-low moments (with the bottom probably being an 18 over par finish at the WGC

Bridgestone tournament in August). Most golf fans were polite (as golf spectators tend to be), but rogue hecklers would be the ones to garner media attention and headlines. Tiger Woods struggled on, playing slightly fewer events than was typical, but often seemingly sleepwalking through the game he dominated not so long ago.

The tide seemed to turn in August, when his divorce from Elin Nordegren was finalized and announced in a brief joint statement where the severed pair said, "while we are no longer married, we are the parents of two wonderful children and their happiness has been, and will always be, of paramount importance to both of us." Woods was playing at the Barclays that weekend, and much of the media coverage focused on the belief that Woods had now lost and suffered enough, including this passage from Gola (2010b):

> There were no sunbeams and no rainbows for Tiger Woods. . . . If there is a new beginning, it doesn't look as though it's coming this week. . . . If anyone thought the divorce was going to be cathartic for Tiger, think again. Nine months after Woods hit that fire hydrant, its symbolic equivalent is still spewing, no matter how hard he tries to plug the hole. (p. 64)

As Woods's game continued to founder (at least by typical Woods standards), public sympathy for the athlete grew, resulting in a groundswell of hope for redemption for Woods, even while stating that redemption would never be fully complete without resuming his successes on the golf course. One London reporter expressed the need to control heckling fans in October's Ryder Cup (held in Wales). Lusetich (2010) encapsulated the feelings of many golf fans around the world who were beginning to show concern that Woods's return to dominance may never occur:

> He was (rightly) condemned for his sins and has paid a high price. He has lost his wife, Elin, who took more than $100 million on her way out of the door, and one day he will have to explain to his two children why their mother left him. He has lost at least $60 million a year in endorsements . . . and, of course, Woods has lost his golf game. The player seen by many as the greatest in history has been reduced to an everyday touring professional. . . . It is inevitable that some in Wales will jeer him and want to extend his punishment. But perhaps, too, others will see a fallen champion in search of redemption and, maybe, with nothing more than polite applause, will help him to his feet. Because, while he may have failed as a husband and a salesman, he is the kind of talent that comes along only once in a very great while. And golf, as much as Woods, will be the loser if he never finds his way back. (p. 2)

Tiger the Tamed

Tiger Woods performed admirably in the Ryder Cup, recording a 3–1 record including a win in his singles match. However, it was clear that the public had witnessed a different Tiger Woods. He had always been reserved in his public appearances, but now there was a tone of sadness. As Sanderson (2010, p. 449) summarized: "This frailty, previously unbeknownst to fans, promoted connection and feelings of similarity to Woods, as he appeared more like them than at any other time in his career."

Given the roller coaster ride of the year following the accident, it is reasonable to ask: to what degree did Woods lose his fans—and to what degree did he gain them back? Zeta Interactive, a digital marketing firm that measures public reputations, reports that there was a great deal of change over this 12-month period (see Elliott, 2010; LaVallee, 2010). Before the SUV accident, Woods had one of the highest ratings of any public figure (celebrity, athlete, or otherwise) with 91% reporting a positive feeling for Woods. That figure was cut in half by January 2010. The percentage moved slowly in a positive direction to the point that, before Woods's apology, 51% had a positive view of Woods, and that number swelled to 68% after the February 19 apology. That number then increased some more with the release of the Nike ad and with Woods's very competitive return at the Masters; 77% felt positive feelings for Woods after his first tournament back. Woods has not (and likely will never) return to a 91% positive rating. Yet, these degraded numbers are incredibly high when considering the enormity of Tiger Woods's transgressions and the degree of negative public exposure. Consider, for instance, the fact that Woods's positive rating among males never dropped below 50%; even when everyone was making fun of him, ask an American male what he thought of Woods, and he was more likely than not to offer a positive assessment.

Still, positive feelings are not necessarily the same as marketability, and there was a clear divide with Tiger Woods. Many people felt sympathy for him and even expressed positive feelings, but that did not translate to his "Q" score, which measures his advertising and marketability opportunities. In June of 2009, Woods was #1 in Q score; in June of 2010, he had dropped to #25.

There are also journalistic lessons to advance from the Tiger Woods saga, as there was a constant tension between the belief that his private life should remain private and the belief that Woods, through the process of being one of the most recognizable persons on the planet, had surrendered that right. There was also the ready evidence that his personal life was significantly impinging on his professional one, making it presumably "fair game" for reporters to cover and pontificate. The general rule that Woods's children and

wife were off-limits was usually but not universally followed. In a case in which the wronged and blamed parties seemed to be clearly defined, the tentacles of what should be part of the story remained fairly gray.

On the one-year anniversary of the incident, Tiger Woods attempted to formally advance a more positive narrative surrounding the crisis, his life, and his future in professional golf by participating in a series of print media experiences. The most prominent of these was a "My Turn" essay in *Newsweek* entitled, "How I've Redefined Victory," in which Woods attempted to display his rehabilitation. Woods wrote that, "I now know that some things can and must change with time and effort. I'm not the same man I was a year ago. And that's a good thing" (Woods, 2010).

At the time of this writing (summer of 2011), Tiger's athletic comeback is still incomplete. Woods failed to win a single tournament in 2010, the first time he had been shut out of the winner's circle since becoming a professional. His personal woes became superseded by physical woes, as knee injuries and other ailments forced him to withdraw from many tournaments.

It is clear that golf needs a dominant Tiger Woods to remain healthy and vibrant. What is not clear is whether the PGA Tour needs Woods to return to dominance so he can fulfill the role of hero or villain. Woods likely will remain a nuanced, multifaceted, and flawed public persona for quite some time. Perhaps Mike Lupica's assertion rings the truest: "If he wins as big as he did before, he will be big all over again, and people will confuse athletic character with real character, the way we have in sports since the beginning of time" (Lupica, 2010, n.p.). Only time (and Zeta Interactive) will tell whether Tiger Woods will be able to regain his status as the world's most dominant (and marketable) golfer.

References

Anderson, C. (2006). *The long tail: Why the future of business is selling less of more.* New York, NY: Hyperion.

Benoit, W. L. (1995). Sears' repair of its auto service image: Image restoration discourse in the corporate sector. *Communication Studies, 46*(1–2), 89–105.

Benoit, W. L. (1997). Hugh Grant's image restoration discourse: An actor apologizes. *Communication Quarterly, 45*(3), 251–267.

Benoit, W. L. (2000). Another visit to the theory of image restoration strategies. *Communication Quarterly, 48*(1), 40–43.

Berman, L. (2010, January 27). Tiger on the prowl: What's motive for his sex addiction rehab? *Chicago Sun-Times,* p. C9.

Billings, A. C. (2003). Portraying Tiger Woods: Characterizations of a 'Black' athlete in a

'White' sport. *Howard Journal of Communications*, 14(1), 29–37.

Eldridge, D. (2010, November 25). Tiger needs new game to get out of the rough; More wins, less attitude from fans. *The Washington Times*, p. A1.

Elliott, S. (2010, April 11). Update: Buzz on Woods improves, data indicate. *The New York Times* [Media Decoder Web log]. Retrieved from http://mediadecoder.blogs.nytimes.com/2010/04/11/buzz-on-woods-improves-data-indicate/#more-32097

ESPN.com (2010, February 19). Retrieved on January 10, 2012 from http://sports.espn.go.com/golf/news/story?id=4928017.

Feinstein, J. (1998). *The first coming: Tiger Woods, master or martyr?* New York, NY: Ballantine Books.

Giacobbi, P. R. Jr., & DeSensi, J. T. (1999). Media portrayals of Tiger Woods: A qualitative deconstructive examination. *Quest*, 51(4), 408–417.

Gola, H. (2010a, March 17). Woods won't be masterful; Long layoff should make him too green. *New York Daily News*, p. 62.

Gola, H. (2010b, August 26). Tiger admits he's in rough; Divorce brings more clouds as season settles. *New York Daily News*, p. 64.

Hartley-Brewer, J. (2009, December 6). Hail St. Elin, the Tigress. *Sunday Express* (UK), p. 39.

Houck, D. (2006). Crouching Tiger, hidden Blackness: Tiger Woods and the disappearance of race. In A. Raney & J. Bryant (Eds.), *The handbook of sports and media* (pp. 469–484). Mahwah, NJ: Lawrence Erlbaum.

Jonsson, P. (2010, March 17). How Tiger Woods's return to Masters Tournament changes golf. *Christian Science Monitor*, n.p.

LaVallee, A. (2010, February 19). Tiger Woods apology boosts his standing online. *The Wall Street Journal*. Retrieved from http://blogs.wsj.com/digits/2010/02/19/tiger-woods-apology-boosts-his-standing-online/

Le Batard, D. (2009, November 29). When Tiger Woods and scandal collide, truth becomes the victim. *Miami Herald*, p. A1.

Lefton, T. (2010, June 7). Penalty drop: Tiger Woods plummets on sports Q score list. *Sports Business Journal*. Retrieved from http://webcache.googleusercontent.com/search?q=cache:iEfd7ix4WbgJ:www.sportsbusinessjournal.com/article/65957+tiger+woods+q+rating&cd=2&hl=en&ct=clnk&gl=us&client=safari (no longer accessible).

Lupica, M. (2009, November 28). Tiger in a big hazard can't leave any doubts about crash. *New York Daily News*, p. 48.

Lupica, M. (2010, March 17). After scandal, Tiger Woods can win green jacket at Masters—Just don't call him a hero. *New York Daily News*. Retrieved from http://www.nydailynews.com/sports/more_sports/2010/03/17/2010-03-17_he_can_win_the_green_jacket__just_dont_call_him_a_hero.html

Lusetich, R. (2010, September 25). He's lost a wife and $160M: Isn't it time Ryder Cup hecklers gave Tiger a break? *The Times* (London, UK), p. 2.

MacFarlane, I. (2010, July 14). Tiger on the prowl for treble scotch. *Daily Star* (Scotland), pp. 53–54.

Mangan, D. (2010, January 21). Sexual healing for caged Tiger; first view of shabby star in horndog rehab. *New York Post*, p. 2.

Martinez, J. (2010, May 3). Elin shapes up; Will Tiger ship out? *New York Daily News*, p. 14.

McShane, L., & Schapiro, R. (2010, February 20). Good for marriage, not image; Apology is par for the course, experts say. *New York Daily News*, p. 5.

Nordlinger, J. (2001, April 30). Tiger time: The wonder of an American hero. *National Review*, p. 8.

Porpora, G. (2010, April 14). Welcome back Tiger. Retrieved from http://www.deepintosports.com/2010/04/14/tiger-woods-masters-2010-pga-golf/

Reason, M. (2010, March 17). Selfish Tiger makes a circus out of prestige event. *The Telegraph* (London), p. 11.

Rosaforte, T. (1997). *Tiger Woods: The makings of a champion*. New York, NY: St. Martin's Press.

Sanderson, J. (2010). Framing Tiger's troubles: Comparing traditional and social media. *International Journal of Sport Communication*, 3(4), 438–453.

Tinley, S. (2010, February 19). And there it is: Tiger's polished apology. Retrieved from http://www.cbsnews.com/stories/2010/02/19/sportsline/main6223746.shtml

Ware, B. L., & Linkugel, W. A. (1973). They spoke in defense of themselves: On the generic criticism of apologia. *Quarterly Journal of Speech*, 59(3), 273–283.

Wilbon, M. (2009, December 12). Man and career, under siege. *The Washington Post*, p. D1.

Woods, T. (2010, November 29). How I've redefined victory. *Newsweek*, 14.

Andre Agassi and the Tides of Tennis Celebrity: Image, Reconstruction, and Confession

C. *Lee Harrington*
Kimberly S. Schimmel

The 2009 publication of Andre Agassi's autobiography, *Open*, was a major media event, with the tennis legend making the rounds of popular television (CBS' *60 Minutes*) and radio (NPR) programs, offering interviews to major online forums oriented to both sport (*ESPN.com*, *SI.com*) and mainstream celebrity (*Oprah.com*, *AccessHollywood.com*), and receiving coverage from the nation's most lauded news outlets, including *The New York Times*, *The Wall Street Journal*, and *The Washington Post*. Such widespread media attention stemmed not just from Agassi's tennis prowess (eight Grand Slam singles championships), Hollywood presence (ex-wife, Brooke Shields), philanthropic success ($85-plus million raised for Agassi's College Preparatory Academy), or even the quality of the book itself—*Time* magazine called it "One of the best sports autobiographies of all time [and one] of the better memoirs out there, period"—but from the three bombshells revealed in its pages. Agassi sported a hairpiece for a time and his first Grand Slam finals match was dominated by fear it would fall off. He used crystal meth and successfully deceived ATP tour officials about it. And he hated tennis. No, really. For most of his 20-year, highly successful, and lucrative career, Andre Agassi *hated* tennis.

In a volume on the hero-to-villain arc of sport celebrity, Agassi's story is less shocking than some—the spectacular free fall of Tiger Woods or the ugly crimes of Michael Vick—but it is notable for its longevity and (as our title suggests) its tidal qualities. Agassi's journey has taken him from brash, upstart Wimbledon champion in 1992 to bush-league, satellite-tour player in 1997, and from tennis' beloved elder statesman at career's end in 2006 to former drug user and thus—to some—sport villain today (a label or identity we question in our conclusion). In this chapter we explore not a *moment* of redemption but a long career defined *through* redemption, examining Agassi's own narrative of atonement to make sense of both his professional and personal

development. While a redemptive interpretation of the media-constructed Agassi text is not new (Kusz, 2001, 2007), we offer an alternative reading by repositioning the analytic starting point to Agassi's self-narrative (as represented in *Open*) and by examining how the psychological concept of *autobiographical reasoning* functions in Agassi's self-storying over time. In short, we examine the tides of tennis (and, more broadly, sporting) celebrity through Agassi's analysis of those same tides.

First, a quick review of the tidal flows in question helps set the stage. High-water marks include child prodigy status; teen tennis stardom; membership on three winning Davis Cup teams; former number one world ranking; the Grand Slam championships noted above, plus an Olympic gold medal; philanthropic acclamation; successful marriage to legendary tennis champion, Steffi Graf; fatherhood; a locker-room standing ovation from fellow players after his final career match; best-selling author; and induction into the International Tennis Hall of Fame in 2011. Low-water marks include brutal childhood training sessions with his overbearing father; widespread condemnation (and emulation) of his late 1980s fast-food diet and unique fashion sense (denim shorts, flowing and streaked hair, pierced ears); the questionable priorities immortalized in a 1990 Canon advertising campaign (see below); eyebrow-raising celebrity connections (Barbra Streisand and her characterization of Agassi as a "Zen master"); a career nosedive in the mid-1990s that took him to 141^{st} in the world; a failed Hollywood marriage to Shields; and the unexpected revelations in *Open*—most especially, his loathing of the sport that defined him.

Our interest is in how Agassi himself has storied these events over time. As part of the narrative turn taking place throughout the academy (including in sports studies; see the special issue of *Sociology of Sport Journal* edited by Denison and Rinehart, 2000), psychologists have begun empirically researching the connections between storytelling and self-development. Among developmental psychologists, storytelling is proposed to be "at the heart of both stability and change in the self" (McLean, Pasupathi, & Pals, 2007, p. 262). The life story is defined as a "selective set of autobiographical experiences that, together with interpretations of those events, explain how a person came to be who he or she is and project a sense of purpose and meaning into the future" (Pasupathi & Mansour, 2006, p. 798). The life story creates unity across time and "anticipates the future in such a way as to provide a life with an overall sense of coherence and purpose" (McAdams et al., 2006, p. 1372). Psychologists agree that there is a cumulative nature of developmental achievements that promote continuity in the self over time (McLeod & Almazan 2003, p. 395). The self changes as we age, of course, but there is personality coherence

from infancy to adulthood (Caspi, 2000). The specific, cognitive strategy people use to create this sense of coherence is termed *autobiographical reasoning* or "the dynamic process of thinking about the past to make links to the self" (McLean, Pasupathi, & Pals, 2007, p. 263). The life story or narrative identity that emerges through autobiographical reasoning thus reveals continuity over time while also manifesting change (McAdams et al., 2006, p. 1371). Consistent with narrative theory, we do not approach Agassi's autobiography as a factual account of his life. Rather, *Open* is a media text (as is this analysis of it) and the past itself is "mediated, indeed produced, in the activity of remembering" (Kuhn, 2002, p. 9).

By examining athletes' self-narratives, sport scholars "have been better able to understand the actions, motives, and conflicting identifications that affect and form an athlete's experience" (Butryn & Masucci, 2003, p. 126). Indeed, Whannel (2002) suggested that the "rise-and-fall hermeneutic structure" is particularly well-suited to sport studies given the "inevitability of the loss of sporting powers" (p. 55). While we address a variety of Agassi's trials and triumphs in this chapter, our main interest is in his self-professed, lifelong hatred for tennis, his cautiously redemptive "hate-love" for it today (*Oprah.com*, 2009), and his reconciliation with this ambivalence (as represented in *Open*) through the process of autobiographical reasoning.

Agassi and Redemption: The Media Construction

Covering Agassi through his 2006 retirement, Kusz (2001, 2007) has written a cogent analysis of how "the theme of Andre's personal and professional redemption . . . largely guides how the public is compelled to envision him" (2007, p. 60). In a narrative of redemption in which one moves "from a moment of committing of sins to alienation from one's self, to suffering, to reconnection to the world as a supposedly 'changed man'" (2007, p. 45; drawing on Pfeil, 1995), Agassi's original (public or mediated) sin was his failure to win a Grand Slam in his first three attempts after being deemed America's "tennis savior" at the start of his career (Kusz, 2007, p. 34). After this inauspicious beginning he became the first unseeded player ever to win the U.S. Open in 1994 and the press launched its redemption narrative. Then came Agassi's (unknown at the time) crystal meth use and his freefall to the 141st ranking in 1997, followed by a comeback victory at the 1999 French Open that "seemingly allowed viewers to see [another] redemptive transformation taking place right before their eyes" (Kusz, 2007, p. 47). This on-court transformation into the *new* "new Agassi" was engendered by a major

change in training (from fast food and Mountain Dew to a punishing workout regime under trainer, Gil Reyes) and rededication to the sport, and was highly lauded by the press, which from 1999 to his 2006 retirement emphasized his humility, work ethic, maturity, and newfound commitment to tennis.

In Kusz's reading, grounded in generational theory and race or gender constructionism, Agassi's mediated identity was "constituted through the meanings and logics of the Generation X discourse" of the 1990s (2001, p. 51), particularly its articulation of White masculinity. According to Kusz, at the beginning of his professional career Agassi was depicted in the media as a slacker—the main figure produced in early Gen X discourse and represented by Agassi through his low level of education (he left school in 8th grade), questionable work ethic and training habits, and apparent disrespect for tennis (indeed, sporting) tradition. Canon's now-infamous, 1990 "Image is Everything" ad campaign, featuring Agassi and the EOS Rebel camera and promoting (aesthetic) style over (athletic) substance, came to define Agassi's reputation and was considered (in Kusz's reading) the nadir of this era. After his championship titles grew, however, the press embraced the seemingly reformed Agassi amid growing cultural fascination in the mid- to late-1990s "for white guys who are struggling to be better men" (Kusz, 2001, p. 62), and Agassi's mediated image shifted from slacker to "slacker savior"—a reformed Gen Xer now offered up for emulation (2001, p. 65). This redemptive narrative appeared in both sports and mainstream publications and ultimately "transcended the American sports world" (2001, p. 63), promoting a new, White masculinity beginning in 1999 that is "both strategically feminized . . . and masculinized . . . ambivalent toward wealth . . . internally conflicted, family oriented, and in general, attempting to manage its relationship to social privilege" (Kusz, 2007, p. 44). The media representation of Agassi was key in what Kusz termed the "white revolt" of the 1990s to 2000s, a "public struggle over the meanings associated with whiteness (particularly white masculinity) in mainstream American popular culture" (2007, p. 9).

As we explore below, Agassi's autobiography offers a storying of his experiences that in some ways echoes Kusz's analysis in its focus on age and gender—Agassi, too, sees his young self as a rebel struggling to forge an identity, and his older self as a man who has come into his own—but in other ways offers a different narrative trajectory in which his central challenge is determining his own path, a victory three decades in the making. By reconciling his father's lifelong goals for him with his own emergent goals through the process of autobiographical reasoning—by transforming the sport forced upon him into one he actively chooses—Agassi eventually makes a sort of peace with tennis and with himself. In his articulation, "I started with hate, but now, it's given

me my life. I made peace with it when I was 27 years old and every day thereaf-
ter" (*Oprah.com*, 2009). Agassi, too, tells a story of atonement but for a differ-
ent set of sins than were debated in the press. (We point out that *Open* was
published several years after Kusz's *Revolt of the White Athlete*.)

Open: Andre Storying Andre

Echoing the media construction of his very public life, *Open* is also an explicit
tale of salvation, revealing new penance-worthy events that guaranteed
immediate and widespread press coverage. The first breaking story from *Open*
was Agassi's mid-1990s crystal meth use and his successful lie to tour officials
that it was accidental (drugs were detected during a routine urine test).
Though the drug use was short-lived and performance-inhibiting rather than
performance-enhancing, it drew condemnation from fellow players including
Roger Federer, Pete Sampras, and Martina Navratilova (who likened him to
Roger Clemens). It seemed to lump Agassi in with a growing list of champion
athletes associated with doping, and threatened to recast his athletic triumphs
as inauthentic—as villainous rather than heroic. In Agassi's telling, however,
the meth use was symptomatic of a larger struggle with depression, with lack of
self-knowledge and any sense of personal agency, and with profound dislike for
tennis. Insisting that "we all make mistakes," Agassi emphasized in press
coverage for *Open* that he did not cheat the game or fellow players but was
(only) hurting himself, and encouraged the same generous reading of other
athletes suspected of drug use: "if athletes are being tested positive, we should
not blame them. We have to discuss this because we should help them,
because maybe they are suffering" (Brinkbäumer, 2009).

This generosity does not extend to the lie itself, it must be noted. Agassi
reported being ashamed of lying and trying to rationalize degrees of truthful-
ness:

> I promise myself that at least this lie is the end of it. I'll send the letter [of explanation
> to the ATP] but I won't do anything more . . . I won't go before any panel and lie to
> anyone's face. I'll never lie about this publicly. From here on, I'll leave it in the hands
> of fate and men in suits. If they can settle it privately, quietly, fine. If not, I'll live with
> what comes. (Agassi, 2010, p. 256)

While regretful of the lie, Agassi's process of autobiographical reasoning
(re)casts the drug use itself not as a sin requiring atonement but as a symptom
of private turmoil—the actual sin is the life devoid of meaning or purpose. The
revelation of crystal meth use thus serves, for Agassi, as merely a portal into the
larger narrative explored in *Open*: acquisition of self. In short, to return to

Pfeil's (1995) construction of the trajectory of redemption—from sin to alienation to suffering to transformation—Agassi's self-narrative repositions the "drug story" to the middle of the trajectory, as an "alienation/suffering" story.

Receiving nearly as much press coverage was the memoir's second reveal, Agassi's use of a hairpiece in the late 1980s and early 1990s:

> I ask myself: You're going to wear a hairpiece? During *tournaments*? I answer: What choice do I have? (Agassi, 2010, p. 117)

> Warming up before [1990 French Open finals], I pray. Not for a win, but for my hairpiece to stay on. Under normal circumstances, playing in my first final of a slam, I'd be tense. But my tenuous hairpiece has me catatonic. (Agassi, 2010, p. 152)

A relatively minor event in the book itself, the news seemed to delight media commentators, in light of the "image is everything" reputation launched by Canon. It offered Agassi a public platform to both explain his fashion aesthetic at that time and to reject association with a corporate slogan (and reputational inference) that he detested. In Agassi's process of autobiographical reasoning, his aesthetic presentation of self was more an attempt to disappear than to be noticed:

> They say I'm trying to stand out. In fact . . . I'm trying to hide. . . . At heart I'm doing nothing more than being myself, and since I don't know who that is, my attempts to figure it out are scattershot and awkward—and, of course, contradictory. I'm doing nothing more than I did at the Bollettieri Academy [the tennis boarding school he attended as a teen]. Bucking authority, experimenting with identity, sending a message to my father, thrashing against the lack of choice in my life. But I'm doing it on a grander stage. (Agassi, 2010, p. 115)

He reports being blindsided by the media frenzy over the advertisement, not realizing the extent to which he would be defined by the seemingly incidental "image is everything" line:

> Overnight the slogan becomes synonymous with me. Sportswriters liken this slogan to my inner nature, my essential being. They say it's my philosophy, my religion, and they predict it's going to be my epitaph. . . . This ubiquitous slogan, and the wave of hostility and criticism and sarcasm it sets off, is excruciating. I feel betrayed—by the advertising agency, the Canon execs, the sportswriters, the fans. . . . The ultimate indignity . . . is when people insist that I've *called myself* an empty image . . . simply because I spoke the line in a commercial. They treat this ridiculous throwaway slogan as if it's my Confession. (Agassi, 2010, pp. 131-132)

In Agassi's self-storying, the Canon campaign represents what Wenner (2009) referred to as media "dirt." Following Mary Douglas's classic articulation, Wenner wrote that dirt is "matter out of place," and in a media context dirt comes to "structure meaning in [a] narrative" and "influence reading

position" (Wenner, 2009, p. 89). As Agassi explained, the ad campaign "stuck to me for years. To be permanently judged by colleagues, the media and the public was horrifying" (Brinkbäumer, 2009). Part of his decision to write *Open* was thus to "clean up" the dirt by presenting a more authentic (to him) counter-narrative: "I've lived a public life, and I feel like things were said about me . . . both good and bad, that were just not accurate" (*Oprah.com*, 2009). The Canon campaign, too, then, is not a sin that Agassi needs to atone for since he interprets it as not *his* sin. The media image created was not (and of course never could be) the "real" Andre Agassi.

But for Agassi, both the meth use and the hairpiece reflect the underlying struggle that is at the core of *Open*—that the world champion tennis player hated tennis, had *always* hated tennis, and had to learn to choose his own life before it was a life worth living. In Agassi's telling, his father dictated the trajectory of his life as he tried and failed to do with Agassi's three siblings, putting him on a tennis court at age four. "I don't have a memory in life without tennis, not a memory," he said (King, 2006). Agassi's father forced hours of practice (up to 2,500 balls per day) with a tricked-out, high-velocity ball machine dubbed "The Dragon"; hustled hitting sessions with reluctant tour professionals passing through their Vegas hometown; sent him to a tennis boarding academy in Florida at 13 against his wishes; and expected nothing less—truly nothing less—than championship titles for his efforts. Agassi hated tennis because of its loneliness as a sport. He saw being on court as "solitary confinement" (Agassi, 2010, p. 9). He also hated tennis because losing felt terrible and winning not much better: "Winning felt . . . like I had dodged a bullet for the day" (*Oprah.com*, 2009). Tennis, he felt, robbed him of his childhood and his family ties: "I fe[lt] abandoned" (Agassi, 2010, p. 70). It defined who he was before he had a chance to define himself.

Hating tennis, and figuring out why, and what to *do* about the fact that he hated tennis, is the original sin explored in *Open*. Agassi wrote about fans' exultations when he walked out onto the court for the beginning of a match: "They love this moment; they love tennis. I wonder how they would feel if they knew my secret" (2009, p. 19). Referring to his fellow players, he said: "I thought when I heard guys talking about how much they loved the arena and loved the competition that they were lying" (Drucker, 2009). Describing the initial reaction of his trainer (and eventual father-figure), Gil Reyes, Agassi said:

> I try to tell Gil about my psyche. I start at the beginning, the central truth. He laughs. You don't actually *hate* tennis, he says. I do, Gil, I really do. . . . Gil scratches his ear. This was a new one on him. He's known hundreds of athletes, but he's never known one who hated athletics. (Agassi, 2010, p. 143)

Explaining his puzzling-to-everyone-but-himself identification with Barbra Streisand, he said:

> The idea that she possessed such a devastating instrument, such a powerful talent, and couldn't use it freely, for pleasure, was fascinating. And familiar. And depressing. . . . She was a tortured perfectionist who hated doing something at which she excelled. (Agassi, 2010, p. 174)

Here he wondered what would happen if he told the truth publicly:

> I sit down for an hour-long interview with Charlie Rose . . . and I lie through my teeth. . . . When the interview is over I feel a vague queasiness. Not guilt so much, but regret. A sense of missed opportunity. I wonder what would have happened . . . how much more we might have enjoyed the hour, if I'd leveled with him, and with myself. Actually, Charlie, I hate tennis. (Agassi, 2010, pp. 333, 334)

Here he reported with glee Steffi Graf's reaction to his confession: "When I tell her that I hate it, she turns to me with a look that says, Of course, doesn't everybody?" (Agassi, 2010, p. 317). Hatred of tennis—or, rather, the absence of an agentically or self-chosen life path (albeit an enormously successful and lucrative one)—is thus the atonement-worthy sin.

Press reports and Agassi's recounting in *Open* portray his father, Mike Agassi, as an overbearing and abusive taskmaster, offering a seemingly easy analysis of Agassi's abhorrence of tennis as some sort of paternal transfer. An Armenian Iranian immigrant and former Olympic boxer, Mike Agassi's rags-to-riches success story and fanatic (in the original meaning of the term) devotion to tennis are well known in the tennis world. (Interestingly, the Agassi ethnic heritage seems to problematize Kusz's "Whiteness" reading as discussed earlier. While beyond the scope of this analysis, it would be interesting to investigate the extent to which Andre Agassi claims this heritage versus his father's clearly lived experience as an "Other" in America.) In the press coverage surrounding *Open*, Agassi reported coming to understand his father's motivation:

> My father is a man who didn't have choice in his own life. And, as a result, he wanted to give us the only thing he could: freedom for us to choose our life by giving us the American Dream. He associated choice with economics, and he wanted the fastest road to the American Dream for his kids. As a child, you don't see these subtleties. But when you are grown-up, you return and look at things differently. (Brinkbäumer, 2009)

More importantly, though he wrote that "No one ever asked me if I wanted to play tennis, let alone make it my life" (2009, p. 33), Agassi acknowledged that the sport had its own peculiar stranglehold on him. He wrote of contemplating quitting at age seven:

something in my gut . . . won't let me. I hate tennis, hate it with all my heart, and still I keep playing . . . because I have no choice. No matter how much I want to stop, I don't. I keep begging myself to stop, and I keep playing, and this gap, this contradiction between what I want to do and what I actually do, feels like the core of my life. (Agassi, 2010, p. 27)

Mike Agassi concluded in his own memoir titled, *The Agassi Story* (interesting in its lack of formal endorsement by Andre), that the sacrifice of Andre's childhood for a life of tennis was worth it because it worked. With Andre, he had finally produced his champion player: "my dream—and, I believe, I *hope*, his dream—came true" (Cobello, Agassi, & Welsh, 2004, pp. 7, 177; see also Nahigian, 2010).

Open was promoted by Agassi and reviewed by the press as a narrative of redemption (e.g., Brinkbäumer, 2009; Davis, 2009; Drucker, 2009; Gross, 2009); a confessional for a life of soul-searching and for the many missteps along the journey; as a way to make sense of his tortured relationship with tennis and with his father; and as a guide to readers suffering from their own life uncertainties. Agassi described his path to meaningful tennis (and thus a meaningful life) as an epiphany that began when the ATP accepted his lie about drug use:

that was the day that I was asking for a second chance and got it, and most people don't get that. And I made a commitment to myself and I made a commitment to all those around me . . . that I would make the most of my second chance, that I would atone for this part of my life in a way that will be real every day. (Gross, 2009)

Rededicating himself to tennis after dropping to 141st in the rankings and vowing to play as long as physically possible was one avenue for atonement:

I play and keep playing because I choose to play. Even if it's not your ideal life, you can always choose it. No matter what your life is, choosing it changes everything. [I'll retire when] I simply can't play anymore. That's the finish line I've been seeking, the finish line with the inexorable pull. Can't play, as opposed to won't play. Unwittingly, I've been seeking that moment when I'd have no choice. (Agassi, 2010, pp. 359, 371)

Writing *Open* was a second avenue for atonement:

It's a story about forgiveness of your parents, forgiveness of yourself. It's about taking ownership of your life. I think this book will give you the tools and inspiration to take ownership. This book is about waking up in a life that you don't want and making it to tomorrow. . . . This book, while not the ideal perception of me, it is the real me. I think that journey can help others. (ESPN SportsNation, 2009)

His philanthropic efforts are a third and perhaps the most publicly meaningful avenue for atonement. As recounted in *Open*, Agassi first understood

the power of giving back when he was able to help the owner of his favorite restaurant save the establishment. He wrote that he realized at that moment that the only perfection is not found on-court but is "the perfection of helping others. This is the only thing we can do that has any lasting value or meaning" (Agassi, 2010, p. 231). He launched the Andre Agassi Foundation for Education in 1994 with a focus on at-risk youth and in 2001 the Foundation opened the Andre Agassi College Preparatory Academy. Acknowledged Agassi, "Of all my contradictions, this is the most amazing, and the most amusing—a boy who despised and feared school becomes a man inspired and reenergized by the sight of his own school being built" (Agassi, 2010, p. 336). Interestingly, while we think of redemption and atonement as fundamentally about *transformation*, Agassi rejected this reading:

> sportswriters muse about my transformation, and that word rankles. I think it misses the mark. Transformation is change from one thing to another, but I started as nothing. I didn't transform, I formed. When I broke into tennis, I was like most kids: I didn't know who I was, and I rebelled at being told by other people. . . . What people see now, for better or worse, is my first formation, my first incarnation. I didn't alter my image, I discovered it. (Agassi, 2010, p. 372)

To simplify, then, the core element of Agassi's self-storied narrative of atonement is his decision to actively choose tennis, and in doing so, form a sense of self over time. To paraphrase from William Wordsworth, the child becomes the father of the man (see Quiller-Couch, 1919).

Conclusion

To return to narrative theory, one of the interesting aspects of *Open* is Agassi's explicit acknowledgment that the book represents a *version* of his life story. Human development scholars advocate for a "poetics of aging" that "emphasizes the creative agency in what we do as we interpret our lives" (McKim & Randall, 2007, p. 148). From this perspective, every life can be seen as a text or a novel, "of which one is simultaneously author, narrative, character, and reader" (2007, p. 150). Even while stating in interviews that *Open* reveals the "real him," Agassi also described it as uniquely revelatory in a way that acknowledged its storied aspect. He reported thinking about penning a memoir while reading J. R. Moehringer's acclaimed, *The Tender Bar*: "It was so powerful. I wondered if my life—looked at through a literary lens—could impact somebody the way this book impacted me" (Brinkbäumer, 2009). After inviting Moehringer to collaborate with him on *Open*, and after working with

the author for several years, Agassi described being taken aback by the final product:

> The surprising part [was] not the stories of my life. . . . I know the stories. But . . . what does it really mean, what were you really feeling, what's the truth that you've been searching about yourself? . . . But did it surprise me? It did surprise me. I mean, I was part of giving birth to this. I was significant in giving birth to this. And when this book was done, I knew it. I knew every word on every page and it still somehow surprised me. (Gross, 2009)

As such, *Open* exemplifies what Richardson (2000) called "evocative writing," or a "class of genres that deploy literary devices to recreate lived experience and evoke emotional responses" (p. 11). Moehringer's success at this approach did not go unacknowledged in the press. Davis (2009), for example, described the book as "literate," "absorbing," and "wrenching"—not, as he put it, "your typical jock-autobio fare" (see Whannel, 2002, pp. 57–58, on the role of ghostwriters in sport autobiographies). Here, as suggested by McKim and Randall (2007), Agassi was positioned as both author and reader (literally and figuratively) of his own life story.

Open is also a story of successful adult development. While neither Agassi nor Moehringer referred to life-course theory explicitly, *Open* explores the transition from young adulthood to middle adulthood in ways that resonate strongly with Erik Erikson's (1959) well-known model of psychosocial development. In short, Erikson believed that there are eight phases of life, beginning at birth and ending at death, through which a healthy human matures. At each phase, people experience a distinct conflict or challenge that represents a turning point for development—an opportunity for personal growth or failure. While Erikson's theory is controversial, in part, because it posits a sequential, hierarchical model of human maturation, we believe it remains instructive to understanding the developmental process. Most relevant to our purposes here (as noted above) are the challenges associated with young and middle adulthood. Erikson posited that the challenge of young adulthood is to forge intimate bonds or risk isolation (intimacy vs. isolation), and that of middle adulthood is to contribute to the betterment of the world through transmission of core values or culture, or to risk stagnation (generativity vs. stagnation). As Davis (2009) explained, *Open*'s narrative arc shifts from "The self-centeredness of 'What do I have to do to be No. 1?' [to] 'What can I do to help others?'" The accomplishment of generativity is thus signaled through two of the methods of atonement noted earlier—publication of the book itself (and Agassi's belief in its therapeutic potential) and his philanthropic largesse— as well as the elder statesman role he adopted toward the end of his career.

In short, in a volume on the hero-to-villain arc in sports celebrity, the decades-long media construction of Agassi's life story might best be described as hero-to-villain-to-reborn-hero-to . . . what? The admission of drug use would seem to recast him as a villain, and indeed some fellow players condemned him as such, but this has not been the dominant media response to *Open's* revelations (again, the hairpiece was as remarked upon as was the meth use), and as of this writing his statesman status appears intact. *Open's* own suggestion invokes neither the villain nor hero trope—rather, Andre has storied his life journey as from no one-to-someone. A different narrative arc indeed.

Acknowledgment

We are grateful to Madeline B. Davis for her research assistance on this project.

References

Agassi, A. (2010). *Open: An autobiography*. New York, NY: Vintage Books.

Brinkbäumer, K. (2009, November 10). Speigel interview with Andre Agassi: 'I really hated tennis.' Retrieved from http://www.speigel.de/international/world/0,1518,druck-660148, 00.html

Butryn, T. M., & Masucci, M. A. (2003). It's not about the book: A cyborg counternarrative of Lance Armstrong. *Journal of Sport and Social Issues, 27*(2), 124–144.

Caspi, A. (2000). The child is the father of the man: Personality continuities from childhood to adulthood. *Journal of Personality and Social Psychology, 78*(1), 158–172.

Cobello, D., Agassi, M. & Welsh. K. S. (2004). *The Agassi story*. Toronto, Canada: ECW Press.

Davis, D. (2009, November 21). 'Open' by Andre Agassi. *Los Angeles Times*. Retrieved from http://articles.latimes.com/2009/nov/21/entertainment/la-et-book212009nov21 (no longer accessible).

Denison, J., & Rinehart, R. (Eds.). (2000). *Sociology of Sport Journal, 17*(1).

Drucker, J. (2009, December 9). Agassi finally understanding Agassi. *ESPN.com*. Retrieved from http://sports.espn.go.com/espn/print?id=4724933&type=story

Erikson, E. (1959). *Identity and the life cycle: Selected papers*. New York: NY: International Universities Press.

ESPN SportsNation. (2009, November 20). Chat with Andre Agassi. Retrieved from http://espn.go.com/sportsnation/print?id=29525

Gross, T. (2009, November 11). A tennis star who hates tennis? *National Public Radio* [Online transcript]. Retrieved from http://www.npr.org/templates/transcript/transcript.php? storyId=120248809

Horton, J. (2009, November 19). Advantage, Agassi. *Oprah.com*. Retrieved from http://www.oprah.com/spirit/Andre-Agassi-Talks-About-His-Book-Open/print/1

King, L. (2006). Interview with Andre Agassi. *CNN Larry King Live* [Online transcript]. Retrieved

from http://transcripts.cnn.com/TRANSCRIPTS/0609/07/1k1.01.html (no longer accessible).

Kuhn, A. (2002). *An everyday magic: Cinema and cultural memory*. London, UK: I. B. Tauris.

Kusz, K. (2001). Andre Agassi and Generation X: Reading White masculinity in 1990s America. In D. L. Andrews & S. J. Jackson (Eds.), *Sport stars: The cultural politics of sporting celebrity* (pp. 51-69). London, UK: Routledge.

Kusz, K. (2007). *Revolt of the White athlete: Race, media and the emergence of extreme athletes in America*. New York, NY: Peter Lang.

McAdams, D. P., Bauer, J. J., Sakaeda, A. R., Anyidoho, N. A., Machado, M. A., Magrino-Failla, K., . . . Pals, J. L. (2006). Continuity and change in the life story: A longitudinal study of autobiographical memories in emerging adulthood. *Journal of Personality, 74*(5), 1371-1400.

McKim, A. E., & Randall, W. L. (2007). From psychology to poetics: Aging as a literary process. *Journal of Aging, Humanities, and the Arts, 1*(3-4), 147-158.

McLean, K. C., Pasupathi, M., & Pals, J. L. (2007). Selves creating stories creating selves: A process model of self-development. *Personality and Social Psychology Review, 11*(3), 262-278.

McLeod, J. D., & Almazan, E. P. (2003). Connections between childhood and adulthood. In J. T. Mortimer & M. J. Shanahan (Eds.), *Handbook of the life course* (pp. 391-411). New York, NY: Kluwer Academic/Plenum.

Nahigian, F. (2010, April 14). Only in America? An interview with Mike Agassi. *The Armenian Weekly*. Retrieved from http://www.armenianweekly.com/2010/04/14/only-in-america-an-interview-with-mike-agassi/

Oprah.com. (2011, August 1). http://www.oprah.com

Pasupathi, M., & Mansour, E. (2006). Adult age differences in autobiographical reasoning in narratives. *Developmental Psychology, 42*(5), 798-808.

Pfeil, F. (1995). *White guys: Studies in postmodern domination and difference*. London, UK: Verso.

Quiller-Couch, A. T., Sir. (1919). *The Oxford book of English verse, 1250-1900*. Oxford, UK: Clarendon. Retrieved from www.bartleby.com/101/

Richardson, L. (2000). New writing practices in qualitative research. *Sociology of Sport Journal, 17*(1), 5-20.

Wenner, L. A. (2009). The unbearable dirtiness of being: On the commodification of MediaSport and the need for ethical criticism. *Journal of Sports Media, 4*(1), 85-94.

Whannel, G. (2002). *Media sport stars: Masculinities and moralities*. London, UK: Routledge.

On Track, off Track, on Oprah: The Framing of Marion Jones as Golden Girl and American Fraud

Lindsey J. Meân

This chapter is *not* about whether Marion Jones knowingly or unknowingly took performance-enhancing drugs (PEDs), but about how her commodification contributed to why she became so highly vilified and heavily disciplined, invoking far more official, media, and public wrath than any other PED-linked athlete to date. Key to this discussion is how the celebrated, winning Jones was constructed for consumption within mainstream media as a Black, female athlete and the ramifications this had for her later demonization as one of American sports' greatest frauds.

Marion Jones was one of few women to dominate the U.S. mediasport narrative. Heavily promoted in the buildup to the 2000 Olympics, Jones's mediated "quest" for five gold medals captured the public imagination. But in 2007, after "years of denial," Jones confessed to committing perjury (in 2003) claiming she had "unwittingly" taken PEDs (Wilson & Schmidt, 2007, para. 1). Found guilty of perjury (and check fraud) in 2007, Jones received the harshest legal punishment to date of the Bay Area Laboratory Co-operative (BALCO) conspirators or other athletes linked to PEDs or perjury. While Jones was never found guilty of *knowingly* taking PEDs, her guilt is widely assumed, and she remains highly reviled despite seeking an elusive public redemption.

Media Framing and Public Discourse

The media are selective about what gets reported and how content is framed (constructed) for consumption. While some argue that framing sets the agenda for what gets talked about but not how it is understood, others argue it has a

powerful impact on the ways people think about and understand mediated events and public figures. The power of sports as an ideological site renders privilege in public discourse, and consumer identification facilitates susceptibility to sociocultural influences (Scherer, 2007; Wenner, 1991). As the identifiable face and voice of the media, journalists have a particularly privileged position as constructors of collective memory and history (Markovitz, 2006). Sports journalists' authority and privilege stem from *both* authenticity and expertness. Because sports journalists are also often assumed to have special access and relations with athletes, they can use rhetorical and discursive strategies to build para-relations for audience consumption (Billings, 2011). Thus, journalistic versions typically become public discourse, framing public understandings and para-relations with the sporting object, which in this instance is Marion Jones.

Journalists are also ideologically and emotionally linked to sports, constructing texts that typically (re)produce their own identities and cultural formations (Kian & Hardin, 2009). Consequently, sports remains predominantly White, male, and heterosexual (Hardin, 2005). Research consistently reveals the (re)production of traditional and orthodox discourses of gender, (hetero)sexuality, and race in mediasports (Hardin, 2005; Meân, 2010; Oates, 2009). This is relevant for Jones, as her framing materialized through gendered, racialized, and heterosexualized narratives. Indeed, the power of her initial commodification as the beautiful, feminine, heterosexual savior of U.S. track and field accounts for widespread failure to question her exceptional athleticism and culpability early in her career. This commodification also rendered her lies and apparent cheating unforgiveable, violating the common discourses of femininity and female heroic used to construct Jones. In its place the familiar cultural disciplining of "bad" women and Blackness become evident (Carty, 2005; Leonard, 2010), (re)producing Jones as an inveterate cheat and criminal who actively seduced the media and duped the public. This framing has implications for whether Jones can emerge to achieve public redemption or will remain cast as one of America's greatest sports frauds.

Untouchable: Goddess, Superstar, and Everyday American Beauty

In mainstream media from her teens, Jones became a key part of the American sports narrative and its patriotic imperative (Butterworth, 2010) in the years building up to the 2000 Summer Olympics. Jones's narrative included the familiar male-heroic sporting discourses of destiny, exceptionalism, and

extraordinary capabilities (i.e., talent) but rarely evidenced the White male heroic of hard work and dedication (Meân, Kassing, & Sanderson, 2010). Instead, Jones's heroic construction as a woman and an African American was tempered by a feminizing emphasis on her beauty and domestic relations, and by the fact that her raw talent and style were honed and managed by men. Similarly, Jones was reproduced as an African American woman athlete but also framed in ways typically reserved for White female athletes. Her race was rendered invisible, making her acceptable for consumption by White America as a racially neutralized American goddess. Media narratives pitched that Jones's athletic destiny entered "her head like a song that would not leave" when she was 8 years old, and she was saved from a neglectful father by a wonderful stepfather who set her on her athletic path and whose "unjust" death made her "heartbroken" (Longman, 2000, para. 1). Revelations over a problematic family background associated with Black athletes (e.g., neglectful father) were tempered by fairytale-like feminizing evocative of Disneyesque heroines.

Jones's power and muscles were consistently underemphasized in favor of references to "linear elegance and strength" (Harasta, 1998, p. 1B), transforming her body into an aesthetically acceptable form and her power into strength. Media descriptors framed Jones through poetic, magical language, noting, for example, how her "charismatic, resourceful presence lends wondrous possibility" (Longman, 2000, para. 8). Widely constructed as the "superstar next door" (Harasta, 1998, p. 1B), Jones's exceptionality was juxtaposed by references to everyday, ordinary (mainly White) femininity, making her culturally familiarized, normalized, and infantilized as the sweet, pretty, kind, approachable, and heterosexual girl. Thus, the direct description of Jones's "mental toughness," "passion," "exception," and "good work habits" attributed these characteristics to her coaching rather than as intrinsic to Jones (Patrick, 1994, p. 1C). Her coach's authoritative description of Jones as "disciplined and self-motivated" was countered by athlete Maurice Green's description of a "sweet person" who "loves working with kids." Juxtaposing strength and passivity, and power and femininity managed the ideological threat of Jones's presence. As one of few women to dominate sporting narrative there were powerful, ideological imperatives to manage Jones's prominence within traditional orthodoxies, but her collaboration with this should be acknowledged.

A key component of Jones's construction as the exceptional but ordinarily heterosexualized, racially neutralized African American woman was achieved through detailing her personal life as para-relational intimacy. The content of this intimacy emphasized her management of domestic life over her work and

ambitions, undercutting her athletic achievements with the White, feminized narrative of heterosexual romance. Thus, the athletic Jones was the "same Jones who joyously plans her fall wedding" (Harasta, 1998, p. 1B). Her (first) marriage to C. J. Hunter, another elite U.S. athlete, enabled a romantic heteronormalization of Jones further feminized by her husband's hypermasculinity. But a para-relational (over)intimacy was also evident in the divided narratives about Hunter as the "right" husband. Pro-Hunter narratives evoked a made-for-each-other romance that overcame obstacles, his coaching position, and his prior marriage, while anti-Hunter narratives framed Jones as seduced by an older father figure despite her mother's disapproval. Both versions evoked the romanticized, soap-opera genre so frequently associated with Jones. Universally absent were any characterizations of Jones as a homewrecker or other woman, negatives that were rendered invisible as part of the wider media pattern of failing to critically question Jones. This effectively constructed an idealized pedestal for Jones as the untouchable embodiment of feminine American athletic prowess.

Golden Girl of the Summer Olympics

Jones's Olympic narrative was actively framed as a "miniseries," a traditionally feminized genre in U.S. television, by NBC President Dick Ebersol (in Leyden, 2000). Consistently referred to as "golden" to capture her "quest" for five gold medals, this phrase also reproduced Jones's youth and beauty as the "golden girl." Jones was consistently framed as a youthful crowd-pleaser, and the subdued sporting detail of Jones's athletic performances reproduced wider patterns of African American female athletes as entertainers (Carty, 2005). This is exemplified in the opening paragraphs of "Mighty Marion; Day 14" from *The Age* (Melbourne):

> There are many Marions. Playful Marion: turning and shooshing the crowd from the blocks before a heats run. Youthful Marion: flashing a little-girl grin after being introduced. Intense Marion: brow furrowed; eyes straight ahead; sprinting a few steps and muttering to herself before a start. And then there is triumphant Marion. Smiling. High-fiving. (Attwood, 2000, p. 1)

The persistent use of Jones's first name also (re)produced wider gendered, discursive practices of athlete naming, constructing a para-relational friendliness or over-familiarity with "Marion." In essence, her problematic, gendered, and racial form (as an empowered Black female), was transformed and subdued by trivialization into a culturally acceptable framing that served (and was subject to) the audience.

As noted earlier, a pivotal aspect of this normalizing narrative was Jones's marriage to Hunter. A world-class shot-putter, Hunter provided a big, hyper-masculine, "330-pound husband" (Weir, 2000, p. 1A) to successfully temper Jones's power and (rarely mentioned) above-average height. While injury reportedly caused Hunter's withdrawal from the 2000 Olympics, he remained part of the Olympic media narrative as her "mighty and most dedicated body-guard" (Weir, 2000, p. 1A). Echoing the miniseries fairytale, Jones and Hunter became known as the "golden couple" and "Beauty and the Beast." This served both pro- and anti-Hunter storylines, enabling Hunter's characterization as domineering, aggressive, and controlling or as a protective, "23 stone teddy bear" (Wilson, 2000, p. 80). Jones was contrasted as the sociable (media-friendly), heroically ordinary girl who tamed the beast. This reproduced traditional discourses of heterosexual power relations and became significant in framing Jones as innocent bystander and heroically loyal when Hunter's recent positive PED-tests were reported during the Olympics.

The 2000 Olympics featured heightened concern with athlete PED usage. Jones had been heralded as "a symbol of all that is best" by Primo Nebiolo, President of the International Association of Athletics Federations (IAAF, 1999). The significance of the Olympics for national identity also meant Jones was especially sacrosanct in the U.S., with questioning of her considered unpatriotic and problematic. As the goddess and the savior of American *and* international track and field, Jones was firmly established as above suspicion. Thus, while the media acknowledged that any and all exceptional performances warranted PED-related cynicism, Jones's extraordinary performances remained unquestioned, and fingers were firmly pointed elsewhere (Patrick, 2000, p. 1A). Jones's early career failure to take a routine drug test was rarely noted or minimized when reported (Patrick, 1993, p. 8C). Consequently, despite a "breathtaking performance" where she "sauntered to victory" (Chadband, 2000, p. 89), Jones's potential use of PEDs was actively denied even in the face of Hunter's positive PED tests. When criticisms of Jones were reported, they were quickly dismissed by a protective media. Perceptions of Jones as "cold, distant and pretentious" were framed as jealousy and envy from rivals (Attwood, 2000, p. 1).

Jones was framed as beyond question and as the supportive wife of a "beleaguered husband" (Chadband, 2000, p. 89). Further, she was constructed as the consummate professional athlete as this had not "deflected her golden focus" (Chadband, 2000, p. 89). While some foreign media questioned such characterizations (Ulmer, 2000, p. 4), a narrative of no guilt by association was commonly reproduced in U.S. and overseas coverage (Chadband, 2000, p. 89; Patrick, 2000, p. 1A; Weir, 2000, p. 1A). Hunter's vilification and depiction as

ideal scapegoat and nasty "Beast" were seated in longstanding problematization of Black masculinity (Leonard, 2010). Indeed, Hunter became reviled as "blubbering," while Jones was the stoic, female victim showing strength by remaining loyal and choosing to "stand by her man" (Chadband, 2000, p. 89). Thus, Jones's everyday, strong wronged woman narrative heightened her ordinary female heroic and a set solid groundwork for public sympathy and support when Jones later divorced Hunter.

Jones emerged from the Olympics on a higher pedestal than before by winning three gold medals (100m, 200m, 4x400m relay) and two bronze medals (long jump, 4x100m relay). She was positioned only as guilty of bad choices in men—a plausibly familiar gendered discourse. Effectively, Jones was unquestionable in the mainstream media at this point, despite all the red flags that were invoked later in revisionist condemnation.

Falling Star to Fallen Woman: Seductress, Liar, and Cheat

Consistently denying accusations arising from the BALCO scandal, Jones denied knowledge of PED use to federal investigators in 2003. Mainstream American media continued to frame Jones as not guilty by association. But discomfort with Jones's continued choices began to emerge, and her sponsors (Nike) demanded she split from her new coach, Charlie Francis, because of his associations with PED-convicted athletes (such as disgraced Canadian sprinter, Ben Johnson). Jones complied, claiming to be "upset about [continued] speculation" (O'Brien, 2003, p. 66). However, Tim Montgomery, Jones's athlete boyfriend, also coached by Francis, tested positive for PEDs. Despite the recently shared coach and the Jones-Montgomery relationship (as parents of a child), journalistic questioning of Jones remained somewhat muted. Some distancing was evident in the production of less para-relational content and a more "fact-based" reporting. Still with Jones's lackluster, "shockingly unimpressive" performances (Bondy, 2004, p. 85), her golden girl narrative no longer required defending nor made her worth defending. Nonetheless, Jones's PED denials remained vociferous. When BALCO founder and executive, Victor Conte, claimed on the popular American news program, 20/20, in December 2004 that he had both supplied Jones with PEDs and seen her inject them, she filed a $25 million defamation suit.

In 2006 Jones tested positive for PEDs in an A sample. This proved a watershed for American and overseas journalists who responded with an emotional, para-relational outpouring constructing her as guilty. Jones as the superstar-next-door was replaced with Jones as a "seductress" and cheat who

"betrayed" duped journalists and, hence, the public with her "guile" (Szczepanik, 2006, p. 55). Szczepanik further quoted Plaschke (from the *Los Angeles Times*) as writing: "She's a fraud. And if I sound angry, it's because, of all the drug cheats that have been exposed in recent weeks, her mission was larger and her abuse was greater." Similarly, *ESPN.com*'s Wojnarowski (2006a) expressed personal disappointment:

> A part of us wanted to believe Marion Jones. . . . She was so smart, so elegant, so charming, it damaged your spirit to believe that her grace, her greatness, might have been a chemical creation. She was an American goddess, seducing with the sweetest of smiles. . . . She'll go down as one of the great frauds in U.S. sports history. If nothing else, we'll never have to listen to her get so indignant over the charges of cheating, never have to hear her claim her innocence again.

Thus, Jones's success and status clearly framed her guilt as more offensive, but what strongly emerged was the breach of para-relational trust and expectations of her commodified role, particularly as the symbol of American success.

While the highly personalized, emotional reaction from journalists might have included real indignation, it also achieved discursive alignment and self-categorization with a disappointed, cheated public audience. As authoritative experts it would be risky for journalists to admit to being so duped. Consequently to account for how she could fool so many, including expert journalists, Jones needed to be framed as master manipulator ("seducing with the sweetest of smiles"). This abrupt revision was easily understood and accepted given the familiarity of discourses reproducing women as good or bad, girl next door or femme fatale, and savior or seducer of honorable men.

Building this revisionist version of Jones required reframing her mediated past. Thus, Jones's previously minimalized failure to take a routine drug test in 1992 reemerged to exemplify a history of calculated practices and denials. Suddenly details emerged that framed the case differently. Notable focus was given to her lawyer being Johnnie Cochran, which was a powerful detail because of Cochran's savvy in successfully defending O. J. Simpson in a 1995 murder trial that split the U.S. along race lines. Amongst White mainstream America, Cochran was synonymous with tricky evidence, bad verdicts, racialized arguments, and celebrity cases. For many African Americans he was celebrated as successfully fighting a racially biased legal system. Cochran's involvement fueled revisions of a racialized Jones who, for the White majority, might be guilty and questionably acquitted.

Given the force of this new media narrative, the limited reporting of Jones's negative B sample was unsurprising. However, while Wojnarowski (2006b) stated "there's no test that exonerates her legacy," *The New York Times* journalist, Rhoden (2006), provided a highly personalized account of the B-

test reprieve, emphasizing the "devastating . . . smear" and "turmoil" of the positive A-test. Rhoden further acknowledged minimal reporting of the negative B-test and claimed that the "presumption of guilt—not the possibility of innocence—is what leaves an indelible impression." Attempts to reframe Jones as fighting media bias and injustice were ineffective because of widespread media framing of Victor Conte's 2004 accusations as persuasively detailed (Slot, 2007).

Confession, Trial, and Punishment

Under increasing legal pressure and scrutiny, in October 2007, Jones publicly confessed to committing perjury in her 2003 testimony to federal agents. In an example of strong public apologia, Jones tearfully read a letter expressing great sadness and shame at letting her family, friends, and the public down. Jones claimed that, during federal questioning, she realized she had "*unwittingly*" taken PEDs from a trusted coach and, in that moment, made the bad decision to lie. Blaming a trusted coach used the familiar narrative of Jones as the victim of bad choices in men and extended it to a bad decision to lie. But despite the strength of her apology, the confession provided explicit proof of Jones's ability to lie convincingly, rendering her continued claims to unwittingly taking PEDs unconvincing to journalists and the wider public.

Years of untruthful denials became *de facto* evidence of Jones as "seductress," "brazen cheat," and "consummate actress" (Gillon, 2008, p. 7), and the narrative of duped journalists and cheated public strongly reemerged. Jones's protected place on the pedestal as the ordinary, heroic American golden girl next door was finally razed by her commodification as the iconic seductress and actress, the femme fatale—irredeemably criminal, purposively seductive, and incurable in nature. The previous, normalizing media narratives of Jones as ordinary wife and mother became almost universally absent. Instead, Jones literally and figuratively became a fallen woman, "tripped up not by a snitch, not by a drug test, but by the floppy loose laces of her own face-saving lie," a femme fatale subject to "flawed, opportunistic men" but ultimately the victim of her own flaws (Araton, 2007, para. 1). This dangerous, criminal feminization ensured that Jones could "not be seen as sympathetic victim" because she "lied to agents" and "nobody else" made her do it (Araton, 2007, para. 1).

The demonization of Jones as a femme fatale enhanced the media defense. It usefully explained their championing of Jones as heroic vulnerability to a seduction they could now resist. Thus, Araton (2007, para. 6–7) discussed

Jones's allure and being "captivated by some storybooks more than others" alongside his nostalgic regret in still "wishing for her to be remembered as the beautiful blur in silver shoes." Jones could simultaneously be framed as "getting increasingly slick and aggressive in dealing with the media" (Slot, 2007, p. 85), with her earlier friendliness reframed as manipulative media-gaming. Repetition emphasized Jones's continued lies ("she objected and she objected," Slot, 2007), and her whole-page declaration in her autobiography, in large red letters, that she had never taken drugs (Jones & Sekules, 2004, p. 173) reinforced her characterization as a "brazen" liar.

Jones's criminality was defined and pathologized for consumption using familiar, gendered discourses—shifting her from the iconic good girl to the iconic bad woman of soaps, serial dramas, and film noir. This dominant framing as a manipulative, pathologically bad woman positioned Jones's claims about unknowingly taking PEDs as untenable and as part of continued attempts to manipulate the media and public. Consequently, claims that "Marion Jones's letter of confession is astonishing because she says that she is finally telling the truth, yet there is evidence to suggest that she is not and the real facts are far more condemning" (Slot, 2007, p. 85) resonated with the wider public discourse.

Jones, as a fallen woman continuing to hide the truth, became significant for the severity of her legal punishment and continued public disciplining. In sentencing Jones for perjury (and check fraud), U.S. District Court Judge Karas was reportedly "troubled by the statement Jones had read at her plea" and concerned that continued claims to unwittingly taking PEDS demonstrated she "had not taken responsibility for her action" (Thompson & O'Keefe, 2009, p. 63). Karas sentenced Jones to six months in prison and 800 hours of community service. This was highly punitive compared to similar cases, and shocking, since prosecutors had stated "they would be satisfied with probation" (Thompson & O'Keefe, 2009, p. 63). The sentence and its rationale suggest that Karas was impacted by the media-framed, public discourse, punishing Jones for perceived actions rather than the crimes for which she had technically been tried. There was little questioning of Karas's rationale, suggesting Jones's guilt had become a public truth; that is, she had already been proven guilty in a trial by media. Media silence suggested tacit approval, while some constructed Jones as getting what she deserved (i.e., no mercy) as a "Cheat Who Showed No Mercy to Athletes" (Gillon, 2008, p. 7).

Jones's status is linked to her harsh treatment as a public example. Indeed, the appeal to President Bush for her sentence to be commuted was contested by the Chief Executive of USA Track and Field who argued leniency would imply celebrities were treated exceptionally (Longman, 2008, p. D1), despite

the exceptionality of Jones's sentence. Thus Jones's punishment also has to be understood as the legal and cultural disciplining of a celebrity Black female athlete whose challenges to the traditional boundaries of femininity and race had been privileged by transformation into an acceptable form for consumption. As such, Jones's contravention of this privilege was heavily disciplined, notably at a time when her athletic performance had also substantively weakened. This argument remains feasible in the face of limited equivalent legal and cultural disciplining of other White and/or male PED- and perjury-linked athletes such as Barry Bonds and Roger Clemens.

Rhoden (2008) noted that the potential for racial injustice to prevail remains a distinct possibility if Roger Clemens is not treated equivalently to African American athletes. Thus, while Clemens's case is yet to be heard, the reported statement by Henry Waxman (Chair of the U.S. House Committee addressing the case) that "lies are not necessarily perjury" (Rhoden, 2008, para. 6) raises alarm bells about ideologically shifting disciplinary imperatives, particularly given the rationale for Jones's punishment. While there is predictably little discussion of racial concerns in the mainstream media (Kian & Hardin, 2009), it is interesting that Jones's most sympathetic, mainstream media framings come from African Americans, such as William Rhoden of *The New York Times*, Oprah Winfrey, and John Singleton who directed the ESPN documentary *Marion Jones: Press Pause* in 2010.

Redemption Seeking

Jones's continued failure to admit her assumed guilt is central to whether she can achieve public redemption. Admission of guilt is necessary in many religious and legal discourses. Thus, Jones's continued denial of knowingly taking PEDs positions her as deserving of continued punishment. Jones cannot be framed as a saved woman while she continues to fail to acknowledge her sins. Even if Jones admits guilt it is doubtful that redemption would be attained as she would become a confirmed liar, cheat, and national disgrace. Many believe her to be these already, with the incurable personality of the femme fatale condemning her in perpetuity.

An alternative, post-prison narrative frames Jones as having completed her punishment and on the path to redemption. This narrative minimizes the past events (like taking PEDs) and focuses instead on her served punishment, emphasizing her current roles as mother, wife, athlete, and community speaker. John Singleton's ESPN documentary followed Jones through her roles as mother, wife, and athlete involved in community work and at church.

It also took her back to prison, retracing her journey to jail as a narrative ploy to explore her punishment, but it failed to explore the journey before this point. Thus, Jones's redemption narrative deploys the disciplinary function of prison and separation from her children, simultaneously reproducing her as a hardworking and loving mother, wife, athlete, and mentor to many young people (i.e., a contrite, ordinary female heroic with a subdued, extraordinary narrative). The past, minimized and made invisible in this narrative, is overshadowed by attention to the reemergence of Jones as an ordinary, heterosexual woman subject to the vagaries of bad men. Her denials are portrayed as just bad decisions.

ESPN's promotion of John Singleton's documentary framed Jones as an extraordinary athlete and unwitting victim of "cheating" men:

> [Jones's] 37-second margin of victory in the 100 meters was the widest margin by a woman since 1952, but in the years that followed she became the center of a storm of cheating coaches, steroid using partners and the Bay Area Laboratory Co-operative. (ESPN Topics, 2010, para. 1)

Similarly the title, *Marion Jones: Press Pause*, and subtitle, "Decisions are sprints. Redemption is a marathon," reproduce her in a long battle to redeem herself from a quick, bad decision, rendering invisible the years of denial. It is also reproduced in the name and rationale of Jones's community youth program, "Take a Break." But this "one moment" narrative cannot satisfactorily address all the other times Jones lied.

Jones's post-prison television interview on *Oprah* in 2008 also reproduced the redemption narrative (http://www.youtube.com/watch?v=3ewja4q0z7s) but did address some of the controversies. While Oprah seemed to ask the difficult questions, Jones's answers were never challenged, tacitly reproducing them as true. So when Oprah observed that it was hard to believe Jones's claims that she unknowingly took PEDs, Jones reproduced the "never knowingly" and trusted coach accounts. Similarly, when Jones talked about her decision to lie "in that moment," Oprah failed to ask Jones why she had continued to lie. Jones's construction as a mother was also forefronted in the *Oprah* narrative, emphasized when a tearful Jones read a letter written to her sons from prison. It was an intimate but strangely confessional letter and Jones's emotive performance of punished motherhood was discomfiting, raising the specter of her framing as a media-savvy manipulator. The video of Jones's "Letter to Her Sons" was posted on *Oprah.com* (Oprah.com, 2008b) alongside a detailed report (not transcript) of the interview, which closed with Jones framed as contrite, accepting of her severe punishment, and ready to move forward to a "bigger and better" future and to "help young people make

certain choices" (Oprah.com, 2008a, final paragraph). A third article, "Marion Jones at Home with Her Family," focused on Jones's post-prison role as ordinary mother (Oprah.com, 2008c). The three articles and the Oprah interview reproduced Jones within the ordinary female heroic. Here, she was linked to exceptionality and emphasized as a mother but also framed as punished, contrite, and forgivable, i.e., ready for redemption.

The mainstream White media, using the same details, continue to reproduce Jones as self-serving and lacking in contrition. Thompson & O'Keefe (2009, p. 63) contended that "Jones continues to downplay her role in the BALCO scandal . . . even as she lectures school kids in her 'Take a Break' program in an effort to satisfy her 800 hours of mandated community service." In this version, Jones becomes hypocritical and her post-prison community service is seen as required rather than altruistic. This undercuts the selfless and redemption-worthy narrative, reproducing Jones as incurably manipulative and deserving of continued cultural disciplining.

Conclusion

The mediated construction of Marion Jones shows that gender and race had consistent, significant implications for her framing and disciplining. The emphasis on her traditional, heterosexual femininity, despite her athleticism, initially constructed her as the acceptable face of empowered, female athleticism and muted her racial identity. It was the contravention of this privileged positioning that made her "crimes" so problematic. The accounts of Jones in the heroic phase of her career set in action a version against which the possibility of PEDs was rendered invisible and consistently discounted, while her dubious associations were excused as heterosexual, feminine vulnerability to "bad" men. Once this version of Jones was undermined, she was instead constructed as a manipulative "seductress" who had duped and cheated an adoring media and public. The sociocultural familiarity of these dichotomous constructions made them easily consumed, especially given their prominence in oversimplified narratives of mediated women. These versions became emblematic of the media coverage of Jones in a spectacularized story of sporting achievements, relationships, faith, and betrayal that became highly personalized and deeply charged in the para-relational media narrative of Jones. These became the dominant, public discourse and collective memory of Jones, impacting the severity of her legal punishment and her wider cultural disciplining.

Attempts to reembrace Jones within a redemption narrative as an ordinary mother and wife have failed to dislodge the power of the collective memory of Jones as a cheat, liar, and manipulator or to capture the public imagination sufficiently to allow her public redemption. This remains evident in postings and blog responses to Jones, revealing a greater reproduction of Jones as an intentional cheat, consistent liar, and actress compared to those offering forgiveness. Strong resistance to the redemption narrative remains, and most media treatments include brief but damning detail about her fall, consistently reproducing her as one of the greatest frauds in American sports. Consequently, it is possible that Jones might never achieve public redemption.

References

Anderson, B. (1991). *Imagined communities: Reflections on the origin and spread of nationalism.* London, UK: Verso.

Araton, H. (2007, October 5). A tarnished golden girl can't outrun the truth. *The New York Times.* Retrieved from http://nytimes.com/2007/10/05/sports/othersports/05araton.html?ref=marionjones

Attwood, A. (2000, September 29). Mighty Marion; Day 14. *The Age* (Melbourne, Australia), Olympics, p. 1. Retrieved from http://lexisnexis.com.ezproxy1.lib.asu.edu/hottopics/lnacademic/

Billings, A. C. (2011). Introduction. In A. C. Billings (Ed.), *Sports media: Transformation, integration, consumption* (pp. 1–6). New York, NY: Routledge.

Bondy, F. (2004, July 13). Marion makes long jump final. *New York Daily News*, p. 85. Retrieved from http://www.lexisnexis.com.ezproxy1.lib.asu.edu/hottopics/lnacademic/

Butterworth, M. L. (2010). Do you believe in nationalism? American patriotism in Miracle. In H. Hundley & A. Billings (Eds.), *Examining identity in sports media* (pp. 133–152). Thousand Oaks, CA: Sage.

Carty, V. (2005). Textual portrayals of female athletes: Liberation or nuanced forms of patriarchy? *Frontiers: A Journal of Women Studies*, 26(2), 132–155.

Chadband, I. (2000, September 27). Business as usual for Super Marion. *Evening Standard*, p.89. Retrieved from http://www.lexisnexis.com.ezproxy1.lib.asu.edu/hottopics/lnacademic/

ESPN Topics. (2010, November 1). Marion Jones. ESPN.com. Retrieved from http://espn.go.com/espn/topics/_/page/marion-jones

Gillon, D. (2008, January 12). Cheat who showed no mercy to athletes. *The Herald* (Glasgow, Scotland), p. 7. Retrieved from http://www.lexisnexis.com.ezproxy1.lib.asu.edu/hottopics/lnacademic/

Harasta, C. (1998, July 15). Rapid ascent; Marion Jones, 22, bearing down on three world records. *Dallas Morning News*, p. 1B. Retrieved from http://www.lexisnexis.com.ezproxy1.lib.asu.edu/hottopics/lnacademic/

Hardin, M. (2005). Stopped at the gate: Women's sports, 'reader interest,' and decision making by editors. *Journalism and Mass Communication Quarterly*, 82(1), 62–77.

IAFF (1999, August 25). Nebiolo shares the disappointment of millions of fans over Marion Jones's injury. The 7th IAFF World Championships in Athletics. Retrieved from http://www.iaff.org/news/printer.newsid=16811.htmx

Jones, M., & Sekules, K. (2004). *Marion Jones: Life in the fast lane–An illustrated autobiography*. New York, NY: Warner Books.

Kian, E. M., & Hardin, M. (2009). Framing of sport coverage based on the sex of sports writers: Female journalists counter the traditional gendering of media coverage. *International Journal of Sport Communication*, 2(2), 185–204.

Leonard, D. J. (2010). Jumping the gun: Sporting cultures and the criminalization of Black masculinity. *Journal of Sport & Social Issues*, 34(2), 252–262.

Leyden, T. (2000, July 10). Me and Mrs. Jones. *Sports Illustrated*. Retrieved from http://sportsillustrated.cnn.com/vault/article/magazine/MAG1019662/index.htm

Longman, J. (2000, September, 11). 2000 Sydney Games; At long last, her golden moment. The New York Times. Retrieved from http://www.nytimes.com/2000/09/11/sports/2000-sydney-games-at-long-last-her-golden-moment.html

Longman, J. (2008, July 23). Letter urges President not to give Jones pardon. *The New York Times*, p. D1. Retrieved from http://www.lexisnexis.com.ezproxy1.lib.asu.edu/hottopics/lnacademic/

Markovitz, J. (2006). Anatomy of a spectacle: Race, gender, and memory in the Kobe Bryant rape case. *Sociology of Sport Journal*, 23(4), 396–418.

Meân, L. J. (2010). Making masculinity and framing femininity: FIFA, soccer, and World Cup web sites. In H. Hundley & A. Billings (Eds.), *Examining identity in sports media* (pp. 65–86). Thousand Oaks, CA: Sage.

Meân, L. J., Kassing, J. W., & Sanderson, J. (2010). The making of an epic (American) hero fighting for justice: Commodification, consumption, and intertextuality in the Floyd Landis defense campaign. *American Behavioral Scientist*, 53(11), 1590–1609.

Oates, T. P. (2009). New media and the repackaging of NFL fandom. *Sociology of Sport Journal*, 26(1), 31–49.

O'Brien, J. (2003, February 7). Not the Marion kind. *The Mirror*, p. 66. Retrieved from http://www.lexisnexis.com.ezproxy1.lib.asu.edu/hottopics/lnacademic/

Oprah.com. (2008a, October 27). Marion Jones, after prison. Retrieved from http://www.oprah.com/world/Marion-Jones-After-Prison_1

Oprah.com. (2008b, October 29). Marion Jones' letter to her sons. Retrieved from http://www.oprah.com/oprahshow/Marion-Jones-Letter-to-Her-Sons

Oprah.com. (2008c, October 29). Marion Jones at home with her family. Retrieved from http://www.oprah.com/relationships/Marion-Jones-at-Home-with-Her-Family

Patrick, D. (1993, January 19). Suspension not inevitable for sprinter who missed test. *USA Today*, p. 8C. Retrieved from http://www.lexisnexis.com.ezproxy1.lib.asu.edu/hottopics/lnacademic/

Patrick, D. (1994, June 1). Jones keeps heels clicking in excitement. *USA Today*, p. 1C. Retrieved from http://www.lexisnexis.com.ezproxy1.lib.asu.edu/hottopics/lnacademic/

Patrick, D. (2000, September 26). Drugs taint games. *USA Today*, p. 1A. Retrieved from http://www.lexisnexis.com.ezproxy1.lib.asu.edu/hottopics/lnacademic/

Potter, J. (1996). *Representing reality: Discourse, rhetoric and social construction.* London, UK: Sage.

Rhoden, W. C. (2006, September 26). Jones tired of running with weight of suspicion. *The New York Times.* Retrieved from http://www.nytimes.com/2006/09/26/sports/other sports/26rhoden.html

Rhoden, W. C. (2008, February 15). Justice will be served only if Clemens isn't given a pass. *The New York Times.* Retrieved from http://www.nytimes.com/2008/02/15/sports/baseball/15rhoden.html

Scherer, J. (2007). Globalization, promotional culture and the production/consumption of online games: Engaging Adidas's 'Beat Rugby' campaign. *New Media & Society*, 9(3), 475–496.

Singleton, J. (Director) (2010). *Marion Jones: Press pause* [Documentary film]. ESPN Films.

Slot, O. (2007, October 6). Chain of mistrust that has run and run. *The Times* (London, UK), p. 85. Retrieved from http://www.lexisnexis.com.ezproxy1.lib.asu.edu/hottopics/lnacademic/

Szczepanik, N. (2006, August 21). Seductress now spurned. *The Times* (London, UK), p. 55. Retrieved from http://www.lexisnexis.com.ezproxy1.lib.asu.edu/hottopics/lnacademic/

Thompson, T., & O'Keefe, M. (2009, December 6). Tracking Marion's tears. Critics say she still won't come clean. *New York Daily News*, p. 63. http://www.lexisnexis.com.ezproxy1.lib.asu.edu/hottopics/lnacademic/

Ulmer, M. (2000, September 26). Americans in a state of denial. *Toronto Sun*, Sports, p. 4. Retrieved from http://www.lexisnexis.com.ezproxy1.lib.asu.edu/hottopics/lnacademic/

Weir, T. (2000, September 21). All eyes on Jones' goal of five golds brings burden of expectation to U.S. sprinter. *USA Today*, p. 1A. Retrieved from http://www.lexisnexis.com.ezproxy1.lib.asu.edu/hottopics/lnacademic/

Wenner, L. A. (1991). One part alcohol, one part sport, one part dirt, stir gently: Beer commercials and television sports. In L. R. Vande Berg & L. A. Wenner (Eds.), *Television criticism: Approaches and applications* (pp. 388–407). New York, NY: Longman.

Wenner, L. A. (1994). The dream team, communicative dirt, and the marketing of synergy: USA basketball and cross-merchandising in television commercials. *Journal of Sport & Social Issues*, 18(1), 27–47.

Wilson, D., & Schmidt, M. S. (2007, October 5). Olympic champion acknowledges use of steroids. Retrieved from http://www.nytimes.com/2007/10/05/sports/othersports/05 balco.html?pagewanted=all

Wilson, N. (2000, July 21). High hopes for Marion. *Daily Mail* (UK), p. 80. Retrieved from http://www.lexisnexis.com.ezproxy1.lib.asu.edu/hottopics/lnacademic/

Wojnarowski, A. (2006a, August 22). Jones: Yet another athletic myth up in flames. ESPN.com. http://sports.espn.go.com/oly/trackandfield/columns/story?columnist=wojnarowski_adri an&id=2554453

Wojnarowski, A. (2006b, September 7). No test can salvage Jones' tarnished legacy. ESPN.com. http://sports.espn.go.com/oly/trackandfield/columns/story?columnist=wojnarowski_adri an&id=2577044

The Ups and Downs of Skating Vertical: Christian Hosoi, Crystal Meth, and Christianity

Becky Beal

At the age of nineteen, he is one of the world's best skateboarders. . . . More important, Hosoi is the skater who currently has the heart—the one who inspires legions of other skateboarders nationwide. He is a charismatic performer and a major style setter. (Gabriel, 1987, p. 74)

If Christian hadn't squandered his great gifts, it is very likely you and your kids would be watching him blast huge air every year at the X Games. (Greenfeld, 2004, p. 68)

I [Hosoi] don't dwell on the past . . . that was Tony's (Hawk) journey and God bless him. This is the path the lord has set me on, and I am grateful that I will be able to use my name and my skating as my key. (Greenfeld, 2004, p. 80)

Christian Hosoi is a beautiful skateboarder known for his graceful style and ability to get big air. His skill in skateboarding is akin to elite dance or figure skating, his physical appearance is striking, and his generosity is without end. His signature tricks were the "Christ Air" and "Rocket Air" and he personified the ideals of freedom and limitlessness that the skateboarding industry promotes. In the mid- to late 1980s, when he was about 20 years old, he was the best ramp and pool skateboarder, and his talents were so in demand that he traveled continually, putting on demonstrations throughout the world. He lived in Hollywood and partook in the "rock star" lifestyle, befriending actors such as David Arquette and musicians such as the Red Hot Chili Peppers and appearing in the Beastie Boys music videos. Youth industry sponsors lined up: Converse (shoes), Swatch (watches), and Jimmy'Z (beachwear), and he owned his own skateboard company. In the late 1980s he was earning nearly three hundred thousand dollars a year. Christian Hosoi is also a crystal methamphetamine addict who reached his low in 2000 when he was arrested for transporting a pound and a half of crystal meth, and sentenced to ten years in jail. It was in this moment when he converted to Christianity and quit using

drugs. Released in 2004, he became an ordained minister. Now in his 40s, he continues to draw on his subcultural capital (Thornton, 1996): he created a reality TV program, *The Uprising*, featuring Hosoi and other skateboarders witnessing to teenagers; he is sponsored by major sporting goods corporations such as Vans and Quiksilver; he has revived Hosoi Skateboards; and he skates in "legends" competitions (most other sports would call this category "masters").

This chapter examines the narratives used in constructing Christian Hosoi and explores the social significance those narratives hold. It has been widely noted that sports stars and celebrities are used to market a variety of products and that celebrities are constructed to represent particular values in order to connect to a target audience. Besides their economic significance, the narratives used to construct celebrities also provide insight into the cultural moment, including what values and attributes are privileged (Cashmore, 2006; Whannel 2002). This chapter will address questions such as: what attributes get privileged for skateboarders and for the sport? What values are being developed to be sold as a commodity? Who benefits and who does not from the narratives that construct Hosoi the celebrity?

These questions about the mediated Hosoi, in turn, provide insight into how the skateboarding industry positions itself. Andrews and Jackson (2001) suggested that "social institutions, practices and issues are principally represented to and understood within, the popular imagination through the actions of celebrated individuals (p. 4). In this chapter, the social institution of skateboarding and its cultural practices will be explained, in part, through the celebrity of Hosoi. Especially pertinent is the constant comparison with his peer celebrity, Tony Hawk.

Boyle and Haynes (2000, p. 107) contended that when scandals arise, media frequently deflect any blame from sports, placing it on individuals instead. Following their contention, it will be argued that narratives around Hosoi's fall focus on Hosoi and his father, Ivan, and their individual moral failures, while skateboarding is actually positioned as source for redemption. While focusing primarily on how the mediated Hosoi embodies the ethos promoted by the skateboarding industry, this chapter also briefly addresses Hosoi's use of his mediated image to gain cultural and economic capital.

Packaging an All-American Rebel

Skateboarding has largely been represented as an alternative to mainstream sport, as it claims to reject formal, bureaucratic structures and a win-at-all cost

attitude. Instead, skateboarding has presented itself as valuing creativity, freedom, independence, and a do-it-yourself (DIY) ethic (Beal, 1995; Borden, 2001; Chivers Yochim, 2010). The commercial success of skateboarding started in the 1960s, and its rise has been linked with the growth of consumer culture, one which sells these bohemian notions of individualism and creativity (Atencio & Beal, 2011; Humphreys, 2003; Muggleton, 2000; Wheaton, 2010).

Significantly, the youth market has always been skateboarding's primary target. Chivers Yochim (2010) argued that throughout its history, the industry has played off the tension between rebellious or bohemian discourses and mainstream ones as they try to simultaneously appeal to teenagers and to parents and corporate sponsors. More recently, the industry has framed this tension as maintaining its "core" image and consumer base while growing its markets (Beal & Wilson, 2004). Like other industries, skateboarding has used the media to promote its image and to create stars to promote the sport (Andrews & Jackson, 2001). In the 1980s this tension was played out in the rivalry between rebellious Christian Hosoi and the mainstream Tony Hawk.

Hosoi and Hawk

The media's presentation of Hosoi's rise and fall always includes references to Hawk. The two are contemporaries (Hosoi born in 1967, Hawk in 1968) and were rivals in the mid- to late 1980s. Tony Hawk is currently the most financially successful skateboarder in the world, whereas Hosoi is a recovering drug addict and former convict. Not only is the narrative structure of "right" versus "wrong" employed, but the tension within skateboarding is expressed in the discourses of Hosoi as rebellious and Hawk as mainstream.

Tony Hawk has become the public face of skateboarding. He has the biggest name recognition of any sports star for young consumers (Iwata, 2008) and he is known for his skills in vert, his innovative tricks, and his personal drive. And, unlike many of his counterparts, he has a clean-cut image: no visible tattoos, short-cropped hair, and an unassuming demeanor. This makes him appealing to a broad audience, as his remarkable skateboarding skills, business savvy and wholesome image have made him an icon (Hyman, 2006). Hawk grew up in an intact, White, middle-class family and his father, Frank Hawk, was very supportive. Even though Frank was the president of the Little League that Tony played in and quit, Frank created institutional support for his son's growing interest and passion in skateboarding. Frank Hawk started the California Amateur Skateboard League and then the National Skateboard Association in 1983 (Layden, 2002).

On the other hand, Hosoi's parents were divorced when he was very young. Hosoi's father is of Japanese descent and his mother is White. Born in Hawaii, he and his father, Ivan, moved to Los Angeles so his father could develop a career in art. When this faltered, Ivan took a job managing the Del Mar skate park where his son spent much of his time. Ivan dedicated himself to Christian's passion for skateboarding, and Christian also had the support of some of the well-known "Dogtown" skaters such as Tony Alva, Stacy Peralta, and Shogo Kubo. At 14 years of age, Christian was sponsored by the top skate company, Powell-Peralta (the "Peralta" refers to Stacy, who was co-owner). His father allowed him to drop out of school to pursue skateboarding. Ivan was known to smoke marijuana regularly, and he shared this practice with his son (Freedman & Montano, 2006; Greenfeld, 2004.)

The media continue to portray the Hawk-Hosoi rivalry as a story extolling the virtues of prudence and condemning the vice of recklessness: Hawk is the more grounded, practical, and technically proficient skateboarder who becomes iconic and rich, while Hosoi is the high-flying, perilous, and stylistic skateboarder who becomes infamous and loses his wealth. Yet, both images are necessary to create drama, engage audiences, and allow for flexibility in the consumption of skateboarding.

Skateboarding media

Initially created and promoted by the surfing industry, skateboarding found its own voice in the 1980s when those who owned skateboard equipment companies published niche magazines. Their goal was to create a unique sport to help capture a market. As one skateboard media executive explained, "The mainstream thing hadn't worked, so we just terrorized. That was how we saw we could promote the sport" (Greenfeld, 2004, p. 69).

Thrasher was created in 1981 by Fausto Vitello (and associates); Vitello also owned Independent Trucks (trucks are the axel-like component that attaches the wheels to the board). *Transworld Skateboarding* was created by Larry Balma who owned Tracker Trucks. Each magazine developed a particular style. *Thrasher* emphasized a more punk, do-it-yourself (DIY) orientation to skateboarding and claimed to be for "core" skaters and not big business. Its motto was "skate and destroy." Thus, Vitello packaged and sold a rebellious image which included embracing skaters such as Duane Peters, a punk rocker. Kevin Thatcher, longtime editor of *Thrasher*, also used images of the high-flying Hosoi as a means to generate interest in the sport.

Larry Balma and other skateboarding advocates such as Neil Blender and Grant Brittain were part of the organization, United Skate Front, and in 1983

they started publishing *Transworld Skateboarding*. Their intention was to make skateboarding accessible to a wide audience, including more mainstream companies and parents who often oversaw what their children purchased. To differentiate their audience from *Thrasher*, they downplayed the anti-establishment ethos and took up the motto, "Skate and Create." This trend has continued as different industry players have put out their own magazines and videos which package a lifestyle including music, art, and fashion around skateboarding.

Skateboarding captures the male youth market

Through its niche media, skateboarding created and sold a lifestyle that embraced youthful independence and an outlaw masculinity which attracted primarily teenaged White males (Beal & Weidman, 2003; Chivers Yochim, 2010; Rinehart, 2005). In the 1990s this "packaged" lifestyle made this highly sought-after demographic easily targeted by those outside of skateboarding (Browne, 2004; Chivers Yochim, 2010). The story of the X Games exemplifies this trend. In the early 1990s, ESPN wanted to target a younger audience with their new station, ESPN2. The managing director, Ron Semiao, had observed a variety of magazines focusing on specific alternative sports. He imagined programming that would appeal to this younger demographic by capturing the individualistic and anti-authoritarian nature of these sports along with their subcultural music and language (Browne, 2004). As Semiao mused, "'there was a lifestyle and culture attached to these guys and no one had tapped into [it] I thought let's create the Olympics of these sports'" (Wise, 2002, para 19). In 1995 the Extreme Games were launched (called the X-Games the following years), and vertical skateboarding became a signature event. It was ESPN's media coverage that catapulted skateboarding into the mainstream consciousness, as alternative or "extreme" sports came to represent the cool, independent teen. Marketers picked up on this, and in the early 2000s there were 1141 registered, trademarked products with "extreme" in their name (Browne, 2004). According to Greenfeld (2004), "Skateboarding, second perhaps only to hip-hop, was the greatest influence on American youth culture of the late 20th century" (p. 70).

Texts and Method

Hosoi received a lot of media coverage in the 1980s in niche magazines, most frequently in photographs and short captions. When he was interviewed, as in

the April 1985 issue of *Thrasher*, the focus was primarily on skateboarding, with such topics as Hosoi's favorite tricks, influential skaters, and what type of equipment he used. Most topics were clearly used to promote skateboarding. In 1987, *Rolling Stone* published a three-page article which contextualized the newfound popularity of skateboarding as it was shifting from suburban roots to a gritty, urban culture exemplified by Hosoi and his crossover appeal in the youth market (Gabriel, 1987).

Although there have been several short pieces (paragraph length) covering his arrest and sentencing and about his conversion to Christianity, there are only two feature-length stories on the rise and fall and rise again of Christian Hosoi. *Sports Illustrated* published an in-depth, eight-page article entitled, "Skate and Destroy" in June 2004, before he was released from jail (Greenfeld, 2004). A 99-minute documentary, *Rising Son: The Legend of Skateboarder Christian Hosoi*, was released in 2006 (Freedman & Montano, 2006). The movie is narrated by Dennis Hopper, an actor best known for his film, *Easy Rider*, which was, in part, homage to a rebellious American spirit. *Rising Son* was directed by Cesario Montano, who is a skater/surfer and photographer. In the 1980s and 1990s, Montano was part of the Venice, CA, skate/surf scene and knew Christian Hosoi (Levy, 2003). Funded by Quiksilver (which is also one of Hosoi's sponsors), the film relies on classic footage of Hosoi interspersed with interviews of those who knew him, including members of his family and over 20 top skateboarders (such as Tony Hawk, Danny Way, and Erik Koston).

The following is a critical read (Birrell & McDonald, 2000) analyzing how these two feature-length texts present Hosoi's rise to fame, his fall, and his religious conversion. As Whannel (2002, p. 154) noted, the narrative structure of rise, fall, and redemption for sports stars has become more common since the 1990s. Both texts share this general structure although the treatment of redemption differs. The *Rolling Stone* article briefly addressed it whereas the film spent more time developing the role the skateboarding community had in Hosoi's redemption.

Hosoi's rise

Several main themes are used in narrating his rise. First, his family upbringing and Asian heritage are highlighted. Second, at the height of his popularity, Hosoi is described as living the "rock star" lifestyle—"he had it all." But this was tempered by marking Hosoi's graceful and theatrical style as excessive and feminine, outside the norm of hard masculinity being represented at that time. Throughout, Hawk is the foil, providing the contrast that highlights the tension within skateboarding. The constant comparison with Hawk also sets

up how Hosoi is simultaneously marked as an insider and an outsider to skateboarding. His dedication, skill, and heterosexuality mark him as part of the skate culture, whereas his artistic sensibility, theatrics, and ethnicity work to marginalize him.

The artistic family

His family heritage was a main part of the commentary. First, his father's influence on Christian as an artist, free spirit, and user of illicit drugs was foremost in both narratives. Second, his ethnicity was frequently highlighted, unlike Hawk whose Whiteness is never explicitly discussed (cf. Atencio & Beal, 2011; Brayton, 2005; Chivers Yochim, 2010; Kusz, 2007, on race and skate culture).

Greenfeld (2004) painted the father as a carefree artist: "when the teachers would call Pops, he would already have smoked his first joint of the day. . . . Pops would then have to slip on some flip flops, start up the '59 Volkswagen bus, drive to school" (p. 68). Ivan mentioned that he was an "unsuccessful painter" who decided to manage a skatepark to support his son. Surfer Herbie Fletcher also referred to Christian's father as easygoing: "Ivan was from Hawaii, hanging out in Hawaii, just laid back and everything, the aloha-type deal, just kick back and family and you know loving things" (Freedman & Montano, 2006).

Ivan's influence on his son's drug use was central. "Consider, for example, the precontest ritual of the two skaters: Frank Hawk would have his son doing calisthenics in the parking lot, while Pops and Christian would alternate sucking pure air from an oxygen tank and taking bong hits. (Pops was smoking marijuana with his only son from the time Christian was 10)" (Greenfeld, 2004, p. 72). Craig Stecyk, a celebrated writer and photographer of skateboarding and surfing, concurred: "both those two fathers were with their sons every second, they said, 'I am going to raise my son', they knew who their kids were. And to a certain extent, I suppose the sons reflect their fathers" (Freedman & Montano, 2006). As Stecyk was speaking, the documentary displayed pictures of Christian smoking pot. In one of the last scenes in the film, the interviewer was talking with Ivan about doing illicit drugs with Christian. Ivan answered softly, "yes." The interviewer continued about smoking crystal meth together and Ivan did not respond right away; then the interviewer asked, "Did you actually pass the pipe back and forth?" Ivan acknowledged that he did. This conversation was occurring while Ivan was the sole focus of the frame, peacefully strumming his guitar (Freedman & Montano, 2006).

Wealth was another point of comparison. The Hosois are presented as living for the moment while the Hawks are planning for the future: "Christian had always been a spendthrift, and Pops, who made most of Christian's business decisions, did not take a long view when it came to managing his son's money. (Hawk's father, Frank, on the other hand, prudently guided Tony's affairs and insisted that Tony invest some of his substantial earnings)" (Greenfeld, 2004, p. 74). In the film, Hosoi talked about the influence of his father on his financial decisions: "seeing my dad as an artist, how there wasn't any desire for money, money came last . . . it's what you're creating and not what you are going to get out of it" (Freedman & Montano, 2006).

Hosoi's Japanese heritage was also explicitly marked. "It was the half Japanese Christian Hosoi, sometimes just called Christ, who resurrected and then transformed the sport into the aerial spectacle it would become" (Greenfeld, 2004, p. 68). Narrator, Dennis Hopper, noted Christian's influences: "as a young half Asian skater, Christian looked up to Shogo Kubo, and tried to imitate his style" (Freedman & Montano, 2006). When Greenfeld (2004) described Hosoi's skills, his remarks racialized his body: "watching him launch aerials was breathtaking. His deep tan, black hair, high cheek bones, long nose and strong jawline made him look like an updated version of those faces carved into Mayan stelae" (p. 70). When Greenfeld described the scene prior to the arrest he, again, marked Hosoi's ethnicity: "If you had been on that United Airlines flight from Los Angeles to Honolulu on Jan. 26, 2000 you would have been praying that that gaunt, unshaven, pock-marked, wide eyed Asian American walking down the aisle with a skateboard wasn't seated next to you" (p. 78).

When Hawk's body was described and compared to Hosoi's, his ethnicity was not explicitly marked. Instead, Hawk was described throughout the documentary as tall and lanky, more "robotic" and a "contest machine." Whereas Hosoi was consistently described as having a more compact body that enhanced his graceful style: "Built low to the ground, with exceptionally strong thighs, chest and upper arms, Christian might have been a good shortstop or soccer midfielder, but it was his exceptional sense of balance that allowed him to pull off aerials that left other skaters shaking their heads" (Greenfeld, 2004, p. 70). Although not explicitly racialized, researchers have noted that Whites are often described as lacking natural, athletic gifts but instead as having to work hard to consistently perform. By contrast, athletes of color often have their athletic excellence explained by "natural" gifts (cf. Coakley, 2009, on this tendency).

"He had it all."

The remarks on Hosoi at his peak are an interesting mix of praise, envy, and derision. The praise was centered on his skills, and the envy was centered on his "rock star" lifestyle, especially his appeal to women. The derision was focused on his style; it was often marked as superfluous or feminine.

The documentary was filled with images of Hosoi's skating and voiceovers praising his skill: "he was a winner, Hosoi was the best, he was the most natural skater, he put on the best show" (Freedman & Montano, 2006). Although his skill was acknowledged, most of the conversation about his peak years (the mid- to late 1980s) concerned his marketability and "Hollywood" lifestyle. The documentary included interviews with several key industry executives about his commercial appeal. For example, the president of Santa Cruz Skateboards, Rich Novak, commented, "Everything he touched turned to gold" (Freedman & Montano, 2006). Top skateboarders, such as Omar Hassan, agreed: "He was the first one to really break through and be marketable enough to be able to go in front of a camera and have enough charisma and style and speak" (Freedman & Montano, 2006).

Greenfeld (2004) depicted Hosoi's high life by describing his three-and-a-half-year relationship with Louanna Rawls (fashion model and daughter of famed singer, Lou Rawls) while living in the former house of W. C. Fields in the upscale L. A. neighborhood of Echo Park. The film provided more details of that life, as his friends recalled the club scene and how Christian knew and introduced them to many of the Hollywood stars of that time. The documentary highlighted Hosoi's generosity and his willingness to pay for his friends' partying. In particular, the antics of Hosoi's skateboard team, the Rockets, were given ample footage. According to one member, "every day was an adventure; it was probably the funnest (sic) time of my life" (Freedman & Montano, 2006).

Hosoi was consistently portrayed as a ladies man. Hawk compared his sexual savvy with Hosoi's: "let's just say that I was lucky to have skateboarding in my life because it finally gave me something that was desirable for girls, Christian never really needed his skating style to be desirable to girls, he already had it. Then when he becomes one of the best skaters in the world, girls just came, he didn't have to put out any effort at all" (Freedman & Montano, 2006). Greenfeld (2004) quoted Christian's remembrance of that period: "I was just a teenager but I was living the full rock-star life. . . . I could have anything I wanted, do whatever I wanted. Girls. Cars. Clubs. Drugs" (p. 74). Tony Hawk summed it up: "he was living in Hollywood and he was a god" (Freedman & Montano, 2006).

Even though Hosoi was represented as having it all, the documentary, in particular, devoted much time to poking fun at Hosoi's flamboyant and spectacular style. Hosoi was known to wear pink shirts and yellow spandex shorts while competing. The film included a friend's description of Hosoi's clothing, noting that when Hosoi was sponsored by the clothing company, Jimmy'Z, Hosoi's house would be full of their clothes: "there would be a box of girls' clothes, like pink pants, and short knicker pants, and a bunch of spandex, and he would be sporting those" (Freedman & Montano, 2006). Another skater commented: "we're dirty, sweaty skateboarders, and somehow Christian can do all that and still look good and be fashionable" (Freedman & Montano, 2006). Tellingly, a segment that illustrated the fascinated uneasiness provoked by Hosoi's style was included. Hosoi's friend Max Perlich stumbled over the statement, "he's really beautiful in a masculine kind of way" which is immediately followed by him looking away from the camera and giggling (Freedman & Montano, 2006).

The documentary continued the representation of Hosoi's style as outlandish or feminine in several ways. It showed how Hosoi would tear up his t-shirts and use part of them for headbands and then tuck the rest in his shorts creating the image of a flame or tail when he skated. His hair changed color and length frequently; often he used hair extensions. He purposefully played to the audience by playing pop tunes before his run and rallying the audience by dancing. He would "whoop" while he skated. Hawk seemed dumbfounded by this behavior: "he'd be yelling for himself, cheering for himself basically" (Freedman, 2006). Finally, the documentary summarized the fascination and rejection of his style through Lance Mountain's discussion of the divergent styles of skateboarding in the 1980s: one was Hawk's technical style and the other was Hosoi's dramatic style, which he referred to as: "it's all theatrics and style." Even as skateboarders were complimenting Hosoi they were simultaneously chastising him for his excessive behavior.

The Fall

The description of Hosoi's descent was very similar in both the article and the documentary. They began to contextualize his impending drug addiction by discussing the shift in skateboarding in the early 1990s. The high-flying, vertical ramp skating of Hosoi and Hawk fell out of favor and was replaced by street skateboarding, causing both Hosoi and Hawk to find themselves virtually unemployed, without many sponsors and little demand for their skills. Both texts also documented growing instability in Hosoi's life, not just

in the loss of income, but in the growing transitory nature of his relationships and his housing. They documented his increasing use of drugs, leading to his addiction to crystal methamphetamine. Both pointed to Hosoi's drug usage as the reason he missed the inaugural X Games in 1995—the ultimate career-ending decision. Finally, both recounted his arrest and conviction for transporting a pound and a half of crystal methamphetamine.

Even though their descriptions were similar, their explanations about who bore the responsibility differed. The article presented the possibility that skateboarding culture itself might be a partial cause of his fall, whereas the documentary not only placed the responsibility squarely on Hosoi but implied that the skateboarding community was a source of redemption.

The article presented a plurality of factors. At one point Greenfeld (2004) stated, "skateboarders have always been exposed to underground—and illegal—temptations. Whether Christian's downward spiral was exacerbated by drugs is impossible to determine. He insists it wasn't drug abuse that destroyed his career but dumb luck, a couple bad business calls, a few rash decisions" (p. 74). Greenfeld ended that statement giving Hosoi agency, and at another point Greenfeld strongly implicated Hosoi: "If Christian hadn't squandered his great gifts, it is very likely you and your kids would be watching him blast huge air every year at the X Games" (p. 68). Greenfeld added Hawk's words to reinforce the missed opportunity: "Christian should have been there," Hawk said, "he would have been the star of the X Games, and he could have ridden this wave with me" (p. 76).

The documentary did provide some complexity in portraying Hosoi's fall by showing that certain skateboarders introduced him to crystal metham-phetamine, and that addiction can be difficult to overcome. Yet it showed those skaters as recovered, while Hosoi was presented as becoming more distant from them and drifting further into the drug world. This drift from the supportive skateboarding world is presented through two skateboarders: "I don't know what the fuck was going on or who he was hanging out with but if they were skateboarders they should have checked themselves before they let them get like that" (Jesse Martinez in Freedman & Montano, 2006). Similarly, Brian Patch claimed he told Hosoi: "you would never hang out with these people if you weren't high, what are you doing?" and "you would rather hang out with them than with us, we're your family, what are you doing?" (Freed-man & Montano, 2006). The narrative of the supportive skateboarding com-munity and the increasingly addicted Hosoi continued as two skaters talked about how they always gave Hosoi bail money, but he would skip bail, leading to bounty hunters looking for him. His skater friends even recalled doing an intervention with Hosoi, who rejected their offer and them.

Redemption

Hosoi's conversion to Christianity while he was in jail was presented in both texts. The article did not go into depth about this but did present Hosoi's commitment:

> He (Hosoi) insists he never thinks about whether it should be him sitting by that pool in Encinitas, banking those fat video-game royalties. "I don't dwell on the past," he says, "that was Tony's (Hawk) journey and God bless him. This is the path the lord has set me on, and I am grateful that I will be able to use my name and my skating as my key." (Greenfeld, 2004, p. 80).

Greenfeld (2004) ended his article by alluding to his own narrative structure of pride before the fall: "he (Hosoi) will gather the children around him and tell them about Christ—Jesus Christ—and he will start his parable by talking about a boy who was not afraid to go too high" (p. 79).

On the other hand, the documentary developed Hosoi's redemption stage. First, the role of Hosoi's girlfriend, Jennifer Lee, in initiating his conversion was addressed. While serving his time, he converted to Christianity and he and Lee were also married (Freedman & Montano, 2006). The film's director then portrayed how skateboarders rallied to support Hosoi. There was a "free Hosoi" campaign that helped raise money for lawyers whose work reduced his sentence to four and a half years from ten. Lee commented: "I was just shocked, they (skateboarding community) were there for Christian, they were there for me, whatever he needed, they gave it to him" (Freedman & Montano, 2006). Next, Hosoi's reception at the X Games was highlighted. Hosoi had been released in June of 2004, and the X Games where he was honored took place in August. Montano showed lots of footage of skateboarders embracing and celebrating Hosoi at those games. Dramatically, he included Danny Way's gold medal mega-ramp run, which he ended with Hosoi's signature "Christ Air" trick, eliciting shrieks and hollers from the crowd.

At the end of the documentary, Hosoi was shown in his new position as a pastor in a church in Huntington Beach talking about his insight on his life. He commented about how he thought he was on top of the world at the peak of his skateboarding career but realized now that there was no peace in his "rock star" lifestyle. The last words in the documentary were Hosoi claiming, "This isn't the end, this is just the beginning, and I thank Jesus for that" (Freedman & Montano, 2006).

Narratives describing redemption are significant, as they reveal power dynamics: what behavior is deemed in need of redemption, and why; who has the power to deliver redemption; and who benefits from this newfound status? The two texts covered in this chapter suggested that Hosoi's major sin was

drug addiction, with the primary concern being him losing the opportunity to be commercially successful, as opposed to a focus on losing his health or family. Redemption granted by the skateboarding community reestablishes and circulates Hosoi's symbolic and economic capital—a move that is mutually beneficial to the industry and Hosoi. Even though past his prime competitive years, he is currently sponsored by Vans and Quiksilver. Hosoi clearly states that he has been redeemed through Jesus Christ. Nonetheless, he has used his skateboarding cultural capital to further his goals of evangelizing as evidenced by his short-lived reality TV program, *The Uprising*, which featured skateboarders witnessing to youth.

Conclusion

The structures and values embedded in narratives of sports celebrities provide insight into societal ideals of success and what attributes are associated with it. Hosoi's story provides a template for understanding cultural assumptions about what causes success and failure. Like most narratives of sports, the individual is given power or responsibility for her or his own success or failure, demonstrated through victory or wealth, reinforcing the ideals of a capitalist meritocracy (Andrews & Jackson, 2001; Baker; 2003; Boyle & Haynes, 2000; Whannel, 2002). In Hosoi's case, he and his father were presented as artistically talented but reckless. Additionally, mainstream Protestant ideas of sin such as pride, wastefulness, and indulgence are marked as leading to failure, whereas prudence and humility lead to success. Finally, normative masculinity is privileged as a key to success.

Not only can cultural norms be inferred from narratives of sports celebrities, but the politics of the sports industry can be illuminated. As noted above, skateboarding has played off the tension of rebellious and mainstream narratives, desiring the best of both worlds by presenting skateboarding as edgy *and* popular. Skateboarding, via the media, has promoted different personalities to represent each strain, such as Hosoi and Hawk. Even as they tell the story of Hosoi's foibles leading to his fall, they are celebrating his rebelliousness. Additionally, and specifically in the documentary, the skateboarding community is represented as good, a place of redemption, and not as contributing to Hosoi's fall. In this narrative version, Hosoi represents the prodigal son who squanders his gifts, and the skateboarding community is merciful and even celebrates the return of the prodigal Hosoi at its premiere event, the X Games.

References

Andrews, D., & Jackson, S. (Eds.). (2001). *Sport stars: The cultural politics of sporting celebrity*. London, UK: Routledge.

Atencio, M., & Beal, B. (2011). Beautiful losers: The symbolic exhibition and legitimization of outsider masculinity. *Sport in Society, 14*(1), 1–16.

Baker, A. (2003). *Contesting identities: Sports in American film*. Urbana, IL: University of Illinois Press.

Beal, B. (1995). Disqualifying the official: An exploration of social resistance through the subculture of skateboarding. *Sociology of Sport Journal, 12*(3), 252–267.

Beal, B., & Weidman, L. (2003). Authenticity in the skateboarding world. In R. Rinehart & S. Sydnor (Eds.), *To the extreme: Alternative sports, inside and out* (pp. 337–352). New York, NY: SUNY Press.

Beal, B., & Wilson, C. (2004). 'Chicks dig scars': Commercialisation and the transformations of skateboarders' identities. In B. Wheaton (Ed.), *Understanding lifestyle sports: Consumption, identity, and difference* (pp. 31–54). London, UK: Routledge.

Birrell, S., & McDonald, M. (Eds.). (2000). *Reading sport: Critical essays on power and representation*. Boston, MA: Northeastern University Press.

Borden, I. (2001). *Skateboarding, space and the city: Architecture and the body*. Oxford, UK: Berg.

Boyle, R., & Haynes, R. (2000). *Power play: Sport, the media and popular culture*. Harlow, UK: Pearson Education.

Brayton, S. (2005). 'Black-lash': Revisiting the 'White Negro' through skateboarding. *Sociology of Sport Journal, 22*(3), 356–372.

Browne, D. (2004). *Amped: How big air, big dollars, and a new generation took sports to the extreme*. New York, NY: Bloomsbury.

Cashmore, E. (2006). *Celebrity/Culture*. New York, NY: Routledge.

Chivers Yochim, E. (2010). *Skate life: Re-imagining White masculinity*. Ann Arbor, MI: University of Michigan Press.

Coakley, J. (2009). *Sport in society: Issues and controversies* (10th ed.). Boston, MA: McGraw-Hill.

Freedman, J. (Producer), & Montano, C. (Director). (2006). *Rising son: The legend of skateboarder Christian Hosoi* [Motion picture]. United States: QD3 Entertainment and Quiksilver.

Gabriel, T. (1987, July 16–30). Rolling thunder. *Rolling Stone, 504–505*, 73–76.

Greenfeld, K. (2004, June 7). Skate and destroy. *Sports Illustrated, 100*(23), 66–80.

Humphreys, D. (2003). Selling out snowboarding: The alternative response to commercial co-optation. In R. Rinehart & S. Sydnor (Eds.), *To the extreme: Alternative sports, inside and out* (pp. 407–428). Albany, NY: SUNY Press.

Hyman, M. (2006, November 13). How Tony Hawk stays aloft. *Business Week, 4009*, 84–88.

Iwata , E. (2008, March 10). Tony Hawk leaps to top of financial empire, *USA Today*, p. 1b.

Kusz, K. (2007). *Revolt of the White athlete: Race, media and the emergence of extreme athletes in America*. New York, NY: Peter Lang.

Layden, T. (2002, June 10). What is this 34-year-old man doing on a skateboard? Making millions. *Sports Illustrated*, 80.

Levy, D. (2003, February) Interview: Cesario "Block" Montano, *Juice Magazine, 56*. Retrieved from http://www.juicemagazine.com/BLOCK.html

Muggleton, D. (2000). *Inside subculture: The postmodern meaning of style*. Oxford, UK: Berg.

Rinehart, R. (2005). 'Babes' & boards: Opportunities in new millennium sport? *Journal of Sport and Social Issues, 29*(3), 232–255.

Thornton, S. (1996). *Club cultures: Music, media and subcultural capital*. Hanover, NH: Wesleyan University Press.

Whannel, G. (2002). *Media sport stars: Masculinities and moralities*. London, UK: Routledge.

Wheaton, B., & Beal, B. (2003). 'Keeping it real': Subcultural media and the discourses of authenticity in alternative sport. *International Review for the Sociology of Sport. 38*(2), 155–176.

Wheaton, B. (2010). Introducing the consumption and representation of lifestyle sports. *Sport in Society, 13*(7–8), 1057–1081.

Wise, M. (2002, August 18). X Games; Skateboarders are landing in real world. *The New York Times*. Retrieved from http://www.nytimes.com/2002/08/18/sports/x-games-skateboarders-are-landing-in-real-world.html

Wrestling with Extremes: Steroids, Traumatic Brain Injury, and Chris Benoit

James L. Cherney
Kurt Lindemann

Since professional wrestling first gained prominence in the 1950s, its competitors have played the roles of heroes and villains for their fans. The trajectories of some wrestler personae have included a journey from "bad guy" to redemption and adoration. Other storylines have told the tale of a seemingly "good guy" who, often inexplicably, turns "evil" and hurts those who were once in his corner. The real-life story of the rise and fall of wrestler, Chris Benoit, plays like a more gruesome, and certainly sadder, version of the latter. In June 2007, Benoit killed his wife and young son and then hanged himself. Attempting to account for this inexplicable tragedy, authorities and journalists attributed Benoit's fall to a variety of causes, including steroid abuse, a rocky marriage, and concussions he suffered while wrestling. No steroids were found in Benoit's body at the time of his death, and authorities eventually expressed doubt that his prolonged use of steroids and his subsequent testosterone replacement therapy—a common treatment for deficiencies caused by steroid use—were contributing factors to the murder-suicide. Instead, doctors found that the multiple concussions Benoit suffered during his wrestling career resulted in severe brain damage and early-onset dementia, similar to that found in professional football players ("Benoit's Brain," 2007). In short, the very wrestling skills that made Benoit one of the most respected professional wrestlers contributed to his brutal demise.

Certainly, brain damage among professional athletes is neither uncommon nor benign. The early deaths of many retired National Football League players speak to the long-term neurological damage professional sports can cause. In 2011 Chicago Bears safety Dave Duerson donated his brain to Boston University so that the effects of professional football on the body might be better studied and then committed suicide by shooting himself in the

chest (Schwarz, 2011). But Benoit's storyline diverges from the traditional rise-fall narrative of many sports heroes. While those tales usually involve drugs, betting, or bribery as the hero's undoing, Benoit's story, like that of an increasing number of professional athletes, involves something more complex. In this chapter, we trace the rise of Chris Benoit and his eventual fall. We examine media portrayals of his masculinity in the wrestling ring, the controversy surrounding the media coverage of his death and those of his wife and son, and the ways that the media continue to valorize him for his wrestling success while constructing multiple counter-narratives about his death.

Myth, Ritual, and Hypermasculinity in the Rise of Chris Benoit

Benoit's myth was surely grounded in his pedigree as a professional wrestler. Benoit showed interest in professional wrestling as a teenager in Canada, idolizing established wrestlers like Bret "The Hit Man" Hart and the one-half of famous tag team The British Bulldogs, Tom Billington, who was known as "The Dynamite Kid." He apprenticed himself to Hart, and began training in Hart's own facility with Hart's father, Stu, himself a former professional wrestler and promoter. Stu Hart trained his sons, Bret and Owen, The British Bulldogs, and countless other wrestlers. Indeed, the Hart family has a rich history in professional wrestling. The father and two of his sons are World Wrestling Entertainment Hall of Fame inductees, and two of his daughters married professional wrestlers. His youngest daughter, Diana, had a significant role in the ring as well; she played a part in several storylines involving her husband, Davey Boy Smith (the other half of The British Bulldogs trained by Stu). By entering into this storied franchise, Benoit ensured that his ascent to fame would have a powerful springboard.

Although his pedigree was forged early through his relationship with the Harts, apprenticing one's self to a more famous and successful professional wrestler was common. Today, Internet videos of backyard wrestling have begun to change how—and how early—one ascends to fame. But in the 1980s, Benoit had to pay his dues like every other professional wrestler. On his way to proving himself worthy of an international stage, he followed his early success in the Canadian Stampede Wrestling League with a trip to Japan to train, and he eventually competed for New Japan Pro Wrestling. In Japan, he donned a mask under the moniker, The Pegasus Kid, and soon began winning matches. While Benoit initially resisted the notion of wearing a mask, he eventually grew accustomed to it, illustrating the power of the ritual of character of which

Ball (1990) wrote. Benoit realized the role of the masked villain was a well-established one in professional wrestling, one that captured audiences' attention, even as someone against whom to root (Ball, 1990). In between tours of Japan, he worked for several U.S. wrestling promotion companies, including Extreme World Wrestling and World Championship Wrestling. Then, in 2000, Benoit entered Vince McMahon Jr.'s wrestling empire, the World Wrestling Federation (WWF). Although Benoit had gained respect among his fellow wrestlers for his athleticism and affable manner, it was on the international stage of the WWF—later named World Wrestling Entertainment (WWE)—and its affiliated events (*Smackdown!*, *Raw*, *WrestleMania*, and *Summer-Slam*) that Benoit finally reached the pinnacle of professional wrestling.

By steeping himself literally and figuratively in the legacies of wrestlers like the Harts and Davey Boy Smith, Benoit made sure his entrance into the world of wrestling would fit seamlessly into the plot of a mythic tale. Describing wrestling in such terms, as on a par with, say, a Greek tragedy, is not inaccurate. Like theatre, professional wrestling takes place on a stage set apart from everyday life, in this case what is commonly called "the squared circle," or a ring. Despite its links to Greco-Roman wrestling, traditionally set in an actual circle, professional wrestling takes place on an elevated platform rectangular in shape, conjuring up a "home" corner for each wrestler and highlighting the drama of competition as well as amplifying the falls and jumps by the wrestlers (Ball, 1990). The comparison to theatre highlights the symbolism and attention to plot and conflict in professional wrestling storylines. McMahon and the WWF/WWE were masters of creating such drama, often involving celebrities and television personalities. These promotional tie-ins were both staged (as when Mr. T hosted *Saturday Night Live* before the first WrestleMania) and unrehearsed (as when Hulk Hogan put talk show host Richard Belzer in a sleeper hold and then let him fall to the ground, splitting his head open) (Ellison, 2008). While he likely knew it at the time (Karp, 2008), Benoit was entering an arena in which entertainment was the ultimate goal, to be achieved at all costs.

With its intersecting storylines, archetypical heroes and villains, and portrayals of conflict and redemption, professional wrestling bears several more than passing similarities to theatre. And certain storylines lend themselves to public visibility and to certain wrestlers attaining a level of celebrity not possessed by others. When McMahon purchased the World Wrestling Federation from his father and began buying out smaller tours and regional promoters, consolidating the multitude of wrestlers and combining those numbers with television syndication deals (Oppliger, 2004), these storylines became a worldwide phenomenon. This international stage made celebrities out of many

wrestlers through star-studded extravaganzas like WrestleMania. In this first pay-per-view event, wrestlers and future television and film stars like Hulk Hogan, Andre the Giant, and "Rowdy" Roddy Piper appeared alongside stars like Cyndi Lauper, Mr. T, and Muhammad Ali. WrestleMania has continued to draw millions of viewers, ensuring some wrestlers invaluable media exposure. This was the world Chris Benoit entered when he became a member of Vince McMahon's "stable" of wrestlers. With his athletic ability and heavily muscled physique, it is no surprise that Benoit eventually became one of the most recognized and well-respected professional wrestlers in the world.

Like Benoit, wrestlers who gained celebrity had to possess certain attributes. The roles a male wrestler can assume usually fall along a continuum of "flat stereotypes" that allow audiences to read into those roles their own hopes, fears, and desires (Ball, 1990). The characters one often finds in professional wrestling encompass composites of stereotypes and archetypes found throughout myths both modern and ancient, including foreign menaces, heroes, masked villains, and nature boys (Ball, 1990). It is common, as was the case with Benoit's public persona, for a wrestler to morph from hero to villain (commonly called a "heel") and vice versa. But as we explore below, Benoit's personal life unfortunately mirrors the tragedies that commonly play out on the theatrical stage. The beginning of the Benoit tragedy seems to start with the unwritten rules established in the McMahon era of professional wrestling.

To get out from under the regulations associated with organized sporting events and leagues, in 1989 McMahon made the seemingly counter-intuitive argument that professional wrestling was not "real" (Beekman, 2006). While it may seem that wrestling's appeal lies in audiences believing that wrestling is real (Ball, 1990), promoters argued to various state boards that professional wrestling was fixed (Oppliger, 2004; Karp, 2008). McMahon maintained that matches "did not represent legitimate athletic contests because their victors were predetermined," that professional wrestling "could not be considered a sport," and that it should be described instead as "sports entertainment" (Beekman, 2006, p. 131). As *entertainment*, wrestling would not be regulated by state regulatory boards, avoiding licensing fees and other forms of government oversight. Importantly, it freed promoters to implicitly or explicitly encourage its wrestlers to "beef up" by whatever means necessary (Karp, 2008). Like his idol, Davey Boy Smith, and others, these "means" for Benoit included both steroids and other pharmaceuticals to dull the pain of injuries acquired in the ring (Karp, 2008). Indeed, the excessively muscled physique of many male wrestlers was, in the McMahon era of professional wrestling, due to the use of steroids and other growth hormones (Oppliger, 2004; Karp, 2008). The move from wrestling as sport to entertainment directed attention from how male

wrestlers' bodies performed to the way they looked. In this culture, part of the reason Benoit rose to become the 2004 World Heavyweight Champion was his willingness to play along with this game.

Stories of the Fall

Around 4 P.M. on Monday, June 25, 2007, deputies discovered the bodies of Chris Benoit, his wife Nancy, and their son Daniel in their Fayetteville home near Atlanta, Georgia. As details became public, the tragedy clearly emerged as a murder-suicide. Nancy and Daniel had been asphyxiated, apparently murdered, and Chris was found hanging from a cable on a weight machine. Nancy's feet and wrists were bound, and she had bruises on her back that suggested Chris had pulled a cord around her neck and strangled her. Daniel was found in his own bed; his internal neck injuries without visible bruising led authorities to speculate that he had been killed with a chokehold (Duffy & Ahmed, 2007). Evidence suggested that the sequence of events had spanned the previous weekend. Reports revealed that Nancy had been killed sometime Friday; Daniel died either late Saturday night or early Sunday morning, and Chris committed suicide hours or a day later (Bluestein, 2007a; Duffy & Jefcoats, 2007).

WWE officials had prompted authorities to investigate after Chris had failed to appear at matches scheduled over the weekend. That Saturday, June 23, Benoit had missed a live wrestling event held in Beaumont, Texas (Duffy & Jefcoats, 2007). The next night, Sunday, Benoit had been slated to wrestle and defeat CM Punk for the Extreme Championship Wrestling (ECW) Championship on the WWE's "Vengeance: Night of Champions" pay-per-view event (Boyd, 2007; Duffy & Jefcoats, 2007; "Wrestler Benoit," 2007). Held in Houston, Texas, this event had a nationwide audience. To explain Benoit's absence to the fans, the WWE announced that he had "a family emergency" and privately contacted the police to check on Chris (Duffy & Jefcoats, 2007).

Soon after the bodies were discovered, several different explanations for the events arose in press coverage. The three most prominent theories identified the root cause as social, emotional, or physiological. The social narrative framed the murder-suicide as the culmination of a long history of spousal abuse, theorizing that Chris had tormented his wife for years and may have exploded in violence when she threatened to leave him. This explanation arose out of revelations that, in May 2003, Nancy Benoit had filed for divorce and sought a restraining order against Chris; the petition was dismissed when the

couple reconciled three months later (Duffy & Jefcoats, 2007). In this story, the social institution of professional wrestling encouraged Chris's behavior, and its violent hypermasculinity reinforced—even legitimized—a system of male-dominant aggression. Similar stories, told by the media and those involved, have framed other wrestlers' alleged spousal abuse throughout the years (Karp, 2008). Of the different narratives accounting for the tragedy, this one seems to damn professional wrestling the most: the activity comes across as misogynist excess, and wrestlers appear as "bullies" and "killers" instead of heroes and athletes (Seeliger, 2007).

WWE officials also promoted a story that emphasized marital conflict, but their narrative placed the burden on the particular, emotional stresses of Chris and Nancy's life. At the center of this explanation were reports that their son, Daniel, had a rare physical and mental disability known as "Fragile X Syndrome," a genetic condition similar to autism (Mosconi & Nichols, 2007). According to Jerry McDevitt, an attorney for the WWE, the Benoits had argued over caring for their son just days before the tragedy, and "it became pretty obvious from several different sources" that Nancy and Chris frequently fought over the issue. McDevitt said that Nancy did not want Chris to quit wrestling, but she did want him to stay home more often to be with Daniel (Duffy & Ahmed, 2007). Evidence backing this explanation was somewhat mixed. District Attorney, Scott Ballard, described the boy as "very small, even dwarfed," and said that "old needle marks in his arms" supported the theory that his parents had considered him undersized and given him growth hormones (Duffy & Jefcoats, 2007). But if Daniel indeed had the condition, the Benoits had kept it secret; Nancy's parents—Paul and Maureen Toffoloni—reported through their lawyer that they had no idea their grandson had the disorder and that he had always seemed "a normal, healthy, happy child with no signs of illness" (Mosconi & Nichols, 2007). In this explanation, hiding Daniel's condition appeared as evidence that his disability was a source of tremendous stress on the marriage.

Narratives identifying emotional causes for the murder-suicide gained credibility from a recent tragedy in Chris's life. Benoit's father, Michael, claimed Chris had been struggling emotionally since the untimely death of his friend and fellow wrestler, Eddie Guerrero in 2005 (Karp, 2008). Tying the events to emotional issues did not answer questions about the reasons for Chris's problems or about the extent to which Chris had such problems, but unlike the abusive spouse theory, it placed the focus on a personal psychological break rather than on a systemic flaw pervading wrestling.

The explanation that appeared most widely in the coverage located a medical or physiological cause: steroids. This framed the tragedy as a case of

"roid rage," a drug-induced frenzy associated with abusing steroids. Stories of wrestlers' hyper-aggressive behavior outside the ring had long been connected with the use of steroids. Davey Boy Smith repeatedly beat his wife, Stu Hart's daughter, Diana, and at one point held a shotgun to her head. While her account has been disputed by many inside the Hart family (Assael, 2002), she attributed the event to his steroid use (Karp, 2008). Steroids had been implicated in the deaths of several professional wrestlers, including Benoit's friend, Guerrero (who died in 2005), Curt "Mr. Perfect" Hennig (who died in 2003), and Davey Boy Smith (who died in 2002) (Bluestein, 2007b).

By Tuesday, the roid rage theory became the most popular explanation, and it quickly generated controversy. Tellingly, the story arose initially from a lack of evidence about its accuracy, when on Tuesday afternoon the press reported that authorities refused to say whether or not drugs or steroids were found inside the Benoit home (Newby, 2007). Later that day, Thomas Pope of the Fayette County Sheriff's Department did reveal that both prescription drugs and steroids were discovered in the house, and the evening television news quickly reported this new development. CBS News aired Pope's statement and followed it with the claim that the WWE had "instituted a new and supposedly tougher drug policy just last year after the death of another wrestler was linked to steroid use" ("Pro Wrestler," 2007). The report noted that there "have been steroid scandals in wrestling before," and quoted the wrestler, Billy Graham, admitting that he had been a steroid user for "almost 25 years" (although he denied ever experiencing roid rage). It concluded: "Authorities will release a final toxicology report in a few weeks, but once again there are new questions in mainstream America about sports, steroids and stardom" ("Pro Wrestler," 2007).

Within hours a press release by the WWE brought even more attention to the possible steroid link by vigorously decrying the very suggestion as "sensationalistic reporting and speculation" ("World Wrestling Entertainment," 2007). They declared that several points ran contrary to the roid rage explanation: the drugs found were believed to be legal prescriptions; steroids could not directly cause Chris's death (asphyxiation by hanging); toxicology reports had not yet been completed; Chris had passed his last drug test administered by the WWE in April; the manner of the deaths and the time between them indicated deliberation instead of rage, and the police had admitted that they had no direct evidence substantiating that Chris had been taking steroids ("World Wrestling Entertainment," 2007). These rather flimsy protests did not stop discussion of the roid rage hypothesis, but they did establish fairly well that the WWE feared the implications that the case would have for professional wrestling if roid rage was blamed for the tragedy. While the

spousal abuse narrative may have depicted wrestling in the most antisocial light, the roid rage explanation probably carried the greatest legal ramifications for the organization. Despite the WWE's efforts, over the next few weeks the roid rage narrative became the focus of the public conversation surrounding the murder-suicide.

On July 17, 2007, the Georgia Bureau of Investigation released the toxicological report compiled on all three family members. Daniel's blood contained Alprazolam (Xanax), an anti-anxiety drug that generally is not prescribed to children. Chief Medical Examiner Dr. Kris Sperry's results revealed the level found was high even for an adult and concluded that the dose "would definitely sedate him" and make him unaware or just marginally aware of the events at the time of his death (Bonnell, 2007). Nancy's results revealed Hydrocodone (commonly known as Lortab or Vicodin), Hydromorphone (Dilaudid), and Alprazolam. An examination of Benoit's urine revealed the steroid testosterone at a level of 207 micrograms per liter—roughly ten times the normal levels. This amount of testosterone in the urine showed that Chris had been "using" testosterone "within some reasonably short period of time" prior to his death. Sperry stated that this amount "could be an indicator that he was being treated for testicular insufficiency." No other steroid "or artificial steroid-like substance" was found in Chris's urine. Sperry concluded that "we found no evidence of any other of the anabolic steroids or anything else of the types of drugs that would be injected for body-building purposes or things like that" (Van Susteren & Wheatley, 2007).

News reports framed the results in radically different ways, encouraging opposing interpretations of the toxicology report. An article in Canada's *National Post* bore the headline, "Benoit's Death Sheds No Light on Steroid Use" (Spector, 2007), while a report from the Fox News Network was headlined, "Toxicology Reports Shed New Light on Chris Benoit's Murder-Suicide" (Van Susteren & Wheatley, 2007). Similarly, some articles linked the presence of the drugs with the crimes—"Chris Benoit Had Steroids, Other Drugs in His System at Time of Murder-Suicide" (Montgomery, 2007), and "Investigators Find Steroids in Body of Wrestler Who Killed Wife and Son Before Hanging Himself" (Bluestein, 2007b)—while others indicated that the report did not answer important questions or explain the tragedy—"Toxicology Report Solves Nothing in Chris Benoit Case" (Mann, 2007). In short, press coverage of the results presented conflicting views as to whether and to what extent drug and/or steroid use contributed to Chris's actions.

Despite the repeated assurances by medical experts that this was not a case of roid rage—and experts' doubts about whether such a condition really exists—several news stories kept the roid rage narrative alive. For example, articles

from two newspapers in New Brunswick, Canada, reported virtually the same information, but the stories suggested opposing interpretations. The article in *The Daily Gleaner*, titled, "Benoit's Body Contained Combination of Drugs" (2007) tended to downplay the link to steroids, while the *Telegraph-Journal* article titled, "Benoit's Dead Body Loaded with Drugs" (2007) directed attention to the possible role that these substances may have had. Both articles reported the presence of testosterone in Benoit's body alongside Sperry's statement that there was "nothing to show that steroids played a role in the death of Nancy and Daniel Benoit," but the latter report seems to encourage the reader to question this. *The Daily Gleaner* included Sperry's claim that "there is conflicting scientific data as to whether or not testosterone creates mental disorders or leads to outbursts of rage," but the *Telegraph-Journal* did not quote this statement. Similarly, the *Telegraph-Journal* put the information that "anabolic steroids were found in the home" in the first half of its report, but the *Gleaner* waited until the article was two-thirds finished before explaining that "*prescription* anabolic steroids" (emphasis added) were discovered in the house. The *Gleaner* article centered attention on the ambiguity of current studies examining a link between steroids and violence, reporting that "Dr. Kris Sperry said *there is no consensus* that the use of testosterone can contribute to paranoia, depression and violent outbursts known as 'roid rage'" (emphasis added). Using nearly identical words, and technically expressing the same fact, the *Telegraph-Journal* wrote that "*Some experts believe* steroids can cause paranoia, depression and violent outbursts known as 'roid rage'" (emphasis added). Finally, the *Telegraph-Journal* placed the negative results of the blood alcohol tests on Benoit in a more prominent position than *The Daily Gleaner*, including that information in the third sentence and immediately after reporting his elevated testosterone levels. The priority implied this finding's significance and the context suggested explanatory power: since alcohol did not play a role, it is more likely that something else did. None of these details strayed from the facts as they have been reported elsewhere, but their presentation in the *Telegraph-Journal* story subtly maintained the roid rage explanation despite the contrary evidence of the toxicology report. Chris's father, Michael Benoit, had long expressed his confusion over the murder-suicide, and he hoped the toxicology reports would provide some answers—and closure (Mosconi & Nichols, 2007). Doctors associated with the Sports Legacy Institute, a nonprofit organization dedicated to studying damage caused by repetitive concussions in athletes, suggested an alternative reason for Benoit's erratic and destructive behavior. Chris Nowinski, himself a former professional wrestler and cofounder of the Institute, asked Michael for permission to examine his son's brain. The results appeared definitive. Dr. Bennet Omalu performed the

examination and concluded that Benoit's 40-year-old brain looked like that of "an 85-year-old in advanced stages of Alzheimer's disease" (Maich, 2007). Despite this evidence—and the toxicology report's negative findings of steroid abuse at the time of the tragedy—explaining the murder-suicide with traumatic brain injury (TBI) did not capture the public interest as had the roid rage narrative.

Conclusion

As of July 2011, the Wikipedia article on testosterone ("Testosterone," n.d.) named only two people in its section on "Athletic Use" of anabolic steroids. Despite several high profile cases that have received widespread attention (e.g., Barry Bonds, Marion Jones, Mark McGwire, Rafael Palmeiro, and Andy Pettitte), none of these athletes was mentioned in the article. The first athlete named was the Canadian sprinter, Ben Johnson. Johnson was stripped of his consecutive gold medals and world records for the 100 meter dash, which he had been awarded at the 1987 World Championships in Athletics in Rome and the 1988 Summer Olympics in Seoul. The second athlete Wikipedia named was Chris Benoit. The article stated that his case brought steroid use back into the spotlight in 2007 but attributed this effect to the "media frenzy" surrounding the murder-suicide and noted that there had been "no evidence indicating steroid use as a contributing factor." In other words, despite the medical evidence against viewing the Benoit tragedy as a case of roid rage, his name has become synonymous with steroid abuse. But why?

Our analysis suggests that explaining Benoit's catastrophic acts as roid rage appeals to those who would distance the murders and suicide from wrestling and sports, because the root cause of his actions can be considered a form of cheating. On the surface, at least, sports do not require using steroids, as prevalent as the practice may be in professional wrestling (Randazzo, 2008). In the roid rage narrative, Benoit's tragedy becomes his responsibility: his own choice to use dangerous drugs means that he brought this disaster upon himself. Wrestling may not be blameless—and its current practices may deserve scrutiny—but in this explanation the sport does not have any inherent responsibility for his crimes. It further ensconces the steroid narrative in the arc of the "dirty athlete."

In contrast, the TBI explanation tends to implicate wrestling as substantially responsible for the events, since head-to-head collisions and other damaging contact are inevitable in the sport. Moreover, practices that might ameliorate the sport's tendency to cause traumatic concussions—like wearing

protective headgear or prohibiting direct blows to the head or face—compete with the sport's presentation of itself as raw masculinity and the mythic qualities embedded in Benoit's rise to fame and celebrity. The head trauma narrative locates Benoit's story alongside those of many other professional wrestlers who died at a relatively young age or otherwise had serious medical conditions associated with participating. "A Fight to the Death," the Canadian Broadcasting Corporation (CBC) documentary on Benoit and other wrestlers, exemplified this pattern (Karp, 2008). In this version of the story, Benoit's tragedy became an extension of his mythic prowess as a competitor, and the regular performance of his impressive signature closing move (a maneuver known as a swan dive or "flying" headbutt) became irresponsible.

It is easier for a sports fan to maintain a moral objection to cheating than it is to accept evidence that a sport might regularly generate permanent mental injuries. As much as cheating may be "part of the game," policing and disciplining cheaters also form an important part of sports. Those who cheat and get caught deserve their fate, and desiring their punishment becomes framed as a moral stance. But if a sport regularly causes players to sustain grievous and unacceptable injuries, then it is the sport itself that comes under moral scrutiny. A sport that maims its players, that by its nature places them in the path of unacceptable risks, could be viewed as an illicit activity. Parents encouraging their sons and daughters to play such a sport may be seen as morally suspect. Distancing a sport from such effects becomes crucial to maintaining its positive moral and social ethos.

In our analysis, the tension between the roid rage and traumatic brain injury explanations is interwoven with powerful cultural beliefs about sports and their relationship with disability and masculinity. In the roid rage narrative Benoit's use of steroids becomes linked to his alleged testosterone deficiency, which might be read as both a disabling condition and as a type of physiological emasculation (since it means he had an insufficient amount of the hormone that literally "makes" one a man). This telling of his tragedy positions his physical deviance from "normal" hormone levels as the root of his problem, so that disability and "emasculinity" appear as failings that contribute to horrible results. Thus, the roid rage narrative fits with the dominant, cultural systems of ableism and hegemonic masculinity. The obverse supports this claim: the head trauma narrative—the only alternative medical frame provided for the Benoit murders and suicide—undermines cultural conventions about sports as healthy and manly. Identifying head trauma as the culprit tends to blame wrestling itself, and the sport's machismo—its flamboyant daredevil antics, the lack of regulation or equipment to protect from head injury, the notion that tough guys play through the pain—becomes its flaw. In contrast

with the roid rage narrative, which generally blamed Benoit's personal choices for these events, the head trauma explanation describes the activity as unwittingly destroying its participants. In this latter story, the most real part of the sports entertainment called smackdown is the tragic toll taken on professional wrestlers themselves.

References

Assael, S. (2002, November 15). Overkill. *ESPNmag.com*. Retrieved from http://espn.go.com/magazine/vol5no24davey.html

Ball, M. R. (1990). *Professional wrestling as ritual drama in American popular culture*. Wales, UK: Edwin Mellen Press.

Beekman, S. M. (2006). *Ringside: A history of professional wrestling in America*. Westport, CT: Praeger.

Benoit's body contained combination of drugs. (2007, July 18). *The Daily Gleaner*. Retrieved from http://www.lexisnexis.com/hottopics/lnacademic

Benoit's brain showed severe damage from multiple concussions, doctor and dad say. (2007, September 5). *Good Morning America*. Retrieved from http://abcnews.go.com/GMA/story?id=3560015&page=

Benoit's dead body loaded with drugs. (2007, July 18). *The Telegraph-Journal*. Retrieved from http://www.lexisnexis.com/hottopics/lnacademic

Bluestein, G. (2007a, June 27). Wrestler strangled wife, suffocated son, hanged himself in weight room; Police offer no motive. *Associated Press*. Retrieved from http://www.lexisnexis.com/hottopics/lnacademic

Bluestein, G. (2007b, July 17). Investigators find steroids in body of wrestler who killed wife and son before hanging himself. *Associated Press*. Retrieved from http://www.lexisnexis.com/hottopics/lnacademic

Bonnell, K. (2007, July 18). Benoit drugged young son. *Windsor Star*. Retrieved from http://www.lexisnexis.com/hottopics/lnacademic

Boyd, G. (2007, June 25). WWE wrestler Chris Benoit and family found dead in Atlanta. *Blogcritics.org Video* [Web log]. Retrieved from http://www.lexisnexis.com/hottopics/lnacademic

Duffy, K., & Ahmed, S. (2007, June 28). The Benoit family tragedy. *The Atlanta Journal-Constitution*. Retrieved from http://www.lexisnexis.com/hottopics/lnacademic

Duffy, K., & Jefcoats, K. (2007, June 27). The Benoit family tragedy: Murder-suicide rocks wrestling fans, Fayette. *The Atlanta Journal-Constitution*. Retrieved from http://www.lexisnexis.com/hottopics/lnacademic

Ellison, J. (2008, October 14). Richard Belzer on his debut novel, Hulk Hogan, and not being related to the Fonz. *New York Magazine*. Retrieved from http://nymag.com/daily/entertainment/2008/10/richard_belzer_on_his_debut_no.html

Karp, M. (Producer). (2008, February 6). *A fight to the death*. [Television broadcast]. Toronto, Canada: Canadian Broadcasting Corporation.

Maich, S. (2007, October 22). The concussion time bomb. *Maclean's*, 120(41), 46–52.

Mann, S. (2007, July 18). Toxicology report solves nothing in Chris Benoit case. *Bleacher Report*. Retrieved from http://bleacherreport.com/articles/1404-toxicology-report-solves-nothing-in-chris-benoit-case

Montgomery, J. (2007, July 17). Chris Benoit had steroids, other drugs in his system at time of murder-suicide. *MTV News*. Retrieved from http://www.mtv.com/news/articles/1564953/chris-benoit-had-steroids-in-his-system.jhtml

Mosconi, A., & Nichols, A. (2007, June 30). Benoit kin didn't know of disorder. *Daily News* (NY). Retrieved from http://www.lexisnexis.com/hottopics/lnacademic

Newby, D. (2007, June 26). Authorities await autopsies in deaths of wrestler Chris Benoit, wife, 7-year-old son. *Associated Press*. Retrieved from http://www.lexisnexis.com/hottopics/lnacademic

Oppliger, P. A. (2004). *Wrestling and hypermasculinity*. Jefferson, NC: McFarland.

Pro wrestler Chris Benoit killed wife and son and then himself; steroid use may have been involved. (2007, June 26). *CBS Evening News*. Retrieved from http://www.lexisnexis.com/hottopics/lnacademic

Randazzo, M. (2008). *Ring of Hell: The story of Chris Benoit and the fall of the pro wrestling industry*. Beverly Hills, CA: Phoenix Books.

Schwarz, A. (2011, May 2). Duerson's brain trauma diagnosed. *The New York Times*. Retrieved from http://www.nytimes.com/2011/05/03/sports/football/03duerson.html

Seeliger, C. (2007, June 28). Hardly a hero: Wrestler was a bully and a killer [Editorial]. *The Atlanta Journal-Constitution*. Retrieved from http://www.lexisnexis.com/hottopics/lnacademic

Spector, M. (2007, July 18). Benoit's death sheds no light on steroid use; Underground culture conceals all the answers. *National Post* (Canada). Retrieved from http://www.lexisnexis.com/hottopics/lnacademic

Testosterone. (n.d.). *Wikipedia.org*. Retrieved from http://en.wikipedia.org/wiki/Testosterone#Athletic_use

Van Susteren, G., & Wheatley, J. (2007, July 17). Toxicology reports shed new light on Chris Benoit's murder-suicide. *Fox on the record with Greta Van Susteren*. Retrieved from http://www.lexisnexis.com/hottopics/lnacademic

World Wrestling Entertainment. (2007, June 26). WWE shocked at latest developments in Benoit tragedy, concerned by sensationalistic reporting [Press release]. Retrieved from http://www.lexisnexis.com/hottopics/lnacademic

Wrestler Benoit, family dead; Atlanta area police are treating case as a murder-suicide, newspaper reports. (2007, June 26). *The Gazette* (Montreal). Retrieved from http://www.lexisnexis.com/hottopics/lnacademic

Bad Landing: Charting the Gold and Criminal Records of Finnish Ski Jumper, Matti Nykänen

Pirkko Markula
Zoe Avner

Ski jumping—a sport that requires skiers to go down a ramp, jump, and attempt to land as far as possible downhill—is a very popular spectator sport in the Nordic countries of Finland and Norway, in the Central European countries of Austria, Germany, Poland, Slovenia, and Switzerland, and in Japan. In these countries, television coverage of such major events as the annual Bavarian Four Hills Tournament is extensive, and successful ski jumpers are hailed as great sporting heroes. Ski jumping is also an Olympic sport open only to male competitors.

As a seemingly high-risk sport, in which athletes' jumps measure over 100 meters, ski jumping is considered to require a certain "daredevil" attitude. For example, ski jumping is described in the North American press as a "fool-hardy" sport, demanding not only courage but lunacy. In this sense, ski jumping could be considered a "masculine" sport that the media further construct as suitable for young, strong, and powerful athletes (Loland, 1999). On the other hand, a light, small body that can fly these extreme distances matches the technical requirements for winning in ski jumping. Consequently, the best ski jumpers are relatively small men, who have to watch their weight very carefully (Loland, 1999; Muller, 2009). For example, our "hero," ski jumper Matti Nykänen, is 177 cm (5 foot 10 inches) tall and weighed around 54 kg (119 lbs) as a competitor (Theiner, 2003). He was among the first generation of ski jumpers with this "flying squirrel" (Meyers, 1992, p. 6D) type of ski jumping body: strong but slightly built. Because of this preferred body type, several cases of eating disorders have also been reported within the sport (Muller, 2009). To a certain extent, the size "feminizes" the ski jumper's body (Loland, 1999). These athletes strive to keep their weight light, instead of seeking to attain the heavy muscularity of the hegemonic masculine type. The

elite ski jumpers have to actively negotiate being "tough" but thin in order to function optimally (Loland, 1999).

These characteristics also constitute the parameters for the emergence of ski jumping heroes. In this chapter, we examine the case of one of the most successful ski jumpers of all time, Matti Nykänen, who still holds the record for most Olympic medals in ski jumping (five) and the most overall World Cup wins in ski jumping (four). This record lends Nykänen a superhero status not only in his native Finland but also around the ski jumping world. Nykänen, nevertheless, has gained even more notoriety through other exploits accompanying his reputation as one of the greatest ski jumpers of all time.

To further analyze the media representations of Nykänen, we draw on a Deleuzian perspective to problematize the dualistic scheme of modernist construction of the self (e.g., masculine/feminine, man/child, champion/retired, good/bad, athletic hero/alcoholic, determined/lost, rational/out of control). Deleuze and Guattari (1987) used the term "faciality trait" to connect these binary characteristics. In this context, an individual is required to take up a position on either side of the binary divide: the masculine, good side is labelled by Deleuze and Guattari as the "majoritarian" face. As it continues to emerge with late capitalism (Lorraine, 2008), the binary gendered face reduces the complexity of one's embodied existence "to what can be captured and coded through the faces that are socially recognizable . . . and psychically convincing" (Lorraine, 2008, p. 84). For example, the media texts might compare Nykänen to other ski jumpers or male Finnish athletes who represent the positive end of the dichotomy, placing him on the negative side and thus, painting a socially unrecognizable, athletic, masculine face for Nykänen. Associating him with the negative can, nevertheless, reinforce the molar line of masculinity by emphasizing the positive as the socially desirable face. Such a majoritarian face or gendered identity "entails a conception of self on relative autonomy from the world who takes a passive or active desiring stance with respect to that world" (Lorraine, 2008, p. 65). Lorraine (2008) argued that in this modernist world, the subject will maintain "self-sameness" through "repetition of personalised patterns of meaning and behaviour" (p. 63). For example, Nykänen might be represented as continually resorting to the same "personalized" patterns of "bad" behavior. From a Deleuzian perspective, Lorraine further observed that

> Whether one lives out these designations and interpellations in comfortable conformity or painful dissonance depends upon whether the multiple forces converging in the durations one lives resonate with dominant memory (that is, the representational memories and history sanctioned by the mainstream) or induce varying tendencies toward counter-memories and minoritarian resistance. (2008, p. 65)

As we will see, Nykänen has several encounters with "dominant memory" of a masculine sports hero, and we plan to further investigate whether the media texts represent him as creating counter memories or living in "painful dissonance" with the dominant memories of masculinity. Consequently, following Braidotti (1997), we use Deleuzian theory as an especially helpful tool to "approach some of the more iconoclastic and at times disturbing aspects of contemporary culture" (p. 76), to make sense of what "can only appear as senseless, anarchical and threatening" (p. 76) in the rise and "fall" of the ski jumping superstar, Nykänen.

The Rise to Stardom: "The Baby-Faced" Super Talent

Nykänen enjoyed a tremendously successful athletic career between the years of 1982 and 1990, when he won a total of five Olympic medals, nine World Championship medals and 22 Finnish Championship medals. The highlight of his career undoubtedly was the 1988 Calgary Olympics where he ended up winning three gold medals, a notable feat which is continually evoked by the media in connection with each Olympics and World Championship.

The media representation of Nykänen in the early years of his career was initially very positive, celebrating his athletic accomplishments and lauding him for being the youngest Nordic champion to win (in 1982) at a World Nordic Ski Championship. In these early years, most newspapers depicted him as a polite young man, a "baby faced 19 year old" (Golla, 1983, p. S3), or as a "jumping ace," giving him the nickname of the "Flying Finn." The first turning point in the press coverage of Nykänen came in 1985, when he received his first bad press after being dropped from the Finnish team and sent home from Lake Placid for bad behavior and a drinking problem. Paradoxically, he had been voted Finland's sportsman of the year just months prior to that incident (see, for example, "Roundup Ski Jumping," 1985).

In 1986, with his strong athletic comeback, Nykänen was redeemed in the press. The media connected this success directly to a more fulfilled personal life and a recent marriage, which was "helping him to settle down . . . [d]iscipline problems being the only blot on a brilliant athletic record" (Davidson, 1986, p. D2). From 1986 to 1987, the articles continued to emphasize his paradoxical persona, contrasting his teenage looks, his childish immaturity, his slight build, and "almost elfin body" with his extraordinary coolness under competitive pressure. These complex, multilayered media representations of Nykänen pointed to the intersection of the two binaries constructing the masculine "face": the myth of frailty of the young and immature athlete who

specialized too early and "who might have reached perfection too soon" (Davidson, 1987, p. D2), and that of the hypermasculine sporting hero, single-minded, performance-driven, possessing essential, extraordinary traits and characteristics. Interestingly, media representations of Nykänen as paradoxically embodying both the frailty of the star child and hypermasculine characteristics of the sporting hero were rendered intelligible in connection with other press representations of another famous ski jumper, the Canadian, Horst Bulau (Davidson, 1987, p. D2). A parallel was drawn between the ups and downs of Bulau's sporting career and Nykänen's own trials and tribulations in his public and personal life, thus helping to provide a larger, contextual framework through which Nykänen was rendered intelligible. Furthermore, the parallel drawn between the two high-performance ski jumpers also served the strategic purpose of contextualizing both their lives within a dominant, modernist face of masculine, high-performance sport, which naturalized these behaviors by tying them to essential character traits common to high-performance athletes (a very competitive and driven nature, only able to concentrate on the ultimate goal of winning). In addition, Theiner (2003), Nykänen's biographer, constructed Nykänen as a likely sufferer of ADHD (Attention Deficit Hyperactivity Disorder): short tempered and easily frustrated, unable to concentrate on anything (besides his training) at school, and only barely completing the compulsory nine years of education in Finland.

Finally, media representations of Nykänen in the later stages of his athletic career (including his most successful year in 1988) pointed to the complex intertwining of two popular binaries of the high performance masculine face: that of the "good" sporting hero as humble; inspirational; a good teammate; a person who "gives back" to the sport, to fans, and to his country; and that of the antihero as a lonesome, selfish, and ungrateful person (e.g., McDonald, 1988; Sons, 1988). Once again, the media drew a parallel with very popular British ski jumper Eddie Edwards, known as "Eddie the Eagle," who earned his heroic status not because of his athletic accomplishments (he repeatedly finished last), but more because of his charm, unconventionality, humility, and determination. Instead, Theiner (2003) described Nykänen as narcissistic and egocentric: a spoiled sport star who only acted as a member of the team when it benefited him.

Despite the fact that certain news articles portrayed Nykänen's despondency in a favorable light (e.g., Cox, 1988; Denlinger, 1988; Miller, 1988), Nykänen was overwhelmingly sanctioned by the press for failing to live up to his moral and public duties as a "true" sporting hero: "Matti Nykänen won three medals but unfortunately has the charisma of wilted lettuce and doesn't inspire the awe his deeds merit" (Sons, 1988, p. 3). Much later, Nykänen

himself reflected on his relationship to the media during his athletic career: "I didn't realize [that I needed] to create good relationships with TV and news-paper journalists. . . . I found their constant presence distracting and their questions unimaginative" (as quoted in Theiner, 2003, p. 10, our translation). He acknowledged not taking an active role in cultivating media relations but also implied that he was to blame, at least partially, for the "bad" press.

The Fall: The "Flying Finn" Descends to Alcoholism

Nykänen's star started to dim when he did not participate in the Bavarian Four Hills Tournament in 1990. The media reported his grandmother's death as the official reason for his withdrawal. The next year, 1991, Nykänen placed 50th out of 65 in the World Championships—a fact repeated by the international press. His coach, Matti Pulli, revealed that Nykänen's training was not at a sufficient level. Pulli also referred to Nykänen's alcohol problem. In addition, Nykänen had personal problems as he was, at 27, divorcing his second wife, Pia Hynninen. According to the media, Nykänen himself blamed his coach for the poor performance, saying, "I made myself a champion" (Baldwin, 1991), and boasting, "I am the greatest jumper in the world and always will be" (Baldwin, 1991). The ski jumping world was, at the same time, switching from the classic style ("flying" with the skis parallel to each other) to the "V-style" ("flying" with the skis in a v-position with the ends close together but the tips far apart). Nykänen had excelled in the classic style and had never jumped using the V-style (Theiner, 2003), a fact never mentioned in the news. Theiner (2003) explained that injuries caused Nykänen's unsuccessful season and were the ultimate reason for Nykänen's retirement. Nykänen had a knee operation and could not practice during the year preceding the World Championships in 1991. During his career, Nykänen had four knee operations; he later underwent two back operations after retiring from ski jumping.

In 1992 Nykänen tried for a comeback but did not make the Finnish Olympic team in Albertville, France. He was, nevertheless, present at the Olympics, where a new Finnish ski jumping hero, 16-year-old Toni Nieminen, made history by obtaining two gold medals. Nykänen, who was there to sign as an advisor for a Japanese sportswear company, was already failing the "majoritarian face" of a champion ski jumper. This was predicated on his repeated "bad" behavior, a "self-sameness" that, through failure, reinforced the masculine, molar, autonomous, athletic self. While Nykänen, at 28 years of age, was still acknowledged as the legendary greatest jumper of all times, he was also

characterized as brooding, flamboyant, temperamental, dour, ill-tempered, fiery, and wayward. Nieminen, on the contrary, was found to be nice, sweet, fresh-faced, and shy but possessing the same characteristics of a champion as Nykänen: having a skinny, frail, wispy body, and being self-confident. The new champion was reluctant to be compared to Nykänen. The following exchange captures these sentiments:

> Super-stardom awaits the 16-year-old double gold medallist. . . . Nieminen shuns talk of another Nykänen. . . . "I have never, ever said that I was at the level of Nykänen . . ." he said. There are more than sporting reasons to avoid the Nykänen tag. Wine, women and nightclub scuffles all put the brooding, sullen Nykänen in the news. . . . Baby-faced Nieminen, by contrast, takes his homework to ski jumping events. (Holmes, 1992)

When asked how he would deal with all the adoring Finnish female fans, "shy" Nieminen "reddened" in a display of "a fresh innocence" before answering: "It's a really difficult question. I really don't know how to answer it" (Holmes, 1992). Nykänen, at the same time, was getting his second divorce. Nykänen's personal characteristics were also evoked by recalling the nickname, "Matti-Nukes," given to him by his Finnish teammates due to his "explosive drinking and social habits" (Ziegler, 1992, p. D-3). Although Nykänen was represented as a colorful, eccentric personality, Nieminen was reported as having more "character" as a ski jumper.

After several attempts at a comeback, Nykänen officially retired in June of the Olympic year 1994. According to Theiner (2003), "Matti was now in a new situation" (p. 123, our translation) where he was no longer the center of attention. All of a sudden, he had to manage his own affairs, a task previously taken care of by the Finnish Ski Association. Nykänen himself admitted: "The world outside of ski jumping was quite different from the one I was used to" (as quoted in Theiner, 2003, p. 114, our translation). He, nevertheless, believed optimistically that "in the life after sport, as during my athletic career, one imagines, hopes and expects that everything will turn out fine" (as quoted in Theiner, 2003, p. 114, our translation). Despite Nykänen's confidence, it was widely reported that he had gone bankrupt in this process and had to sell his 42 championship and Olympic medals to sustain himself. Eventually a Finnish museum obtained the medals. Having to resort to such measures was considered the most disgraceful and desperate act by the former champion, who had now clearly embarassed himself. As White (1994, p. C11) reported: "There was a time when crowds passionately embraced him, when noisy celebrations marked another jump documenting his greatness. . . . The drinks still flow, but there are no more celebrations. Financial constraints forced him to sell the four Olympic gold medals. His country looks at him with shame."

Nykänen himself explained that due to lack of sponsorship, he had had to engage in some "bad deals." Such behavior is presented as consistent with Nykänen's general characteristic as a failed champion. His disgraced downfall was accentuated by a career as a pop singer, which Nykänen himself reported failing due "to business men who took advantage of who I was" ("Ski Jumping–Finnish," 1994). Nykänen, nevertheless, took the blame once again: "That I'm in financial difficulties is to a big extent the result of my own stupidity" ("Ski Jumping–Finnish," 1994). In addition to being somewhat gullible and incompetent in business matters, Nykänen was also considered "too crazy," battling with drug and alcohol problems which "killed his career."

Curiously, Nykänen was present at the Lillehammer Winter Olympics selling t-shirts: "Easy going, but now grounded in disgrace–he is selling T-shirts in Lillehammer, clinging to his fame" (White, 1994, p. C11). In subsequent years, Nykänen continued to appear in the news every time a new ski jumping hero was close to breaking his medal-winning record and also due to his marital or legal troubles. His extraordinary athletic career claimed a headline only once: he finished second in the voting as Finnish sports person of the century in 1999 after legendary Finnish runner Paavo Nurmi (also nicknamed the "Flying Finn" in 1930s), and just ahead of another Olympic champion, long-distance runner Lasse Viren. Nykänen, once again, was constructed as struggling to have an acceptable hero's "face" in comparison to Viren (originally trained as a policeman) who had successfully gained a new, respectable career and sustained his hero status as a member of the Finnish parliament. For example, a British newspaper, *The Times*, provided an explicit comparison of three "Flying Finns":

> No surname required for Matti Nykänen. Finns have long had two loves: athletics and ski jumping. Nurmi was their greatest athlete, winning nine Olympic gold medals in middle and long-distance running in the 1920s. "Matti," Viren says, "is the best ski jumper of all-time." Viren, by common consent, is up there, too, only he won't say so. That isn't his style. He is charming, intelligent and too political. Viren today runs his own charity to help young people in sport and is a member of parliament; Nykänen on Wednesday was on trial for aggravated assault. (Slot, 2004, p. 30).

After his retirement from ski jumping, Nykänen's curious career choices continued to interest the press. Sometimes he was introduced as an entertainer but most often as a (bad or unsuccessful) singer. For example, a Finnish journalist assessed Nykänen's talent as a singer in a U.S. newspaper: "He was a singer but he could not sing," said Finnish journalist, Juha Hölttä. "He released two records. They were terrible. . . . He has done so many stupid things" (Ziegler, 1994). Nykänen's singing career did not exactly fail, as his first album, "Yllatysten Yo'" sold over 25,000 copies in Finland (Ronay, 2010) and ob-

tained a Golden record (his other two albums are "Samurai," 1993 and "Ehkä Otin, Ehkä En" (Maybe I Took, Maybe Not), 2006). However, teamed with the world's worst ski jumper, Eddie "The Eagle" Edwards, he had planned an album launch on the international market. This plan failed, but Eddie Edwards recorded a single in Finnish titled, "Mun nimi on Eddie" (My Name Is Eddie) that was a huge hit in Finland (Ronay, 2010).

Although Nykänen himself denied this charge, he was also found working as a stripper in a Helsinki nightclub. This last employment garnered significant publicity during the World Championships in Japan. These articles compared Nykänen to his former fellow competitor, Eddie "The Eagle" Edwards, establishing Nykänen, a champion ski jumper, as a bigger failure than Edwards. For example, the British newspaper, *The Guardian*, reported:

> As exposed as Eddie "The Eagle" Edwards may have felt during his brief ski jumping career, it was never the Full Monty. No such luck for Matti Nykänen, the Finn who won the Olympic gold medal in 1988 only to be outrageously upstaged by Edwards. He has turned to stripping in order to earn a living. (Downes, 1998, p. 16)

Nykänen's stripping was also found of poor quality:

> On his debut at a Helsinki nightclub last week he was booed off, not so much because he refused to drop his Y-fronts but because he staggered all over the stage. The balance that served him so faithfully while he was jumping had deserted him, allegedly because he was the worse for drink. (Downes, 1998, p. 16)

In these reports, Edwards's failure as a ski jumper turned into an acceptable, even admirable and entertaining feat, whereas Nykänen's attempts at entertainment were presented as "self-destructive." For example, *The New York Times* reported:

> The winner of three ski-jumping gold medals in Calgary was a sour Finn named Matti Nykänen. Unable to control his drinking and fighting, the self-destructive Nykänen later sold his medals. At last report, he was working as a stripper. No wonder reporters preferred Edwards. He will be sorely missed at the Winter Olympics in the Japanese Alps. (Longman, 1998, p. 3)

While being "sour" and drinking alcohol might be considered a part of the masculine "face," Nykänen was too out of control to constructively create an acceptable identity, so much so that "anti-athletic" hero, Eddie Edwards, was preferred over him. These comparisons were resurrected when Edwards reappeared in the news in 2008, 20 years after the 1988 Calgary Olympics. In these reports he was described as having successfully completed a law degree and as having a family while still working as a plasterer. Similar to Nykänen, Edwards had also declared bankruptcy because, as he explained, he was taken

advantage of by his trustees, who he later sued (Sekeres, 2008). While described as "eccentric," he was also "an everyman, being accessible, folksy, funny and, yes, foolish" (Sekeres, 2008, p. S1). Edwards, thus, appeared as an affable and stable character who had successfully completed a degree and started a family compared to Nykänen's "crash due to drinking, marital and legal woes" (Bradford, 2008, p. F2).

In these stories, Nykänen turned from a soaring eagle to a nearly flightless turkey. In addition, Nykänen also provided a cautionary comparison for Finland's new world championship hope, Janne Ahonen:

> Finns hope the 25-year-old, whose recent form has been impressive, will not go the way of their 1988 triple gold medallist, Matti Nykänen, who has squandered $750,000 in earnings, been divorced three times and now works as a striptease act in a Helsinki bar. (Ziegler, 1994)

This brief description summarized Nykänen's problems with money and marriage, while others added alcohol to the repeated behavioral patterns for Nykänen.

Nykänen's battle with alcohol was consistently mentioned in any news item regarding his career, but he was depicted as one of the living legends, an affable, yet somewhat sorry character so dearly loved by the Finns that they forgave his shortcomings. For example, when Nykänen's latest biography by Austrian writer, Egon Theiner, was released, an American journalist noted:

> The book launching in Finland was aired on national TV. Nykänen showed up drunk. "I have to admit that I was out on the town a bit last night and I had a few drinks," said the man who has been in and out of rehab clinics. "Well, actually, it's always a bit more than a few with yours truly." People laughed. They always laughed when it came to Matti. (Zeigler, 2004, p. C-2)

Some years later in 2006, a movie titled "Matti: Hell Is for Heroes" was released. The movie, a huge hit in Finland, charted Nykänen's early years and drunken exploits. It also made news in the British press. For example, Felperin (2006) provided the following headline review: "Finnish biopic 'Matti–Hell Is for Heroes' reps a winning portrait of ski jumping gold medalist and champion screw-up Matti Nykänen. Helmer Aleksi Makela transmutes babyfaced Nykänen's slow descent into alcoholism." In this sense, the Finnish treatment of Nykänen's failure to control his drinking equalled the British response to Eddie "The Eagle" Edwards's dangerously poor ski jumping ability: an affectionate, good-natured smile, and a head shake. However, even the Finns stopped laughing when Nykänen's alcohol-induced violence resulted in a prison sentence. As the British newspaper *The Times* reported: "There is no longer any temptation to smirk at the self-destructive streak that is the ruin of

Matti Nykänen, the quadruple Olympic gold medal-winning ski jumper and one of Finland's most revered athletes" (Slot, 2005, p. 89).

Excessive alcohol use was often connected to Nykänen's failed marriages, although only his last marriage was reputedly troubled by drinking (by both partners). Nykänen has been married four times (twice to the same woman, Mervi Tapola) and has two children from two different marriages. Nykänen's violent behavior was first reported when he allegedly assaulted Tapola, an heiress of a wealthy Finnish family, during a Christmas holiday in Europe in 2000. He received a suspended sentence for assault.

This event was reported often in connection with a more serious, later assault (in 2004) during which Nykänen stabbed a man. In this "bizarre" event, Nykänen was watching the Summer Olympics in his own summerhouse with a man who had come to repair windows at the house. An American journalist described the events:

> They had been watching the Summer Olympics on TV, and they had been drinking, and they had engaged in sormikoukku, a Finnish form of arm wrestling where you link index fingers and try to tug the other person toward you. An argument ensued. The 41-year-old grabbed a 5-inch blade, allegedly, and drove it into the other man's back. Twice.
>
> The 41-year-old was hardly a saint—a bad nightclub singer who had reportedly worked as a stripper and had been married five times and had a history of drunken rampages, and who was already on probation for a domestic violence charge the previous year. (Zeigler, 2004, p. C-2)

Nykänen himself claimed having no recollection of the events due to heavy drinking. He was sentenced to prison for 24 months. Having served half of his sentence, Nykänen was released in 2005 on parole for good behavior but was arrested five days later, again, for beating up his wife, Tapola. He received a further four months in prison. Tapola claimed that Nykänen "was drinking the minute he got home and he neither ate nor slept" (Slot, 2005, p. 89). Nykänen's most recent violent event also involved Tapola. On Boxing Day 2010, Nykänen was accused of assaulting his wife with a knife and also attempting to strangle her with the belt of a bathrobe. The charges for attempted murder were dropped, but Nykänen was again sentenced to prison for 16 months for assault. He has, nevertheless, appealed the sentence and the hearings are still ongoing. Notably, Tapola has filed for a divorce from Nykänen 15 times. Their divorce is now finalized.

Even the Finns were reported to be weary of Nykänen's continued downfall that has rivaled his earlier sporting success. For example, *The Guardian* quoted a Finnish journalist:

"After that we didn't hear about his sports history any more," says Veli-Matti Peltola of the *Helsinki Times*, who, like every other Finnish journalist canvassed in the writing of this article, seems both wearied by and fondly indulgent towards his nation's ski-jump icon. "In fact, people who didn't grow up when he was winning all his medals only really think about him as someone who is in the tabloid newspapers. It was quite funny at first. Now it's just sad." (Ronay, 2010, p. 12)

Nykänen's problems transpired as personal problems largely unconnected to the social world around him. On rare occasions, ski jumping as a sport was assumed as a partial cause for Nykänen's drinking problem. For example, Slot (2004) acknowledged: "It did not help Nykänen that his was a sport that took courage and machismo to extremes and where drinking was part of the culture." As a modernist (male) subject, Nykänen was deemed to behave with relative autonomy: he had chosen his strange career path after sport, he had chosen to drink excessively, and he had made bad investment choices. In the media reports, Nykänen himself appeared to agree. For example, in a Reuter's story ("Ski Jumping–Olympic," 2003) Nykänen confessed to having considered suicide due to his unsuccessful battle with alcoholism. He nevertheless admitted that "he has only himself to blame for his problems. 'After the competitions and training camps we were drinking a lot and building up courage,' he said. 'No one poured spirits down my throat, my own hand raised the glass.'" As a solution, he sought therapy and later reasoned that "The problem is not only alcohol, the reasons are deeper. . . . I am disappointed in myself, it can't go on this way. I am going to go back to therapy and clear up my condition. That's the only possibility." In 2011 Nykänen examined his life further and revealed to a Finnish tabloid:

> I have begun to recall my career with a more professional manner only recently. It is difficult to remember anything, when one is entirely lost with life. After my sport career, I have not, at one moment, known who I am or where I am going. My only place of escape was the pub. I only had the "hill" and the pub. This means that I never lived normal, everyday life. (Matti Nykänen avoimena ongelmistaan, 2011, our translation)

As a modern, molar subject, Nykänen took the blame for hovering uncomfortably in between the dualist requirements of the masculine face which he was only able to create as an athlete or, as he confessed, when drinking. Everywhere else he was lost and disappointed. He did not reflect on the differences between the years of training that made him a successful athlete and the entire lack of training for his careers as a singer who produced "the single worst album in the history of modern rock" (Ziegler, 2004, p. C-2), as a stripper who was booed off the stage, or as an entertainer famous only for constantly appearing in the tabloid press for his alcohol-infused exploits. As an

athlete, Nykänen asserted, "failing means that you have not trained enough" (as quoted in Theiner, 2003, p. 78, our translation), but the ambition and determination gained in sport should have naturally resulted in a success in the world outside of sport without further education. In this sense, he has been unable to break the bond of the molar, masculine, athletic face to move beyond the contradictory, masculine and feminine requirements of his sport. He was uncomfortable yet continually aimed to fulfil the requirements for the face of the "Flying Finn," a celebrated sport hero in Finland. Nevertheless, Nykänen has maintained himself consistently as a public figure through "self-sameness" (Lorraine, 2008), repeating the personalized patterns of excessive drinking, failed career choices and marriages, and violent behavior. His exploits have never been represented as creative "counter-memories" that construct a "new masculine, athletic face" but as a constant battle and repeated failure to adopt a respectable, recognizable, and acceptable, majoritarian face.

Conclusion

Faithful to his repeated behavioral patterns, Nykänen has already found a new "love" after his recent divorce from Tapola. While the court case concerning Tapola's assault is still ongoing, Matti's new fiancée is a recent celebrity in Finland, the businesswoman, Susanna Ruotsalainen, who obtained fame as a participant in the Finnish version of the American reality show, "The Apprentice." Nykänen is reported as having lost a significant amount of weight and has also returned to ski jumping, winning the World Masters championships in 2011 in his age group (Nykänen won his first World Ski Jumping Masters in 2007). He recently confessed to a Finnish tabloid that "Now I feel good inside and in my heart" (Leinonen, 2011). He continues to follow the "self-same," masculine pattern of having a new wife whose love has changed him and of resuming his athletic success.

Nykänen's more "feminine" exploits (such as stripping) could be considered as creating "counter-memories" to masculinity, yet they have been created as disgraceful acts for a sports hero—a soaring eagle. The media reporting, thus, reconstructs the masculinity of a ski jumper through negative comparisons to its binary. Nykänen's most serious struggle is, nevertheless, presented as stepping over the accepted boundaries of masculinity through alcohol abuse and violent behavior. However, the tolerance of Nykänen in Finland is constructed by painting his behavior as "psychically convincing" (Lorraine, 2008) against the nature of a sport that requires borderline "flakiness," courage, and heavy drinking; the Finnish tradition of ski jumping as a national sport; and

Nykänen among few (if not the only) successful sports heroes of the nation. Meanwhile, Nykänen has successfully stayed in the public eye—a necessity for a professional, nonspecified entertainer wanting to survive. As Theiner, Nykänen's biographer, explained: "Ski-jumping is one of the national sports and he unites two very important parts of life: the most successful ski-jumper ever, and so many headlines in his private life" (as quoted in Ronay, 2010, p. 12). A British journalist explicated Nykänen's "enduring, almost unbelievable popularity" (Ronay, 2010, p. 12) among the Finns further: the Finns continue to really like Nykänen as a simple sporting character. He is a lovable, friendly guy, who is always in a good mood—a ski jumping legend (Ronay, 2010).

Having Nykänen in the headlines still sells newspapers, particularly tabloids. One of them, *Seiska* (*7 Days*), continues to cover news about Nykänen because "People always say that you just sell your paper with Matti's help. . . . We would not cooperate with him if he did not help to sell the paper. Whenever Nykänen is on the cover, the paper sells better than normal" (*7 Days* writer, Kai Merilä, as quoted in Ziegler, 2004, p. C-2). The media, thus, reconstruct the need for a certain kind of masculine face but also call for heroes, like Nykänen, who struggle to create such an accepted and well-understood modernist face. Nykänen is well aware of this symbiotic relationship: "The truth is that a celebrity needs the media and the media need famous people. Without the media there would not be sports or at least, not the prestige of sporting success" (as quoted in Theiner, 2003, pp. 9–10, our translation). Nykänen uses the media to stay on top of his current game: he stays troubled with his "face" without challenging the memory of a simple ski jumping legend too radically. Nykänen, thus, does not necessarily desire to reconcile with the normalized masculine face: "Many people would like me to be 'normal' or be treated 'normally.' Did I not set my goal to be better than average as an athlete? Perhaps I must maintain my goal to the end" (as quoted in Theiner, 2003, p. 163, our translation). The molar lines of majoritarian masculinity stay intact when Nykänen excels as a media celebrity in contemporary capitalism: as a simple, yet competitive, former sports star who is better than average in creating headlines that continue to sell.

References

Baldwin, (1991, February 15). Off-form Nykänen in danger of missing Olympics—Nordic skiing. *Reuters*.

Bradford, K. (2008, February 14). Flying Finn crasher due to drinking, marital and legal woes; Nykänen has spent time working as stripper. *Vancouver Sun*, p. F2.

Braidotti, R. (1997). Meta(l)morphoses. *Theory, Culture & Society*, 14(2), 67–80.

Cox, K. (1988, February 27). The winter Olympics exotic athletes face last hurrah. *The Globe and Mail*, p. A17.

Davidson, J. (1986, December 8). Wedding bells bad news for ski jumpers. *The Globe and Mail*, p. D2.

Davidson, J. (1987, December 7). Nykänen wins World Cup jumping. *The Globe and Mail*, p. D2.

Deleuze, G., & Guattari, F. (1987). *A thousand plateaus: Capitalism and schizophrenia*. London, UK: Athlone.

Denlinger, K. (1988, February 26). Open admission is fine; equal treatment is different and losing proposition. *The Washington Post*, p. G04.

Downes, S. (1998, January 23). Hall of infamy—jumper off. *The Guardian*, p. 16.

Felperin, L. (2006, February 7). Matti—Hell is for heroes. *Daily Variety*. Retrieved from http://www.variety.com/review/VE1117929514?refcatid=31

Golla, J. (1983, January 22). Nykänen leads points race. Finn excites ski jumping fans. *The Globe and Mail*, p. S3.

Holmes, P. (1992, February 17). Battle begins for schoolboy star Nieminen—ski jumping, Winter Olympics. *Reuters*.

Leinonen, A-M. (2011, January 1). Matti Nykänen paljastaa: Nain kosin Susannaa (Matti Nykänen reveals: This is how I proposed to Susanna). Retrieved from http:www.mtv3.fi.viihde/uutised/muut.shtmla/1251549/matti-Nykänen-paljastaa (no longer accessible).

Loland, N. W. (1999). Some contradictions and tensions in elite sportsmen's attitudes towards their bodies. *International Review for the Sociology of Sport, 34*(3), 291–302.

Longman, J. (1998, February 1). Soaring with the turkeys at the Olympics. *The New York Times*, pp. 3, C1.

Lorraine, T. (2008). Feminist lines of flight from the majoritarian subject. *Deleuze Studies, 2*, 60–82.

Matti Nykänen avoimena ongelmistaan. Retrieved from E:\google\2010-2011 google news archive\IS Talviurheilu Iltalehti_fi.mht (no longer accessible).

McDonald, M. (1988, February 29). Party's over for Calgary. U.S. had plenty of mettle series: Calgary '88. *The Dallas Morning News*, p. 1B.

Meyers, C. (1992, February 4). World's jumpers soar using a new technique. *The Denver Post*, p. 6D.

Miller, R. (1988, February 26). XV winter games/television/Nykänen has made work tough for ABC. *Houston Chronicle*, p. 7.

Muller, W. (2009). Determinants of ski jump performance and implications for health, safety and fairness. *Sports Medicine, 39*(2), 85–106.

Ronay, B. (2010, January 10). A very slippery slope: Matti Nykänen was Finland's greatest sportsman, winner of four Olympic golds. Since then has stabbed someone in a finger-pulling contest, worked for a sex phoneline—and found God. *The Guardian*, p. 12.

Roundup ski jumping. (1985, December 17). *The Globe and Mail*, p. D2.

Sekeres, M. (2008, February 23). Remember Eddie? Who could forget. *The Globe and Mail*, p. S1.

Ski jumping—Finnish jumper Nykänen to sell medals. (1994, November 1). *Reuters*.

Ski jumping—Olympic great Nykänen was ready to shoot himself. (2003, April 19). *Reuters*.

Slot, O. (2004, October 24). Finnish legend hits rock bottom. *The Times*, p. 30.

Slot, O. (2005, October 1). Fears rise as Nykänen falls farther: Magic sponge; athletics. *The Times*, p. 89.

Sons, R. (1988, February 29). Farewell to oohs and ahs in Oz. *The Chicago Sun Times*, p. 3.

Theiner, E. (2003). *Matti Nykänen: Huipulla ja montussa* (P. Jäntti, Trans.). Keuruu, Finland: Otava.

Wester, K. (1988). Improved safety in ski jumping. *The American Journal of Sports Medicine, 16*(5), 499–500.

White, T. (1994, February 27). Lillehammer breakdown. *Greensboro News & Record*, p. C11.

Ziegler, M. (1992, February 7). Ski jumping, Nordic combined. *The San Diego Union-Tribune*, p. D-3.

Ziegler, M. (1994, February 21). Flying tigers: Ski jumpers get the gold for courage. *The San Diego Union-Tribune*.

Ziegler, M. (2004, November 14). Fallen Finn: In a small nation, Matti Nykänen is the biggest of stars, a golden 'eagle' whose bizarre life has turned into the biggest of stories. *The San Diego Union-Tribune*, p. C-2.

Traitor on High Seas: Russell Coutts, Kiwi Loyalty, and Opportunism in International Yachting

Alistair John
Toni Bruce
Steven J. Jackson

In this chapter, we investigate the tensions that arise when historically amateur notions of loyalty to the nation confront the realities of globalized and corporatized professional sports. Our focus is the America's Cup, which serves as a strategic site of analysis for understanding the relationship between sports, media, nationalism, and global corporations (Jackson, 2004). Despite being more accurately "characterised as a contest for the wealthy" (Bruce & Wheaton, 2009, p. 586) and offering a global showcase for corporate branding, teams often represent themselves and are taken up by the public as national teams that evoke patriotic sentiment and emotions. We investigate the rapid and visceral shift in public conceptions of New Zealand sailor Sir Russell Coutts, who was initially embraced as a national hero as skipper of two successful New Zealand America's Cup campaigns, yet became a reviled "traitor" seen as deserting the nation because he chose to sail for a rival syndicate against Team New Zealand (see Becht, 2002; Hodder Moa Beckett, 2000; Larsen & Coutts, 1996). Rather than being embraced as a New Zealander succeeding on the world stage, Coutts became a target for condemnation and even death threats.

In order to understand public conceptions of Coutts, a New Zealand professional sailor competing in one of the world's most corporatized and transnational or global sports, it is necessary to first consider the broad terrain of New Zealand sporting culture. Whereas many European and North American nations are comfortable with professional sports and the economic imperatives therein for players and organizations, New Zealand remains caught in transition; profoundly ambivalent and suffering "acute anxieties" about whether

proceeding down the professional track is the right way to go, especially in relation to the "national" sport of men's rugby union (Hope, 2002; Jackson & Hokowhitu, 2002; Obel & Austrin, 2011, p. 260; Scherer & Jackson, 2010; Wensing & Bruce, 2004). Laidlaw (1999) argued that rugby no longer responds to the "nationalistic fervour of an adoring public but to the television programme schedulers and the corporate sponsors"; the result is "a growing sense of unease, if not resentment, among supporters of the game that it is somehow being taken away from them" (p. 174). Analyses of other sports also suggest that, as a nation, New Zealand is "shifting towards" but has "strong reservations about a more professionalized model of sport" (Wensing & Bruce, 2004, p. 214). New Zealand's America's Cup campaigns and the global mobility of New Zealand professional sailors thus intersected with these broader concerns, and resulted in public and media reactions that first celebrated and later vilified Russell Coutts, the man whose actions made him a catalyst for anxieties over the intersections of global corporate sports and national identity.

Our analysis draws upon a wide range of published material, including media coverage, America's Cup promotions, Russell Coutts's biography (Larsen & Coutts, 1996; Larsen, Forster, & Coutts, 1999), two explicitly patriotic national campaigns, and interviews with key members of one campaign. We first discuss the rise of Coutts to heroic status as he skippered Team New Zealand to its first America's Cup win in 1995, followed by an historic first defense of the Cup by a non-USA team in 2000. Then we consider Coutts's fall from grace as he first "defected" from Team New Zealand and later led Swiss syndicate Alinghi to victory over his own nation in 2003.

The Rise and Rise of Russell Coutts: 1995–2000

Even a cursory look at sports heroes and heroines, both historical and contemporary, indicates that they emerge in different ways, from a wide range of social backgrounds, personal achievements, and cultural contexts (Jackson, 2006). Numerous typologies exist (e.g., Browne et al., 1990; Ingham, Howell, & Swetman, 1993; Rojek, 2001; Smith, 1973), and it is clear that an individual can become a hero/ine in a variety of ways. However, in general, "the hero was distinguished by his [sic] achievement; the celebrity by his image or trademark. The hero created himself; the celebrity is created by the media" (Boorstin, 1992, p. 61).

Like many others, Coutts became a hero through his achievement. Indeed, he has been described as "the most influential figure in the 159-year history of

the America's Cup," winning four times, as a helmsman, skipper, and CEO and not losing an America's Cup race in 15 years (Johannsen, 2010, p. A1). In this outstanding achievement, he sits alongside others who have performed at a much higher level and with much greater consistency than the average athlete (see Ingham et al., 1993), such as Australian cricketer Sir Donald Bradman; Finnish runner Paavo Nurmi; Romanian gymnast Nadia Comaneci; U.S. basketballer Michael Jordan; and Canadian ice hockey player Wayne Gretzky. In addition, and perhaps more importantly, Coutts's achievements took place within a specific sociohistorical context; he was the right person at the right time (see Ingham et al., 1993; Rojek, 2001). As Rojek (2001) argued more generally, Coutts's actions help to "work over 'useful' questions" (p. 12) related to increasingly contested issues of the "loyalty" of professional athletes to the nation in a rapidly globalizing sporting and national landscape (see also Wong & Trumper, 2002). Miller, Lawrence, McKay and Rowe (2001) pointed out that "globalization confuses identity—one effect of which is to question the meaning and efficacy of nationalism" (p. 37), especially when individuals compete for other nations, or national teams are made up of individuals from a range of origins. Such combinations "blur the meaning of 'us' versus 'them,' the traditional core of nationalist sentiment" (Miller et al., 2001, p. 37).

Although Coutts was internationally successful, winning Olympic gold in 1984 and the world match race yachting title in 1996, it was via New Zealand's America's Cup campaigns that he rose to heroic status. The 1995 America's Cup success captured the nation's hearts and catapulted Coutts and others into the public limelight:

> Peter Blake, already a hero, now achieved a godlike status, his fellow crew being right there with him. Names such as Russell Coutts . . . were 12 months previously known only to those associated with yachting. Now they had a place and a meaning in every New Zealand household. (Freer, 1995, p. 19)

Coutts was represented as a "hero" (e.g., Knight, 1995, p. 23; Sanders, 1996, p. 11) and his contribution to the team's success recognized in awards including New Zealand's second highest civilian honor, the Companion of the British Empire (CBE), the International Yacht Racing Union World Sailor of the Year ("Sailing's Best," 1995), and induction into the America's Cup Hall of Fame. However, others saw Coutts's sudden, iconic status differently. Jackson (2004) asserted that it was "through a carefully orchestrated and corporate and media manufactured spectacle [that] a group of white middle class Kiwis competing in a relatively exclusive sporting event on the other side of the world emerged as both global and local heroes" (p. 24). The influence of corporate sponsors, including the national broadcaster, Television New Zealand (TVNZ), on Coutts's and Team New Zealand's national profiles is

confirmed by veteran journalist, Ron Palenski (1995), who argued that "it was television, and its bedfellows, the sponsors, which turned *Black Magic's* outstanding success off San Diego into an orgy of national celebration and back-slapping" (p. 24). Mass celebrations took place around the country as the team, Cup in tow, paraded through major urban centers in front of the largest crowds since the end of World War II; more than a third of the population turned up to demonstrate their patriotism and affection (Boshier, 2002; Daniels, 1995; Larsen, Forster, & Coutts, 1999).

In order to defend the Cup, the Auckland harbor had to be redesigned, with the American Express New Zealand Cup Village being developed to host the syndicates, as well as private industries (such as hospitality and apartments) looking to reap financial benefits from a large global event (Larsen, Forster, & Coutts, 1999). It has been estimated that the waterfront development of Viaduct Harbour and 2000 America's Cup added $640 million to New Zealand's economy (Becht, 2002). By this time, Coutts had joined Blake as the main face of a campaign that cruised to a 5-0 victory over Italy's Prada syndicate, the first time in the history of the Cup that the USA was not represented in the finals (Rayner, 2003). Team New Zealand, buoyed by a vast crowd of supporters, also made history as the first country outside the USA to successfully defend the Cup (Rayner, 2003).

The initial response was to further increase Coutts's heroic status. He was described as "a national hero" (Broomhall, 2000, p. 17) and "the best in the world" ("Dialogue," 2000, para. 18) and nominated for New Zealand's top sportsman award. Coutts thus joined a long line of male New Zealand heroes whose status derived from achieving for New Zealand on the global stage. These include his America's Cup teammate, Sir Peter Blake (Bruce & Wheaton, 2009, 2011; Cosgrove & Bruce, 2005) and Sir Edmund Hillary, the first to stand at the world's highest point, Mount Everest, with Sherpa Tenzing Norgay in 1953 (Hansen, 2000; Pickles, 2002).

Fallen Hero: Russell Coutts the "Traitor"

Coutts's fall from grace was rapid, occurring only 10 weeks after the celebrated defense of the Cup, when he and long-time tactician, Brad Butterworth, announced they had taken roles with a rival syndicate, soon to be followed by the majority of Team New Zealand's sailors, designers, and tacticians who signed on with a range of different syndicates (Rayner, 2003). Although some media acknowledged the global context in which professional athletes ply their trade ("Team NZ Defectors," 2000), their decision was widely decried as a

betrayal and treason, and they were called traitors, defectors, gold miners and "mercenary mariners" (Smith, 2000, para. 2) "who valued love of money above love of country" (Phillips, 2000, p. 324; see also "A Year of Pain and Glory," 2000; Broomhall, 2000; Bruce & Wheaton, 2011; "From Hero to Villain," 2000; Hinton, 2000; Holloway, 2000; John & Jackson, 2010).

Unlike other fallen heroes, whose actions may include violence (domestic or sexual violence, assault, murder), socially unacceptable activities (drunk-driving, recreational drug-taking), or cheating (match-fixing, betting, perform-ance-enhancing drugs), the problem for Coutts was that his patriotism was brought into question. Unlike Blake, whose continued heroic status relied upon the fact that he "*identified* as a New Zealander, sailed *for* New Zealand syndicates and won international recognition *for the nation*" (Bruce & Whea-ton, 2011, p. 194), Coutts was seen as not only *defecting to* another nation but sailing *against his own*.

However, there were other layers to the sense of betrayal, related to the in-consistency of promoting a transnational event in nationalistic terms. Several media commentators linked "the derision of a public scorned" to the overtly patriotic way in which Team New Zealand "had marketed themselves as a national challenge, asking for moral and monetary support to unite a small sports-mad country against the foreign raiders" ("Dialogue," 2000; Johnstone, 2000; Laxon, 2001; Tunnah, 2000, para. 5-6). Sports commentator Murray Deaker put it more bluntly:

> Dear Russell, you conned me. . . . I don't have a problem with you taking the money, but don't ask me to believe any more bull****. No more talk ever about dynasties, loyalty, team or traitors. You see, the favour you've done is to show that it isn't about sport—it's just about money. I don't know why I ever changed my mind. (Laxon, 2001, para. 46)

In the face of the public backlash, Coutts withdrew from his role as an Olympic torchbearer, a decision one newspaper attributed to his recognition of "the extent of his tumble from public grace" ("Editorial," 2000, para. 4; Smith, 2000).

The vitriolic nature of the media and public response clearly demonstrated that Coutts's decision had touched a cultural nerve, activating already acute, cultural anxieties about the shift of sports from the historically amateur ethos of commitment to the nation to a professionalised model. It is likely that Coutts did not fully anticipate the public antipathy his announcement would provoke. He appeared to believe that the New Zealand public understood the realities of life for professional yachtsmen, arguing that "many people were beginning to understand the moves as part and parcel of a sport that was becoming totally professional" (Larsen & Coutts, 1996, p. 110) and that

"Kiwis can understand sailors leaving their nation for greater rewards on a foreign boat" (p. 20). However, as Coutts was to discover, New Zealanders might understand sailors leaving for greater rewards, but few condoned competing against, let alone defeating, the home country.

The Meaning of Loyalty: 2002–2003

The emotion and anxiety about Coutts's defection did not die down over time. Instead, it intensified as the 2003 defense neared, with Coutts (and his long-time tactician, Brad Butterworth) functioning as the most visible target of broader concerns about (sporting) patriotism and loyalty. Throughout the Cup competition, Coutts and New Zealand sailors in other syndicates were regularly described as mercenaries, traitors, deserters, turncoats, and defectors who had abandoned their country.

The intensity of these concerns emerged in highly visible ways via two campaigns—Loyal and BlackHeart—each of which directly responded to issues related to patriotism and transnationalism, albeit in different ways (Jackson, 2004; John & Jackson, 2010). The contested nature of New Zealanders' search for identity that results from both embracing and resisting transnational processes (Andrews, Carrington, Jackson, & Mazur, 1996) was evident in the acceptance (or tolerance) of foreign funding and sponsorship of Team New Zealand but resistance to New Zealanders sailing for other syndicates. It could be argued that Team New Zealand and the national broadcaster, TVNZ, attempted to conceal these transnational processes through promoting the team in nationalistic terms, despite a number of sponsors (such as Toyota and SAP) being multinational corporations. Some members of the public were quick to note the inconsistencies in media and public portrayals of transnational processes within Team New Zealand and the negative representation of New Zealanders like Coutts on opposing syndicates:

> Team New Zealand have French sailing legend Bertrand Pace sailing for them, but he is not referred to as a traitor. . . . And nobody has dared to suggest that the Japanese and German multinationals who are funding Team New Zealand are traitors. (Wood, 2003, p. A20)

Thus, while TVNZ highlighted and promoted Team New Zealand's America's Cup defense as being about *us* versus *them*, there remained some public disquiet that this position contradicted the commercial and personnel makeup of the team. Other media also directly acknowledged the effects of transnational processes, including the many New Zealanders on rival boats, with one newspaper referring to Alinghi as "Team Swit-zealand" (Nicholson,

2003, p. A1). Just before the Louis Vuitton final, one newspaper highlighted the New Zealand sailors leading each team: Russell Coutts was shown with the backdrop of a Swiss flag (for Alinghi), while Chris Dixon appeared in front of an American flag (for the other challenger, Oracle BMW). Indeed, throughout the Louis Vuitton Cup finals many articles and editorials encouraged Kiwis to be proud of all *our* sailors no matter who they sailed for. In part, this focus could be read both as a celebration of New Zealand achievement and a critique of rival teams as dependent upon, and perhaps even poaching, New Zealand's elite talent pool.

The complexity of New Zealand's relationship with transnational sporting practices also became visible in two simultaneous campaigns around the America's Cup. Coutts was a major catalyst and activating force for the short-lived but highly controversial BlackHeart campaign (Coffey, 2003; Ralston, 2003) which directly targeted sailors who had left Team New Zealand in 2000. Watkin (2003) explained that Coutts was attacked from the beginning by BlackHeart, which comprised "a bunch of blokes having a beer, who decided to form a deep cover group to say the things Team New Zealand couldn't" (para. 14). BlackHeart developed what one newspaper categorized as the "'Country before Money' traitor-targeting media campaign" ("Once Was," 2003, p. 1) that included billboard messages such as "Coutts and Co—Swiss Bankers since 2000" (Watkin, 2003, para. 7). A BlackHeart supporter explained that BlackHeart wanted to "ensure all New Zealanders remember the fact that Russell Coutts declared he was going to build an America's Cup dynasty for New Zealand then betrayed that promise . . . and lured half of the Team New Zealand crew to defect with him" (Ralston, 2003, p. 22). Black-Heart's actions appeared to challenge the group's stated aims of linking patriotism to support of Team New Zealand:

> We are proud of our country and everything it has achieved. If you, too, are a staunch and *true* New Zealander, you have the right to wear the Black Heart. . . . Home is where the heart is, and ours is Black.[1] . . . This summer we're putting our hearts right behind *our* boat, New Zealand. Show *them* your pride, and show the world your Black Heart. (BlackHeart, as cited in Smythe, 2002, p. A19, emphasis added)

The campaign voluntarily ended after "some of the so-called traitors," including Coutts and other members of Alinghi, received letters threatening "grievous bodily harm" (Rayner, 2003, p. 96) from a group called Teach the Traitors a Lesson; the letters used phrases similar to those in emails BlackHeart circulated to its 3,000 members, although BlackHeart was not found to have any direct involvement (Ash, 2003; Chapple, 2003; "Children of Cup," 2003; Lowe, 2003). BlackHeart generated a significant backlash that suggested some level of acceptance of the realities of the global sporting

environment. Columnist Doug Golightly, who described BlackHeart as "pathetic" and "a bunch of disaffected dickheads. . .living in a dream world where sportsmen and women are not supposed to ply their trade in a professional environment" (2002, p. 36), was not alone in his response. Golightly pointed out that Coutts and others "have done wondrous things for New Zealand over the years" and described the campaign "that actively puts the boot into them" as "disgraceful" (2002, p. 36).

The potency of issues of patriotism was also evident in a second campaign, developed by Saatchi & Saatchi New Zealand and launched by Team New Zealand's major sponsors, known as the Family of Five, which comprised five global and local corporations, along with Television New Zealand, the event broadcaster (see John, 2008). The Loyal campaign, centered on the popular song of the same name by New Zealander, Dave Dobbyn, aimed to "give our team the emotional advantage" and "unleash the nationalism that lies deep within the Kiwi psyche" (Effie, 2003, p. 2). Yet, as Saatchi & Saatchi general manager, Peter Moore, pointed out, the Loyal campaign also highlighted the *us* versus *them* theme central to BlackHeart's approach: "We have to make it look like . . . it would be disloyal to support those other guys; we have to be loyal to ourselves (Peter Moore, personal communication, October 26, 2006).

Sports, through the positioning of heroes and villains, are a useful marketing tool (Jackson & Andrews, 2005). Thus, both the Loyal and BlackHeart campaigns seemed to position Dean Barker and Team New Zealand as heroes, while Russell Coutts and Alinghi were regarded as pirates attempting to capture the Cup and the subsequent economic benefits:

> BlackHeart was saying things that we all felt, but it'd be inappropriate to say it with a sponsor's logo anywhere near you. Somebody had to come out and call Russell Coutts a cheat, a traitor, because that's how we felt. (Peter Moore, personal communication, October 26, 2006)

Andrew Tinning, creative director, emphasized that the Loyal campaign was developed to build a strong following for the sailors who stayed loyal to New Zealand while distracting New Zealand sailors in other syndicates: "it was sort of designed to add to the pressure . . . that was on those guys" (Andrew Tinning, personal communication, November 30, 2006).

With this approach, the Family of Five strategically constructed a vehicle through which people could both identify as patriotic but also be targeted as consumers (Jackson, 2004; John & Jackson, 2010); the aim was to create a devoted base of support for the syndicate and their own brands. The use of the loyalty theme thus encouraged New Zealanders to be loyal to the purchasing of Family of Five commodities as well as to the syndicate and those sailors who showed "loyalty" to the nation. However, because of the BlackHeart campaign,

concern arose that Loyal was predominantly about putting pressure on the "defectors." Tinning explained that "there was sort of a bit of fear at some point that people would associate the two . . . obviously there was reference to those guys defecting . . . [but] it was more about staying loyal to our team" (Andrew Tinning, personal communication, November 30, 2006). Likewise, Telecom's summary report of the 2003 America's Cup illustrates that it was equally concerned with the BlackHeart campaign, believing it had been detrimental to the sponsors and the Loyal campaign:

> The manner in which the group conducted themselves and the aggressive way it targeted members of the Swiss syndicate was not always well received by the public and many of them were unable to distinguish between "Blackheart" and *Loyal*. The aggressive approach of "Blackheart" in fact probably divided the country rather than uniting it. ("Telecom 2003 America's Cup," p. 12)

Although there was a conscious effort to differentiate the campaigns and frame Loyal positively, it remains unclear whether BlackHeart was completely separate from Loyal or initiated to coincide with it. Loyal producer, Juliet Dreaver, was aware of at least one person involved in the Loyal campaign who might have been affiliated with BlackHeart but explained that this person "didn't have any official or obvious link at all, because he couldn't, because it would have looked very bad if any of the Family of Five sponsors were linked to that" (Juliet Dreaver, personal communication, October 8, 2006).

Conclusion: Loyalty in a Transnational Context

Our analysis suggests that New Zealanders are increasingly cognizant of, but remain resistant to, the realities of being a small nation that produces world-class athletes yet struggles to hold on to them in an increasingly global sporting landscape. In this context, the public anger towards the "defections" of Russell Coutts and others from Team New Zealand is understandable. Given that people's understandings of nationalism tend to be grounded in "real individuals, real places and real community groups" rather than abstract ideals (Phillips & Smith, 2000, p. 220), it should not be surprising that "acute anxieties" about New Zealand's increasing immersion in transnational processes were worked over in the nationally significant context of international sports and in relation to an individual, Russell Coutts.

New Zealanders had invested heavily in America's Cup campaigns, both emotionally and financially via direct government funding of Team New Zealand and indirect support through government-funded agencies that sponsored the team (Jackson, 2004; John & Jackson, 2010). This funding, in part,

publicized and enabled Coutts to demonstrate his skill to potential employers, with the result that he "defected" to another syndicate for a salary similar to that of the highest paid footballers (Ash, 2004).

However, there is some irony when comparing the similarities between those labelled as mercenaries and the involvement of transnational corporations in sponsoring Team New Zealand. In 2003, the patriotic Loyal promotional campaign drew directly on the public anger towards sailors such as Coutts. By implementing the theme of loyalty, the corporations were advising New Zealanders to resist the processes of globalization that encourage people to sell or export their skills, while at the same time encouraging New Zealanders to buy or import global commodities. Within the context of years of economic deregulation, we should not be surprised that many New Zealanders may have been confused as to how to react to New Zealanders sailing for other syndicates. Should New Zealanders support these so-called mercenary sailors— doing what they had been informed to do under years of neoliberalism "where looking after Number 1 transcended collective aspirations" (Boshier, 2002, para 29)—or should they decry their actions that ultimately had a significant detrimental economic impact on the nation? The overall reaction suggests that most took the route of vilification; despite having won two America's Cups *for* New Zealand, it was Coutts's success *against* the nation that galvanized public emotion and anger and cemented his place as a traitor and fallen hero in the public consciousness. Loyalty was the action recommended by journalists, the media, BlackHeart, the Family of Five and Television New Zealand. However, the media coverage and campaigns left unanswered questions: Loyal to what? Loyal to whom? Loyal under what conditions? And loyal in whose interests?

Note

[1] The word *black* is intimately connected with New Zealand identity, particularly through sports teams, which carry names such as the All Blacks, Black Ferns, Tall Blacks, and Black Sticks, and often compete in black uniforms.

References

Andrews, D. L., Carrington, B., Jackson, S. J., Mazur, Z. (1996). Jordanscapes: A preliminary analysis of the global popular. *Sociology of Sport Journal*, 13(4), 428–457.

Ash, J. (2003, January 8). Threats prompt flood of support for Alinghi. *New Zealand Herald*, p. A5.

Ash, J. (2004, September 8). Coutts' salary up with soccer superstars says Bertarelli. *New Zealand Herald*. Retrieved from http://www.nzherald.co.nz/sport/news/article.cfm?c_id=4&object

id=3589922

A year of pain and glory. (2000, December 30). *Southland Times*, no page number.

Becht, R. (2002). *The Team New Zealand story, 1995-2003*. Auckland, New Zealand: Saint.

Boorstin, D. (1992). *The image: A guide to pseudo-events in America*. New York, NY: Random House.

Boshier, R. (2002, March 2). *Cultural struggle, learning and leadership on the down-under quest for the America's Cup*. Paper presented at the Annual Conference of the Australasian Studies in North America Association, University of British Columbia, Vancouver, British Columbia, Canada. Retrieved from https://www.edst.educ.ubc.ca/boshier/RBtcultural.htm (no longer accessible).

Broomhall, K. (2000, December 26). The good, the bad, and the ugly. *Dominion*, p. 17.

Browne, R. B., Browne, G. J., Browne, K. O., Straub, D. G., Rooney, T. M., & Barnes, D. R. (1990). *Contemporary heroes and heroines*. Detroit, MI: Gale Research.

Bruce, T., & Wheaton, B. (2009). Rethinking global sports migration and forms of transnational, cosmopolitan and diasporic belonging: A case study of international yachtsman Sir Peter Blake. *Social Identities, 15*(5), 585-608.

Bruce, T., & Wheaton, B. (2011). Diaspora and global sports migration: A case study in the English and New Zealand contexts. In J. Maguire and M. Falcous (Eds.), *Sport and migration: Borders, boundaries and crossings* (pp. 189-199). London, UK: Routledge.

Chapple, I. (2003, January 3). Controversial sails pitch the big news. *New Zealand Herald Online*. Retrieved from http://www.nzherald.co.nz/business/news/article.cfm?c_id=3&objectid=3049713

Children of Cup sailors threatened. (2003, January 4). *Waikato Times*, p. 2.

Coffey, J. (2003, January 16). Team NZ support group BlackHeart to step out of public eye. *Christchurch Press*, p. 7.

Cosgrove, A., & Bruce, T. (2005). 'The way New Zealanders would like to see themselves': Reading white masculinity via media coverage of the death of Sir Peter Blake. *Sociology of Sport Journal, 22*(3), 336-355.

Daniels, C. (1995, May 26). Celebration brings city to a halt. *Dominion*, p. 3.

Dialogue: Man of the year, if we remember. (2000, December 23). *New Zealand Herald*, no page number.

Editorial: Few loyal to footloose sports pros. (2000, June 3). *New Zealand Herald*, no page number.

Effie. (2003). *2003 Effie Awards case study*. Retrieved from http://www.caanz.co.nz/pdf/effie_2003_19.pdf (no longer accessible).

Freer, J. (1995, December 22). One out of four in prizes, but nine out of 10 in effort. *Evening Post*, p. 19.

From hero to villain. (2000, September 6). *Waikato Times*, p. 1.

Golightly, D. (2002, September 20). A disgrace. *The Truth*, p. 36.

Hansen, P. H. (2000). Confetti of empire: The conquest of Everest in Nepal, India, Britain, and New Zealand. *Comparative Studies in Society and History, 42*(2), 307-332.

Hinton, M. (2000, December 31). Running with pack ain't all bad. *Sunday Star Times*, p. 4.

Hodder Moa Beckett. (2000). *Back to back: Black Magic*. Auckland, New Zealand: Author.

Holloway, B. (2000, December 23). Welcome to the real gong show . . . *Waikato Times*, no page

number.

Hope, W. (2002). Whose All Blacks? *Media, Culture & Society, 24*(2), 235–253.

Ingham, A., Howell, J., & Swetman, R. (1993). Evaluating sport 'hero/ines': Contents, forms, and social relations. *Quest, 45*(2),197–210.

Jackson, S. J. (2004). Reading New Zealand within the new global order: Sport and the visualisation of national identity. *International Sport Studies, 26*(1), 13–29.

Jackson, S. J. (2006). Sport heroes and celebrities. In G. Ritzer (Ed.), *The Blackwell encyclopedia of sociology* (pp. 4711–4713). Oxford, UK: Blackwell.

Jackson, S. J., & Hokowhitu, B. (2002). Sport, tribes, and technology: The New Zealand All Blacks haka and the politics of identity. *Journal of Sport and Social Issues, 26*(2), 125–139.

Jackson, S., & Andrews, D. (Eds.). (2005). *Sport, culture and advertising: Identities, commodities and the politics of representation.* London, UK: Routledge.

Johannsen, D. (2010, February 16). Coutts' four Cups for three nations: 1995, 2000, 2003 Kiwi record holder. *New Zealand Herald,* p. A1.

John, A. (2008). *Call me loyal: Globalisation, corporate nationalism & the America's Cup in New Zealand* (Unpublished master's thesis). University of Otago, Dunedin, New Zealand.

John, A., & Jackson, S. (2010). Call me loyal: Globalisation, corporate nationalism and the America's Cup, *International Review for the Sociology of Sport.* doi:10.1177/10126902103 84658

Johnstone, D. (2000, June 4). Conned by the rich boys. *Sunday Star Times,* p. 2.

Knight, L. (1995, December 27). Plenty to savour from heroes despite setbacks. *Dominion,* p. 23.

Laidlaw, C. (1999). *Rites of passage: Beyond the New Zealand identity crisis.* Auckland: Hodder Moa Beckett.

Larsen, P., & Coutts. R. (1996). *Russell Coutts: Course to victory.* Auckland, New Zealand: Hodder Moa Beckett.

Larsen, P., Forster, D., & Coutts, R. (1999). *America's Cup 2000: Including the Louis Vuitton Cup.* Auckland, New Zealand: Hodder Moa Beckett.

Laxon, A. (2001, November 26). If the jersey fits, then wear it. *New Zealand Herald,* no page number.

Lowe, M. (2003, January 5). BlackHeart newsletter linked to America's Cup threats. *Sunday Star Times,* p. 1.

Miller, T., Lawrence, G., McKay, J., & Rowe, D. (2001). *Globalization and sport: Playing the world.* London, UK: Sage.

Nicholson, O. (2003, March 1–2). Team Swit-zealand close in on victory as Black Boat sailors vow to battle on. *New Zealand Herald,* p. A1.

Obel, C., & Austrin, T. (2011). Touring, travelling and accelerated mobilities: Team and player mobilities in New Zealand rugby union. In J. Maguire & M. Falcous (Eds.), *Sport and Migration: Borders, Boundaries and Crossings* (pp. 259–273). London, UK: Routledge.

Once was a New Zealander? (2003, September 29). *Sunday Star Times,* p. 1.

Palenski, R. (1995, May 16). Television a catalyst for barnstorming national pride. *Dominion,* p. 24.

Phillips, J. (2000). Epilogue: Sport and future Australasian cult. In J. A. Mangan & J. Nauright (Eds.), *Sport in Australasian society: Past and present* (pp. 323–332). London, UK: Frank Cass.

Phillips, T., & Smith, P. D. (2000). What is 'Australian'? Knowledge and attitudes among a

gallery of contemporary Australians. *Australian Journal of Political Science, 35*(2), 203–224.

Pickles, K. (2002). Kiwi icons and the re-settlement of New Zealand as colonial space. *New Zealand Geographer, 58*(2), 5–16.

Ralston, B. (2003, January 22). PR wins over advertising as BlackHeart folds its tents. *The Independent* (New Zealand's Business Weekly), p. 22.

Rayner, R. (2003). *The story of the America's Cup: 1851–2003.* Auckland, New Zealand: David Bateman.

Rojek, C. (2001). *Celebrity.* London, UK: Reaktion Books.

Sailing's best. (1995, November 9). *Evening Post,* p. 28.

Sanders, A. (1996, October 13). Japan dangled deal to Coutts to jump ship. *Sunday Star Times,* p. 11.

Scherer, J., & Jackson, S. J. (2010). *Globalisation, sport and corporate nationalism: The new cultural economy of the New Zealand All Blacks.* Oxford, UK: Peter Lang.

Smith, G. (1973). The sports hero: An endangered species. *Quest, 19,* 59–70.

Smith, T. (2000, December 29). ABC of success. *The Press.* Retrieved from www.stuff.co.nz

Smythe, M. (2002, September 20). BlackHeart a bold branding blunder. *New Zealand Herald,* p. A19.

Team NZ defectors deserve their money. (2000, June 1). *Evening Post,* p. 4.

Telecom 2003 America's Cup Summary Report. (2003). Auckland, New Zealand: Telecom New Zealand.

Tunnah, H. (2000, December 19). Team NZ dominates on and off the water. Retrieved from http://www.stuff.co.nz

Watkin, T. (2003, January 19). BlackHeart sailed off course. *New Zealand Herald,* no page number.

Wensing, E. H., & Bruce, T. (2004). Playing to win or trying your best: Media representations of national anxieties over the role of sport participation during the 2002 Commonwealth Games. *Waikato Journal of Education, 10,* 203–220.

Wong, L. L., & Trumper, R. (2002). Global celebrity athletes and nationalism: *Fútbol,* hockey, and the representation of nation. *Journal of Sport & Social Issues, 26*(2), 168–194.

Wood, P. (2003, January 4–5). America's Cup rules. *New Zealand Herald,* p. A20.

Running Down What Comes Naturally: Gender Verification and South Africa's Caster Semenya

Cheryl Cooky
Shari L. Dworkin

At the turn of the 20th century, the increased participation of women in sport, combined with Cold War strategies wherein sports were often used to justify and legitimate a country's economic, political, and social organization, led to questions regarding the sex or gender of female athletes (Cole, 2000; Ljungqvist, Martinez-Patino, Martinez-Vidal, Zagalaz, Diaz, & Mateos, 2006). In this way, the history of sex testing (also referred to as gender verification testing) is inextricably linked with the Cold War, as international sports competition became the symbolic realm wherein politically based, ideological struggles between capitalism and communism manifested.

Gender ideologies intersected with assumptions of ascendancy in both capitalist and in communist societies. Capitalist countries suspected Soviet or communist female athletes of not being "real" women, given their "masculine" appearance. Fears that the elite performances in women's sports, especially among athletes from communist countries, were not the product of "real" female competitors, combined with the high political stakes of international competition during the Cold War, led governing sports bodies to implement mandatory "sex tests" for female athletes. In the 21st century, after the fall of the Berlin Wall in Germany and the dissolution of the communist Soviet Union, some have suggested that previous Cold War tensions between capitalism and communism have been replaced by tensions between First World or Global North and Third World or Global South nations. In this postcommunist context, the fear is that Third World nations will send men disguised as women to international sport competitions (Schuhmann, 2009). Thus in contemporary sport, the justification for sex testing has been displaced onto tensions between First World or Global North and Third World or Global

South nations, whereby the Global South is disproportionately accused of violating fair competition.

Recently, these fears were embodied in the sex or gender controversy surrounding Caster Semenya. Semenya, a University of Pretoria student and track athlete, age 18 at the time, competed in the 800 meters at the World Championships in Berlin on August 19, 2009. She won the event in 1:55.45, two seconds slower than the world record but 2.45 seconds faster than second place finisher, Janeth Jepkosgei. The International Association of Athletics Federations (IAAF) officials first suspected Semenya of doping. Several news media accounts claimed the IAAF ordered the tests because of Semenya's "deep voice, muscular build and rapid improvement in times" (Associated Press, 2009). Pierre Weiss, general secretary of the IAAF stated in a press conference that Semenya was undergoing testing because of "ambiguity" regarding her gender and not because the IAAF suspected her of knowingly cheating.

Gender verification policies positioned Caster Semenya to be a "fallen hero" within the context of international track and field, and she was framed as such within the mainstream news media, particularly in the United States. Yet, given the political context of international sports competition, wherein athletes, and especially female athletes, serve as representatives of the nation-state (Bruce, 2009), and where sports competition becomes a powerful site for contemporary struggles between the First World or Global North and the Third World or Global South, Semenya was embraced as a heroine within South African society and was framed in South African media as a "Golden Girl" and "Our First Lady of Sport" (Cooky, Dycus, Dworkin, 2012; Dworkin, Swarr & Cooky, in press).

In this chapter, we explore these paradoxes by examining the ways in which the controversy surrounding Caster Semenya and her possible intersexuality were framed by mainstream newspapers in the United States and in South Africa. We begin the chapter with a brief discussion of the history of gender verification in sports. We then discuss the ways in which Semenya was framed as a "fallen hero" in United States print news media reports given her alleged sex or gender liminality. We contrast the United States frames to the different framings of Semenya in South African media that contested her status as "fallen heroine" by using discourses of human rights, nationalism, and accusations of sexism, racism and Eurocentrism against the IAAF. We conclude the chapter by contextualizing Caster Semenya's fall and rise within broader power relations between the Global North and Global South. We argue that the media frames of Caster Semenya and the subsequent controversy offer unique understandings of how fallen heroes become implicated

within broader sociopolitical dynamics and tensions. In the case of the United States media frames, personal failings and individualism prevailed, as blame was placed on Semenya for her potential intersexuality. In the South African context, accusations of sexism and racism in international sports and in broader global contexts were central.

Gender Verification or Sex Testing: Constructing Semenya as a "Fallen Heroine"

The International Olympic Committee first instituted mandatory sex testing in 1968, later abandoning its policy in 1998 (Ljungqvist et al., 2006). For the International Amateur Athletic Federations (IAAF) competitions, mandatory sex testing was established in 1960 (Simpson et al., 1993). Prior to mandatory sex testing, female athletes would participate in "nude parades" wherein athletes would walk naked in front of an appointed medical professional or sports official. However, advances in technology (specifically the Barr Body chromosome test) eliminated the need to rely solely on a physical test to verify sex or gender and were thought to be less invasive for the athlete. The Barr Body chromosome test was used until 1992 when it was replaced by the Polymerase Chain Reaction (PCR) test of the SRY gene, a DNA-based form of testing. However, the test produced an "unfortunate number of false-positive test results" (Reeser, 2005, p. 696), and female athletes were wrongly told they were not "real women."

While there are no documented instances where sex testing uncovered a male athlete masquerading as a woman in order to gain an unfair advantage in sport (Ritchie, Reynard, & Lewis, 2008), there have been several known cases where female athletes were determined not to be "biological" females and were subsequently barred from competition (see Cavanagh & Sykes, 2006). Thus, the fall of female athletes due to sex testing serves an ideological and practical function of policing the boundaries of sex in sex-segregated, male-dominated sports. There is no institutionally recognized place for women who are determined not to be biologically female to compete in the institution of sports. Athletes who "fail" the tests and who are deemed to have an "unfair advantage" receive a recommendation from the international governing bodies to feign injury or to quietly "retire" from the sport.

In the late 1980s and early 1990s, as a result of several high profile cases involving female athletes who failed sex tests along with scientific criticisms regarding the veracity of the tests, members of the international medical community argued against the use of chromosomal or genetic screening of

female athletes (see Simpson et al., 1993). As a result, the IOC abandoned mandatory sex testing of female athletes in 2000 during the Sydney Olympic games. Similarly, the IAAF's "Policy on Gender Verification" (2006) no longer requires "compulsory, standard or regular gender verification during IAAF sanctioned championships." For the IAAF, determining an athlete's gender "should not be done solely on laboratory based sex determination." National team doctors are expected to be aware of any "problems related to the issue" through either health inspections of their athletes or during doping controls at major athletic events. The IAAF's policy also states that should a "suspicion" or "challenge" arise, the athlete will be asked to undergo a medical evaluation by a panel of scientific experts, including a gynecologist, an endocrinologist, an internal medicine specialist and an expert on gender or transgender issues.[1]

Sports governing bodies and their policies assume that all men in athletic competitions will be categorically superior to all women in the same event (Kane, 1995). This is part of the rationale for keeping the sexes segregated in sports competition. Female athletes who undergo gender verification testing risk becoming fallen heroines when science serves the ideological purpose of identifying those who are "in-between" the rigid sex dichotomy and attempts to place them in one sex category or the other.

Similar to other female athletes, including Ewa Klobukowska, Maria Jose Martinez Patino, and Santhi Soundarajan, all of whom were not allowed to compete as women or had their medals revoked, Caster Semenya was nearly denied the opportunity to participate in sport. However, she was ultimately allowed to keep her gold medal from the 2009 competition and remained eligible to compete in women's sport competitions. A key distinction between Semenya and other female athletes who underwent gender verification testing was the unique response in South Africa. Political leaders, including South African President, Jacob Zuma, and leaders within South African sports organizations and women's advocacy groups vociferously chastised the IAAF. The National Assembly Sports Committee Chairperson and the African National Congress filed an unprecedented complaint with the United Nations Commission on Human Rights, accusing the IAAF of racism and sexism. The presumptions of Semenya's gender liminality among the international sport community and in many countries outside of South Africa, including the United States, was in stark contrast to South Africa's contestation of her fall and their embracement of Semenya as a national "heroine." Rather than viewing her participation as a violation of the policies of sex-segregated sports, South African politicians, sports stakeholders, and members of South African society viewed the mandatory gender verification test as racist, sexist, and as a

violation of Semenya's human rights to compete in sports (Dworkin, et. al., In press).

Method

Mediated messages (e.g., news media coverage) are not objective accounts of events. Instead, the media privilege certain interpretations while simultaneously discouraging others (Fiske, 1996). In other words, what is included in the story, and more importantly, how it is discussed help "frame" an event for the reader or viewer (Fiske, 1996). We utilized a combination of content analysis (quantitative counts of media framings) and textual analysis (qualitative examination of media frames) to examine how the news media create and recreate narratives, which are linked to dominant ideas or ideologies that circulate in wider society (for a detailed explanation of this methodology see Cooky, Wachs, Dworkin, & Messner, 2010). In this chapter, we direct our analysis to explore the ways in which "fallen heroes" are framed by the mainstream news media, and offer important comparisons between newspapers in the United States and South Africa. This comparison provides a critical analysis on the role of the news media in privileging certain interpretations (Fiske, 1996).

We analyzed newspaper coverage of the Caster Semenya controversy in 13 national and regional newspapers in the United States and in three South African newspapers (as U.S.-based scholars, we were limited by the accessibility and availability of South African media in the United States). Articles on Caster Semenya were retrieved from August 19, 2009 to January 21, 2010, which produced a total of 215 articles, 53 from United States newspapers and 162 from South African newspapers.

United States Media Frames: Semenya as "Fallen Heroine"

One of the prominent ways that Semenya was framed as a "fallen heroine" in the United States news articles was to compare her with other "fallen heroes" in sports. Interestingly, the athletes with whom Semenya was compared had fallen from hero status due to their personal behavior and actions, whereas Semenya's "fall" was due to no fault of her own. Rather, she failed to conform to the limiting notions of sex or gender as constructed by sport organizations to legitimize sex-segregated sports. Here it is fairly important to underscore that Semenya cannot be personally blamed if she did not conform to the sex or gender binary. Rather than blaming Semenya for some sort of perceived

personal failing, print media frames could have engaged with the way that key stakeholders within international sports organizations make policies that refuse to accommodate a continuum of sex or gender within men's and women's sports. Unfortunately, Semenya herself was often blamed for not fitting uniformly into the sex or gender binary. For example, in an article in *The New York Times* sports journalist Lynn Zinser explained,

> We now have definitive proof that all sports scandals are not created equal. Some, like the controversy over the gender of the women's 800-meter world champion, are impossible to escape without staring for several minutes at the picture of the 18-year-old South African, Caster Semenya, and mulling the options: woman, man, genetics gone awry, we need new glasses? Others, like another NCAA violations case involving John Calipari, are almost instantly digested in one word: again?!?? (2009a, p. 1)

This article compared Semenya and the gender verification controversy to other sports figures who experienced falls, including University of Memphis's then-Coach, John Calipari, whose team had their entire 2007–2008 season stricken from the books as the result of NCAA academic violations (Zinser, 2009a). Another article from *The New York Times* noted how "sports have offered up a wonderful lesson in how not to improve your public image." It discussed the controversy that emerged when former NFL quarterback Michael Vick celebrated his comeback to the NFL by drinking a cocktail during a televised interview, which raised suspicions that he had not changed since serving prison time for running a dog-fighting ring (Zinser, 2009b). Also mentioned were Plaxico Burress, another NFL player who was suspended after he accidentally shot himself in the leg with a firearm at a nightclub, and Michael Beasley, an NBA Miami Heat player who was in rehab. This article focused on how athletes keep their public relations people busy and mentioned that Semenya needed some public relations help after a *London Telegraph* article reported that she had "three times the normal level of testosterone for a woman." The article also noted that even Renee Richards, a retired transsexual women's tennis athlete, doubted Semenya was eligible to compete with women (Zinser, 2009b).

Some articles that discussed the Semenya controversy in the context of other contemporary fallen heroes were more sympathetic and drew linkages between Semenya and other teenage athletes whose lives had come under the public microscope. An article titled, "For some, life lessons come early," written by sport journalist, George Vecsey for *The New York Times*, discussed the challenges of being a teenage sports phenomenon. Andre Agassi, a male professional tennis player, was mentioned as someone who made it through the pressures relatively unscathed. Melanie Oudin, a female professional tennis player, whose parents announced their divorce after her father claimed

that her mother was involved with Melanie's tennis coach; and Jennifer Capriati, who faced shoplifting and drug charges when she was a teen athlete, were mentioned as examples of athletes who faced intense media scrutiny at a young age. Although Caster Semenya was uncritically lumped in with these other athletes, Vecsey did make the following distinction: "Scandal and gossip are almost tame compared to the horrible experience of having one's sex debated in public" (Vecsey, 2009, p. 8). And while sympathetic on the surface, ultimately Vecsey argues this public humiliation was necessary given that so many "athletes will take potent illegal drugs to give them an edge" (Vecsey, 2009, p. 8). In addition to categorizing Semenya as another "failed" athlete, this particular journalist clearly revealed ideals that seek to protect "unfair advantage" in sports whether that "advantage" is achieved through drugs or the biological nuances of one's sex. We will return to debates on unfair advantage in the conclusion. Next, we turn to South Africa's media response to this controversy.

From Fallen Athlete to National Heroine: South Africa's Response to Semenya

The role of sports in nation building cannot be underestimated, especially in developing countries (Padayachee, Desai, & Vahed, 2004). The historical relationship between sports and nation building deserves brief coverage in order to contextualize the South African print media framings of the Caster Semenya controversy. During apartheid in South Africa, the ruling National Party had a highly segregated sports policy and myriad laws and regulations that limited involvement in sport to those designated as white (Cornelissen, 2011; Hargreaves, 2000). For decades, South Africa was not allowed to participate in the Olympics due to apartheid policies that only allowed whites to compete for South Africa in events (Merrett, 2004). In 1994, at the official end of apartheid, Nelson Mandela "brilliantly appropriated the Springbok emblem [in rugby] and transformed it from a symbol of white superiority to one of national unity" (Hargreaves, 2000, p. 29). Unquestionably, in the transitional period, the institution of sports has been represented as a means to bring together South Africans and as central to a struggle for liberation within the country more broadly.

Hargreaves (2000) argued that Black female athletes tend to be "appropriated as heroines in mainstream consciousness as well and not to be seen as representative of their specific communities and identities. The production of Black heroines boosts nation-building and the ideology of equality" (p. 35).

Given the unique role that sports have played in nation building in South Africa's transitional democracy (Cornelissen, 2011; Padayachee et al., 2004), and given the specific role that Black women have played in unifying national identities in sports and in South Africa (Hargreaves, 2000; Pelak, 2010), track star Caster Semenya is a particularly important national icon to South Africans. She is the first Black South African woman to win a gold medal at an IAAF World Championship. She was raised in a rural village in Limpopo where the unemployment rate exceeds 40%, and sporting opportunities are nowhere near what they are in urban areas. Hence, her success in sports was and continues to be seen as emblematic of the ascendency of the "new" South Africa in a burgeoning, emergent democracy. This sentiment is evident in articles, which detail her Horatio Alger-like trajectory through narratives such as: "The classroom has cheap wooden desks lining a bare concrete floor. Paint is peeling off the graffiti-strewn walls beneath a corrugated tin roof. Caster Semenya was just another pupil in this impoverished corner of South Africa until her body propelled her to international glory" (Smith, 2009, p. 1).

A central component of her "glory," which was nothing like the "fall" described in the United States newspapers, were the repeated assurances that, "we in South Africa have no doubts" about Semenya's gender. She was often referred to as "100% female woman." Highlighting the relationship between sports, ideologies of femininity, and nationalism, South African news media reports stated that Caster Semenya returned home after the gender verification controversy and was greeted with cheering crowds who were standing by to welcome "our golden girl," and "our first lady of sport." Her parents and relatives were also featured in media frames when they offered statements such as "she is a woman and I can repeat that a million times" ("Semenya Family: 'She's a Girl,'" 2009). A physician waiting to greet her in the crowd was quoted as saying that the tests were "unfair," and when one sex tests a female athlete, "they are undermining South Africa as a country" (Brooks, 2009). Her school friends from her upbringing stated that "she's a girl" (Smith, 2009), and her parents made claims that they knew this because "I bathed with her, I know" (Schuhmann, 2009). Thus, in contrast to the United States print media frames of Semenya as a fallen heroine, dominant media frames in South Africa defended her by ensuring that Semenya fit firmly into the female sex category.

Further underscoring the important linkages between sports, femininity, and nationalism as well as the overwhelming sentiment of support for Semenya, South African Sports Minister Makhenkesi Stofile said if Semenya was stripped of her gold and disqualified from future sporting events "it would be the *Third World war*" (Geoghegan, 2009; emphasis added). Referring to her

possible removal from sports he stated that, "we would go to the highest levels in contesting such a decision." Stofile's response clearly merged ideologies of gender protectionism and nationalism when he stated that he was "shocked" at how media reports handled and responded to the test results. For Stofile and other South African politicians and sports administrators, Caster Semenya "is a woman, she remains our heroine. We must protect her" (Ori & Johnsson, 2009).

South African leadership was centrally featured in media frames. Through their various claims it was evident that in protecting Semenya, they were also defending South Africa as a nation. In addition to frames that declared the incontrovertibleness of her sex, below we discuss other frames contesting the fall of Semenya.

Contesting the "Fallen Hero": Accusations of Sexism, Racism, and Eurocentrism

In print news media coverage, several groups argued that the treatment of Semenya reflected sexism and gender discrimination in sport. For example, the African National Congress (ANC) spokesperson, Brian Sokutu, stated, "Caster is not the only woman athlete with a masculine build and the IAAF should know better" ("SA Lashes out at 'Racist' World Athletics Body," 2009). He added, "We condemn the motives of those who have made it their business to question her gender due to her physique and running style. Such comments can only serve to portray women as weak" ("ANC Condemns Semenya Gender Row," 2009). The ANC Women's League stated that questions about Semenya's gender "suggest that women can only perform to a certain level and that those who exceed this level should be men" (Bryson, 2009). Butana Komphela, sports committee chairperson, said, "the humiliation of Semenya was a sign of sexist action by the IAAF as it undermined the achievements of women" ("SA to Lodge Complaint with UN over Semenya," 2009). These comments are understandable considering the context of South African society that has moved to embrace women's rights in the postapartheid period, and has worked to fight against the prominence of gender discrimination in sport (Hargreaves, 2000; Pelak, 2005).

In addition to claims of sexism, dominant media frames centered on the racism of subjecting Semenya to gender verification testing. For example, the ANC youth spokesperson implied that the Semenya controversy (e.g., the need for a gender verification test and the interpretation of the results) was shaped by race. He stated, "people who complained about the gender status of Se-

menya were from a different colour" (Letsoalo, 2009). News articles made clear that the treatment of Semenya paralleled the racist subjective testing that was carried out during apartheid to determine if someone belonged to the Black race. A South African journalist reflecting on gender verification testing reported:

> Science it may be, but there is something that, to me, borders on the kind of guesswork reminiscent of the apartheid era "pencil test" which was carried out on black people to determine their race . . . if there was a question mark over your race, you would be called in by the authorities for them to determine what your race was. If the official concerned could not come up with a satisfactory answer simply by looking at you, then the said bureaucrat would whip out a pencil, shove it in your hair, and wait. This was critical state business you see. (Bikitsha, 2009)

Scientific racism during apartheid did indeed define the boundaries of "race" with subjective measures such as the shape and size of one's skull and the texture of one's hair (Dubow, 1995). Moreover, during the "Truth and Reconciliation Commission" that was assembled after the official end of apartheid, there were reports of medical experimentation on Black South Africans, which were documented and shared during public hearings. Thus, given this historical context, it is not surprising that contemporary news reports from South Africa framed IAAF members as "ghoulish, white coated scientists" (Brooks, 2009) and that the President of the South African Track Federation, Leonard Chuene, argued that "we are not going to allow Europeans to define our children" ("Politicians Weigh in on Semenya Debate," 2009). Chuene declared that the controversy "is about racism. These are the same people who don't want the 2010 World Cup, the same people who bring black people down, and the same people who refuse to believe that Africans can make it on the world stage" (Tucker & Dugas, 2009).

The intensity of South African claims concerning racism and sexism and the treatment of Black women have strong histories that are understandable in the context of histories of exploitation of colonialism and present impositions by the Global North (Posel, 2001). However, South African claims of racism and Eurocentrism also negate the reality of Semenya's liminal position regarding her sex and erase a discussion of the social organization of sports that reaffirms dichotomous sex categories in the face of a biological continuum. Such comments also leave readers wondering how Semenya's supporters would have responded if they embraced recognition of a continuum of sex, particularly given South Africa's history of strict gender policing, homophobia, transphobia, and fears of intersexuality (Swarr, 2012).

Conclusion

Female athletes around the world have been required to undergo gender verification testing. However, it is also the case that in particularly contentious political climates women from certain parts of the world, such as the Eastern Bloc, have been disproportionately subject to sex testing (Cole, 2000). Indeed, there is a dearth of athletes from the "First World" who have had to undergo gender verification, underscoring how power relations between regions are implicated and should be more closely monitored to see whether, and to what extent, regional profiling may exist.

In sports, ideologies of nationalism clearly intersect with those of sex and gender to produce surveillance of certain women's bodies. To be clear, under current policies female athletes who present superior athletic performances are viewed with "suspicion" and are subject to sex testing. Ironically, other genetic advantages that are unrelated to sex are allowed without question in the institution of sport (Cooky & Dworkin, in press; Dworkin & Cooky, 2012). As noted by Hercher (2010),

> Taking an excess of testosterone is cheating. Producing an excess of testosterone is a genetic advantage, and there is nothing inherently wrong with that. Genetic advantages are the norm and not the exception in competitive sports. High-level competitive athletes are rife with individuals who are genetic outliers. Men over seven-foot tall are conspicuously overrepresented in the NBA. Lance Armstrong has astounded cardiologists with his freakish ability to maintain the flow of oxygen to his muscle cells. Michael Phelps, possessor of fourteen Olympic medals in swimming, has a long lanky body and an even longer arm span. (p. 552)

Other scholars have also questioned whether one's sex should remain one of the only categories for intense scrutiny in sports:

> Why has Semenya's story made international headlines, while Phelps's genetic advantages have not? Are male athletes permitted to have genetic advantages because they do not have the same ceiling that society puts over women athletes? Are genetic advantages only "unfair" when they give women male-like qualities? (Cooper, 2010, pp. 234–235)

Some feminist scholars note that sex-segregated sports are maintained when sex testing occurs only in women's competitions (or on male-to-female transsexuals) and not in men's (Cavanagh & Sykes, 2006; Cole, 2000; Cooky, et. al., 2012). Recognition of a sex and gender continuum in sports (Kane, 1995) is antithetical to the way sports are organized—maintaining that there are two, and only two sexes, and that separating them into discrete categories serves to ensure "fair competition."

To understand the vastly different frames of Semenya in print news media coverage, it is vital to consider that the United States news media tend to make sense of athletes, both on and off the field, through individualized frames that blame athletes for personal failings and focus on individual behaviors, while negating broader relations of race, class, gender, and sexuality (Cooky et al., 2010). By contrast, frames in South Africa of Semenya as "our girl" who is in need of protection are clearly at odds with United States frames that drew parallels between Semenya and other fallen heroes. In South African print media coverage, Semenya is a "real woman" or a "girl" in need of protection. Because of this frame, she was able to rise up as either an "appropriate woman" or as innocent—someone who cannot or should not be blamed for the actions of adults, who should all have known better. These frames helped solidify her heroine status. Therefore, while the assertions in South African newspapers that Semenya is "our golden girl" ostensibly challenge the way muscularity and superior athletic performances have traditionally been associated with manhood, the terms invoked a paternalistic and protectionist stance toward Semenya. As South African gender activists pointed out, "there was a concerted effort to normalize and feminize Ms. Semenya, to turn her into a "proper symbol of national honour and pride" (Gender DynamiX, 2009). These responses are logical within the historical specificities of the United States and South African contexts, but do little to advance social justice by recognizing a continuum of sex that cannot be ignored when running down what comes naturally in sports.

Note

¹ Since the writing of this chapter, the International Olympic Committee and the International Amateur Athletics Federations have changed their policies. For a discussion of the changes see: Dworkin & Cooky (2012) and Cooky & Dworkin (in press).

References

ANC condemns Semenya gender row. (2009, August 20). *Mail & Guardian.* Retrieved from http://mg.co.za/article/2009-08-20-anc-condemns-semenya-gender-row

Associated Press. (2009, September 16). IAAF: Semenya decision in November. Retrieved from http://sports.espn.go.com/oly/trackandfield/news/story?id=4464405

Audit Bureau of Circulation. (n.d.) Retrieved from www.accessabc.com

Bikitsha, N. (2009, September 2). Run, Caster, run! *Mail & Guardian.* Retrieved from http://mg.co.za/article/2009-09-02-run-caster

Brooks, C. (2009, August 25). Warm welcome home for champ Semenya. *Mail & Guardian*. Retrieved from http://www.mg.co.za/article/2009-08-25-warm-welcome-home-for-champ-Semenya

Bruce, T. (2009). Winning space in sport: The Olympics in the New Zealand sports media. In P. Markula (Ed.), *Olympic Women and the Media: International Perspectives* (pp. 150-167). London, UK: Palgrave Macmillan.

Bryson, D. (2009, August 22). SA rallies behind runner in gender storm. *Mail & Guardian*.

Cavanagh, S. L., & Sykes, H. (2006). Transsexual bodies at the Olympics: The International Olympics Committee's policy on transsexual athletes at the 2004 Athens summer games. *Body & Society, 12*(3), 75-102.

Clarey, C. (2009, December 30). Sporting flops of 2009. *The New York Times*, p. 1.

Cole, C. L. (2000). One chromosome too many? In K. Schaffer & S. Smith (Eds.), *The Olympics at the millennium: Power, politics, and the game* (pp. 128-146). New Brunswick, NJ: Rutgers University Press.

Cooky, C. & Dworkin, S. L. (in press). Policing the Boundaries of Sex: A Critical Examination of Gender Verification and the Caster Semenya Controversy. *Journal of Sex Research*.

Cooky, C. Dycus, R. Dworkin, S. L. (2012). "What makes a woman a woman?" vs. "Our First Lady of sport": A comparative analysis of Caster Semenya in U.S. and South African news media." *Journal of Sport and Social Issues.* [Published Online First: DOI: 10.1177/0193723512447940].

Cooky, C., Wachs, F. L., Dworkin, S. L., & Messner, M. A. (2010). It's not about the game: Don Imus, race, class, gender and sexuality in contemporary media. *Sociology of Sport Journal, 27*(2), 139-159.

Cooper, E. J. (2010). Gender testing in athletic competitions—Human rights violations: Why Michael Phelps is praised and Caster Semenya is chastised. *Journal of Gender, Race, and Justice, 14*(1), 233-264.

Cornelissen, S. (2011). Prologue: Sport past and present in South Africa: (Trans)forming the nation? *International Journal of the History of Sport, 28*(1), 2-8.

Dickinson, B. D., Genel, M., Robinowitz, C. B., Turner, P. L., & Woods, G. L. (2002). Gender verification of female Olympic athletes. *Medicine and Science in Sports & Exercise, 34*(10), 1539-1542.

Dubow, S. (1995). *Scientific racism in modern South Africa*. New York, NY: Cambridge University Press.

Dworkin, S. L. & Cooky, C. (2012). Sport, sex segregation, and sex testing: Critical reflections on this unjust marriage. *American Journal of Bioethics, 12*(7), 1-3.

Dworkin, S. L., Swarr, A. L., & Cooky, C. (in press). Sport and sex and gender injustice: The case of South African track star Caster Semenya. Manuscript submitted to *Feminist Studies*.

Fiske, J. (1996). *Media matters: Race and gender in U.S. politics*. Minneapolis, MN: University of Minnesota Press.

Gender DynamiX. (2009, October 27). Meanings of masculinity and femininity. *Gender DynamiX.* Retrieved from http://www.genderdynamix.co.za/content/view/429/198/

Genel, M., & Ljungqvist, A. (2005). Gender verification of female athletes. *Lancet, 366*(1), S41.

Geoghegan, A. (2009, September 12). Third world war if Semenya barred: South Africa, ABC News. Retrieved from www.abc.net.au/news/stories/2009/09/12/2683897.htm

Hargreaves, J. (1997). Women's sport, development, and cultural diversity: The South African experience. *Women's Studies International Forum, 20*(2), 191–209.

Hargreaves, J. (2000). *Heroines of sport: The politics of difference and identity.* London, UK: Routledge.

Hercher, L. (2010). Gender verification: A term whose time has come and gone. *Journal of Genetic Counseling, 19*(6), 551–553.

Hersh, P. (2009, August 20). Gender issues; Others in 800 meters raise questions about surprise winner Caster Semenya of South Africa; International officials start inquiry. *Los Angeles Times*, p. C1.

International Association of Athletics Federation as Medical and Anti-Doping Commission (2006). *IAFF policy on gender verificiation.* Retrieved from www.iaaf.org/mm/document/imported/36983.pdf .

Kane, M. J. (1995). Resistance/transformation of the oppositional binary: Exposing sport as a continuum. *Journal of Sport and Social Issues, 19*(2), 191–218.

Letsoalo, M. (2009, August 28). Malema raps ANC leaders on race. *Mail & Guardian.*

Ljungqvist, A., Martinez-Patino, M., Martinez-Vidal, A., Zagalaz, L., Diaz, P., Mateos, C. (2006). The history and current policies on gender testing in elite athletes. *International SportMed Journal, 7*(3), 225–230.

Ljungqvist, A., & Simpson, J. L. (1992). Medical examination for health of all athletes replacing the need for gender verification in international sports. The International Amateur Athletic Federation Plan. *Journal of the American Medical Association (JAMA), 267*(6), 850–852.

Merrett, C. (2004). From the outside lane: Issues of 'race' in South African athletics in the twentieth century. *Patterns of Prejudice, 38*(3), 233–251.

Ori, K. O., & Johnsson, P. K. (2009, September 12). Caster Semenya enigma: IAAF tests will disqualify most women athletes. *Afrik-News.* Retrieved from www.afrik-news.com/article16160.html

Padayachee, V., Desai, A., & Vahed, G. (2004). Managing South African transformation: The story of cricket in KwaZulu Natal, 1994–2004. *Patterns of Prejudice, 38*(3), 253–278.

Pelak, C. F. (2005). Negotiating gender/race/class constraints in the New South Africa: A case study of women's soccer. *International Review for the Sociology of Sport, 40*(1), 53–70.

Pelak, C. F. (2010). Women and gender in South African soccer: A brief history. *Soccer & Society, 11*(1–2), 63–78.

Politicians weigh in on Semenya debate. (2009, August 26). *Mail & Guardian.* Retrieved from http://mg.co.za/article/2009-08-26-politicians-weigh-in-on-semenya-debate

Posel, D. (2001). Race as common sense: Racial classification in 21st century South Africa. *African Studies Review, 44*, 87–113.

Reeser, J. C. (2005). Gender identity and sport: Is the playing field level? *British Journal of Sports Medicine, 39*(10), 695–699.

Ritchie, R., Reynard, J., & Lewis, T. (2008). Intersex and the Olympic games. *Journal of the Royal Society of Medicine, 101*(8), 395–399.

SA lashes out at 'racist' world athletics body. (2009, August 20). *Mail & Guardian*. Retrieved from http://mg.co.za/article/2009-08-20-sa-lashes-out-at-racist-world-athletics-body

SA to lodge complaint with UN over Semenya. (2009, August 22). *Mail & Guardian*. Retrieved from http://mg.co.za/article/2009-08-22-sa-to-lodge-complaint-with-un-over-semenya

Schuhmann, A. (2009, August 31). Feminine masculinities, masculine femininities. *Mail & Guardian*. Retrieved from http://www.mg.co.za/article/2009-08-31-feminine-masculinities-masculine-femininities

Schultz, J. (2011). Caster Semenya and the 'question of too': Sex testing in elite women's sport and the issue of advantage. *Quest, 63*(2), 228–243.

Semenya family: 'She's a girl.' (2009, August 20). *Mail & Guardian*. Retrieved from http://mg.co.za/article/2009-08-20-semenya-family-shes-a-girl

Simpson, J. L., Ljungqvist, A., de la Chapelle, A., Ferguson-Smith, M. A., Genel, M., Carlson, A. S., Ehrhardt, A. A., & Ferris, E. (1993). Gender verification in competitive sports. *Sports Medicine, 16*(5), 305–315.

Smith, D. (2009, August 23). Semenya sex row causes outrage in SA. *Mail & Guardian*, p. 1.

Swarr, A. (2012). *Sex in transition: Apartheid and the remaking of gender and race*. New York, NY: SUNY Press.

Tucker, R., & Dugas, J. (2009, August 21). From sad to ugly: Semenya's detractors 'are racists of the highest order.' *The Science of Sport*. Retrieved from www.sportsscientists.com/2009/08/caster-semenya-debate-takes-racist-turn.html

Vecsey, G. (2009, September 13). For some, life lessons come early. *The New York Times*, p. 8.

Zinser, L. (2009a, August 21). Calipari scandal doesn't demand a double take. *The New York Times*, p. 1.

Zinser, L. (2009b, August 26). Vick, Burress and Beasley keep image consultants busy. *The New York Times*, p. 1.

Fallen Team Sports Celebrity

Dog Bites Man? The Criminalization and Rehabilitation of Michael Vick

Michael D. Giardina
Mar Magnusen

[President Obama] wanted to talk about two things, but the first was Michael [Vick] He said, "So many people who serve time never get a fair second chance." He was . . . passionate about it. He said it's never a level playing field for prisoners when they get out of jail. And he was happy that we did something on such a national stage that showed our faith in giving someone a second chance after such a major downfall. (Jeffrey Lurie, owner, Philadelphia Eagles, quoted in King, 2010)

Michael Vick killed dogs, and he did it in a heartless and cruel way. And I think, personally, he should've been executed for that. He wasn't, but the idea that the President of the United States would be getting behind someone who murdered dogs? Kind of beyond the pale. (Tucker Carlson, host, Fox News Channel)

"Welcome to the Michael Vick Experience." So proclaimed the soft-toned voiceover in Nike's 2004 advertisement featuring its star endorser. In the ad, we see an African American teenager queuing up for an immersive amusement park ride à la Disneyworld. When his turn in line comes, the individual is strapped into a hanging chair, puts on a football helmet and cleats, and begins his journey into the ride. There he meets a holographic image of Vick, who says "Welcome to my ride; this is where the fun starts." The rider then enters darkness—mechanical climbing sounds are heard (like a roller coaster approaching its apex)—and then reemerges in the middle of a simulated football field, playing the role of Vick himself. A ball is hiked and the play unfolds; the rider is swung about in his harness, dodging tackles as he "runs" the ball upfield, each athletic move becoming more and more incredible (from a simple stutter-step move, to a 360-spin, to finally a leaping somersault into the end zone). Upon scoring, the holographic Vick reappears, grinning, and states with a laugh to the stunned "rider": "Now that's not in the playbook, but it should be."

Here was Vick, on top of the world: A Pro Bowl quarterback in the National Football League (NFL), revolutionizing the position; a major product

endorser for global brands such as Nike, Coca-Cola, PowerAde, EA Sports, and Kraft; and a role model for kids, someone who (as the story went) had "escaped" the "rough-and-tumble" upbringing of the Newport News, Virginia, public housing projects to "make it" in the world of professional sports. How quickly it all came crashing down.

This chapter seeks to understand the rise and fall *and rise again* of Michael Vick, not so much through his own words and singular accomplishments but through the media narrative(s) used to both frame and produce his celebrity identity throughout his career. To this end, we explore the descriptive language of Vick's rise to prominence and how, up until the time when his noteworthy public "transgressions" began to surface (c. 2005), fans and viewers alike came to know and recognize him primarily through what Richard deCordova (1990) has outlined as physical performance, or the physical characteristics that made him unique to football or the field of athletics more broadly. Such a discourse, argued P. David Marshall (1997, p. 95), is one that emphasizes body type, tangible skills, and other visually stimulating physical characteristics over more abstract notions of personality and subjectivity. We further examine Vick in relation to deCordova's celebrity trajectory of both mediated identity (i.e., the combination of publicity, promotion, marketing, advertising, and other forms of textuality that constitute a public persona) and transgression (i.e., the point at which the individual transgresses the boundaries of "accepted" norms and/or the mediated fiction upon which his or her celebrity has been constructed). In this way, we chart a course through his public struggles (e.g., dog fighting, marijuana possession, prison sentence, etc.) and his eventual media rehabilitation (e.g., return to the NFL, PETA spokesperson, reality-TV series, etc.).

The Rise of Michael Vick

Michael Vick was the second of four children born to Michael Boddie and Brenda Vick, and like the over-determined Horatio Alger myth of young Black men rising up from impoverished circumstances to achieve success in sports, he believed football revealed a way to escape the drugs and drive-by shootings that riddled his neighborhood. Indeed, the story of Michael Vick had been brewing since his early days in the Ridley Circle Homes public housing project, as even drug dealers would shy away from him because of his athletic talent (Lowitt, 1999). As one of Vick's childhood friends recalled, "They saw Mike as somebody who was going to be something someday and kept him away from the drugs and all that. They weren't trying to target him out on the

corner. They were like, 'Hey, Ook, stay away from here. Go throw a football or something'" (as cited in Davis, 1999, p. B1).

Five years before the Atlanta Falcons would make Vick the first overall pick in the 2001 NFL Draft, he was a high school quarterback poised to take college football by storm. In 1996, Vick (then a sophomore) and his coach, Tommy Reamon, arrived at Warwick High School from nearby Homer L. Ferguson High School. Once at Warwick, Vick became a three-year starter and accumulated over that time nearly 5,000 passing yards with 43 touchdowns as well as more than 1,000 rushing yards with 18 rushing touchdowns. Ironically, and although Vick's high school football accomplishments were indeed impressive, he still vied for the attention of college scouts and local media with another standout athlete down the road, Ronald Curry of Hampton High School, who was considered one of the greatest prep athletes the state had ever known. Though overlooked to some extent in comparison to Curry—which Vick attests he used for motivation—college coaches had still taken notice of Vick, particularly those at Syracuse University and Virginia Tech (both considered "good" but not necessarily "great" college programs). Come National Signing Day, both schools had scholarship offers on the table. In the end, Vick was sold on Tech; he joined the Hokies as a redshirt freshman quarterback in 1998.

By 1999, and having yet to take a college snap, Vick entered the season as the most hyped quarterback in Tech's football history (King, 1999). To many in the press, Vick was the representative heir apparent to Syracuse's Donovan McNabb, another highly-skilled African American quarterback with both a rifle-arm and highlight-reel scrambling abilities who was selected by the Philadelphia Eagles as the second overall pick in the 1999 NFL Draft. Paul Pasqualone, McNabb's head coach at Syracuse, even went so far as to assert that Vick was ahead of McNabb at the same point in their respective careers (White, 1999). Vick, too, saw the similarities, and noted that while he was quite fond of McNabb as a person, he decided not to attend Syracuse at least in part because: "I didn't want to be the next Donovan McNabb. . . . I wanted to go somewhere where I could establish my own tradition" (as cited in Minium, 1999). Ultimately, Vick would live up to the early hype: his team would lose only one game in his first season as starting quarterback, the national championship title match against the Florida State University Seminoles. Despite the loss, Vick was nonetheless praised in the press and by a multitude of college football coaches for his skill, poise, and potential, including legendary Seminoles head coach, Bobby Bowden, who spoke of Vick as the "quarterback of the future": a multithreat talent, one who was equally effective as both a passer and as a runner (White, 2000).

From 1998 through early 2005, Michael Vick was described in nearly every mainstream press account as possessing all of the attributes deemed necessary to usher in a new and exciting era of mobile quarterbacks—unbridled athleticism, a strong throwing arm, deft moves, "natural" swiftness, sub 4.4/40 speed, patience, and pocket presence. In light of his near-championship run in 1999, the following quotes are a small but nevertheless representative testament to the early media portrayal of Vick as physical performer:

> No question Vick has the tools to do the work. He's got a cannon arm. Vick's frozen ropes nearly ripped the fingers off some of his receivers in the first week of spring drills. The guy can run, too. His recent 4.33-second clocking in the 40-yard dash still has Tech coaches drooling over their stopwatches. (King, 1999)

> Vick fits perfectly in Tech's pocket. And if it collapses around him, he can always use those feet. He's an exceptional scrambler. He has been compared favorably to McNabb and Charlie Ward, Florida State's 1993 Heisman Trophy winner. (Lowitt, 1999)

> Vick might be the best athlete in college football. A sculpted 6-foot-1 and 212 pounds, he runs the 40 in 4.25 seconds, has a 40-inch vertical leap and bench-presses 340 pounds. . . . Because of all that, and because he is a dazzling, dangerous runner, because there is lightning in his left arm (he can throw 75 yards) and because there are similar but less talented models at other programs, the notion has been expressed that Vick is redefining the quarterback position. (Cohn, 2000)

Vick's encore to the historic 1999 season was almost as impressive as his rookie campaign, as Virginia Tech finished 11–1 for the second year in a row. Following the season, Vick finished sixth in the Heisman Trophy balloting behind, among others, future Hall of Famers Drew Brees and LaDanian Tomlinson and announced his decision to forego his two remaining years of eligibility and enter the NFL draft (a decision that sparked heated debate among football analysts as to whether or not college football's hottest prospect was indeed ready to transition from Saturdays to Sundays). This debate, however, was short lived and largely silenced in 2002 after Vick started 15 of 16 games for the Atlanta Falcons, a season in which he passed for nearly 3,000 yards with 16 touchdowns and rushed for almost 800 yards with 8 rushing touchdowns. As far as the media were concerned, Vick remained the Athenian Greek incarnate—a mythic physical talent who was going to change the complexion of football in the NFL much like he had impacted the nature of the quarterback position in college football during his two-year highlight-reel stint at Tech.

During the next several years, the established narrative of Vick continued with little to no divergence from familiar journalistic territory, either about his "physical" gifts, or the relative (if racially charged) association of "natural

athleticism" ascribed to African American athletes (see Sailes, 1993). That is, and much like his collegiate playing days, he was still positively represented as the "new age quarterback" and synonymous with phrases such as "cheetah," "a Frankenstein," and "x-factor." Consider the following descriptions:

> He ran 40 yards in 4.36 seconds. That's fast for a wide receiver, fast for a cornerback. For a quarterback, it's beyond comprehension. It was so fast as to make this jaded correspondent emulate Keanu Reeves and go, "Whooooaaaa." It's so fast as to make even a jaded correspondent want to believe the hype. (Bradley, 2001)

> If the 22-year-old Vick is not throwing a 40-yard strike on the run after shedding a defensive lineman, he's leaving linebackers in his wake after a Barry Sanders-like move that has them grasping nothing but air. (Spiros, 2002)

> Entering his third NFL season and second as the Falcons starting quarterback, the 23-year-old Vick bears the weight of a forlorn franchise's hopes for a first championship on his smallish frame. A dazzling runner and strong-armed passer, he's the centerpiece of a revitalized team, the focus of its sudden and stunning appeal at the box office and among the league's most popular players with fans. (Weisman, 2003)

Heading into his third season in the NFL, Vick was clearly established as one of the premier young stars in the league. However, he suffered a severe leg injury at the start of his third season, which forced him to miss the first 11 games on the schedule. He roared back from injury with a vengeance, however, posting three consecutive seasons of 2,000-plus yards passing, and, in 2006, he became the first quarterback in NFL history to rush for more than 1,000 yards in one season (1,039, to be exact). Yet despite being firmly ensconced as a dynamic on-field performer, the shine on Vick's growing celebrity was starting to wear thin. Rather than any one specific, paradigm-shifting event (such as we saw with Tiger Woods and his marital infidelity), it was a confluence of events that signaled a swing in how Vick was portrayed—a swing that ultimately set the stage for the public interpretation of a much larger event: accusations of, and later a conviction for, involvement in an illegal dog fighting ring.

The Fall of Michael Vick

> It's business from this point on. Michael has to hear it 'cause that's what it is. Your private life is gone. You have to produce year in and year out. What you do off the field is going to affect your life. You'd better watch who you touch, who you look at, how you smell, and everything else. (Tommy Reamon, Vick's high school football coach, as cited in Lowitt, 1999)

Since the time Michael Vick first distinguished himself at Warwick High School through his early years in the NFL—effectively an entire decade—he was known primarily to North American audiences through the lens of physical performance outlined above. Whether as a promising high school quarterback, a dominant college star, or a budding NFL superstar, Vick's appeal was ostensibly a disarticulated celebration of body parts (his quick feet, his strong arm, his "natural" speed, etc.). Such semiotic consumption of Vick carries far beyond journalistic treatments. In a CGI-enhanced ad for sports drink, Powerade, for example, Vick is seen on a practice field knocking down receivers with powerful passes or hurling a ball for what seems to be 200-plus yards. Likewise, as part of Nike's "What If" series of ads (which feature athletes performing in sports other than their own), Vick is digitally added to footage of an ice hockey game, where he scores a goal to the acclaim of announcers who declare, "Look at that breakaway speed!"

In essence, the reiterative discursivity of Vick's physical prowess obviated any deeper understanding of Vick as a free moral agent. And, when any of his off-field or family life was the topic of media reports, profiles, or storylines, most followed the typical athlete-biography format (brief interviews with parents and/or coaches; short, yet positive anecdotes about childhood; humble comments from the athlete, etc.) that revealed little beyond a surface understanding. Thus, at the end of 2004, we had a seemingly "perfect" celebrity for widespread appeal and consumption: electrifying athleticism, familiar personal narrative, and global brand orientation. Importantly, he was set against the notion put forth by William C. Rhoden (2006) with respect to Black athletes being used by Madison Avenue to "project the feel and fashion of inner-city America to an eager global marketplace" (p. 1). As David Leonard and C. Richard King (2011) might put it, he was presented much like Michael Jordan or (pre-scandal) Tiger Woods; that is, like other celebrated

> black athletes who are deployed as free-floating signifiers and symbols of the American Dream, of opportunity available to those who follow the right path, as well as symbols of a post-race America, whereupon these BLACK athletes are not only accepted but also celebrated and praised; they are "the moral obverse" of those black athletes who are condemned, vilified, and policed inside and outside of sports. (p. 11)

Yet as the next three years unfolded, a much harsher personal reality would set in as a series of key events collided to rewrite Vick's celebrity persona—Vick effectively became the "*immoral obverse*" of his theretofore public persona. The first event took place on April 7, 2005, when Sonya Elliot, 26, sued Vick, claiming he knowingly gave her genital herpes. Elliot alleged Vick had visited clinics under the alias "Ron Mexico," thereby revealing he was cognizant of his sexually transmitted disease. A settlement was reached a year

later between the two parties, but by then Vick had already become the target of minor ridicule on numerous sports blogs and broadcasts because of it. This was compounded by his actions on November 26, 2006, when Vick "flipped the bird" to a rowdy Georgia Dome crowd as he walked off the field after the Atlanta Falcons lost to the New Orleans Saints by a score of 31–13. The incident helped to highlight the fourth consecutive defeat for the Falcons, as well as Vick's frustration with the Falcons' lineup of average receivers, which, collectively, dropped five passes in the game. In the "vortextual" sport-media-entertainment environment of 24-hour coverage, in which "[c]ertain super-major events come to dominate the headlines to such an extent that it becomes temporarily difficult for columnists and commentators to discuss anything else" (Whannel, 2002), this relatively small act would slowly begin to turn Falcons fans against Vick. And, finally, on January 18, 2007, a water bottle carried by Vick was confiscated by airport security at Miami International Airport under the suspicion it contained marijuana. The NFL and law enforcement officials investigated the event, but charges were never filed; later that year, however, Vick was charged for marijuana possession stemming from a different incident.

Alone, each of these incidents may not have significantly impaired Vick's mediated public persona. In combination, however, we can say it was at this time that the public narrative about Vick took a decidedly different swing away from widespread praise for his athletic accomplishments and humble background toward a more negative—if tabloidized—accounting of him. The award-winning football blog, *Kissing Suzy Kolber*, for example, began to parody Vick with a semi-regular series of dialogues, which began running under the title, "The offseason adventures of Michael Vick." Written by novelist and current *Deadspin* contributing editor, Drew Magary, and running from 2007–2010, each dialogue portrayed Vick as stoned, uneducated, and/or disinterested in football (all highlighted by the inclusion of a photoshopped image of Vick holding a plastic bag filled with marijuana). It also became customary to see Atlanta Falcons jerseys with the nameplate bearing words such as "Mexico" or "Herpes" instead of "Vick" at NFL games, which forced the official NFL store to ban the purchase of jerseys customized in that fashion (see "NFL No Fan of Vick's 'Ron Mexico' Jerseys," 2005), though they could still be purchased or made in various other retail outlets; the "Mexico" moniker also found its way to replica Virginia Tech jerseys (as of this writing, some can still be found on eBay).

While this shift does not mean Vick was no longer recognized as a great (if not superior) athlete, it does point to the larger discursive orientation in which he was now seen as transgressing (the artificiality of) his theretofore celebrated

public persona: he had "suddenly" become a greatly flawed human being, one who was "immature," hung out with the "wrong" kind of people, and was "lazy." Case in point: during Vick's early years in the NFL he was compared favorably—in both talent and temperament—to McNabb, who was by now a dominant NFL star. After the water bottle incident in Miami, Vick, in an ironic if not unsurprising twist, given the lack of originality in sports journalism, was more likely to be compared to the National Basketball Association's (NBA) often "controversial" but decidedly talented star, Allen Iverson, than the NFL's McNabb. Specifically, as one columnist for the _Chattanooga Times Free Press_ wrote: "But much as Iverson eventually wore out his welcome in Philly, running off both good coaches and bad despite leading them to the NBA finals a few years ago, Vick is fast approaching his point of no return in Atlanta" (Wiedmer, 2007). Ironic, because in 2002 a columnist for the _Florida Times-Union_ wrote: "On watching the legal problems that hounded NBA star Allen Iverson, who like Vick grew up in Newport News, VA, the 22-year-old quarterback has learned the importance of avoiding bad influences" (Henry, 2002). Consequently, at least to some Falcons fans (and, increasingly football fans in general), Vick, much like Iverson, was both now a "troubled" celebrity athlete off the field due to these numerous transgressions, and a "coach killer" on the field due to his increasingly unpredictable Sunday performances.

More to the point, Vick was now represented as a troubled _Black athlete_ rather than as a "racially neutered" (Denzin, 1996, p. 321) shining star of NFL and brand marketing campaigns; he was no longer privileged as a "Black version of a White cultural model" (Denzin, 1996, p. 321), as the devout Christian who slept with a bible near his pillow (Minium, 1999) and gave back to his community, but rather as the second coming of Allen Iverson—a cornrows wearing, tattoo sporting, "controversial" athlete with "attitude" whose very blackness now situated him alongside _other_ "troubled" or "problematic" (Black) athletes of the day such as Ron Artest, Adam "Pac Man" Jones, Ricky Williams, Gilbert Arenas, and Randy Moss. As Leonard and King (2011) would say, Vick was now being "castigated" as a threat "to the profitability, moral values, and cultural significance of sporting culture" (p. 12). Which is to say that Vick was well on his way to "falling from grace" even _before_ he was implicated in dog fighting.

Discussion

The facts of Vick's participation in dog fighting are not in dispute, nor do we find it necessary to revisit the intricacies of the case against Vick and the court

proceedings that followed. It suffices to say that on June 7, 2007, police entered property owned by Vick on suspicion of dog fighting. The following month, Vick and three others were charged with conspiring to engage in competitive dog fighting, procuring and training pit bulls for the purpose of fighting, and conducting the dog fighting enterprise across Virginia state lines. Five months later, Vick pleaded guilty to the charge of "Conspiracy to Travel in Interstate Commerce in Aid of Unlawful Activities and to Sponsor a Dog in an Animal Fighting Venture," whereafter he began serving his term at Leavenworth.

We are interested, rather, in the larger public debate over Vick that circulated during the time he was under investigation for, convicted of, and served time as a result of his involvement in dog fighting. That is, we suggest that the prior over-determination and now-normal public understanding of Vick as "just another" in a long line of "commodified and criminalized" (see Leonard & King, 2011) Black athletes helped animate and hasten his fall from grace—a fall which was injected with decidedly racialized overtones, and which by the time he was released from prison in May 2009 would find him consistently ranked as the *most disliked athlete in professional sports*. At the same time, the very public reactions to Vick effectively problematized the cultural politics on which the backlash to Vick over dog fighting was grounded.

In truth, there was a sizable constituency of avowed animal lovers who were publicly outraged at Vick for his actions as well as many folks who were plain shocked and horrified at the descriptions of dog fighting in general. This public backlash ranged in broad scope from a protest by People for the Ethical Treatment of Animals (PETA), which organized a "Sack Vick" campaign intended to pressure NFL commissioner, Roger Goodell, into suspending Vick prior to any conviction (Goldberg, 2007); to then-U.S. Senator Robert Byrd's (D-VA) remarks on the Senate floor following Vick's indictment, in which he stated as part of a lengthy screed against dog fighting in general that he was "confident that the hottest places in hell are reserved for the souls of sick and brutal people who hold God's creatures in such brutal and cruel contempt" (Byrd, 2007); to any number of sportswriters and columnists referring to Vick as "human waste" (Tezer, 2007, who also suggested Vick should be "sent to prison for stupidity" even if he was found innocent of the charges), a "complete and total idiot" (Hall, 2007), a "gangster athlete" (Ziemba, 2007), and someone who should be "executed" (Carlson, 2010). This dehumanization of Vick is further complicated in that much of the vitriol directed toward him was couched in terms of a larger, discursive frame of "problem" athletes (which was more often than not deployed as a euphemism for "Black").

Vick is further complicated in that much of the vitriol directed toward him was couched in terms of a larger, discursive frame of "problem" athletes (which was more often than not deployed as a euphemism for "Black").

Yet not all of the discourse was positioned as anti-Vick. In fact, and though not the majority opinion, a vocal minority endeavored to add perspective to growing criticisms. To wit: in the midst of Vick's criminal prosecution, ESPN hosted a "Town Hall" meeting in Atlanta under the title of "The Vick Divide," which was advertised as a means through which "to expose the divided feelings over his dog fighting case" ("Vick Supporters Turn Out," 2007). Much to ESPN's apparent surprise, the town hall audience was filled with supporters (some wearing "Free Michael Vick" t-shirts), while panelists such as R. L. White, president of the Atlanta chapter of the NAACP, lambasted the media for the "overkill" of negative press directed toward Vick ("Vick Supporters Turn Out," 2007). Still others, such as Pro Football Hall of Famer Deion Sanders, defended dog fighting altogether (partially on "cultural" grounds); and others still, such as comedian Chris Rock (2010), criticized the media for their hypocritical treatment of Vick in relation to other celebrities (such as when he posited on stage during his worldwide *Kill the Messenger* tour: "Sarah Palin out there shooting mooses. . . . I see her holding up a dead moose, I'm like, 'What the fuck is Michael Vick in jail for?'").

As Vick's incarceration moved toward his impending release in 2009, the media turned to questions of what should happen to him professionally once he had served out his sentence. Now almost two full years since the original dog fighting allegations had come to light, the prevailing wisdom amongst the professional commentariat class—with some notable exceptions, such as *Sports Illustrated*'s Pulitzer Prize-winning writer, George Dohrmann—was that Vick had "served his debt to society," that in the process his case brought needed attention to the horrors of dog fighting, and he should be allowed to get on with his life and rejoin the NFL—a view that ultimately won out with the commissioner's office. As celebrated ESPN writer, Bill Simmons (2010), summed it up, by the time Vick was released from prison he had: "torched his career, blew a lucrative contract [10-years, $130 million from the Falcons], went bankrupt, spent 19 months in prison and became a public pariah. . . . The man paid his price."

In the court of public opinion, however, that was still open to some debate. To blunt the impending backlash to his return to the NFL, Vick's public relations team went to work rehabilitating his image. Most specifically, this amounted to partnerships with PETA and the Humane Society to speak out against dog fighting (in Public Service Announcements and as a speaker in schools and communities); a series of sit-down interviews on national media

tian conservative, Tony Dungy (which lent religious undertones to his redemp-tive narrative); and perhaps most directly, engaging in a 10-part "docu-series" titled "The Michael Vick Project" with cable channel Black Entertainment Television (BET), which was pitched "as a redemption story, couched in religious terms" (Lloyd, 2010).

Vick's voiceover in the opening credits to Episode One of the series laid bare its narrative-changing intent: "I'm Michael Vick. My fall from grace was tragic, but it was all my fault, and I'm on a mission to get everything back. Not the money and the fame, but to restore my family's good name." Essentially, this was a 10-part infomercial designed to change the perception of Vick from "dog killing felon" to "remorseful and reformed human being," using a heavily sympathetic angle as it renarrated his biography for public consumption. Although strikingly blatant in its attempt to rehabilitate and soften his image—thus also illustrating the commercial interests behind it—it was nonetheless effective in presenting a counter-narrative for viewers to struggle with while making sense of Vick's journey. But as Robert Lloyd (2010) reminded us in his review of the series, "for many, [Vick's] redemption will be strictly a matter of his playing football well." That Vick then went out and had a Pro Bowl season, leading the Eagles to the playoffs just a few months later, would go a long way to proving Lloyd correct. As the old saying goes, "winning solves everything" (at least when it comes to celebrities).

Conclusion: A Hero Redeemed(?)

> We have re-signed Michael Vick as a Nike athlete. Michael acknowledges his past mistakes. We do not condone those actions, but we support the positive changes he has made to better himself off the field. (Nike press release, July 1, 2011)

Now two years removed from prison and entering his third full season as the starting quarterback of the Philadelphia Eagles, the current, if potentially ephemeral, narrative about Vick does seem to be one of successful, even authentic, redemption. Corporate sponsors have come back, led most recently by Nike and, to an extent, EA Sports. Fans in Philadelphia, many of whom originally gave him a cold response when he joined the team a few months removed from prison, have by and large come to support if not necessarily embrace him. Perhaps giving someone a second chance is America's true national pastime. Yet now his every move is effectively watched; he is forever suspect. And thus it would be naïve to suggest that Vick's image—remade and remolded such as it has been—is simply a matter of confessed remorse, regret, and "moving on."

Rather, his redemption song is situated as a socially accepted narrative of policing Black bodies, especially when read over and against comments Vick made that can be read as suggestive of the *positive* role of prison in his life (Tony Dungy made similar comments on ESPN with respect to Vick's time in prison). As Courtland Milloy (2010) argued, the quasi-endorsement of the prison-industrial complex by "celebrated black ex-offenders" such as Vick, with prison being "the best thing that ever happened to them" (para. 1), is troubling when you consider that "[not] every inmate gets released into the arms of loved ones, to say nothing of being embraced by the NFL" (para. 17). Although such an admission by Vick may have "played well," it is ignorant of and *yet entirely dependent upon* the complicated racial logics that gave rise to—and then struck down—his celebrity in the first place, and which continue to pave his road to redemption.

In the last analysis, Vick's saga is a prime illustration of the constructed nature of modern celebrity, a "hyper-mediated brand of storytelling" (Sternheimer, 2011) inscribed by the contextual factors governing the historical present. Whether rising star, fallen hero, or redemptive soul, his "story" is just that, a mediated fiction served up for public consumption. For as Jean Baudrillard would likely suggest, there is no "real" Michael Vick (any more than there is a "real" Peyton Manning or Derek Jeter)—his celebrity is "the simulation of something which never really existed," manifest only through a series of news stories, product advertisements, *SportsCenter* highlight clips, and "docu-series" infotainment—produced in and through the historical contingencies of the current conjuncture and giving rise to the received knowledges about the "authentic" Vick we have come to "know."

References

Bradley, M. (2001, May 5). Auspicious start: Vick's speed, strength turn heads in minicamp. *The Atlanta Journal-Constitution*, p. E1.

Byrd, R. (2007, July 19). Remarks of Sen. Robert Byrd on the floor of the U.S. Senate. Washington, D.C.

Carlson, T. (2010, December 7). Great American panel [Host; TV Show]. Fox News Channel.

Cohn, B. (2000, August 27). Tricky Vick. *The Washington Times*, p. A1.

Davis, B. (1999, December 29). Rubbed the right way: Friends, family keep Vick on path toward greatness. *The Washington Times*, p. B1.

deCordova, R. (1990). *Picture personalities: The emergence of the star system in America*. Champaign, IL: University of Illinois Press.

Denzin, N. K. (1996). More rare air: Michael Jordan on Michael Jordan. *Sociology of Sport Journal*, 13(4), 319–324.

Goldberg, D. (2007, November 18). PETA tells NFL to "Sack Vick" after dogfighting charges.

Associated Press. Retrieved January 9, 2012 from http://www.nfl.com/news/story/09000 d5d80028494/article/peta-tells-nfl-to-sack-vick-after-dogfighting-charges

Hall, S. (2007). Vick has a disease for which there is no cure. NBCSports.com. Retrieved January 9, 2012 from http://nbcsports.msnbc.com/id/30852862/

Henry, G. (2002, August 9). After reality check, Vick ready to start: Q&A with Falcons QB Michael Vick. *Florida Times-Union* (Jacksonville, FL), p. C-1.

King, P. (2010, December 27). Monday Morning Quarterback. *Sports Illustrated.* Retrieved from http://sportsillustrated.cnn.com/2010/writers/peter_king/12/26/week-16/1.html

King, R. (1999, April 19). Quarterback feels no pressure: Vick ready to take reins of Virginia Tech offense. *The Roanoke Times* (Virginia), p. C6.

Leonard, D. J., & King, C. R. (2011). Celebrities, commodities, and criminals: African American athletes and the racial politics of culture. In D. J. Leonard & C. R. King (Eds.), *Commodified and criminalized: New racism and African Americans in contemporary sports* (pp. 1–22). Lanham, MD: Rowman & Littlefield.

Lloyd, R. (2010, February 2). 'The Michael Vick project.' *The Los Angeles Times.* Retrieved from http://articles.latimes.com/2010/feb/02/entertainment/la-et-michael-vick2-2010feb02

Lowitt, B. (1999, December 29). All the right moves: With key support, Michael Vick has let talent take him to the national stage. *The St. Petersburg Times.* Retrieved from http://www.sptimes.com/News/122999/news_pf/Sports/All_the_Right_Moves.shtml

Marshall, P. D. (1997). *Celebrity and power: Fame in contemporary culture.* Minneapolis, MN: University of Minnesota Press.

Milloy, C. (2010, November 23). Hard time and testimonials. *The Washington Post.* Retrieved from http://www.washingtonpost.com/wp-dyn/content/article/2010/11/23/AR2010112 306351.html

Minium, H. (1999, October 15). Tech's emerging superstar: In facing Vick, Syracuse will see what it missed. *The Virginian-Pilot* (Norfolk, VA), p. C1.

NFL no fan of Vick's 'Ron Mexico' jerseys. (2005, April 14). *NBCSports.com.* Retrieved from http://nbcsports.msnbc.com/id/7504682/

Rhoden, W. C. (2006). *Forty million dollar slaves: The rise, fall, and redemption of the Black athlete.* New York, NY: Crown.

Rock, C. (2008). Kill the messenger. London, UK, New York, NY, Johannesburg, SA: HBO Entertainment [Original Airdate: September 27, 2008].

Sailes, G. (1993). An investigation of campus stereotypes: The myth of black athletic superiority and the dumb jock stereotype. *Sociology of Sport Journal, 10*(1), 88–97.

Simmons, B. (2010, October 1). Rooting for Michael Vick. *ESPN.com.* Retrieved from http://sports.espn.go.com/espn/page2/story?page=simmonsnfl2010/101001

Sorkin, A. (2010, December 8). In her defense, I'm sure the moose had it coming. *The Huffington Post.* Retrieved from http://www.huffingtonpost.com/aaron-sorkin/sarah-palin-killing-animals_b_793600.html

Spiros, D. (2002, November 29). In a class by himself: Michael Vick isn't the best quarterback in the NFL, but then again, he's only 22 years old. *Star Tribune* (Minneapolis, MN), p. 1C.

Sternheimer, K. (2011). *Celebrity culture and the American dream: Stardom and social mobility.* New York, NY: Routledge.

Tezer, A. (2007, July 19). The Inhumanity of Michael Vick. *Bleacher Report.* Retrieved from http://bleacherreport.com/articles/1407-the-inhumanity-of-michael-vick

Vick supporters turn out for town meeting in Atlanta. (2007, September 26). *ESPN.com.* Retrieved from http://sports.espn.go.com/nfl/news/story?id=3036419

Weisman, L. (2003, August 15). Sky's the limit for Vick, Falcons. *USA Today,* p. 1C.

Whannel, G. (2002). *Media sport stars: Masculinities and moralities.* London, UK: Routledge.

White, J. (1999, October 14). Vick compared to ex-Orangeman. *Richmond Times Dispatch* (Virginia), p. C-6.

White, J. (2000, January 1). Natural born thriller: Vick comfortable stepping in and taking charge. *Richmond Times Dispatch* (Virginia), p. D-1.

Wiedmer, M. (2007, January 24). Similarities between Vick, Iverson are eerily notable. *Chattanooga Times Free Press* (Tennessee), p. D1.

Ziemba, C. (2007, July 28). Had enough with gangster athletes. *The Meridian Star* (Missouri). Retrieved from http://meridianstar.com/columns/x681086799/Had-enough-with-gangster -athletes

Guns Are No Joke: Framing Plaxico Burress, Gilbert Arenas, and Gunplay in Professional Sports

Katherine L. Lavelle

"Guns and athletes go together like popcorn and butter" (Dohrmann, 2010, para. 6). The link between violence and professional athletes is well documented (Enck-Wanzer, 2009; Teitelbaum, 2010). Between November 2008 and December 2009, two high-profile, professional athletes, New York Giant, Plaxico Burress (NFL), and Washington Wizard, Gilbert Arenas (NBA), faced weapons charges that were national news stories. Burress, a standout in the Giants' 2008 Super Bowl victory, shot himself in the leg at a New York City nightclub with an unlicensed gun (Grace & Goldiner, 2009). Arenas, known for his affable personality and scoring abilities, brought four unloaded guns into the Washington Wizards' locker room as part of an alleged prank to settle a bet with a teammate (Hamilton, 2010). Previously, Arenas (Carter, 2006) and Burress were praised for their abilities as athletes (Bondy, 2008). Afterwards, both men faced media scrutiny for their lack of professionalism and became part of a national discussion regarding the relationship between Black athletes and guns (Leonard, 2010). Professional, famous Black athletes have little latitude for what is considered acceptable behavior (Berry & Smith, 2000). While their sports achievements are celebrated, if a Black athlete is accused of a crime, negative stereotypes about hip-hop culture are often used to paint him as dangerous, and suggest that he must be monitored (Leonard, 2010).

In contemporary society, athletes are often revered as mythic figures facing conflict and pressure on the field (Butterworth, 2008). However, their athletic glory can be easily tarnished by personal behavior (Berry & Smith, 2000). By examining the rise and fall of Burress and Arenas, we can assess how the mythology of the Black athlete is upheld in media portrayals. By understanding the meaning, impact, and longevity of these cases in the context of the

construction of athletes as heroes, we can evaluate how the mythology of Black athletes is reinterpreted when they commit violent crimes.

Role of Myth in Sports

Myths contribute to the development of culture and help humans make sense of their world (Hawkes, 1977; Rowland, 1990). The individual achievements of athletes can operate as the foundation for American contemporary myths (Butterworth, 2008; Eitzen, 2000). Sports myths allow athletes to embody the larger cultural myths of competition, masculinity, and racial identity (Dickinson & Anderson, 2004). Unlike traditional, literature-based myths, these myths function uniquely as part of everyday society. Professional sports have a long history of heroes who embody myths. For instance, when a basketball player is faced with an injury in a critical game, commentators often allude to New York Knick Willis Reed, an injured player who returned to a playoff game in the 1970s and saved the game ("Reed Inspires," 2010). Sports are full of stories that tell of mythic heroism in competition.

A common myth, frequently used to explain the motivation of contemporary athletes, is framing sports success as a means to escape poverty. Such myths often "combine to lead us to believe that sport is a social mobility escalator" (Eitzen, 2000, p. 256), even though mobility is often not permanent, especially for Black athletes. Eitzen argued that while this belief is strong within the Black community (that a great athlete earns a college scholarship and becomes rich as a professional athlete), this transformation rarely occurs. Instead, what does happen is athletes of color are faced with more scrutiny than White athletes are, and when they do encounter problems, they become a focal point for criticism of sports (Berry & Smith, 2000). Langley (1994) argued that limitations placed on Black athletes result in expression of individuality through "toughness." These athletes have a limited range of acceptable behaviors, and if they violate these expectations, it is harder to recover from controversy (Leonard, 2009). O. J. Simpson has become an extreme example of this phenomenon. Prior to the murder of his ex-wife and her boyfriend in 1994, Simpson was considered an exemplary collegiate and professional athlete who transitioned into a successful career as a pitchman and football commentator (Dickinson & Anderson, 2004). But in the summer of 1994, Simpson suffered a "fall" when he was accused of homicide and lost his privileged identity (Dickinson & Anderson, 2004). What the Simpson case demonstrates is that even the most beloved athletes, when faced with criminal charges, can lose their heroic status. In the case of Burress and Arenas, this

chapter seeks to evaluate how their weapons charges interacted with media understandings of their athletic success.

Plaxico Burress

Plaxico Burress was an 8-year veteran of the league and in his 3rd season with New York in 2008 (LaPointe, 2008). His single mother raised him in a low-income household. As a child, Burress was tempted but rejected the lure of crime and drugs around him (Burress & Cole, 2008). This narrative is an example of what Grainger, Newman, & Andrews (2006) referred to as an "escape from poverty" in sports media (p. 451). Burress himself reinforced the myth of the Black athlete who uses sports to rise in social status (Eitzen, 2000). As Eitzen (2000) argued, football is viewed as the easiest route for young Black athletes to escape from poverty because there are more scholarships available.

In 2008, Burress's autobiography (co-authored with *Yahoo News* NFL writer Jason Cole) documented his rise from poverty to NFL stardom. Prophetically, Burress bragged about his gun collection: "I have several guns and I had them before Sean [referring to Washington Redskin player Sean Taylor who was killed during a 2007 home burglary attempt] got killed—a long time before that. I can get to them with all the lights out, blindfolded. I can go get them in all situations" (Burress & Cole, 2008, p. 168). Burress characterized himself as a stealthy and protective force at home and embodied what Langley (1994) defined as some of the negative aspects of the "cool pose."

During the 2007–2008 season, Burress suffered a series of career-threatening injuries (Robinson, 2008). O'Connor (2008) described Burress's season as "doing a Monday-through-Saturday limp throughout the locker room with considerable chunks of ice attached to his right ankle" (para. 13). Despite Burress's myriad injuries, his season was successful. He had more receptions than anyone else on the team (70) and scored 12 touchdowns, a career best ("Giants Suspend," 2008). Burress was on a team in transition, his quarterback Eli Manning was still trying to prove himself in the league, and veteran Tiki Barber retired before the season started (Vacchiano, 2007). In addition to his regular season success, Burress was heroic in the 2008 playoffs. In subzero temperatures playing in Green Bay, he made 11 catches, setting up a spectacular postseason that sent the Giants to the Super Bowl (Lupica, 2008). In the Super Bowl, he caught the game-winning touchdown pass in leading the Giants to victory over the previously unbeaten New England Patriots (Rhoden, 2008).

After these accomplishments, Burress was praised as the "Super Bowl hero" (Grace & Goldiner, 2009) and "an elite wide receiver" (LaPointe, 2008). Suddenly, he became a modern-day Joe Namath, a reference to a New York Jets quarterback, beloved for his Super Bowl victory and media personality (Bondy, 2008). Burress's accomplishments were amplified because he played through injury all season (Lupica, 2008). This characterization of Burress exemplifies what Chidester (2009) reasoned is necessary for contemporary sports heroes to develop as mythical heroes.

Burress did not play much in the Fall of 2008 and could not build on his 2007–2008 accomplishments (Battista, 2009). He had some contractual disagreements with management, and there were some concerns that other interests surpassed team commitments ("Giants Suspend," 2008). Because Black athletes have less flexibility than White athletes do in regards to disagreement with those in power (Dickinson & Anderson, 2004; Leonard, 2010), Burress ran into trouble because he underestimated how little behavioral flexibility he had (Lupica, 2008).

On November 28, 2008, as an injured reserve player, Burress accidentally shot himself in a New York City nightclub (the Latin Quarter) (Jonsson, 2009). Jonsson summarized the incident: "An unlicensed gun tucked into Burress's waistband slipped down his leg and went off. The bullet pierced Burress's right thigh and narrowly missed a nearby security guard" (2009, p. 2). Burress delayed hospital treatment and later used an alias and claimed that he was shot at Applebee's (Lombardi, Gendar, & Lemire, 2008).

After the details of this evening surfaced, multiple sources criticized Burress. New York Giants Vice President of Communications, Pat Hanlon, called it a "tragic, sad, disappointing situation from the beginning" (Eligon, 2009, para. 19). Since the NFL has no guaranteed contracts, Burress was dismissed in April 2009. Giants General Manager Jerry Reese (Eisen, 2009) explained, "We hung in there as long as we could in hopes that there could be a resolution to this situation other than the decision we made today to release Plaxico. It wasn't to be, so now we have to move on" (para. 3). New York City has strict hand gun laws, and Burress had an unregistered weapon and no legal concealed weapons permit ("Burress: I Will," 2010). New York City Mayor Michael Bloomberg stated, "I don't think that anybody should be exempt from that [mandatory minimum sentencing]. It would be an outrage if we don't prosecute to the fullest extent of the law" (Lombardi, Gendar & Lemire, 2008, para. 8). These statements about Burress echo Dickinson and Anderson's (2004) assessment that when a Black athlete fails in a White world, he is given less latitude than a White player. In less than a year, Burress had moved from

the position of irreplaceable player, to one banished by his team for not following the rules.

Burress's job and freedom were in jeopardy in the aftermath of the shooting. He was cut by the Giants and forfeited the $27 million left on his contract (Teitelbaum, 2010). Despite his attorney's attempts to avoid jail time, Burress accepted a plea bargain with a two-year prison term in August 2009 (Teitelbaum, 2010). While Burress was released on June 6, 2011, many believed that his brief prison sentence would end his NFL career (Schwartz, 2011). Michael Vick, whose career was interrupted by a prison term for dogfighting, thought that Burress's career could be saved (Schwartz, 2011). After Burress was sentenced, the NFL Commissioner Roger Goodell suspended Burress until his jail term had been served in full (Maske, 2009). There are other players who served prison sentences and returned, such as Michael Vick, whose image and career was rehabilitated during the 2010–2011 season (Schwartz, 2011).

After 20 months in prison and two denials of work releases, Plaxico Burress was released (Kinkhabwala, 2011). After his release, Burress was ordered to complete two years of parole, get a job, and follow any directives of his parole officer ("Burress Released," 2011). As of August 23, 2011, Burress signed with the New York Jets for $3 million for one year, and played in preseason games ("Jets' Burress Opens," 2011). While Burress made some initial moves towards rehabilitating his image after his prison release, in an interview with Bryant Gumbel on *Real Sports* ("Plaxico Burress recounts," 2011), Burress claimed that the grand jury indicted him only because he is African American. Later in the interview, he admitted to not owning guns anymore ("Jets' Burress Opens," 2011). While Burress may still be working to rehabilitate his public image, he does have a contract and plays for an NFL team. While his initial steps might be rocky, he has the opportunity to rehabilitate himself on the field.

Gilbert Arenas

Like Plaxico Burress, Gilbert Arenas used sports to improve his economic status (Eitzen, 2000). Arenas's rise from poverty to NBA star is celebrated (Wise, 2007). Arenas was raised by his single father, and he had no contact with his mother from the time he was two until he was an NBA rookie (Wise, 2007). Arenas was considered an unlikely college prospect; many thought he would find little success in Arizona (Wise, 2007). However, he was a leader on a national championship squad for Coach Lute Olsen in 2002 (Wise, 2007). Arenas was characterized as an athlete motivated by criticisms of his talent and

abilities (Wise, 2007). Chosen late in the 2001 draft, Arenas used his short contract as an opportunity to sign as a free agent earlier than players who were drafted higher (Wise, 2007). His ability to use career setbacks to improve his personal situation was crucial. Arenas maintained a positive attitude and used setbacks as a motivating factor.

In Washington, Arenas distinguished himself through an engaging public persona. Historically, Black athletes have fought the myth that they were successful only because of their physical strength (Grainger, Newman, & Andrews, 2006). Arenas was able to challenge this established myth in several ways. First, Arenas willingly talked to the media but also maintained an often-quoted personal blog, an example of a thoughtful and insightful player. As described by the *Washington Post*'s Michael Wilbon (2010b):

> Arenas connected with people here like no pro basketball players since Wes Unseld. He had charisma. And if he wasn't Kobe Bryant or LeBron James, he wasn't far behind, and at least he seemed a threat to them, an All-Star, a peer (p. D01).

Second, Arenas used his celebrity and success to serve as an advocate for and to help his community. In 2005, Arenas established "Zero Two Hero," a charity supporting disadvantaged youth ("About Zero Two," n.d.). The NBA recognized his achievement by awarding him the 2005 NBA Community Assist Award ("Arenas Receives NBA," 2005). Through his foundation, Arenas donated $18,000 to a Hurricane Katrina shelter and mentored a 10-year-old DC boy who lost his family in a fire ("Arenas Receives NBA," 2005). During the 2006–2007 season, he pledged $100 for every point he scored to fund local schools (Johnson, 2007). Team owner Abe Pollin matched him, and in 2006–2007, they donated nearly $215,000 to needy schools (Johnson, 2007).

Arenas's engagement with his community as well as his on-court abilities made him valuable to the Wizards. Arenas was labeled "a cornerstone for years" for the team; he served as a team spokesperson and captain, and his image was used to sell season tickets and attract national television audiences (Wise, 2007). Wise (2007) summarized Arenas's rise in Washington:

> In one dizzying year, he went from being considered an enigmatic gunner with questions about his maturity to a refreshing, authentic oddball who could also carry a team. Arenas came to Washington at a time when its woebegone basketball team, on the heels of a bitter breakup with Michael Jordan, was headed toward insignificance. With each season, Arenas has brought more hope and buzz to a franchise that had lost whatever promise came with Jordan. (para. 10)

Arenas brought admirable qualities to the team, but he was human. Dan Steinberg (2010) detailed various pranks that Arenas committed as an NBA player, including filling a teammate's bathtub with coffee and playing pranks

with unguarded cell phones. Arenas functions as a successful player who is relatable, what Chidester (2009) considered critical for contemporary heroes. While there is an expectation that they are excellent, Chidester argued that people best relate to heroes who seem human. Despite a series of career-+ threatening injuries that made him miss substantial playing time, Arenas often demonstrated these qualities (Wise, 2007). However, his heroic abilities were questioned on December 24, 2009.

Arenas and teammate Javaris Crittenton (a little-used reserve player) had an unsettled bet stemming from a card game on the team flight. To settle it, Arenas placed four unloaded weapons in Crittenton's locker space with the note "Pick one" (Wise, 2010). Crittenton, in turn, pulled out his own loaded weapon and placed it in the ready position (Wise, 2010). Originally, this story was kept quiet because Arenas wanted to protect Crittenton, and he took responsibility for the episode (Wise, 2010). Arenas claimed that he brought the weapons to work to protect his young children, even though that action violated NBA rules (Leonard, 2010). *CBS Sports* broke the story in late December 2009, and it quickly spread. Between December 27, 2009 and January 18, 2010 (the time period between the event and as the story unfolded), there were 525 stories on LexisNexis Academic Universe's All-English section with the phrase "Gilbert Arenas w/5 guns." Just as the media helped build the myth of Arenas, they also facilitated his downfall. David Leonard (2010) documented how the media turned the Arenas incident into a referendum on the relationship between basketball players and guns, where Arenas was representative of negative consequences of gun ownership in the NBA and potentially threatened the reputation of the league.

Arenas, known for his media savvy prior to this incident, made poor decisions attempting to rebuild his hero status. First, in response to the media coverage, Arenas posted on Twitter, "I wake up this morning and seen I was the new John Wayne. . . . Lamo [meaning "laughing my ass off] media is too funny" (Alfonso G., 2004; Lee, 2010a, p. D1). Second, he was photographed making gun shapes with his fingers and shooting during introductions at an NBA game on January 5. Arenas was known for being a prankster and a jovial character. However, actions that were perceived as harmless before suddenly suggested that he was a threat. Commissioner David Stern suspended Arenas indefinitely because Arenas was "not currently fit to take the court in an NBA game" (Lee, 2010b, p. D7). Stern's punishment cost Arenas $7 million for the season and up to $50 million in endorsements and bonuses (Alexander, 2010b). These punitive measures by Stern are acceptable under the terms of the current NBA contract; players can be cut for a wide range of transgressions, including, "failing to conform to standards of good citizenship, charac-

ter, or sportsmanship" (Lane, 2007, p. 97). Arenas was brought back to the Wizards after his suspension was fulfilled, but he was traded to Orlando in the Winter of 2011 because the Wizards wanted to rebuild around 2010 draft pick, John Wall ("Magic Get Gilbert," 2010).

The gun incident had a chilling effect on the Washington Wizards' relationship with Arenas. Team captain Antawn Jamison addressed the home crowd on January 8, 2010: "We're definitely sick of it, too much negative publicity, and I think guys are just to the point where we just want to get some positive publicity and turn things around and start winning some games, start having fun" ("Coach Meets Examiners," 2010, para. 2). The Washington Wizards organization responded as well. The team traded several players to change the chemistry in the locker room, including Jamison. After Arenas's suspension, Coach Flip Saunders said, in describing the team's performance, "The thing with Gil really tainted everything" (Lee, 2010c, para. 6). All images of Arenas were removed from the arena, his jerseys were pulled from the team shop, and a banner was removed bearing his image with the words, "Character. Commitment. Connection" (Lee, 2010b, p. D7). In effect, the team distanced itself from its former superstar.

Gilbert Arenas is not the first NBA player to be arrested or charged with weapons possession. But many argued that he violated the sanctity of the locker room (Lee, 2010a). J. Freedom du Lac (2010) described the significance of Arenas's perception problem:

> But in the rest of the country, the news that the Washington Wizards' star guard displayed his guns in the team locker room—and the utter lack of seriousness with which Arenas and his teammates handled the incident in the ensuing days—is being perceived as a morality play about thuggish behavior in the NBA, race and the age-old debate over athletes' responsibility to young fans. (para. 1)

Leonard (2010) identified two problems with Arenas bringing guns into the locker room. First, Arenas was viewed as a product of his "culture" in media texts. While athletes are elevated to superstar status because of their athletic abilities, they are punished for identification with violence and previously held stereotypes related to Black athletes (Dickinson & Anderson, 2004). Second, Arenas's punishment was used to warn other players about gun use (Dickinson & Anderson, 2004). Perpetuated by the media, young Black men are often believed to use guns as solutions (Leonard, 2010). The prevalence of weapons among Black men to "solve" problems is frequently criticized (Grainger, Newman, & Andrews, 2006) and many NBA players who grew up in rough neighborhoods are thought to possess these views about guns as a solution (Lane, 2007). Consequently, Arenas's weapons resulted in a "tragic flaw" (Dickinson & Anderson, 2004). Rowe (1994) argued that an athlete can have

a "deviant career" when they commit a crime or have a public scandal that runs counter to the public's expectations of them. Rowe argued that perception of an athlete after a controversial incident depends on how they are able to function within society's expectations. In the case of Arenas, he was quickly dismissed because his weapons use and seeming lack of remorse characterized him as a figure who had to be removed from the league (Wilbon, 2010a). Guns are not considered acceptable in mainstream society, and Arenas was violating these expectations.

Legal issues for Arenas were resolved more quickly than for Burress. On January 15, 2010, Arenas pled guilty "to a felony count of carrying a pistol without a license" (Alexander, 2010b, p. D01). He did not receive jail time, but was given an 18-month suspended sentence, 2 years of probation (including a month in a halfway house), 400 hours of community service, and required to donate $5,000 to a crime victims fund (Duggan, 2010). Arenas is back in the league, but Commissioner Stern forbade him from discussing the locker room incident (Lee, 2010d). Unfortunately, Arenas has continued to be controversial. When he faked a knee injury to help a teammate get playing time, he received a fine of $50,000 (Hamilton, 2010). As of August 2011, Arenas has not had the opportunity to begin rehabilitation. The NBA is currently locked out, and may lose a season (Young, 2011). Arenas has gotten in trouble over the past few months with his Twitter feed—losing a court case to block his ex-girlfriend from appearing on *Basketball Wives* ("Arenas Loses," 2011), and even wrote several posts about the locker room incident (Young, 2011). Arenas claimed that the Wizards wanted to get rid of him and used this incident as an excuse to trade him (Young, 2011). Clearly, Arenas is not positioning himself as a franchise player right now, and that window might be closing. It will be interesting to see what happens to Arenas as his career devolves.

Conclusion

The examination of Gilbert Arenas and Plaxico Burress is important because these cases are used as evidence for the link between Black professional athletes and weapons. As examined by several scholars (Berry & Smith, 2000; Dickinson & Anderson, 2004; Enck-Wanzer, 2009; Grainger, Newman, & Andrews, 2006; Leonard, 2010), this is a rich area of academic study. Burress and Arenas are singled out as examples of how out-of-control athletes should be contained. In fact, early after the Arenas story broke, Dorhmann (2010) argued, "The particulars of Arenas' case (he admits to storing weapons but

denies threatening Crittenton) doesn't matter as much as the broad meaning: Burress' downfall apparently had no impact on Arenas" (para. 4). Both cases generated ready academic consideration. Teitelbaum devoted part of his 2010 book, *Athletes Who Indulge Their Dark Side: Sex, Drugs, and Cover-ups* to dissecting Burress's behavior, and Leonard (2010) analyzed the link between Arenas and the conversation about weapons and NBA players. Leonard argued that Arenas's incident had been unfairly classified as part of the gun and NBA player culture. Leonard argued that the NBA has a conflicted relationship with weapons and players, with a culture of ignorance that permeates the NBA. Looking at these two cases together demonstrates how the presence of weapons changes the tone of rhetoric that attempts to make sense of criminal charges against athletes.

Both Arenas and Burress were seen as "safe" before their criminal cases, yet afterwards, they have morphed into threats. Arenas and Burress became what Enck-Wanzer (2009) described as "The Black athlete out of control" (p. 5), a stereotype often used in media discourse to describe weapons charges and athletes. A representative quote of this type of discourse in coverage of Burress is Daly's (2008): "It was a tragedy one year ago when Sean Taylor was shot to death with a gun and a tragedy that Plaxico Burress put his life and the future of his teammate [Antonio Pierce] at risk with a gun" (para. 4). Leonard (2010) quoted columnist Jason Whitlock, who is often critical of NBA players and their hip-hop lifestyles. Whitlock connected Arenas with other NBA players facing weapons charges, arguing that "Arenas can't think critically" (Whitlock, as cited in Leonard, 2010, p. 255). These types of over-generalizations demonstrate how quickly an athlete can move from being a hero to a deviant.

Arenas's and Burress's falls from their heroic status also show how the media can work in mysterious ways to classify crimes, especially when they are linked to weapons and violent behavior. When charges and public outcries were brought against Arenas, Michael Wilbon (2010a) identified the hypocrisy in the attention to Arenas's actions and reactions. Wilbon listed other charges made against professional athletes that were much worse than Arenas's actions, such as violence against women. These charges did not result in jail time or significant suspensions from play, while Arenas was in danger of a voided contract and indefinite suspensions (Wilbon, 2010a). Here, Wilbon made the argument that the use of guns, as opposed to physical strength, changes how a crime is perceived. While serious and systematic abuse issues may be ignored, once a player is caught with a weapon, he has difficulty avoiding punishment. While these other athletes were suspended for a game or two, the fact that Arenas and Burress were vilified in the press before charges were brought,

emphasizes the unique role that weapons play regarding a culture of fear in athletes linked to them.

References

About Zero Two Hero. (n.d.). *Gilbert Arenas' Zero Two Hero Foundation.* Retrieved from http://www.zerotwoherofoundation.org/about/index.html

Alexander, K. L. (2010a, January 16). Arenas pleads guilty to felony count. *The Washington Post,* p. D01. Retrieved from http://web.lexis-nexis.com/universe

Alexander, K. L. (2010b, March 24). Prosecutors: Arenas led a cover-up, deserves jail. *The Washington Post,* p. D01. Retrieved from http://web.lexis-nexis.com/universe

Alfonso G. (2004, July 9). Lamo. *Urban Dictionary.com.* Retrieved from http://www.urban dictionary.com/define.php?term=lamo

Arenas loses 'Basketball Wives' bid. (2011, August 26). *FoxSports.com.* Retrieved from http://msn.foxsports.com/nba/story/gilbert-arenas-loses-bid-to-block-ex-fiancee-from-basketball-wives-082511

Arenas receives NBA Community Assist Award for August (2005, September 9). *NBA.com.* Retrieved from http://www.nba.com/news/community_award_aug05.html

Battista, J. (2009, April 3). Future in doubt, the Giants' Burress is released. *The New York Times.* Retrieved from http://www.nytimes.com/2009/04/04/sports/football/04giants.html

Berry, B., & Smith, E. (2000). Race, sport, and crime: The misrepresentation of African Americans in team sports and crime. *Sociology of Sport Journal, 17*(2), 171–197.

Bondy, F. (2008, February 4). Burress' glory is guaranteed. *New York Daily News,* p. 12.

Burress: 'I will play again.' (2010, February 3). *ESPN.com.* Retrieved from http://sports.espn.go.com/nfl/news/story?id=4882622

Burress, P., & Cole, J. (2008). *Giant: The road to the Super Bowl.* New York, NY: HarperEntertainment.

Burress released from jail with comeback as goal. (2011, June 6). *Associated Press.* Retrieved from http://www.nytimes.com/2011/06/07/sports/football/plaxico-burress-is-released-from-prison.html

Butterworth, M. L. (2008). Purifying the body politic: Steroids, Rafael Palmeiro, and the rhetorical cleansing of Major League Baseball. *Western Journal of Communication, 72*(2), 145–161. doi: 10.1080/10570310802038713

Carter, I. (2006, December 19). Arenas's Hollywood Night. *The Washington Post.* Retrieved from http://www.washingtonpost.com/wp-dyn/content/article/2006/12/18/AR2006121801428.html

Chidester, P. J. (2009). 'The toy store of life': Myth, sport and the mediated reconstruction of the American hero in the shadow of the September 11th terrorist attacks. *Southern Communication Journal, 74*(4), 352–372. doi: 10.1080/10417940802510365

Coach meets examiners, bans gambling. (2010, January 9). *Associated Press.* Retrieved from http://sports.espn.go.com/nba/news/story?id=4808994

Daly, D. (2008, December 4). Burress' blunder is no tragedy. *The Washington Times,* p. C01. Retrieved from http://web.lexis-nexis.com/universe

Dickinson, G., & Anderson, K. V. (2004). Fallen: O. J. Simpson, Hillary Rodham Clinton, and the re-centering of White patriarchy. *Communication and Critical/Cultural Studies, 1*(3), 271–296. doi: 10.1080/14791420420000244970

Dohrmann, G. (2010, January 4). Agent Zero learned zero from Plaxico Burress' downfall. *Sports Illustrated*. Retrieved from http://sportsillustrated.cnn.com/2010/writers/george_dohrmann/01/04/gilbert.arenas/index.html

Duggan, P. (2010, March 27). Arenas avoids a jail sentence in gun incident. *The Washington Post*, p. A01. Retrieved from http://web.lexis-nexis.com/universe

Eisen, M. (2009, April 3). Giants release WR Plaxico Burress. *Inside Giants*. Retrieved from http://www.giants.com/news/headlines/story.asp?story_id=36356

Eitzen, D. S. (2000). Upward mobility through sport? The myths and realities. In D. S. Eitzen (Ed.), *Sport in contemporary society: An anthology* (6th ed., pp. 256–262). New York, NY: Worth.

Eligon, J. (2009, August 21). Burress will receive 2-year prison sentence. *The New York Times*, p. A23. Retrieved from http://web.lexis-nexis.com/universe

Enck-Wanzer, S. M. (2009). All's fair in love and sport: Black masculinity and domestic violence in the news. *Communication and Critical/Cultural Studies, 6*, 1–18. doi: 10.1080/14791420802632087

Freedom du Lac, J. (2010, January 8). Word on the street: Seriously stupid, Gil. *The Washington Post*, p. B01. Retrieved from http://web.lexis-nexis.com/universe

Full court mess: Time for a new face of the franchise. (2010, January 3). *The Washington Post*, p. D01. Retrieved from http://web.lexis-nexis.com/universe

Giants suspend WR Burress for one game. (2008, September 25). *Associated Press*. Retrieved from http://nbcsports.msnbc.com/id/26868096

Grace, M., & Goldiner, D. (2009, July 29). Under the gun. *Daily News* (New York), p. 7. Retrieved from http://web.lexis-nexis.com/universe

Grace, M., Vacchiano, R., Schapiro, R., & McShane, L. (2009, August 21). Plax's 2-year punt. *Daily News* (New York), p. 7. Retrieved from http://web.lexis-nexis.com/universe.

Grainger, A., Newman, J. I., & Andrews, D. L. (2006). Sport, the media, and the construction of race. In A. A. Raney & J. Bryant (Eds.), *Handbook of sports and media*, (pp. 447–467). Mahwah, NJ: Lawrence Erlbaum.

Hamilton, T. (2010, October 15). Gilbert Arenas: Still faking it when it's time to get real. *The Washington Post*. Retrieved from http://www.washingtonpost.com/wp-dyn/content/article/2010/10/14/AR2010101404140.html

Hawkes, T. (1977). *Structuralism & semiotics*. Berkeley, CA: University of California Press.

Jets' Burress opens up about shooting, jail in HBO interview. (2011, August 13). *Sports Illustrated*. Retrieved from http://sportsillustrated.cnn.com/2011/football/nfl/08/13/jets.plaxico.burress.ap/index.html (no longer accessible).

Johnson, D. (2007, October 30). 82 schools win the lottery, Wizards-style. *The Washington Post*. Retrieved from http://www.washingtonpost.com/wp-dyn/content/article/2007/10/29/AR2007102901892.html

Jonsson, P. (2009, August 20). Burress case: No legal free pass for athletes any more. *Christian Science Monitor*, p. 2. Retrieved from http://web.lexis-nexis.com/universe

Kinkhabwala, A. (2011, June 7). Bound for home, Burress reflects. *The Wall Street Journal.* Retrieved from http://online.wsj.com/article/SB10001424052702304432304576369761217788054.html

Lande, R. (2011, June 10). With incentive to behave and produce, Plaxico Burress could be great bargain. *The Sporting News.* Retrieved from http://aol.sportingnews.com/nfl/story/2011-06-10/with-incentive-to-behave-and-produce-plaxico-burress-could-be-great-bargain#ixzz1PNAQZvoo

Lane, J. (2007). *Under the boards: The cultural revolution in basketball.* Lincoln, NE: University of Nebraska Press.

Langley, M. R. (1994). The cool pose: An Africentric analysis. In R. G. Majors & J. U. Gordon (Eds.), *The American Black male: His present status and his future* (pp. 231-244). Chicago, IL: Nelson-Hall.

LaPointe, J. (2008, December 3). Giants say Burress's season is over. *The New York Times,* p. B11. Retrieved from http://web.lexis-nexis.com/universe

Lee, M. (2010a, January 2). Arenas comes under closer scrutiny. *The Washington Post,* p. D01. Retrieved from http://web.lexis-nexis.com/universe

Lee, M. (2010b, January 16). After Arenas's plea, Wizards refocus. *The Washington Post,* p. D07. Retrieved from http://web.lexis-nexis.com/universe

Lee, M. (2010c, February 18). Wizards trade Antawn Jamison to Cavaliers. *The Washington Post,* p. D01. Retrieved from http://www.washingtonpost.com/wp-dyn/content/article/2010/02/17/AR2010021704909.html

Lee, M. (2010d, September 22). David Stern to Gilbert Arenas: Don't talk about gun incident. *The Washington Post.* Retrieved from http://www.washingtonpost.com/wp-dyn/content/article/2010/09/22/AR2010092205677.html

Leonard, D. J. (2009). It's gotta be the body: Race, commodity, and surveillance of contemporary Black athletes. *Studies in Symbolic Interaction, 33,* 165-190. doi: 10.1108/S0163-2396(2009)0000033013

Leonard, D. J. (2010). Jumping the gun: Sporting cultures and the criminalization of Black masculinity. *Journal of Sport & Social Issues, 34*(2), 252-262. doi:10.1177/0193723510367781.

Lombardi, F., Gendar, A., & Lemire, J. (2008, December 2). Mayor Bloomberg fuming over Plaxico shooting. *Daily News* (New York). Retrieved from http://www.nydailynews.com/news/ny_crime/2008/12/01/2008-12-01_mayor_bloomberg_fuming_over_plaxico_shoo-3.html (no longer accessible).

Lupica, M. (2008, November 30). Punt this guy who's gone from hero to zero. *Daily News,* p. 2. Retrieved from http://web.lexis-nexis.com/universe

Magic get Gilbert Arenas in banner day. (2010, December 19). *ESPN.com.* Retrieved from http://sports.espn.go.com/nba/news/story?id=5932861

Maske, M. (2009, August 20). Burress pleads guilty. *The Washington Post.* Retrieved from from http://web.lexis-nexis.com/universe

O'Connor, I. (2008, January 28). Plax's fork in road. *The Record* (Bergen County, NJ), p. S01.

Plaxico Burress recounts nightclub shooting on HBO, says, 'who's Mayor Bloomberg?' (2011). *CBSNewYork.com.* Retrieved from http://newyork.com/2011/08/17/plaxico-burress-recounts-nightclub-shooting-on-hbo-says-whos-mayor-bloomberg/

Reed inspires Knicks to victory. (2010). *NBA.com*. Retrieved from http://www.nba.com/history/reedwins_moments.html

The Reliable Source. (2011, June 13). Plaxico Burress' next move: Joins Brady Center to prevent gun violence. *The Washington Post*. Retrieved from http://www.washingtonpost.com/blogs/reliable-source/post/plaxico-burress-next-move-joins-brady-center-to-prevent-gun-violence/2011/06/13/AGSF0YTH_blog.html?wprss=reliable-source

Rhoden, W. C. (2008, October 20). Burress's tremor of discontent gains magnitude. *The New York Times*, p. D3. Retrieved from http://web.lexis-nexis.com/universe

Robinson, T. (2008, January 31). Good season has erased bad reputation for Burress. *The Virginian-Pilot* (Norfolk, VA), p. C1.

Rowe, D. (1994). Accommodating bodies: Celebrity, sexuality, and 'tragic Magic.' *Journal of Sport and Social Issues*, *18*(1), 6–26. doi: 10.1177/019372394018001002

Rowland, R. C. (1990). On mythic criticism. *Communication Studies*, *41*, 101–116.

Schwartz, P. (2011, May 25). Vick says Eagles good fit for Burress. *New York Post*. Retrieved from http://www.nypost.com/p/sports/giants/vick_says_eagles_good_fit_for_plax_YKDeeRNyDeBA60Mi6LTzoI

Steinberg, D. (2010, January 7). A history of Gilbert's practical jokes. *The Washington Post*. Retrieved from http://voices.washingtonpost.com/dcsportsbog/2010/01/a_history_of_gilberts_practica.html

Teitelbaum, S. H. (2010). *Athletes who indulge their dark side: Sex, drugs, and cover-ups*. Santa Barbara, CA: Praeger.

Vacchiano, R. (2007, September 26). Jacobs 'getting very close' to return. *New York Daily News*. Retrieved from http://origin.nydailynews.com/blogs/giants/2007/09/jacobs-getting-very-close-to-r.html

Wilbon, M. (2010a, January 14). Let's not erase Arenas. *The Washington Post*, p. D01. Retrieved from http://web.lexis-nexis.com/universe

Wilbon, M. (2010b, January 16). In the end, it's time for a new beginning for all involved. *The Washington Post*, p. D01. Retrieved from http://web.lexis-nexis.com/universe

Wise, M. (2007, October 28). The story of O. *The Washington Post Magazine*, p. W12. Retrieved from http://web.lexis-nexis.com/universe

Wise, M. (2010, January 7). NBA hands Arenas indefinite suspension. *The Washington Post*, p. A1. Retrieved from http://web.lexis-nexis.com/universe

Young, R. (2011, July 15). Arenas tweets about the gun incident. *CBS Sports.com*. Retrieved from http://www.cbssports.com/mcc/blogs/entry/22748484/30631485

Interrogating Discourses About the WNBA's "Bad Girls": Intersectionality and the Politics of Representation

Mary G. McDonald
Cheryl Cooky

During the closing seconds of a Detroit Shock (the franchise subsequently moved to Tulsa in 2009) and Los Angeles Sparks Women's National Basketball Association (WNBA) game on July 22, 2008, an altercation took place on the floor. Based on journalistic accounts of the event, here is what seems to have transpired: a brief, under-the-basket scuffle took place in the closing seconds of the game between Shock forward Cheryl Ford, and Sparks then-rookie Candace Parker. Immediately after a free throw by the Sparks' Marie Ferdinand-Harris put the score at 82–78 in favor of the visiting Sparks, Detroit's Plenette Pierson initiated contact with Parker, causing the 2008 college player of the year to fall to the floor. Then "Pierson got up and stood over Parker, who pulled her back to the floor" (Fratto, 2008). Several players from both teams left the bench area and joined in the event. Detroit Shock assistant coach, Rick Mahorn, and Los Angeles Sparks star, Lisa Leslie, were involved in a physical encounter in which (depending upon which account you believe) Mahorn had either attempted to play peacemaker by stopping Leslie or had shoved Leslie to the floor. Apparently thinking that Mahorn was escalating the situation, Sparks teammate Shannon Bobbitt physically confronted the coach. When the altercation between the two WNBA teams concluded, three players—Shock forward Plenette Pierson, and Sparks forwards Candace Parker and DeLisha Milton-Jones—were ejected. Detroit star Cheryl Ford injured her knee during the incident.

That Los Angeles ultimately won the game 84–81 was lost in the subse-quent media coverage and narrative proliferation which accompanied the event (or what several sources characterized as a *catfight*). Another commenta-

tor suggested the controversy was a way for some men to proclaim, "Dude! Check it out! Chicks fighting!" (cited in Voepel, 2008, para. 6). One headline characterized the fight as "Malice at the Palace 2" (Friday, 2008), a curious reference to the player-fan altercation that occurred in a National Basketball Association (NBA) game between the Detroit Pistons and Indiana Pacers on November 19, 2004 at The Palace of Auburn Hills in Auburn Hills, Michigan—which was also the site of the Sparks-Shock fight. One account merged these characterizations, calling the scuffle the "catfight in the Palace" (Michaelson, 2009, para. 29). Helene Elliott of the *Los Angeles Times* wondered about a double standard in the United States media responses which greeted the event, asking: "Will we ever reach a point where femininity and competitiveness are considered complementary, not mutually exclusive? Or when a clash between female athletes won't be demeaned as a catfight?" (Elliott, 2008, para. 23).

That many of the responses referred to the event as a catfight speaks to a history where female aggression and violence have been mediated in particular, often sensationalized ways suggestive of a deep cultural ambivalence when women are involved in physical confrontations. Most often the catfight involves an altercation or argument between two women and typically includes hair pulling and scratching. At the most basic level, the media construction of the WNBA catfight reinforced negative stereotypes of women as "catty" and "cunning." It also conjures a particular patriarchal imagining of cattiness, where women presumably compete against each other for the attention of men (see Tanenbaum, 2002). No less a cultural authority than comedian Jerry Seinfeld explained the catfight as a particular (hetero)sexual fantasy: "Men think if women are grabbing and clawing at each other, there's a chance they might somehow, you know . . . kiss" (Berg & Schaeffer, 1997).

Additionally, it is important to point out the trivializing dimension of this popular culture fetish. While the term *catfight* has been in existence since the early 20th century, it became popular in the 1970s, in part because of the ways in which the media portrayed the women's movement as a catfight between "hippies" and housewives (Douglas, 1995). Characterizing both physical and nonphysical confrontations and differences between women as catfights points to the regulatory power of this characterization. Such characterizations focus on the alleged behavioral and personality traits of the particular women involved while diverting scrutiny from normative understandings of gender and sexuality, which hierarchically organize bodies and shape institutional structures like sport.

In the midst of the considerable media response to the event, then WNBA president, Donna Orender, issued a statement countering suggestions of a catfight, arguing that

> The WNBA and its players represent all that is good about sports: passion, hard work and sacrifice. On a nightly basis our players display extraordinary skill, athleticism and competitive fire. The events Tuesday, however, were inexcusable and in no way indicative of what the league stands for. We hold our players to a very high standard and these suspensions should serve notice that the behavior exhibited at the end of Tuesday's game will not be tolerated. ("WNBA Announces," 2008, para. 2)

Complementing Orender's response were a whole host of other WNBA spokespeople who condemned the altercation, influencing the narrative construction process. Washington Mystics general manager, Linda Hargrove, was typical of this position: "I don't think it's good for our league. . . . It's not how our league wants to be portrayed. It's not how our players want to be portrayed. I don't really see anything good coming out of this" (cited in Carrera, 2008, para. 15). The WNBA subsequently suspended 11 individuals involved with sanctions ranging from one to four games. Shock forward Pierson was suspended "four games for her actions that initiated and escalated the altercation," while Shock assistant coach Mahorn earned a two-game suspension "for escalating the altercation" ("WNBA Announces," 2008, para. 4-5). Sparks guards Bobbitt and Murriel Page both earned two-game suspensions "for leaving the area of the bench and becoming physically involved in an on-court altercation," while Leslie and Milton-Jones of the Sparks were each "suspended for one game for throwing a punch" ("WNBA Announces," 2008, para. 10-11). Other players earned suspensions for leaving the bench area ("WNBA Announces," 2008).

In this chapter we use the lens of feminist cultural studies to both explicate and recontextualize some key narratives generated through the WNBA "sport event" as a point of entry into the historically specific, intersecting social relations which have helped to produce its larger cultural salience. To do so, we have investigated over 70 web and blog posts as well as newspaper, magazine, and television accounts of the fight, reading these against and alongside previous scholarly analysis of the WNBA and its complicated relationship to the NBA. We also provide a brief discussion related to ways in which female aggression and violence are represented in the broader culture.

This analytic strategy is grounded in the recognition that the media storylines, which constitute dominant framings of the Sparks-Shock fight, are powerful texts to be read for their larger cultural meanings. Thus our goal is not to search for the facts of this incident or to document the actual fallen hero status of the principal players such as Candace Parker or Plenette Pier-

son. Rather this analysis offers a different strategy in searching "for the ways in which those 'facts' are constructed, framed, foregrounded, obscured, and forgotten" (McDonald & Birrell, 1999, p. 292). This critical perspective guides us toward an investigation into the ideological power of this incident, and we suggest it additionally resonates with other popular, cultural images of sensationalized deviance, mobilizing particular narratives of gender, Whiteness, and commodification to promote a historically specific and politically salient version of *bad girls*.

This analysis will specifically demonstrate that the Sparks-Shock fight not only provided a way for many commentators to imagine the WNBA within binary gender norms but also offered yet another opportunity for commentators to marshal the power of White privilege in hailing stereotypical depictions of deviant Blackness. While acknowledging the disparate and competing responses to this event, this analysis makes visible some of the dominant framings of the Sparks-Shock fight—an altercation that fractured the crafted marketing persona of the WNBA as a postfeminist site of athletic superwomen, which had been carefully cultivated since the league's inaugural season in 1997.

In order to better explicate some of the dominant framing(s) of the incident, we organize this chapter in the following way: First, we make visible and historically contextualize the WNBA's idealized marketing image as embedded in the logic of consumerist postfeminist ideals committed to representing the predominately African American playing force as responsible and socially concerned. Next, we investigate two important narratives related to the fight which disrupt this carefully crafted image: the first we characterize as the "women can be competitive, too" storyline, a new twist on a recurring theme related to the gender binary which homogenizes bodies according to normative assumptions about gender. In the case of the Sparks-Shock fight, this framing also mirrors racialized and classed images of violent deviance circulating in the wider U.S. culture. The second narrative we highlight documents the way in which several commentators also used the occasion of the Sparks-Shock altercation and Assistant Coach Rick Mahorn's role in the event to (re)produce racialized narratives about the National Basketball Association (NBA). This framing offers a new twist on a recurring racist theme about Black men misbehaving in sport and the wider culture, a narrative which similarly demonstrates the power of intersectionality as articulated through complicated, classed, gendered, and racialized meanings.

The Rise of the WNBA's "Good Girls" and Postfeminist Ideals

What is intriguing about this WNBA altercation is that it briefly displaced the dominant marketing construction of the league and its predominately African American playing force as the embodiment of ideal role models and heroes. That is, prior to this event, the players were frequently represented by the league, corporate sponsors, and sympathetic members of the media as athletic, socially responsible in promoting opportunities for women in and out of sports and as embodying heteronormative and feminine sensibilities (McDonald, 2000).

Since its inaugural season (when it was financially supported solely by the NBA), the league has existed within postfeminist, consumerist sensibilities most notably through the accommodation of particular second wave feminist demands regarding inclusion (McDonald, 2000). Marketers of the WNBA and their corporate sponsors have been especially active in promoting postfeminism by repackaging second wave feminist quests for freedom, choice, and opportunity as images, desires, lifestyles, and emotions that can be attained through consumption. In doing so, advertisers reduce everyday relations women encounter and negotiate to a series of attitudes and styles that can be consumed (McDonald, 2000, p. 38).

In contemporary popular culture, professional female athletes like the women of the WNBA continue to be marketed as postfeminist heroes who presumably provide girls and young women with positive role models, given that they exemplify *girl power*, an explicitly nonthreatening and nonpolitical form of feminism (Taft, 2004). Rather than focus on ideologies and historical forces of inequality that still persist,, postfeminist "girl power" posits that equality between the sexes has been achieved. This means that girls and women can celebrate and embrace femininity rather than rejecting it outright while still enjoying the benefits of second wave feminism, especially the achievement of access to male-dominated institutions such as sports. This postfeminist focus on access and individualism does little to disrupt hegemonic masculinity that continues to shape sports (Cooky, 2010).

The promotional apparatus of the league has continued to offer a plethora of images representing the players as postfeminist role models—as achievement-oriented and socially concerned (McDonald, 2000). During her rookie year in the league, Parker, an African American, already had been cast as what then-Sparks coach, Michael Cooper, termed the "face of the league" (cited in Wood, 2008, para. 16), following in the footsteps of such celebrated stars as fellow teammate, Leslie, as well as founding league members, Rebecca Lobo

and Sheryl Swoopes. According to Lobo, Parker deserved this honor, as she has "the whole package . . . [h]er game, her personality, just everything" (cited in Wood, 2008, para. 9). This vision of engaging personalities, postfeminist role models, and committed competitors stands in stark contrast to the stereotypical and historical depictions of African American women as lacking civility and morality, and of homophobic depictions denouncing female athletes as lesbians. This image additionally reveals the complicated power of intersectionality, which suggests that gender relations are fluid and always already complicated by the interlocking narratives and structures of social locations including race, class, and sexuality—which also operate differently within particular temporal and spatial contexts.

As Patricia Hill Collins (2004) has demonstrated, Black women historically have been "othered" in ways that preclude their access to conventional (i.e., White, middle-class) feminine norms. Understood from this perspective, representations of WNBA and other successful Black female athletes have served complicated ends. These images have helped to "provide a range of images that challenge the contemporary controlling images of Black women like the 'bitch' and the 'bad mother,' while closing the gap between men's and women's sports" (Collins, 2004, p. 135). The case of the WNBA supports Collins's (2004) larger argument related to intersectionality as the homogenizing stereotypes of "female athletes as 'manly' and as lesbian, and for Black women as being more masculine than white women," which, she contended, "converge to provide a very different interpretive context for Black female athletes" (p. 135).

The idealized representations of African American female athletes marketed by the WNBA gain further salience when contrasted to dominant representations of Black masculinity. According to Banet-Weiser (1999) the popular construction of the WNBA and its players as the embodiment of a modest and morally superior form of femininity serves a powerful racialized function as the obverse image of the NBA as "a group of spoiled, ungrateful, violent Black men invading the minds of innocent White middle class boys and girls" (p. 405). Seemingly, then, until this particular incident between the Shock and Sparks, there does not appear to have been any comparable racialized bad girl equivalent in the dominant media constructions of the WNBA.

Suffice it to say that at the time of this incident in the league's 12th year of existence, the WNBA had generally countered lingering stereotypes of Black women as undisciplined and morally deficient by promoting the league as a bastion of both girl power and *good girls*. That is, the WNBA appeared to be stocked with talented, presumably morally superior, and gracious athletes who all played for the love of the game and served as appropriate role models, for

example, by engaging in community service via such vehicles as WNBA CARES. This imagining is suggestive of what Banet-Weiser argued is a politicized representation of "wholesome players, grateful that they have a job at all" (1999, p. 405).

The emphasis in both WNBA marketing and news media coverage is often disproportionately on the players who are fashion models, such as Parker, and/or mothers, such as Leslie. This recurring construction contributes to the league's defensive response to the homophobia that permeates sports. In sum, the representational strategies are part of a larger effort to project a class-based, racialized image of respectability in order to appease and appeal to White, middle-class, and normative sensibilities in a delicate balancing act to remain financially viable (Banet-Weiser, 1999). Like all representations, this dominant construction of the league and WNBA players is unstable, shifting, and subject to counter narratives, historical needs, and fresh understandings. Indeed, for a time following the Sparks-Shock altercation, the WNBA found itself cast outside of this idealized, postfeminist image—back within the stereotypical realm of Black womanhood as immodest and uncivilized (Collins, 2004). In the following section we further discuss key important narratives and contexts which helped to constitute representations of the Sparks-Shock fight.

Fallen Heroes: "Bad Girls," Intersectionality, and Narrative Construction

According to one news media account, the Sparks-Shock fight was the most widely covered event related to the WNBA during the 2008 season. Another commentator suggested:

> we will leave it to sports sociologists to determine if women's basketball is better off because players for the Detroit Shock and Los Angeles Sparks squared off. But one fact is indisputable: More people have been talking WNBA this week than ever in the league's 12 seasons. That has to be a good thing for an enterprise still searching for a major league identity. (Horn, 2008, para. 3)

That the fight still resonates is not only apparent by the continued presence of videos of the incident on YouTube, but also by the fact that as recently as July 23, 2010, Street Level blog named the scuffle as among the 11 most outrageous fights in recent sports history. The Sparks-Shock brawl is also a Wikipedia entry and a Google search on the Internet for "bad girls and WNBA" brings up links to the fight. At the time of the event, President Orender explained: "There's no doubt that there has been a tremendous amount of attention, but it's not the type of attention that we seek" (cited in

the Associated Press, 2008, para. 26). Another account was similarly ambivalent: "Out of this melee, the Detroit Shock brought some swagger to the league that was sorely lacking. The WNBA needed a shot in the arm to boost viewership—albeit not the one that they were looking for, but nonetheless they got it" (Parker, 2008, para. 9).

While the storylines elevated the fight into the popular imagination, a discussion within popular accounts did ensue over the question of whether the word "fight" was even an appropriate characterization. Indeed one pundit noted that the event was a "rather toothless mini-brawl between several players" (Michaelson, 2009, para. 29). Another journalist noted that there were varied ways in which the altercation could be understood, including that of "brawl, melee, incident, altercation, tangle, and tussle" (Voepel, 2008, para. 3). According to that author, "'fracas' really is my favorite. It suggests less mayhem than brawl or melee, but a little more than altercation, etc. And that fits this Sparks-Shock thing" (Voepel, 2008, para. 3).

These and the previous discussions regarding characteristics of a catfight reveal the power of language to shape divergent representations and understandings of the incident. While various words were used to characterize the event, commentators also used the occasion to reassert what we refer to as the "women are competitive, too" narrative framework, which served to homogenize all men and all women in a way that suggested gender similarity and a sense of empowerment in that similarity. At times this framing constructed the fight as a sin of "progress," suggesting that the men's game served as the standard for women to emulate—a very postfeminist take on equity. For example, one account noted:

> Tuesday night's bench-clearing scuffle between the Los Angeles Sparks and Detroit Shock proved women can be just as boneheaded as men in the thick of intense athletic competition. Progress? Absolutely. The fight, which, by the way, isn't the WNBA's first, showed that squaring up isn't a man thing. It's a sports thing. It's an athlete thing. It's an I'm-so-ticked-off-that-Candace-Parker-just-drilled-me-in-the-chest-and-the-refs-didn't-notice thing. (Hill, 2008, para. 3)

Another commentator observed:

> Here's what the skirmish proved: There is passion in the women's game. For many, the WNBA is a below-the-basket game played by the old girls club. The brawl has revealed the players to be competitive athletes who would not be more at home on the Ladies PGA Tour. No one is advocating turning the WNBA into the WWE, but an outpouring of pure emotion is never bad for a sport. (Horn, 2008, para. 9)

As sportswriter Jemele Hill proclaimed: "Female athletes are just as competitive as men and when some are pushed to the edge, they'll exhibit the same lack of control" (Hill, 2008, para. 16).

While this narrative takes on the "double standard" that "women aren't supposed to fight," this frame is simultaneously embedded in the gender binary and homogenizes all women as similar to all men. Interestingly, this frame of "women are competitive, too" simultaneously suggests that all women are athletically inferior to all men, yet women are just as capable of violence as men. Importantly, this type of framing displaces the social, political, and historical conditions that help to produce violence both within, and importantly, outside the world of sports. It ignores what social scientists and cultural critics point to as the culturally produced, gendered character of violent and aggressive behavior that exists in relationship to hegemonic masculinity within sports. The narrative of "women can be just as violent as men" has been deployed in other contexts to downplay the gender regimes, which continue to influence numerous men to disproportionately perpetrate violence in intimate relationships. It also downplays the important contributing factors beyond excessive masculinity that help to perpetuate violence committed by both men and women outside of competitive sport settings including poverty, disenfranchisement, structural racism, and state power (Chesney-Lind & Jones, 2010).

Narratives of the Sparks-Shock fight thus resonate beyond the world of sport, articulating with broader representational patterns. As Chesney-Lind and Irwin (2008) demonstrated, media hype over a range of violent and aggressive actions by women are part and parcel of a lineage of images that reveal cultural fears and fascination around female force and aggression and a broader cultural obsession with the image of the bad girl. Furthermore, this narrative and the intense scrutiny of this WNBA event are closely aligned with contemporary millennia discourses lamenting the alleged decline of girlhood and womanhood in America due to what popular accounts see as the phenomenon of "mean girls" and "girls gone wild" and/or "girls in gangs." Examples of these images can be found in such popular books as *Queen Bees and Wannabes* (2002) and *Odd Girl Out: The Hidden Culture of Aggression in Girls* (2002); popular films such as *Mean Girls* (2004), *Thirteen* (2003) and *Mi Vida Loca* (1993); and in newscasts highlighting the gang activities of young women and girls. Similar images lamenting the increased aggressive and bullying behavior of young women, and the "moral panic" revealed in the proliferation of these characterizations have not been supported by decades of social scientific research. In fact, researchers argue that although actual violence by young women has not increased, incarceration and detention rates have increased (Chesney-Lind & Irwin, 2008; Males, 2010).

These contemporary imaginings represent the latest version of a broader, historical trajectory. While the bad girl image has long been seared into the American imagination since at least the 1950s, the media have intensified this focus, most frequently sanctioning bad girls who break feminine norms for seemingly threatening the moral fiber of American society. While the archetype of the bad girl has changed throughout time—from the sexually promiscuous girls of the 1950s to the revolutionaries of the 1970s, the girl gangster of the 1980s, the mean girl at the turn of the century, and the "violent" girl of the new millennium—the theme is the same: more bad news about girls and women and their allegedly declining character. That is, despite the external feminine trappings, many of the media framings suggest that deep within their core, women's true venom—cattiness—comes out via competitive interactions with other women (Chesney-Lind & Irwin, 2008). This framing takes critical scrutiny away from the institutional production of unequal gender relations, producing the material consequences related to important social issues like domestic violence and sexual harassment. Instead, narratives focus on the allegedly bad behavior and individual failings of girls and women.

Importantly, and as is the case with contemporary imaginings of the WNBA, these sensationalized discourses are not just about gender surveillance. These phenomena also promote complicated, racialized, and classed meanings and implications as well. In short, historically working-class White women and women of color have been positioned outside of the White, middle-class ideal of good girls. While both the good and bad girls are controlling images, the complicated and shifting classed and racialized discourses are important to interrogate as well (Chesney-Lind & Irwin, 2008). According to Mike Males (2010, p. 15), these recent discourses which construct an "irrational fear and hostility" toward young girls and women must be understood in light of the changing U.S. demographics where 40% of "the young girls and women under the age of 25 are black, Latina, Asian or otherwise of color, a dramatically larger percentage than in older generations." Too frequently, the moral panic featuring images of violence has served to stereotype girls and women of color as excessively and naturally violent. Far from benign, the proliferation of these millennium discourses has contributed to the increasing rates of detention and severe penalties many girls of color face within the juvenile detention system (Males, 2010).

The second narrative of the Sparks-Shock fight we highlight here reveals additional complicated, gendered, classed, and raced meanings as numerous members of the media and bloggers focused on the presence of Detroit head coach Bill Laimbeer and assistant coach Rick Mahorn through references to their statuses as former NBA players during the 1980s. For those not familiar

with their playing careers—this narrative includes reminders that both were members of the Detroit Pistons team of the 1980s, a team that was nicknamed the "bad boys" for their physical and intimidating style of play. The Pistons were famous for their rivalries with the Chicago Bulls and the Los Angeles Lakers. That the 2008 altercations also featured teams from Detroit and Los Angeles, one of the important rivalry cities of the NBA during the 1980s, was perhaps too much for commentators to ignore. However, the narrative that the media and bloggers constructed for this included characterizations of Mahorn who is Black, and Laimbeer who is White, as thugs and muggers (Parker, 2008, para. 1), "goons" (Boswell, 2008, para. 2), and "enforcers" ("Cat Fight Ends," 2008, para. 2). To be fair, there were competing media discussions of Mahorn, who was involved in the shoving incident with Lisa Leslie of the Sparks. Mahorn himself promoted this latter view that he was trying to stop the flight, asserting, "I was trying to protect the whole game, the integrity of the game" (cited in "WNBA Reviewing," 2008, para. 13). Both the Los Angeles head coach, Cooper, and Detroit head coach, Laimbeer, referred to Mahorn as a peacemaker ("WNBA Reviewing," 2008).

Yet, despite this framing it is important to note the racialized language—most frequently deployed by bloggers—attached to Mahorn who was differently characterized than was Laimbeer as "very scary" (Basketbawful, 2008, para. 3), and as a "street tough," "monstrous man" who had given the league "a black eye" (Parker, 2008, para. 3). One account suggested that Mahorn had not just shoved Lisa Leslie but it "looked like he said, 'Is Rick gone (sic) have to slap a b*tch? B*tch better have my money!'" ("Ed Hearts," 2008, para. 4-5). This blogger went on to observe, "Rick Mahorn was definitely a pimp in his former life" ("Ed Hearts," 2008, para. 7). Another commentator offered a similar analysis suggesting that Mahorn had executed a "pimp shove of Leslie" (Daulerio, 2008, para. 2), while another blogger sarcastically referred to the incident as "a vicious mugging of Leslie" (O Kadah, 2008, para. 7).

These characterizations of "pimp" and "thug" hail stereotypical, racial meanings of Black men as naturally violent and criminal. Importantly, as Banet-Weiser (1999) has demonstrated, and as discussed earlier, the connections between the WNBA and the NBA suggest that the racial and gender politics of WNBA discourses gain meaning not just in opposition to stereotypical representations of both Black and White womanhood but also in relationship to the dominant notions of the NBA. "Media portrayals of the NBA represent Black players as potentially dangerous and menacing, allowing the WNBA to construct itself in positive opposition to these racial politics" (Banet-Weiser, 1999, p. 405). Thus, historical and contemporary economic, gender, sexual, and racialized regimes have merged through the WNBA in

such a way that prior to this incident, the dominant construction of the league also served as a notable contrast to the NBA's "bad boy," racialized imagery.

The gendered, classed, and racialized connection between the WNBA and NBA was also apparent in other ways as this incident also hailed images of "original Palace brawl." Consider these framings: The bench-clearing brawl occurred at the Palace of Auburn Hills, appropriately enough. The Detroit venue is the site of the infamous "near-riot" involving the NBA's Detroit Pistons and Indiana Pacers in November of 2004, when a fan threw a cup of ice that hit the Pacers' Ron Artest, who charged into the stand to confront the fan, leading to a fight. In many accounts of the WNBA fight, the discussion shifted to the NBA, with one particular pundit characterizing the Pacers-Pistons fight as "the most notorious episode of violence in the history of the NBA . . . David Stern's worst nightmare" (Tolomeo, 2008, para. 3).

As scholars (see especially Leonard, 2006) have demonstrated, the Pacers-Pistons-fans NBA fight drew upon negative images of Black men misbehaving and the allegedly uncontrollable character of urban Black men represented via the body of basketball player/rap artist Ron Artest. Importantly, numerous framings of the 2008 Sparks and Shock event repeatedly conjured up this gendered and racist imagery. One might argue that the focus of these narratives is simply inevitable given that the NBA helped to originate the WNBA, that Detroit franchises were involved in both episodes, and that Rick Mahorn played a role in each incident (going into the stands to separate Ron Artest from the fans and attempting to restrain Lisa Leslie). Certainly, these similarities offer points of connection. However, Banet-Weiser's (1999) broader analysis of the mutually constitutive gender and racial politics, evident in the relationship between the WNBA and NBA, suggests another important, analytical framework for understanding the Sparks-Shock fight. Words like "riot," "thug," and "monster" are racialized terms historically directed towards African Americans by Whites in order to justify inequitable treatment. The historical construction of the WNBA as the racialized moral obverse of the NBA allows these particular articulations to continue to circulate within popular culture. Ironically, an incident, which on the surface seems about gender politics in relationship to women's bodies, was also mediated in a way that reifies the power of Whiteness to shape dominant understandings of Black men's bodies.

Conclusion: Redeemable Narratives?

In this paper we have argued that the altercation between the Los Angeles Sparks and Detroit Shock during the 2008 season helped to ignite new, and to reinvigorate already existing, narratives—ones which shifted and connected to historical constructions related to gendered, raced, and classed discourses. As feminist sociologists and criminologists demonstrate, the media sensationalize female assertiveness, aggression, and violence. Popular representations help to shape public understandings, which in turn have fueled new policy interventions that further police the behavior of bodies and move particular individuals into the punishment industry.

It is important to note the broader representational politics in which the coverage of the Sparks-Shock fight participates. In this case, this event cast the league outside of its idealized, postfeminist image. These media narratives mirrored new millennium constructions of bad girls as well as racist characterizations of Black men misbehaving. What we hope this analysis has generated are new ways to reimagine the incident between the Detroit Shock and the Los Angeles Sparks, especially in regard to the workings of intersectionality and to the power of narratives to shape the dominant framings of the event. Read from this perspective, this chapter suggests the need to generate new counter-hegemonic narratives—ones which question the ways in which aggression and violence are enacted and represented. This includes the historical and con-temporary imaginings of violence and the ensuing consequences of these imaginings, including the reproduction of dominant power relations and structural forms of social inequalities.

References

Associated Press. (2008, August 6). WNBA hands down suspensions for Shock-Sparks skirmish. *ESPN.com*. Retrieved from http://sports.espn.go.com/wnba/news/story?id=3503435

Banet-Weiser, S. (1999). Hoop dreams: Professional basketball and the politics of race and gender. *Journal of Sport & Social Issues, 23*(4), 403–420.

Basketbawful. (2008, July 23). Malice at the Palace part 2: Girl fight! *Basketbawful*. Retrieved from http://basketbawful.blogspot.com/2008/07/malice-at-palace-part-2-girl-fight.html

Berg, A., & Schaeffer, J. (1997). The summer of George [Television series episode]. In *Seinfeld*. Los Angeles, CA: Shapiro/West Productions, Castle Rock Entertainment. Retrieved from http://www.seinfeldscripts.com/ TheSummerofGeorge.htm (no longer accessible).

Boswell, J. (2008, August 1). Sports Q & A: WNBA fighting: Rumble pie. *Sports Central*. Retrieved from http://www.sports-central.org/sports/2008/08/01/sports_qa_wnba_ fighting_rumble_pie.php

Carrera, K. (2008, July 24). WNBA brawl grabs Mystics' attention. *The Washington Post.* Retrieved from http://www.washingtonpost.com/wp-dyn/content/article/2008/07/23/AR2008072302112.html

Cat fight ends in brawl in WNBA. (2008, July 23). *Chicago Funnies.* Retrieved from http://chicagofunnies.blogspot.com/2008/07/cat-fight-ends-in-brawl-in-wnba.html

Chesney-Lind, M., & Irwin, K. (2008). *Beyond bad girls: Gender, violence and hype.* New York, NY: Routledge.

Chesney-Lind, M., & Jones, N. (2010). *Fighting for girls: New perspectives on gender and violence.* New York, NY: SUNY Press.

Collins, P. H. (2004). *Black sexual politics: African Americans, gender, and the new racism.* New York, NY: Routledge.

Cooky, C. (2010). Do girls rule?: Understanding popular culture images of 'girl power!' and sport. In S. Spickard Prettyman & B. Lampman (Eds.), *Learning culture through sports: Perspectives on society and organized sports* (2nd ed., pp. 210–225). Lanham, MD: Rowman & Littlefield.

Daulerio, A. J. (2008, July 23). Rick Mahorn still can't figure out how to talk to girls. *Deadspin.* Retrieved from http://deadspin.com/5028089/rick-mahorn-still-cant-figure-out-how-to-talk-to-girls

Douglas, S. (1995). *Where the girls are: Growing up female with the mass media.* New York, NY: Random House.

Ed hearts the WNBA!! (2008, July 23). *Ed the sports fan.* Retrieved from http://www.edthesportsfan.com/2008_07_01_archive.html

Elliott, H. (2008, July 24). All of a sudden, WNBA has a fighting chance. *Los Angeles Times.* Retrieved from http://articles.latimes.com/2008/jul/24/sports/sp-elliott24

Fratto, M. (2008, July 25). For all the wrong reasons; Shock-Sparks brawl boosts national attention on WNBA. *The Washington Times.* Retrieved from http://goliath.ecnext.com/coms2/gi_0199-8137249/For-all-the-wrong-reasons.html

Friday, B. (2008, July, 24). Malice at the Palace—2: The Sparks and Shock brawl. *BrooWaha.com.* Retrieved from http://www.broowaha.com/articles/3871/malice-at-the-palace-2-the-sparks-shock-brawl (no longer accessible).

Gabarino, J. (2006). *See Jane hit: Why girls are growing more violent and what we can do about it.* New York, NY: Penguin Press.

Hill, J. (2008, July 25). In real life, female athletes lose their temper, too. *ESPN.com.* Retrieved from http://sports.espn.go.com/espn/page2/story?page=hill/080723

Horn, B. (2008, July 26). Hot air: WNBA brawl attracts attention, but what about viewers? *The Dallas Morning News.* Retrieved from http://www.allbusiness.com/humanities-social-science/visual-performing-arts/15469999-1.html

Leonard, D. (2006). The real color of money: Controlling black bodies in the NBA. *Journal of Sport and Social Issues, 30*(2), 158–179.

Males, M. (2010). Have 'girls gone wild'? In M. Chesney-Lind & N. Jones (Eds.), *Fighting for girls: New perspectives on gender and violence* (pp. 13–32) New York, NY: SUNY Press.

McDonald, M. G. (2000). The marketing of the Women's National Basketball Association and the making of postfeminism. *International Review for the Sociology of Sport, 35*(1), 35–47.

McDonald, M. G., & Birrell, S. (1999). Reading sport critically: A methodology for interrogating power. *Sociology of Sport Journal, 16*(4), 283–300.

Michaelson, L. (2009, June 3). A (flagrant) case for women's basketball. *Women's Hoops.* Retrieved from http://wbb.scout.com/2/869478.html

O Kadah, D. (2008, July 23). Bad boy? *SportsDOK.* Retrieved from http://sportsdok.com/ 2008/07/23/ bad-boy.aspx (no longer accessible).

Parker, B. (2008, July 23). Malice in the Palace part II: Detroit Shock mug L.A. Sparks star Candace Parker. *Bleacher Report.* Retrieved from http://bleacherreport.com/articles/40268-malice-in-the-palace-part-ii-detroit-shock-mug-la-sparks-star-candace-parker

Taft, J. K. (2004). Girl power politics: Pop-culture barriers and organizational resistance. In A. Harris (Ed.), *All about the girl: Culture, power, and identity* (pp. 69–78). New York, NY: Routledge.

Tanenbaum, L. (2002). *Catfight: Women and competition.* New York, NY: Seven Stories Press.

Tolomeo, N. (2008, November 17). NBA violence. *Doc's Sports Service.* Retrieved from http:// www.docsports.com/2008/nba-violence-330.html

Voepel, M. (2008, July 23). 'Bad girls' mind-set, Pierson and Parker a volatile mix. *ESPN.com.* Retrieved from http://sports.espn.go.com/wnba/columns/story?columnist=voepel_ mechelle&id=3502251

WNBA announces penalties from Shock-Sparks game (2008, July 24). *WNBA.com.* Retrieved from http://www.wnba.com/news/ suspensions_080724.html (no longer accessible).

WNBA reviewing Sparks-Shock skirmish in entirety. (2008, July 23). *ESPN.com.* Retrieved from http://sports.espn.go.com/wnba/news/story?id=3501654

Wood, S. (2008, June 19). Sparks star rookie Candace Parker seeks 'magic.' *USA Today.* Retrieved from http://www.usatoday.com/ sports/basketball/wnba/sparks/2008-06-19-parker_N.htm (no longer accessible).

Liquid Beckham: Inoculating a Star Against Falls from Grace

Oliver Rick

Michael L. Silk

David L. Andrews

Beckham. The footballer, the man, the metrosexual, the husband. Beckham, the singer, the fashionista, the designer, the wife, the mother. Beckham, the brand. A ubiquitous "global phenomenon," with David being referred to as the "chosen-one, sporting messiah, corporate and commercial standard-bearer" (Cashmore & Parker, 2003, p. 215). Together, with four children in tow—Brooklyn Joseph, Romeo James, Cruz David, and Harper Seven—*Brand Beckham* is perhaps the embodiment of contemporary celebrity culture: the Hollywood lifestyle; best friends with the Cruises; guests of "Kate & Wills" at their wedding; designer labels; the glamorous image construction; wedding pictures exclusively published in *OK!* magazine; the shameless display of conspicuous consumption; the narcissism; the self-deprecation; the strangely elusive, anchorless, and rootless free-floating signifiers that allow for attachment to a range of discursive elements, formations, and products (Whannel, 2002). In this chapter we center on David Beckham (recognizing that, in many promotional and cultural contexts, his imaged identity is crafted in relation to that of his wife, Victoria, the onetime member of the Spice Girls pop group, and a celebrity figure with a seemingly enduring thirst for public visibility), contrasting the careful contouring, manufacture, and negotiation of the Beckham brand in two distinct locales: Britain and the United States. Within this discussion, we consider the Beckham phenomenon with special focus on the mechanisms used to manufacture the rise and blunt the severity of the falling of the Beckham brand as it negotiates different national contexts.

The Corporate Constitution of the Celebrity Corpus: Team Beckham

As Lash and Lury (2007) argued, "cultural objects are everywhere; as information, as communications, as branded products, as financial services, as media products, as transport and leisure services; cultural entities are no longer the exception, they are the rule" (p. 4). We should add to this partial list the body, for as a cultural object it provides the material/physical entity for the display and performance of the market—it is, quite literally, the vessel upon which the signifiers of late capitalism are adorned, displayed, performed, hung, carved, pierced, worn, and attached. Contemporary celebrity culture's constitutive link with consumer capitalism is most visibly evidenced by the dual role occupied by celebrities as both products (the preponderance of celebrity-driven media and commodities) and processes (the preeminence of celebrity endorsement) within the dominant, symbolically propelled regime of capital accumulation underpinning the late capitalist economy (Jameson, 1991; Marshall, 1997).

Although at one point in time the emergence of celebrity figures was a haphazard and arbitrary voyage of discovery, today the process is considerably more proactive in its focus on the cultivation and management of celebrities. Indeed, the celebrity industry (the institutions and individuals responsible for the manufacturing of celebrity identities) has evolved into a multifaceted, integrated, and highly rationalized phenomenon through which "people can be manufactured into, and marketed as, celebrities in any field" (Rein, Kotler, & Stoller, 1997, p. 5).

According to Marshall (1997), the contemporary celebrity is an embodied exaltation of the twinned discourses of late modernity: neoliberal democracy and consumer capitalism. Indeed, Western liberal democracy represents a political system preoccupied with "the personal, the intimate, and the individual" (Marshall, 1997, p. xiii). It incorporates an equally solipsistic regime of economic (re)production (consumer capitalism). Both are nurtured by the supreme technology of hyper-individualization (commercial television). From the outpourings of the commercial media, referred to by Braudy (1997, p. 550) as the "arbiters of celebrity," we are, at least superficially, privy to a wealth of information encouraging us to develop a sense of familiarity, intrigue, and sometimes obsession with celebrity figures. While the celebrity is usually a complete stranger, the virtual intimacy created between celebrity and audience can have a very real effect on how individuals negotiate and experience their everyday lives. So, in addition to being a consequential force within late capitalist, Western, liberal economies, celebrities are significant public entities

responsible for structuring meaning, crystallizing ideologies, and offering contextually grounded maps for private individuals as they navigate contemporary conditions of existence (Marshall, 1997).

As with any cultural product, there is no guarantee that celebrities will be consumed in the manner intended by those orchestrating the manufacturing process. Audiences are far from homogenous entities, and consumers habitually display contrasting expressions of celebrity appropriation depending on the cultural, political, and economic contingencies of their social location (Hall, 1980; Johnson, 1987). Given their contested nature, those within the celebrity industry seek to manufacture celebrity identities that acknowledge, and seek to engage, the perceived sensibilities of the audience(s) in question. As such, celebrities are crafted as contextually sensitive points of cultural negotiation, between those controlling the dominant modes and mechanisms of cultural production, and their perceptions of the audience's practices of cultural reception. Thus, the celebrity becomes a potentially potent "representative subjectivity" (source of cultural identification) pertaining to the "collective configurations" (social class, gender, sexuality, race, ethnicity, age, nationality) through which individuals fashion their very existence (Marshall, 1997, pp. xi, xii).

To understand the resultant celebrity corpus as part of the ubiquitous *global culture industry* requires considering consumption, social identities, the flow and transformation of cultural products, and the operation of organizations and institutions engaged in the creative production of symbolic products for the marketplace (see, for example, Elliot & Davies 2006; Lash & Lury 2007). Of particular interest are strategies used by cultural intermediaries (Bourdieu, 1984; Cronin, 2004) to reconcile contradictory forces in the construction of celebrity identities. Fully understanding Brand Beckham requires a comprehension of multinational creative production set amidst local mores and norms that influence interpretation of multivocal, polysemic discourses (Negus, 2002; Soar, 2000).

Without question, and within both cultural and economic terms, David Beckham represents one of the biggest global sporting stars of the recent era (Smart, 2005). This elevated status can be attributed, in large part, to the machinations of the promotional team responsible for the global massaging, manicuring, and manipulation of Brand Beckham (Milligan, 2004). Specifically, Simon Fuller, and his company, 19 Entertainment, and more recently its parent organization, CKX (owner of *American Idol* and *So You Think You Can Dance* television franchises, amongst others, and representatives for many high profile celebrities) have proved instrumental in the constitution, dissemination, and diversification of the Beckham brand. For instance, Fuller intro-

duced Beckham to his future wife, and heavily influenced his decision to move to Major League Soccer, with the rationale that the "time was right to move [the brand] to the USA" (Chadwick & Burton, 2008, p. 308). Furthermore, through Fuller—a gifted cultural intermediary who "skillfully crafted his contradictory multiple brand personalities or identities into multiple markets" (Vincent, Hill, & Lee, 2009, p. 179)—Beckham has managed "to leverage his sports fame as few have ever done." Fuller has been responsible for the fluidity—the global circulation—of Brand Beckham. Recognizing that products no longer circulate as fixed, static, and discrete identities but instead spin out of the control of producers, transposing, translating, and transforming as they move through a range of territories (Lash and Lury, 2007), Fuller has crafted a ubiquitous yet polyvocal brand—like the mimic octopus that can change its shape and color to defy predators—a corporatized chameleon that can reshape itself according to the logics of the particular market in question.

We thus understand the fluidity of Brand Beckham and his enduring, "authentic" nature in an increasingly rationalized celebrity culture. Following Bauman (2000), the liquidity of Beckham's branded image becomes the central tool for globally accruing capital. The construction of Brand Beckham is constantly evolving as it scours the globe for new consumer markets to engage—finding new areas and moments in which to exploit consumers for additional profits (Bryant, 2007). Seeking dominion over new territories, the Beckham brand, as with capitalism itself, is "unmoored to any one locality" (Jay, 2010, p. 97), and any permanence is assigned solely to the state of transience (Bryant, 2007). As such, in the balance of this chapter, we examine the liquidity of commercially inspired inflections of Brand Beckham within particular locales in which his chameleon-like corpus has attempted to engage. While we concentrate on two iterations—the UK and the US—the globally ubiquitous Beckham brand is not solely limited to these areas; the other canvases upon which his celebrity corpus is painted in the Italian, Spanish, Japanese, and South Korean markets provide fertile ground for future analysis and for understanding his liquidity.

Brand Beckham in the UK:
The Establishment and Rise of *Authentic* Celebrityhood

In an era of artifice, when many footballers lack fiber, when many announce retirements, Beckham's genuine commitment to the cause of St George chimes even more readily with those who follow the national sport. (Winter, 2010)

The informed soccerati were fully aware of the youthful David Beckham's steady progress along the Manchester United talent conveyor belt, with his impressive performances at youth level, during a loan spell at Preston North End, and during his initial forays in the senior side, leading to great expectations of him becoming a first-team regular. Nonetheless, for the less attuned football observer, Beckham seemingly exploded into popular consciousness following his nationally televised goal from the halfway line, in a game against Wimbledon on the first day of the 1996–1997 Premier League season. From that moment on, Beckham was thrust into the maelstrom of contemporary celebrityhood—the cross-, and at times counter-, promotional vortex (Wernick, 1991)—through which he became defined to the British public. Of course, from its earliest vestiges, Beckham's celebrity was defined in a shifting relationship of contrast to that of his girlfriend, and subsequently wife, Victoria Adams, aka Posh Spice. For, as Bauman noted:

> The cult of one celebrity does not exclude, let alone prohibit, joining the retinue of another. All combinations are allowed and indeed welcomed, because each one of them, and particularly their profusion, enhances the allure of celebrity worship as such. (2005, p. 50)

Indeed, Beckham's relationship with his wife provides important clues as to the very nature, and reception, of his celebrity persona. From the earliest strategies for constituting Brand Beckham, a central element of the process has been the advancement of Beckham as a genuine, down-to-earth, English *everyman* (Milligan, 2004), despite his atypical sporting talent, physical attributes, and attendant riches. Thus, at least part of the Beckham brand centered on establishing him as an authentic celebrity (Tolson, 2001); a self-reflexive and *authentic* Beckham lurking not far below the surface of the *promotional* Beckham created for his corporate sponsors and commercial partners. Ironically perhaps, Beckham's *authenticity* was validated through the contradistinction between him and the hyper-inauthenticity that his wife came to embody.

Within the promotional landscape of the commercial media, David Beckham has been able to simultaneously nurture a celebrity and a seemingly *real* persona; the former being able to exist because of the knowing acknowledgement exhibited by the latter. Of course, as Whannel (2002, p. 51) noted, creating any distinction between celebrity "image and reality . . . becomes problematic when all we are dealing with is layer upon layer of mediation." It is the perception of reality—of authenticity—which matters. In the case of Beckham, while the celebrity Beckham and the real Beckham are equally manufactured, the level of authenticity, and thereby public acceptance, generated by the real Beckham provides some explanation as to how his popularity has been able to endure concerted attacks. Despite his much-publicized, on-

the-field and off-the-field failings and indiscretions, he remains, at the core, a decent and genuine "bloke."

The creation of a schism between celebrity and authentic Beckham has been partially achieved through the use of carefully orchestrated releases of media images and performances exhibiting his very ordinariness and bolstering his credentials as the English everyman. In the same vein as Tiger Woods (Cole & Andrews, 2000), the early substantiation of Beckham's commitment to the sport came through the repeated replaying of the young Beckham's involvement in several TV programs, exhibiting his precocious football skills. Oftentimes, such (re)presentations of the young Beckham were accompanied by *ex post facto* celebrations of him as "hailing from good working-class roots" (Rahman, 2004, p. 220).

Further expositions of authentic Beckham came within high profile media appearances, most notably the Beckhams' (David and Victoria) appearance on *The Ali G Show* segment for the 2001 Comic Relief broadcast. In his habitually excruciating "interviewing" style, Sasha Baron Cohen (as Ali G) openly ridiculed the Beckhams' sex life and particularly David's stupidity. That the Beckhams were clearly willing participants in their own public humiliation—indeed, they appeared to enjoy the experience—displayed the type of willing self-deprecation that is a requirement of an English "everyman."

Beckham was provided another high-profile platform for displaying his basic humanity, this time at the opening ceremony of the 2002 Manchester Commonwealth Games. As the then captain of the England football team, and certainly the nation's most prominent football icon, Beckham assisted Kirsty Howard (a terminally ill six-year-old, renowned for her bravery and fundraising efforts) in passing the opening ceremony baton to Queen Elizabeth II. As one commentator noted, "Beckham was cheered louder than the Queen by 38,000 people" (Dougherty, 2002). More significantly, the natural ease and subtle affection with which Beckham engaged the child contrasted starkly with the Queen's distant manner—"the Queen gave only a brief smile and did not stop to chat to Kirsty before turning her back and walking away" (Fitzmaurice, 2002)—appearing to be proof positive of what the public seemed to believe: that David Beckham was a caring, genuine, and grounded hero of the people. Certainly, the media coverage hailed him as such.

Perhaps even more significant has been Beckham's positioning as an unerring patriot through his exploits for the England team, by highlighting his role as a member of the team coaching staff in the 2010 World Cup (despite not being on the squad due to injury) (Smith, 2010), and through his role as ambassador for the 2012 Olympic bid (successful) and the 2018 World Cup bid (unsuccessful). Beckham's status as a valued national symbol was further

confirmed when he was selected to make a "surprise" visit to Afghanistan to boost the morale of the British troops stationed there. The grounded authenticity of his image was graphically portrayed there, as Beckham got "his hands dirty" by involving himself in the day-to-day experiences of the ground troops, while UK politicians held meetings in Kabul (BBC, 2010).

Many of these involvements are less contrived, promotional orchestrations, and more serendipitous opportunities for the embellishment of the Beckham aura, as in the recent reportage of Beckham assisting a motorist whose car had broken down. In discussing this most mundane of incidents, Levy (2011) suggested that "David Beckham's path to a Knighthood just got one step closer," as he "put sports to one side Wednesday, all in the name of being a Good Samaritan."

Tempering Falls from Grace

In allowing Beckham to reach elevated levels of popular acceptance within the specific, cultural logic of the UK celebrity economy, the widespread dissemination of the authentic Beckham persona has also enabled his imaged identity to survive the frequent challenges to his national, iconic status resulting from various moments of villainy. Two major events within the UK can be seen as the important, and potentially irreversible, falls from grace for the David Beckham image. The first, "fueled by the British tabloids, [was when] Beckham went from hero to villain after the 1998 World Cup" (Whitmire, 2007). The catalyst for Beckham's fall from grace was his needless ejection from (precipitated by a petulant act of retaliation against a harrying opponent) the match against Argentina. This game, as would any contest against Argentina, took on added significance due to the enduring national enmity created by the Falkland Islands/Las Malvinas conflict in 1982 (Barnes, 2005). Beckham's red card proved instrumental in England's eventual defeat. As a result, Beckham faced "scathing attacks in the media, was hung in effigy and received death threats" (Haydon, 2009).

The virulence of the popular reaction to Beckham's on-field indiscretion proved relatively short-lived, as performances for Manchester United and England contributed to the resuscitation of his imaged identity. This process was conclusively confirmed in 2001, with his last-minute goal in the 2002 FIFA World Cup qualifier against Greece, confirming England's involvement in the upcoming tournament. This goal signaled a moment of the "nation recanting," and the redemption of a national hero (Kuper, 2004).

Beckham's second notable falling from grace—from which he recovered even more quickly—centered around accusations of infidelity between

Beckham and his onetime personal assistant, Rebecca Loos (Mock & Wang, 2011). That the much-publicized alleged affair between the two did little to disrupt the Beckham brand identity (Milligan, 2004) was an interesting, if not wholly surprising, turn of events. One explanation could be the success of promotional narratives in framing Beckham as a "doting father" (Rahman, 2004, p. 220) with the inference being that behind the celebrity artifice, the authentic Beckham was an exemplary family man, allowing allegations of infidelity to be convincingly refuted.

Within the UK context, over the past fifteen years, those marketing and impression management consultants responsible for building and consolidating Brand Beckham (Milligan, 2004) have consciously augmented the imaged identity of celebrity Beckham with the inner, authentic Beckham. As an embodied paean to celebrity authenticity (Tolson, 2001), Brand Beckham has emerged relatively unscathed from various moments of villainy, such that he has come to occupy a level of popular acceptance unprecedented within the divisive world of English football. It is the creation of the English "everyman" narrative that has provided the crucial anchors solidifying the Beckham image. Propelled by this affective symbolic core, Beckham "has risen above his trials and tribulations—a poor 2006 World Cup finals and bedroom revelations that fuelled the tabloids for months—and remains as popular as ever" (Eason, 2007).

Brand Beckham in the USA: Savior of the MLS?

> He brings a powerful combination of transcendent soccer skill, massive marketing potential and Hollywood-hunk good looks. But who is David Beckham? (Whitmire, 2007)

In 2007 David Beckham agreed to a contract that would take him to the LA Galaxy and make him the highest paid player in Major League Soccer (MLS). Doubtless not unrelated to his wife's desire to further her commercial presence within the US market (Meyers, 2010), Beckham's move to the MLS evidenced a desire to more aggressively globalize his own imaged and commodified identity. As such, Beckham exemplified Bauman's (2000) understanding of fluidity as a core tool and way of being for a postmodern celebrity brand whose raison d'etre is the accrual of capital. In Sabbagh's (2006) terms, "Beckham and his agent, 19 Entertainment, have spent the past two years putting in place a series of long-term global deals as a hedge against damage to his brand image in his home country." In contrast to the UK where his image had become ubiquitous, within the American context, if recognized

at all, it would likely be as the face of specific global brands. Differently put, the image of Beckham in the US was based around his commercial relations, as opposed to any sporting identification or notoriety. Unlike in the UK where there were many aspects of the Beckham narrative that could ground his authentic celebrity in ways that would resonate with popular experience and consciousness, within the US such nuanced cultural signifiers were simply not ascribed to the Beckham persona. This meant that within the U.S. context, the Beckham image was effectively rationalized; shorn of any distinctive local provenance, the liquidity of Brand Beckham became rendered as a sign of superficial (Anglo) Otherness conjoined with a generally acknowledged global celebrityhood.

Beckham was framed as the potential savior of a struggling MLS, rescuing it from sporting and financial torpor, through a combination of his sporting influence and accumulated celebrity value. In terms of the former, Beckham stated, "people are expecting me to play at a high level like I can and I do" (quoted in Goff, 2007). As for the latter, as Hirschhorn (2007) noted, Beckham's move to the US was the "ultimate in celebrity arbitrage," since "No one is as good at the art of celebrity as David Beckham." Certainly, Beckham's entrée into American sporting culture became a vehicle for the spectacularization of his celebrity person, with his carefully orchestrated arrival, and public presentation, in Los Angeles in 2007, displaying "rock star elements" (Lemke, 2009). In the short term, the Beckham hype appeared to have succeeded, with his New York-area debut drawing some 66,000 people to Giants Stadium, or five times the average attendance, and "Beckham 23" shirts selling more than 300,000 in 2007 (Schwartz & Badenhausen, 2008). However, as speculated by Longman (2007), "The question [was] whether Beckham's presence [would] have a shooting star's bright but quickly fading arc, similar to Pelé's path in the 1970s in the North American Soccer League."

There was significant questioning whether Beckham's celebrity would flow out of the American cultural landscape as quickly as it had flowed in. Such warnings were astute, as within a short space of time, Beckham went the way of many celebrities before him, and saw the decline of his onetime "great lure at the box office" (Witz, 2010). Indeed, after several years of being loaned back to major European clubs in the MLS's season, Beckham's return to the league in 2010 "instead of landing with a splash . . . barely creat[ed] a ripple" (Witz, 2010).

The reasons for Beckham's precipitous fall from popularity—and thereby grace—within the US context are complex. Many of them can be attributed to the contrived staging of Beckham's rather superficial and depthless über-celebrity status and image in the US, which contrasted starkly with the devel-

opment of his bifurcated authentic and celebrity images in the UK. In the US, Beckham was introduced, engaged, and ultimately evaluated as a global celebrity. As such, his football exploits were always likely to detract from his celebrity aura. A combination of numerous injuries, indifferent performances, and an inability to single-handedly dominate the sport (as was expected of soccer's global über celebrity) exposed Beckham's basic flaw, his inability to live up to the Beckham hype on the soccer field. Although his playing ability was only a part of his celebrity persona within the US, it was still key. In the US, he existed as a "star" because his celebrity and fame were still "grounded in 'talent' rather than solely the result of the image building machinery of the media" (Meyers, 2010, p. 320).

While perhaps not ridiculed, Beckham's celebrity definitely waned with his diminishing soccer impact: his baseline for success (Oates & Polumbaum, 2004). The not inconsiderable influence Beckham had on his LA Galaxy team, when he was fit enough to play, was largely overlooked by an expectant fan base envisioning grander gestures and outcomes from this putative soccer savior. Clearly, the expectations of the American soccer public had not been appropriately managed: even with Beckham on the team, "Los Angeles will not win every game, and Beckham will not score five goals a game." Unlike "Ronaldinho, the Brazilian star, Beckham is not likely to inspire regular oohs and aahs with mesmerizing inventiveness" (Longman, 2007).

Beckham's popular acceptance was not helped by his being loaned to Italian giants, AC Milan, during the MLS's season, nor his being a vocal representative of the English national team. Most damagingly, he regularly questioned the quality of the league—the MLS—in which he was plying his trade. This caused some to question Beckham's commitment to his US soccer odyssey (Pilbeam, 2009) and to his fans. Subsequent condemnations of Beckham's reaction towards this treatment illustrated the degree to which an "increasing hostility or indifference to him" (Wahl, 2009) had developed. Perhaps the most telling illustration of Beckham's decline as a celebrity figure is not that he incites anger and indignation but that his exploits and his persona now generate little more than a general disinterest. Within the US context, it would appear the Beckham moment is definitively past.

Unlike in the UK, where Beckham's on-the-field (and indeed, off-the-field) disappointments and difficulties have been countered by his enduring "everyman" authenticity, in the US he has to a large extent become hoisted by his über-celebrity petard. As Roberts (2006) indicated, Beckham's celebrity light was fading given that he could no longer demonstrate his "euro-diva" footballing talent, nor could he, as high-priced talent, seamlessly assimilate with his humbly paid MLS teammates. Indeed, for some, Beckham has emerged as a

villainous character, due to his failure to live up to popular expectations of him: a deficiency not overcome by any attempts to match his celebrity to the mood of the local market. For many, Beckham was doubly vilified since he possessed no semblance of authentic commitment to localized place or peoples: he was merely the overhyped and overpaid global soccer mercenary failing to live up to his exaggerated billing. In Bauman's (2000) terms, Beckham's image in the US lacked viscosity—that sense, however fabricated—of local identification and rootedness, unlike his image in the UK.

Conclusion

Our intent in contrasting Beckham's image in the US and the UK has been to demonstrate the fluidity of his commercial corpus. In so doing we have pointed to the construction of liquid celebrity and the pitfalls inherent in such corporatized or corporeal constitutions. Beckham's embodiment of the late capitalist moment on a global scale, organized and managed by Simon Fuller, has been quite exact and complete. As Brand Beckham has travelled the Earth to new and relatively untapped consumer markets, it has found moments of solidity in the form most relevant to the locale. This has led Brand Beckham through the homegrown "*national* hero playing the *nation's game*" (Grainger, Newman, & Andrews, 2005) to the imported Hollywood star and potential savior of soccer in the US. In between the moments of his constructed image on which we have focused, there have been numerous other differential constructions of Brand Beckham. These have further established his global notoriety, status as a fashionista, and the constitution of an unmoored hyper-celebrity—the epitome of a cultural good with little material base. Oftentimes, these engagements were fashioned by his employers (both Manchester United in the UK and Real Madrid in Spain), and to some extent by the England team's presence at the 2002 World Cup in South Korea and Japan, giving an opportunity to exploit new markets in an increasingly profitable South East Asian region (see Cashmore & Parker, 2003). In these contexts, Beckham's celebrity was almost exclusively based on his looks, style, and deportment, with little overt attention to his soccer prowess (other than the recognition that he possessed it). In this sense, Beckham became fabricated through aesthetically driven, promotional narratives designed to interpolate consumers identified as being more attentive to, and satisfied through recourse to his hairstyle, rather than to the outcome of any game in which he is involved (Joanilho, 2002).

With these moments of heroic stardom came varying forms of villainy. It was the development, in these national contexts, of Beckham's star qualities, and the differentiated belief in the authenticity of the man behind the image

that has allowed him to survive (or not) these downturns. Although meticulously managed, the mostly intentional but sometimes unintentional impacts of the Beckham image have been far-reaching, fluid, enduring, and tumultuous. The Beckham brand flows quickly, constantly morphing and meandering while accruing global capital. As Bryant would observe, for Brand Beckham, the quality of permanence is assigned solely to the state of transience (Bryant, 2007). His sporting prowess/performance/authenticity is deemed both relevant (as during loan spells at AC Milan in 2008 and 2010) and irrelevant as he morphs according to the logic of the distinctive marketplace with which he engages—no matter how superficially. In this sense, Brand Beckham embodies an idealized, yet momentarily solid local image or discourse—one that can be constantly reinvented, shaped, and moored within the many pools of postmodern, celebrity image construction.

References

Barnes, S. (2005, October 25). Beckham's inner idiot comes back to haunt him. *Independent.ie*. Retrieved from http://www.independent.ie/sport/soccer/beckhams-inner-idiot-comes-back-to-haunt-him-237105.html

Bauman, Z. (2000). *Liquid modernity*. Malden, MA: Polity Press.

Bauman, Z. (2005). *Liquid life*. Malden, MA: Polity Press.

BBC. (2010, May 22). David Beckham visits British troops in Afghanistan. Retrieved from http://news.bbc.co.uk/2/hi/8697996.stm

Bourdieu, P. (1984). *Distinction: A social critique of the judgement of taste* (Repr.). New York, NY: Routledge.

Braudy, L. (1997). *The frenzy of renown: Fame and its history*. New York, NY: Vintage Books.

Bryant, A. (2007). Liquid modernity, complexity and turbulence. *Theory, Culture & Society. 24*(1), 127–135.

Cashmore, E., & Parker, A. (2003). One David Beckham? Celebrity, masculinity, and the soccerati. *Sociology of Sport Journal, 20*(3), 214–231.

Chadwick, S., & Burton, N. (2008). From Beckham to Ronaldo—Assessing the nature of football player brands. *Journal of Sponsorship, 1*(4), 307–317.

Cole, C. L., & Andrews, D. L. (2000). America's new son: Tiger Woods and America's multiculturalism. In N. K. Denzin (Ed.), *Cultural studies: A research volume* (pp. 109–124). Stamford, CT: JAI Press.

Cronin, A. (2004). Regimes of mediation: Advertising practitioners as cultural intermediaries? *Consumption, Markets and Culture, 7*(4), 349–369.

Dougherty, H. (2002). Beckham and his tracksuit upstage the games ceremony. *London Evening Standard*. p. 3

Eason, K. (2007, January 11). Brand plays on never mind the global icon's destination. *The Times* (London), p. 71.

Elliott, R., & Davies, A. (2006). Symbolic brands and authenticity of identity performance. In J. Schroeder & M. Salzer-Mörling (Eds.), *Brand culture* (pp. 138–152). London, UK: Routledge.

Fitzmaurice, E. (2002). Brave Kirsty unfazed by royal 'snub': Commonwealth Games. *The Sun Herald* (Sydney, Australia), p. 11.

Goff, S. (2007, August 8). Beckham 'doubtful' for United match; Ankle still bothers Galaxy's superstar. *The Washington Post*, p. E03.

Grainger, A. D., Newman, J. I., & Andrews, D. L. (2005). Global Adidas: Sport, celebrity and the marketing of difference. In J. Amis & T. B. Cornwell (Eds.), *Global sport sponsorship* (pp. 89–105). Oxford, UK: Berg.

Hall, S. (1980). Encoding/decoding. In S. Hall (Ed.), *Culture, media, language: Working papers in cultural studies, 1972–79* (pp. 128–138). London, UK: Hutchinson.

Haydon, J. (2009, March 14). Kicked into the spotlight: Beckham hoopla brings worldwide attention to MLS. *The Washington Times*, p. B02.

Hirschhorn, M. (2007). Will America buy David Beckham? *Details.com.* Retrieved from www.details.com/celebrities-entertainment/cover-stars/200702/socce3r-star-david-beckham-invades-america

Jameson, F. (1991). *Postmodernism, or, the cultural logic of late capitalism.* Chapel Hill, NC: Duke University Press.

Jay, M. (2010). Liquidity crisis: Zygmunt Bauman and the incredible lightness of modernity. *Theory, Culture and Society, 27*(6), 95–106.

Joanilho, M. (2002, June 3). Beckham's winning streak gels with supporters. *South China Morning Post* (Hong Kong), p. 2.

Johnson, R. (1987). What is cultural studies anyway? *Social Text, 16,* 38–79.

Kuper, S. (2004, January 27). Beckham—From derision to adulation. *Fifa.com.* Retrieved from http://www.fifa.com/theclub/news/newsid=90593/index.html

Lash, S., & Lury, C. (2007). *Global culture industry: The mediation of things.* Cambridge, UK: Polity Press.

Lemke, T. (2009, February 11). Nearly out of this Galaxy; Beckham's possible move is 'disappointment.' *The Washington Times*, p. C01.

Levy, G. (2011, February 10). Soccer star, model, mechanic? David Beckham helps stranded motorist. Retrieved from http://newsfeed.time.com/2011/02/10/soccer-star-role-model-mechanic-david-beckham-helps-stranded-motorist/

Longman, J. (2007, July 8). Beckham arrives to find a sport thriving in its own way. *The New York Times.* Retrieved from http://www.nytimes.com/2007/07/08/ sports/soccer/08sports /soccer/08beckham.html

Marshall, P. D. (1997). *Celebrity and power: Fame in contemporary culture.* Minneapolis, MN: University of Minnesota Press.

Meyers, E. (2010). Reality television and the hypertrophic celebrity in Victoria Beckham: Coming to America. *Celebrity Studies, 1*(3), 319–333.

Milligan, A. (2004). *Brand it like Beckham: The story of how brand Beckham was built.* London, UK: Cyan Books.

Mock, J., & Wang, J. (Eds.). (2011). *David Beckham: Biography.* Retrieved from http://www.people.com/people/david_beckham/biography/0,,20010351,00.html

Negus, K. (2002). The work of cultural intermediaries and the enduring distance between production and consumption. *Cultural Studies, 16*(4), 501–515.

Oates T. P., & Polumbaum, J. (2004). Agile big man: The flexible marketing of Yao Ming. *Pacific Affairs, 77*(2), 187–210.

Pilbeam, L. (2009). Becks gets shirty: (Again) star confronts fan in England kit over Posh abuse. *The Mirror*, p. 17.

Rahman, M. (2004). Beckham as a historical moment in the representation of masculinity. *Labour History Review, 69*(2), 219–233.

Rein, I., Kotler, P., & Stoller, M. (1997). *High visibility: The making and marketing of professionals into celebrities.* Chicago, IL: NTC Business Books.

Roberts, S. (2006, November 15). Bending the rules to tempt Beckham. *The New York Times*, p. D1.

Sabbagh, D. (2006, July 4). Beckham's image is still football's most valuable. *The Times* (London). Retrieved from http://business.timesonline.co.uk/tol/business/industry_sectors/media/article682516.ece

Schwartz, P. J., & Badenhausen, K. (2008, September 9). Major League Soccer's most valuable teams. *Forbes.com*. Retrieved from www.forbes.com/2008/09/09/mls-soccer-beckham-biz-sports-cz_kb_0909mlsvalues.html

Smart, B. (2005). *The sport star: Modern sport and the cultural economy of sporting celebrity.* London, UK: Sage.

Smith, B. (2010, May 14). David Beckham presents England's 2018 World Cup bid to FIFA. *The Sunday Times* (London). Retrieved from http://www.timesonline.co.uk/tol/sport/football/international/article7126138.ece

Soar, M. (2000). Encoding advertisements: Ideology and meaning in advertising production. *Mass Communication and Society, 3*(4), 415–437.

Tolson, A. (2001). 'Being yourself'—The pursuit of authentic celebrity. *Discourse Studies, 3*(4), 443–457.

Vincent, J., Hill, J. S., & Lee, J. W. (2009). The multiple brand personalities of David Beckham: A case study of the Beckham brand. *Sport Marketing Quarterly, 18*(3), 173–180.

Wahl, G. (2009, October 14). Broken like Beckham—How the American dream turned into a nightmare for the world's most famous sports star. *Alpha Magazine*, 48.

Wernick, A. (1991). *Promotional culture: Advertising, ideology, and symbolic expression.* London, UK: Sage.

Whannel, G. (2001). Punishment, redemption and celebration in the popular press: The case of David Beckham. In D. L. Andrews & S. J. Jackson (Eds.), *Sport stars: The cultural politics of sporting celebrity* (pp. 138–150). London, UK: Routledge.

Whannel, G. (2002). *Media sport stars: Masculinities and moralities.* London, UK: Routledge.

Whitmire, K. (2007, July 29). Beckham: Staff writer Keith Whitmire explains how the English star brings more than great soccer skills to the U.S. *The Dallas Morning News*, p. 13C.

Winter, H. (2010, August 13). Lionhearted luminary's patriotism will always be cherished, but English football's favourite son was past international sell-by date. *The Daily Telegraph*, pp. 2–3.

Witz, B. (2010, September 10). Beckham returns, without the pomp. *The New York Times*. Retrieved from http://www.nytimes.com/2010/09/11/sports/soccer/11beckham.html

No Gagging Matter: John Terry Plays Centre Back from Dad of the Year to (Alleged) Debauchery

Bill Grantham

He who is subjected to a field of visibility, and who knows it, assumes responsibility for the constraints of power; he makes them play spontaneously upon himself; he inscribes in himself the power relation in which he simultaneously plays both roles; he becomes the principle of his own subjection. (Foucault, 1995, pp. 202–203)

Morals reformed–health preserved–industry invigorated–instruction diffused–public burthens lightened. (Bentham, 1787/1995, p. 31)

When Bridgey got injured in the FA Cup tie at Newcastle in February, the manager was the first one down to the hospital to see him. He reassured him about everything. And the rest of us set up a rota for visiting him so that he would have mates coming to see him every day. We all stand up for each other and stick by each other. I think that's why other players look at what we have built here with a degree of envy. (Terry, 2005, p. 22)

Among the seemingly numberless subtitled online parodies of the celebrated meltdown of Adolf Hitler, as portrayed by Bruno Ganz, in the movie *Der Untergang* (Downfall), is one in which Hitler is shown raging against the seduction of his wife by the English footballer, John Terry ("Mrs. Hitler," 2010). In the world of football, as the game is known historically (Goldblatt, 2006),[1] Terry—onetime captain of the England national team and a core player at a leading professional side, Chelsea Football Club—is a big enough star to rate a widely circulated Internet send-up. Terry lost the England captaincy and drew a firestorm of public condemnation when he attempted unsuccessfully to obtain a court order to restrain publication of accusations that he had had an affair with the estranged wife of a former teammate, Wayne Bridge. Although Terry ultimately regained the captain's armband on the England team and continues to play for Chelsea, the Bridge affair—regardless of what may or may

not have actually happened (which remains in dispute)—has caused Terry to sink from being a heavily sponsored Dad of the Year elected by fans ("Soccer Star Terry Voted Top Father," 2009), to becoming the punch line or punch bag of a mountain of bad jokes (Masters, 2010) and the butt of scabrous "news" stories, such as one claiming he resembles a pre-op Scottish transsexual ("John Terry's tranny," 2009). Why and how this happened requires a tour of the social and industrial milieu in which English football operates.

Contexts for John Terry's Story

The social context

From the 1870s at least, and despite the origins of its codification and initial spread through the efforts of private school and university men, football in England has been primarily a working-class activity. The leading teams—largely professional, because workers had neither the funds nor the leisure to engage fully in amateur sport—were initially mainly located in the industrial, manufacturing, and mining communities of England's north and midlands, spreading gradually into the working-class communities of London and the south (Walvin, 2010, pp. 52–71). Players were overwhelmingly working class, too, and because of owner-imposed salary caps, were rarely wealthy. Unmarried players lived in lodgings and took the same buses to work as the fans who came to see them. Ticket prices effectively segregated stadiums, with working-class supporters standing in thick crowds on terraces usually placed at the ends of the ground behind the goals, while the more affluent sat in raised stands with better views. And class consciousness brought class division, as in this description of English football in the 1920s by a professional player of a later era:

> The truth is that professional football was deformed at birth. The game was never honorable, never decent, never rational or just. Class was the root of all professional football's evils: those who played the game for money, the heroes who drew the crowds, were working class; those who administered the game, the directors and football club shareholders, were, as the greatest player of the age, Billy Meredith, contemptuously described them, "little shopkeepers who govern our destiny." (Dunphy, 2007, pp. 27–28)

Moreover, because of the homogeneous demographics of the country until the late twentieth century, football was also overwhelmingly White. It appears that just one Black player—a striker named Jack Leslie—played in the Football League (then the principal professional football competition) between the First and Second World Wars, and Leslie's selection for the England national team

was withdrawn once it was known he was "a man of colour" ("An England Dream," 2004). England did not field a Black player until 1978: Viv Anderson, a defender whose very successful career was nonetheless scarred by vicious abuse and actions such as regularly getting pelted by bananas thrown by racist spectators (Wheeler, 2010). (Since Anderson's debut, some 60 additional Black players have appeared for England, roughly one in four of all new players selected ("England's Black Players," 2011).) In the 1970s and 1980s far-right racist political groups sought to co-opt the fan base of leading football clubs, of which John Terry's Chelsea was a particularly prominent example, in support of their White supremacist message (Glanvill, 2005, pp. 301–308; Walvin, 2010, pp. 194–195). While a number of factors—including organized, political pushback from anti-racists, as well as the transformation of stadiums into all-seat venues, with attendant increases in seat prices—combined to diminish open race antagonism in English football, openly racist groups continue to cultivate working-class support: in municipal elections, the votes of fascist parties such as the English Defence League (EDL) and the British National Party (BNP) have on occasions broken the 30% barrier, while only in 2010 an EDL official called for the recruitment of football fans into an anti-Islamic "street army" (Lowles, 2010). One stronghold of the BNP for many years has been in Barking and Dagenham, the east London suburbs in which Terry grew up: in 2006 it won nearly one quarter of the seats on the local council, although it lost them all four years later (Travers, 2010).

The first chapter of a substantial fan biography of John Terry is headed "Barking Lad" (Derbyshire, 2010, p. 1). Once you realize it is a description of a place, not an action, the "Barking" part is straightforward: it is where Terry comes from, a suburb that expanded in the 1950s as families moved out from the traditional, working-class enclaves of the East End of London, much of which was devastated by bombing during the Second World War. These families moved in search of homes and jobs and found them, up to a point: according to Oliver Derbyshire, Terry's father worked a 60-hour week as a forklift operator, but at the time of his 2010 trial for a minor instance of cocaine dealing, he was described as unemployed ("John Terry Dad Spared Jail," 2010). As recently as 2011, 40% of students at the secondary school Terry attended were entitled to free meals—a standard proxy for poverty, albeit one that tends to understate the true level of local deprivation (Campbell, 2011; Lawton, 2006; Rogers, 2009). In 2009, Terry's mother and mother-in-law admitted shoplifting from supermarkets near their homes (Hale, 2009).

The "Lad" piece of "Barking Lad" is more complicated, since in England it has multiple connotations of gender, class, and affect: "a boy, a youth, a young man . . . a workmate, drinking-companion . . . [a] man of humble birth and

position; a menial, a labourer . . . [a] high-spirited or roguish man or boy, a daredevil" (Trumble, Stevenson, & Brown, 2002). In specific class terms, a Google search discloses more than 160,000 instances of the phrase "working class lad," many of them used in connection with sentimental narratives of transformation—from humble origins to the status of cabinet minister, sports promoter, novelist, playwright, architect, operatic tenor, rock musician, and, of course, many footballers. The combination of words is accordingly semantically complex, their atavistic connotations of pride and condescension coexisting in perpetual conflict, permanently suggestive of contradiction.

The industrial context

Football always made money, because it always attracted spectators: in the six seasons following the end of the Second World War, nearly 240 million fans paid to see professional football in England (Walvin, 2010). The profitability of football clubs was helped by the salary cap that the team owners had succeeded in imposing from 1901 on, and which by 1958 had reached just £20 per week (£17 in the summer months between seasons): handsome enough compared to the wages typically earned by football fans, albeit about half of what a typical dentist would have expected to earn at the time. The very top players could earn more through various other rewards (Taylor, 2001, pp. 109–111). Wages began to grow quite significantly from the 1960s on. But the real change in the economy of English football came as prices paid for television rights began to escalate. In 1992, the leading English clubs broke away from the lower-ranked teams to create a Premier League driven by a three-year, £304 million rights deal with Rupert Murdoch's BSkyB satellite television system—at the time a sum of unprecedented size. By 2010, the value of just the non-UK portion of these rights had risen to £1.4 billion (Harris, 2010)—an immense sum divided among just 20 teams.

The division of these spoils between the clubs and the players became a far more equal process than during the period of the maximum wage, although these huge increases in player salaries contributed to (but were by no means the sole reason for) the equally heady rises in ticket prices over the same period. By 2007, the England star, David Beckham, would have five-year playing, merchandising, and sponsorship deals worth at least $250 million (Bose, 2007). And in 2009, John Terry was reported to be earning £135,000 per week—more than 6,500 times as much as his 1958 counterpart would have earned (Hale, 2009).

However, relatively few of the recipients of this bounty were, like Beckham and Terry, English. The ascent of Terry coincided with near-panic in the

English sports media at the influx of foreign players to the Premier League. A landmark European Court of Justice decision in 1994 dismantled long-standing limits on the number of nonnational players permitted in each team, in favor of the principle of unfettered mobility of labor with the European Union, which now numbers 27 countries (*Union Royale Belge des Sociétés de Football Association ASBL v. Jean-Marc Bosman*, 1995). The *Bosman* judgment transformed English football from a sport dominated by players from England and its immediate English-speaking neighbors (Scotland, in particular, having been a big source of talent for the English professional leagues since at least the 1880s), to a cosmopolitan melting pot of athletes from across Europe but also, thanks to a more general relaxation of immigration rules, from South America, Africa, and Asia. This sea change should have been of as great benefit to English-born players, who were now free to play for the great clubs of Italy, Spain, and Germany. In fact, relatively few of them—David Beckham being a notable exception—availed themselves of the opportunity. British players had been notorious for the provincial attitude to "the Continent," and stories were legion of the difficulties they had in adapting to foreign mores and styles. One Welsh player, who moved from stardom in England in the 1980s to a single, painful season in Italy, is alleged to have said of his temporary offshore home, "It seemed like a foreign country." (He has denied this, and to spare him further pain his name is withheld here.) When in 2005 the London club, Arsenal, winner of the Premier League three times since its creation in 1992, fielded a team without a single English-born player, the media reaction was uniformly pained ("Wenger Backs Non-English Line-Up," 2005).

Unlike most team sports in the United States, contests involving national sides are a key part of soccer's popularity: the quadrennial World Cup is one of the biggest television events in the world, and the qualification matches that whittle the contestants down from more than 200 teams to 32 qualifiers last for two years. Interstitial regional tournaments in Europe, Asia, Africa, and the Americas are almost as important for teams and spectators in those zones. In most countries, the success of the national football team is connected psychologically to a collective sense of well-being. In England, the health of the England football team sometimes feels as if it is more important than life itself. When England (without any help from Russians, Americans, Canadians, French, or Poles) won the World Cup for the only time in 1966, defeating West Germany barely 20 years after the end of the Second World War (a period during which it had also lost the global empire on which the sun once never set), it seemed at home as if England was still Top Nation, after all. England's failure to recapture the trophy in the half-century since has been a

constant reminder that this self-image was a fantasy, that Albion's greatness in football as in empire, was firmly in the past.

Of course, the national team depends on national players. Smaller countries, such as Ireland, comb the globe for diasporized descendants with a smidgen of the blood of the motherland in their veins so as to construct national teams that can compete in the international tournaments. But a large country such as England looks to its own born and bred John Bulls to wear the white jersey. And if the professional leagues are stacked with fine players from other countries in which the English-raised players disdain to play themselves, it is obvious that the number of opportunities for these players to join their local clubs is accordingly diminished.

The burden of the exemplar

Taking these two contexts together, John Terry emerged in the 1990s as an emblem of maybe too many things. He was English, when England needed footballers. He was White when the game was becoming multicolored. He was from the working class when economic transformation was driving the gentrification of the sport. He became rich at a time when footballers were making more money than they ever had in the history of the game. And he was a teenager with only a basic education—in Europe, professional athletes generally do not emerge through college sports (although the educational benefits for athletes of the U.S. college system are, of course, highly contested).

As if in recognition of these contrasts, Terry's rise to fame was bumpy, not smooth. He signed with Chelsea at the age of 14, made his professional debut in the first team when just 17, played for England at 22 and was named national captain at 25. He was voted young player of the year when 19 and professional player of the year when he was still 24. But in 2001, when the professional football calendar was halted out of respect for the victims of the September 11 attacks in the USA, Terry, then aged 20, and some teammates went on a drinking spree in a number of places in West London, including a hotel near Heathrow airport, where many Americans were stranded and watching news from home on television. The revelers threw food around the bar while the TV showed footage of firefighters searching the rubble of the attacks (Rousewell, 2001). Less than three months later, Terry was charged with assault following a fight in a London nightclub and faced a potential life imprisonment sentence before being acquitted at trial. The month after the nightclub affray, Terry was caught on CCTV cameras urinating into a beer glass in another bar (Derbyshire, 2010, pp. 116–118; Thompson, 2002). Chelsea players had a hard-drinking tradition, but Terry's behavior—

particularly the September 2001 incident—was too much for most. Even Alan Hudson, a former Chelsea and England star once sent home from a club tour of Australia following an intense drinking session, wrote of Terry and his friends, "[t]hese so-called professionals should be punished with the worst possible penalty after showing so little respect for the dead and injured in America" (Hudson, 2001, p. 11).

Terry's problems extended further, from booze to other newsworthy vices, such as sex and gambling. Long before the Wayne Bridge affair, Terry was accused repeatedly of cheating on his longtime girlfriend and later wife, Toni Poole, with the British tabloids relishing the lurid details (Hartley & Bonnici, 2005). In 2004, Terry and Bridge were reported to be gambling £40,000 a week on horseracing. In 2008, Terry was spotted parking his luxury Bentley in a disabled spot outside a pizzeria. And in 2009, he was alleged to have charged visitors (who turned out to be reporters in disguise) £10,000 for a tour of the Chelsea training ground ("The Top 10 John Terry Scandals," 2010). He seemed to be a magnet for trouble.

But this tawdriness could not efface the glamour of Terry, the great White hope. By the end of the 2010-2011 season, when he was still just 30, Terry had played 504 times for Chelsea, scoring 42 goals (a lot for a defender) and 68 times for England, 30 as team captain. He was on the Chelsea team that won the Premier League championship three times and the knockout FA Cup competition four times. He had been named by fellow players to the World XI on five occasions and was thrice voted European defender of the year. He was rich and successful and still attempted, despite the scandals, to project a wholesome image of husband, father, and role model. Then . . .

Being Private in Public

Players and Wags

In his public sex life, there has always been something sexless about Terry. In this, he differs from his England teammate, David Beckham, whose sexuality—in Heraclitean flux between masculine and feminine poles—seems constantly foregrounded in his public sphere (Fowler, 2006; Miller, 2001, pp. 8-9; Rahman, 2004). By contrast, Terry is a celebrity who, despite his oft-reported (alleged), erotic escapades, is not considered sexy, and accordingly finds that his sex appeal is to an extent vested in the companion(s) with whom he is seen. In England, these women have been institutionalized, commodified, and mediatized as glamorous accessories to their star footballer companions. (And they're always women—in England, only one top-flight professional footballer,

Justin Fashanu, has ever come out as gay: following his suicide eight years later, the coroner suggested that the pressure of Fashanu's sexual identity may have contributed to his death ("Suicide Verdict on Footballer Fashanu," 1998).

These accessories have a name: in 2002, the staff of the luxury Jumeirah Beach Club in Dubai, playing host to 23 England players and their companions, coined the term, "Wags"—for "Wives and Girlfriends"—to identify the footballers' consorts, and the name stuck (Amoore, 2002). Prominent Wags have included Victoria Beckham, who bore the sobriquet, Posh Spice, during her singing career; the singer Cheryl Cole, née Tweedy; and, briefly, the model, Katie Price, better known as Jordan, who dated the England footballers Teddy Sheringham and Dwight Yorke. Indeed, the Wag category has included a disproportionate number of girl-group singers, lingerie models, and the occasional lap dancer and waitress. (Which is not to imply the absence of other qualities: Claudine, the wife of Ireland international Robbie Keane, has a first-class honors degree in economics and finance. She's also a lingerie model.) Some Wags—like Beckham and Cole—were celebrities before they became footballers' wives and maintained careers afterwards. Others, like John Terry's wife, Toni, had greatness thrust upon them merely by the fact of their intimacy with a player.

Clearly, the footballer-Wag nexus is a public one—indeed, it is hard to explain its existence otherwise. It is, in a sense, a media creation—albeit one spurred by substantial collaboration between the messengers and the messages—and its prime effect on its subjects is to make their private lives entirely public: essentially, the thing that defines a footballer and his Wag is the fact that the relationship is conducted in public, before cameras, in bars, clubs, resorts, and on beaches. But the crafted, calculated, modeled aspect of this public proxy for a truly private life is always vulnerable to the intrusions of the real upon the virtual: in other words, susceptible to the discontents of actual living, such as disharmony and infidelity. If the truthiness—that is, the contrivance—of a footballer-Wag coupling is inherent in its public display, it is always vulnerable to deconstruction by the intrusion of facts which under other circumstances might be considered private.

Using the law to make the public private

It is said that privacy is under attack by modernity—that a combination of divulging or invasive technologies and the confessional or voyeuristic zeitgeist is exposing that which hitherto was entitled to remain hidden. But looked at another way, privacy is a *product* of modernity, or at least the industrial-capitalist phase of the early modern; of the move from small communities

where everybody knew everything about each other, to anonymizing towns and cities, where lives are sheltered behind closed doors and where, as Edgar Allan Poe observed, men "die nightly in their beds . . . on account of the hideousness of mysteries which will not suffer themselves to be revealed" (Poe, 1840/1912, p. 101). As news technologies and lifestyle patterns advance, one result is the ebbing of this temporary early modern tide. In this sense the end of privacy is a reversion to the more ancient norm when arguably very little was private.

On January 18 and 19, 2010, a French lingerie and swimwear model, Vanessa Perroncel, took phone calls from someone—never publicly identified—with whom she was in some kind of dispute. Perroncel learned from the caller that the English media had photographs of her with John Terry, considered "relevant" to a relationship it was being alleged that she had with him. On January 20th and 21st, Terry and a business associate began to receive calls suggesting that rumors were flying about the alleged relationship with Perroncel and that *News of the World*, a large-circulation, tabloid Sunday newspaper, was going to publish a story about it on January 24th.

At 2:45 P.M. on Friday, January 22nd, Terry's lawyers made an application before the High Court of Justice in London, seeking an order to prohibit publication of information regarding the alleged relationship. Following a two-hour hearing (at which media organizations were not represented, since they had not been given notice of the application), the judge, Mr. Justice Tugendhat, made the requested order pending a full hearing of the issue. As a result, *News of the World* was restrained from publishing its story the following Sunday, and nothing appeared.

In the United States, so-called prior restraint—the action of the state for itself or on behalf of private citizens, to prevent publication of unwelcome or sensitive information before it becomes known—has been generally disfavored for 80 years (*Near v. Minnesota*, 1931). In other countries, the presumption against prior restraint may be less pronounced. In Europe, for instance, courts seek to balance two sets of rights enshrined in the European Convention on Human Rights (ECHR), which has been adopted in most European countries, including the UK. Article 8 of the ECHR addresses each person's "right to respect for his private and family life." Article 10 enshrines each person's "right to freedom of expression . . . and to receive and impart information and ideas without interference by public authority." In other words, Article 10's protections of press freedom may be balanced—and outweighed—by Article 8's protections of individual privacy.

Before adoption of the ECHR by the UK, British courts tended to lean towards the rights of the individual over those of the press. And even post-adoption, there are those who believe that in applying the balancing test

between Article 8 and Article 10, some judges have kept their thumbs on the scales of justice. Unfortunately for John Terry and Vanessa Perroncel, when their case got to court, the thumb was off the scales. Mr Justice Tugendhat, having granted the original order restraining all media, including *News of the World*, from publishing the allegations, appears to have felt he was sandbagged by Terry's lawyers: a week after making the original order, on January 29th, he lifted it, complaining that adequate notice had not been given of the proceedings to newspapers that might wish to object to the application, that it was not clear that Terry could defeat a defense that publication was in the public interest, and casting doubt on whether the evidence presented on Terry's behalf was "full and frank." Following the lifting of the order, the press could publish the story (*John Terry v. Persons Unknown*, 2010).

Because the order was lifted on a Friday, *News of the World*, which only published on Sundays (the paper is now defunct), missed its scoop. Rival papers raced to get stories into print on Saturday, January 30th. The *Daily Mail* claimed that Terry had made Perroncel pregnant, and then paid for her to have an abortion (Perthen, Gallagher, Chapman, & Millbank, 2010). In the weeks that followed, a feeding frenzy ensued: in the words of *The Guardian*'s Nick Davies, Perroncel "became the fictional object on whom journalists projected classic stereotypes: the beautiful woman who was 'gagging for it' . . . 'shameless', a 'maneater', a 'football groupie' . . . the 'gold digger' who was 'money hungry', seducing men for their wallets" (Davies, 2010). *News of the World*'s daily stable-mate, *The Sun*, claimed that Perroncel had affairs with five different Chelsea players (Sullivan, Syson, & Crick, 2010). The victim, of course, was Terry's old friend, Wayne Bridge–"Bridgey"–the "mate" traduced by his best pal and a wanton strumpet, a biblical betrayal. However, just over four months later, both the *News of the World* and the *Daily Mail* acknowledged that the purported information regarding Perroncel that they had published in January was "private and . . . untrue in any case."

Conclusion

John Terry and the British media have both been on the field playing the fame game. Terry has grown rich and successful–principally because of footballing talents, of course, but also because of his skill in navigating the mediatized roles of Barking lad, great White hope, and Wag custodian. The press collaborates in this endeavor, but also relishes the moments when the hero stumbles. Terry's wounds may have been self-inflicted, but there is complicity in the way in which his fame and those who convey it to the public depend on

each other. In its own fantasies, the media may believe they have a corrective role, the all-seeing invigilator who surveys people constantly and removes their privacy, much as Jeremy Bentham regarded his Panopticon prison—where prisoners could never hide from the gaze of the supervisor—as a place that would reform social ills as a result of perpetual surveillance—*Morals reformed—health preserved—industry invigorated—instruction diffused—public burthens lightened*, as he described it. Of course, as Foucault pointed out, this putatively positive relationship between observer and observed is another fantasy, in which "[a] real subjection is born mechanically from a fictitious relationship." On one level, Terry recovered from the Perroncel affair: he resumed his football career, won back the England captaincy, and reconciled with his wife. But it seems no coincidence that afterwards the press began to remark on those things that all sportsmen have to confront one day. He was getting older. He was getting slower. He was making mistakes. He was subjected to scrutiny he no longer welcomed. Still famous, but no longer golden—just mortal, like the rest of us.

Notes

[1] A note on terminology: properly, the game in question is called "Association Football," after the rules codified in England by the Football Association in 1864 (Goldblatt, 2006). "Soccer" is an infantilization of the word, *Association*, or rather, of its abbreviation, "Assoc.," similar to other examples of the so-called "Oxford-'er'," such as "rugger" (for rugby) and "footer" (for various types of football) (Partridge, 1984). Although the word, *soccer*, is interchangeable with the word, *football*, in many countries and languages, and is used in some places—e.g., the USA, Australia, and Ireland—to differentiate it from competing, local sporting codes, this chapter will use the word, *football*, to describe the game, in keeping with the predominant global usage—fútbol, футбол, voetbal, فوتــبول, etc.

References

Amoore, T. (2002, May 19). Footballers' wives. *The Telegraph*. Retrieved from http://www.telegraph.co.uk/news/uknews/1394667/Footballers-wives.html

Bentham, J. (1995). Panopticon, or, the inspection-house. In M. Božovič (Ed.), *The Panopticon Writings* (pp. 29–95). London, UK: Verso Books.

Bose, M. (2007, January 11). The 275 million dollar man. *BBC Sport*. Retrieved from http://news.bbc.co.uk/sport2/hi/football/6253829.stm

Campbell, A. (2011, July 12). The press furore won't swing an election, but it will change the nature of the debate to Labour's benefit. Retrieved from http://www.alastaircampbell.org/blog/2011/07/12/the-press-furore-wont-swing-an-election-but-it-will-change-the-nature-of-the-debate-to-labours-benefit/

Davies, N. (2010, April 9). Vanessa Perroncel: 'The stories are untrue. Who are they to do this?' *The Guardian*. Retrieved from http://www.guardian.co.uk/media/2010/apr/10/vanessa-perroncel-interview

Derbyshire, O. (2010). *JT—Captain, leader, legend: The biography of John Terry*. London, UK: John Blake.

Dunphy, E. (2007). *A strange kind of glory: Sir Matt Busby & Manchester United* (Updated ed.). London, UK: Aurum Press.

An England dream. (2004, September 27). *BBC, Inside Out—South West*. Retrieved from http://www.bbc.co.uk/insideout/southwest/series6/jack_leslie.shtml

England's Black players. (2011, June 4). *England Football Online*. Retrieved from http://www.englandfootballonline.com/TeamBlack/Black.html

Foucault, M. (1995). *Discipline and punish: The birth of the prison* (A. Sheridan, Trans.). New York, NY: Vintage Books.

Fowler, C. (2006). Spending time with (a) celebrity: Sam Taylor-Wood's video portrait of David Beckham. In S. Holmes & S. Redmond (Eds.), *Framing celebrity: New directions in celebrity culture* (pp. 241–252). London, UK: Routledge.

Glanvill, R. (2005). *Chelsea FC: The official biography: The definitive story of the first 100 years*. London, UK: Headline.

Goldblatt, D. (2006). *The ball is round: A global history of soccer*. New York, NY: Riverhead Books.

Hale, B. (2009, March 27). England captain John Terry's mother 'shoplifted flip-flops, a tracksuit, leggings and pet food.' *Daily Mail Online*. Retrieved from http://www.dailymail.co.uk/news/article-1165218/England-captain-John-Terrys-mother-shoplifted-flip-flops-tracksuit-leggings-pet-food.html

Harris, N. (2010). Premier League nets £1.4bn TV rights bonanza. *The Independent*. Retrieved from http://www.independent.co.uk/sport/football/premier-league/premier-league-nets-16314bn-tv-rights-bonanza-1925462.html

Hartley, C., & Bonnici, T. (2005, November 11). Cheat Terry at it again. *The Sun*. Retrieved from http://www.thesun.co.uk/sol/homepage/news/191301/Cheat-Terry-at-it-again.html

Hudson, A. (2001, September 30). Breaking all the rules: Shamed Chelsea stars are a disgrace, says the man who knew when to party. *The Sentinel* (Stoke). Retrieved January 20, 2012 at http://0-www.lexisnexis.com.linus.lmu.edu/hottopics/lnacademic/

John Terry dad spared jail after NoW 'entrapment.' (2010, June 1). *Press Gazette*. Retrieved from http://www.pressgazette.co.uk/story.asp?storycode=45525

John Terry's tranny lookalike shock. (2009, February 4). *Inside World Soccer*. Retrieved from http://www.insideworldsoccer.com/2009/02/john-terrys-tranny-lookalike-shock.html

John Terry v. Persons Unknown, EWHC 119 (QB) (2010).

Lawton, J. (2006, August 19). John Terry: Defender of the faith. *The Independent*. Retrieved from http://www.independent.co.uk/news/people/profiles/john-terry-defender-of-the-faith-412513.html

Lowles, N. (2010). The growing Islamophobic international. *Searchlight*. Retrieved from http://www.searchlightmagazine.com/index.php?link=template&story=334

Masters, D. (2010, February 3). Fans take aim at love-rat John Terry with gags galore. *The Sun*. Retrieved from http://www.thesun.co.uk/sol/homepage/features/2836377/Fans-jokes-put-boot-into-love-rat-John-Terry.html

Miller, T. (2001). *Sportsex*. Philadelphia: Temple UP.

Mrs. Hitler has an affair with John Terry. (2010). Video retrieved from http://www.youtube.com/watch?v=fS5h-dYTZdk

Near v. Minnesota, 283 U.S. 697 (1931).

Partridge, E. (1984). *A dictionary of slang and unconventional English* (8th ed.). London, UK: Routledge.

Perthen, A., Gallagher, I., Chapman, A., & Millbank, J. (2010, January 30). John Terry made Wayne Bridge's girlfriend Vanessa Perroncel pregnant—and England captain then arranged for abortion. *Daily Mail Online*. Retrieved from http://www.dailymail.co.uk/sport/football/article-1247408/John-Terry-Wayne-Bridges-girlfriend-Vanessa-Perroncel-pregnant—England-captain-arranged-abortion.html

Poe, E. A. (1840/1912). The man of the crowd. In *Tales of mystery and imagination* (pp. 101–109). London, UK: J. M. Dent.

Rahman, M. (2004, November). Is straight the new queer?: David Beckham and the dialectics of celebrity. *M/C Journal*, 7(5). Retrieved from http://journal.media-culture.org.au/0411/15-rahman.php

Rogers, S. (2009, March 9). Free school meals compared to local children in poverty. *The Guardian*. Retrieved from http://www.guardian.co.uk/news/datablog/2009/mar/01/poverty-schoolmeals

Rousewell, D. (2001, September 23). Drunk football aces jeered at N.Y. Terror; They joked and threw food around as families wept over the tragedy. *The People* (London). retrieved from http://www.thefreelibrary.com/DRUNK+FOOTBALL+ACES+JEERED+AT+N.Y.+TERROR%3B+They+joked+and+threw+food . . . -a078515726

Soccer star Terry voted top father. (2009). *PA Regional Newswire of English Regions*. Retrieved from www.nexis.com

Suicide verdict on footballer Fashanu. (1998, September 9). *BBC News*. Retrieved from http://news.bbc.co.uk/2/hi/uk_news/167715.stm

Sullivan, M., Syson, N., & Crick, A. (2010, February 3). JT girl's flings with 5 Chelsea stars. *The Sun*. Retrieved from http://www.thesun.co.uk/sol/homepage/news/2836871/Wayne-Bridges-ex-Vanessa-Perroncel-scored-with-five-Chelsea-stars.html

Taylor, M. (2001). Beyond the maximum wage: The earnings of football professionals in England, 1900–39. *Soccer and Society*, 2(3), 101–118.

Terry, J. (2005). *My winning season*. London, UK: HarperSport.

Thompson, P. (2002, March 2). Terry's night club shame. *The Sun*. Retrieved from http://www.thesun.co.uk/sol/homepage/news/146797/Terrys-night-club-shame.html

The top 10 John Terry scandals. (2010, January 29). *Daily Mirror*. Retrieved from http://www.mirror.co.uk/news/top-stories/2010/01/29/john-terry-faces-private-life-allegations-after-lifting-of-injunction-115875-22004507/. Updated version (October 26, 2011) retrieved from http://www.mirror.co.uk/news/top-stories/2010/01/29/john-terry-faces-private-life-allegations-after-lifting-of-injunction-115875-22004507/

Travers, T. (2010, May 8). Local elections: Labour's overlooked boost. *The Guardian*. Retrieved from http://www.guardian.co.uk/commentisfree/2010/may/08/local-elections-labour?INTCMP=SRCH

Trumble, W. R., & Stevenson, A., & Brown, L. (Eds.). (2002). *Shorter Oxford English dictionary on historical principles* (5th ed.). Oxford, UK: Oxford University Press.

Union Royale Belge des Sociétés de Football Association ASBL v. Jean-Marc Bosman, No. C-415/93 (European Court of Justice, 1995).

Walvin, J. (2010). *The people's game: The history of football revisited* (2nd ed.). Edinburgh, Scotland: Mainstream.

Wenger backs non-English line-up. (2005, February 15). *BBC Sport*. Retrieved from http://news.bbc.co.uk/go/pr/fr/-/sport2/hi/football/teams/a/arsenal/4266443.stm

Wheeler, C. (2010, April 28). Viv Anderson exclusive: Racists were raining down fruit. Brian Clough just said 'get me two pears and a banana.' *Daily Mail Online*. Retrieved from http://www.dailymail.co.uk/sport/football/article-1269285/Viv-Anderson-Exclusive-Racists-raining-fruit-Brian-Clough-just-said-pears-banana.html

"Wayne's World": Media Narratives of Downfall and Redemption About Australian Football "King," Wayne Carey

Jim McKay
Karen Brooks

Wayne Carey was the type of football player about whom coaches, fans, and sponsors dream: a handsome, strapping country boy, who married his teenage sweetheart, captained his Australian Football League (AFL) team to two national championships, was nicknamed "King," and became one of Australia's most recognizable and marketable sports stars and a celebrity. However, his distinguished, 15-year sporting career ended following a series of off-field scandals that included a highly publicized extramarital affair, indecent assault, alleged domestic violence, physical altercations with police in two countries, and alcohol and drug abuse, leading to therapy and public confessions of his transgressions. Carey's demise and attempts at salvation were some of the most widely covered media events in recent Australian history. One journalist called the coverage of Carey's tryst in a toilet with the wife of his friend and vice-captain, "the most salacious scandal in Australian sport" (Le Grand, 2002). A Melbourne tabloid newspaper devoted more stories to this incident than to the 9/11 terrorist attacks on the United States (Rowe, 2010), and Carey's confessional autobiography made the top 10 overall bestsellers list within days of its release. Rather than providing an exhaustive overview of a story of this magnitude, we have thematically analyzed the main media narratives surrounding Carey's downfall and attempted redemption. Sports stars are often perceived as possessing a veneer of authenticity. This makes them less vulnerable than other celebrities "to the mass-media cycle of celebration, transgression, punishment and redemption" (Turner, 2004, p. 106). In Carey's case, he was not only less susceptible to being harmed by the

discursive cycle but was able to use it in facilitating personal and professional "recovery."

As cultural industries, football and celebrity colluded to cover up, justify, and create conflict around Carey. In doing so they helped shape public reaction to his rise and fall. Graeme Turner stated that, "those who have been subject to the representational regime of celebrity are reprocessed and reinvented by it. To be folded into this representational regime—to be "'celebritised'—changes how you are consumed and what you can mean" (Turner, 2010, p. 13). For Carey's fans and the general public, his identity as both a football "great" and a disgraced hero were continually merged and, later, distinguished in order to maintain and protect the industries which shaped him, and with an eye to his ultimate redemption and the ensuing commercial benefits. Turner (2010, p. 13) suggested that celebrity can be defined and approached "as representation, as discourse, as an industry and as a cultural formation." We therefore argue that the central accounts of Carey's fall were constituted by a recursive configuration of celebrity culture, commodification, individualism, obdurate relations of gender and power in sport, and a scandal-driven media and its salacious audiences.

Carey's career needs to be situated in the context of the AFL (also known as "Australian Rules Football" or simply "Aussie Rules"), which is one of the nation's most popular and profitable sporting organizations. The AFL is not privately owned; clubs attract strong, local support (the word "tribal" is often used to describe fans' loyalties). The annual championship game usually draws over 90,000 spectators and is always one of the most watched Australian TV programs. The AFL has 17 teams in all states, but its heartland has always been Victoria, especially the capital city, Melbourne, where the sport is closely entwined with two other male-dominated spheres: business and politics. However, both the AFL and its main rival, the National Rugby League (NRL), have been embroiled in an ongoing series of scandals related to public intoxication, use of performance-enhancing and recreational drugs, racial vilification, and abuse of and violence against women. In 2004 some AFL and NRL supporters were so disaffected that they established Football Fans Against Sexual Assault (FFASA, 2005) , a grassroots lobby group designed to prevent gender violence (http://www.purplearmband.org/ffasa.htm). Carey's demise occurred against this scandal-ridden backdrop and also coincided with the downfall of three other highly talented players: Gary Ablett, Ben Cousins, and Brendan Fevola. In 2001, the retired Ablett, who was known as "God," and whose highly talented offspring, Gary Jr., is called "Son of God," pleaded guilty and was fined $1,500 in a case related to a young female fan who died from a drug overdose in his hotel room. Like Carey, both Cousins and Fevola

publicly confessed their attempts to recover from "addiction"—alcohol and gambling for the former, and alcohol and drugs for the latter (Schembri, 2010; Smith, 2010; *Sunday Night*, 2011).

From "King" to "Pariah Carey"

Carey's first, major, public transgression occurred in 1996 when he left a Melbourne nightclub after a typical binge-drinking session with his North Melbourne Kangaroo teammates, grabbed a woman's breast, and said to her: "Why don't you get a bigger set of tits?" He subsequently pleaded guilty to indecent assault and settled a civil suit out of court. Part of his public statement—"If I have offended anybody"—became known as a "Carey apology" and was used generically to disparage admissions that were perceived to be insincere. In 2000 Carey provided character evidence for a mobster who was subsequently murdered in Melbourne's notorious gang wars. Two years later he sensationally resigned from North Melbourne following condemnation and ostracization by his teammates over the liaison with Kelli Stevens, the wife of his close friend, Anthony, with whom he had been having an affair for several months. While his wife, Sally, subsequently spent three days in hospital under mild sedation, with her mother at her bedside, and Kelli was besieged by reporters, Carey took a holiday in Las Vegas with his older brother and a friend. After a year's absence from the AFL, it looked like Carey had made a fresh start by signing with the Adelaide Crows and reconciling with Sally, only to anger 200 guests at a sportsman's lunch when he opened his speech with a "joke" about his relationship with Kelli. Subsequently, transnational corporations, Nike and Oakley, failed to renew his endorsement contracts. In 2004 Carey was arrested for misdemeanor battery while holidaying with Sally in Las Vegas, placed in custody for a night and then released with the DA dropping the case. He retired mid-season following a disc-related neck injury.

For the next two years Carey was a part-time coach with two AFL clubs and despite openly despising the media as a player, he also worked as a football commentator and host on Fox TV. Announcing he was leaving a pregnant Sally for model, Kate Neilson, he later separated from the former six weeks after the birth of their first child, Ella, which earned him epithets like "Love-rat" (Kogoy, 2006). Neilson allegedly reported Carey to the police for domestic violence but she and Carey denied the report. By 2007 Carey was a football analyst on the Nine TV network and special radio commentator on Melbourne's 3AW. He allegedly "glassed" Neilson while holidaying in Florida; when police were called to their hotel room, Carey allegedly assaulted a police

officer, a charge to which he pleaded guilty. For this he was ordered to do 50 hours of community service, to attend alcohol- and anger-management classes, and to pay US$500 to a Miami police charity. He was placed on two years probation.

Australian police responded to a domestic fracas at Carey's home and considered pressing charges after subduing him with capsicum spray when he allegedly assaulted officers. Nine and 3AW decided not to renew his contract and by now "King" was being called "Pariah Carey" (Rule, 2008b). In 2008 Carey and Neilson were reputedly paid $AUD180,000 for an interview with the popular women's magazine, *New Idea*, in which they both confessed to having a drug problem. They had an off-again-on-again relationship until 2009 when Neilson scaled the concrete fence of Carey's $3 million home (dubbed both "Wayne's World" and a "love pad") after suspecting he was seeing another woman, resulting in Carey calling the police (Bedo, 2009).

Media Narratives of Carey's Fall

The media played a contradictory role in narrativizing Carey's descent. On one hand, he was partially exonerated by a familiar "boys will be boys" script, with a former AFL "bad-boy" reportedly saying that Carey just "had been silly on a few occasions" (Hinds, 2008). His downfall also was partially attributed to the failure of friends to rectify his behavior:

> Melbourne football identity and former politician Phil Cleary said Carey's *plight* [emphasis added] was also an indictment of the football culture, which fails to make its champions accountable. "It's sad that people around him—his football co-commentators or his mates—haven't picked him up. . . . The football club culture has to say when a bloke does wrong, just tell him it's wrong." (Stewart, 2008)

Carey also was constructed as yet another sporting "stud" who had been victimized by predatory females. According to journalist Melissa Kent (2008):

> Sexual conquests and women willing to snare a footballer no matter the cost have long been part of the AFL culture. . . . Neilson, presumably, must decide whether she will tolerate that violence or leave Carey and her WAG (women and girlfriends) status for a quieter life.

On the other hand, Carey's legendary sporting achievements and public confessions could not save him from widespread condemnation. Indeed, such extreme denunciation of a male sports star was arguably unprecedented in a nation where sportsmen traditionally have been revered (McKay & Roderick, 2010), and where even publicly intoxicated male athletes have been admired

(McKay, Emmison, & Mikosza, 2009; Rowe & Gilmour, 2009). A main reason for this shift is that both male and female sports stars have been increasingly incorporated into celebrity culture, meaning that sports are now covered for their "scandal value" by a wider spectrum of journalists (global coverage of golfing superstar Tiger Woods's extramarital affairs is an example of this process), and the exploits of sports stars are consumed by a much broader audience. Indeed, the conflict of values as expressed through different media—from sports pages to women's magazines—became fundamental to Carey's reception. Different identities were strategically constructed for him according to the media outlet and audience. Regardless, Carey was perceived to have violated the entitlements usually accorded to male sports stars. So while Kent (2008) portrayed Carey as the target of a WAG, she also wrote that, "It is one thing to be a 'larrikin,' as a compulsive philanderer like [superstar cricketer] Shane Warne could at best be painted, or a drug-taking party boy like Cousins, but a wife-beater is quite another." Thus sports journalists particularly excoriated Carey for being a spoiled athlete instead of a good role model. For example, Rebecca Wilson (2010) railed against a TV network's announcement that Carey would be returning to one of its programs:

> Why do we keep elevating Wayne Carey to such prominence? He has overstepped far too many rules of society to deserve another high-profile role. Australia is incredible in the way it treats its footy stars. Like their Brazilian and English soccer brethren, Australian rules players in Melbourne and league stars in Sydney are treated like royalty. . . . One such person is Carey. Never was there a better example of all that is bad about instant sporting fame than this flawed character. . . . Forgiveness is handed out readily to the superstars of football. The more talented . . . on the field, the more likely they are to keep avoiding normal scrutiny as they live their adult lives. They are not expected to live by the same rules as the rest of the community. . . . Champion or not, Carey is everything a modern footballer should not be.

Former NRL coach and columnist, Roy Masters (2004), similarly argued that Carey typified the Hollywood lifestyle of AFL stars:

> many club executives resemble bosses of movie studios unable to satisfy the multitude of demands of pampered stars. . . . The best AFL players of the past two decades have been found in a room with a young woman who'd overdosed (Geelong champion, Gary Ablett), and in a bathroom with the wife of a teammate (Wayne Carey).

It was therefore perceived that Carey had misused his position:

> Glossing over Carey's flaws was a pattern that would let his adolescent habits become adult vices over the next decade. The only person to say 'no' to Carey in his senior football career was his first coach, Wayne Schimmelbusch. He recalls dropping Carey and another player . . . because they had broken team rules. The Kangaroos lost the game. Not long later, Schimmelbusch lost the coaching job. After that, Carey was

treated as if he could do no wrong. "The more he got away with, the more he thought he could get away with," muses Schimmelbusch. "There were never any repercussions." And there were always "minders" to clean up the mess. (Rule, 2008a)

This apparent complicity can be attributed to the effects of both commodification and celebrity culture. For instance Richard Hinds (2008) likened Carey's situation to the stock market:

> Like Marion Jones and Ben Cousins and a host of others, Carey is not just a fallen star but a failed investment. The fans, the coach, the club, the agents and the media have all invested heavily in the once blue-chip Carey stock. They all cashed in on the heavy returns when it peaked in the 1990s . . . to torture the stock market analogy further—once we have invested in a star, we ignore the gloomiest market forecasts and continue to throw good money after bad. Not out of any sense of pity or human kindness, mind you. We stick with our portfolio of fallen stars because we can't bear to take a loss. . . . Fame? Infamy? It sells just the same. And we have to make a return on our failed Carey investment somehow.

Amidst this vortex of criticism, Carey was spiraling downward so acutely that he seemed destined to imitate myriad gifted male athletes whose lives ended hubristically—George Best, Alex Higgins, Mickey Mantle—until he embarked on the formulaic celebrity path of "performative contrition" (Hyde, 2009).

In order for remorse to be successful, the sports star or celebrity must enable access to his or her private life to uncover what Richard Dyer described as "the authentic self" (as cited in Turner, Bonner, & Marshall, 2000, p. 12). As Turner, Bonner and Marshall (2000) argued, the effect of this "revelation" is to turn celebrities into commodities (p. 12), who can be, as Turner (2010) notes, "manufactured, marketed and traded—and not only by the promotions, publicity and media industries . . . [but so they] can repay investment, development, strategic planning and product diversification" (p. 14). Performative contrition also enables celebrity-commodities to be exposed to a different market, thus maximizing them as an investment by structuring a new identity that is at once commercial, cultural, and, as Turner et al. (2000) noted, often highly contradictory.

Return of the King?

Carey began his quest for redemption by publicly confessing his transgressions, most prominently on an extended television interrogation by respected interviewer, Andrew Denton (*Enough Rope*, 2008). This coincided with the release of his highly anticipated autobiography, *The Truth Hurts* (Carey, 2009). Carey's revelations about his abusive father prompted some sympathy, and

journalist, Jessica Halloran (2008), even pleaded for compassion following his television interview:

> It was the spare grand final tickets that made me feel for Wayne Carey. The ones never used, the ones sold, the fact this AFL premiership-winning captain's father saw his son play the game only once. While Carey was adored on the field, it was revealed this week he was still desperately fighting for a parent's approval as a grown man. His sadness was visible. For the first time in my eyes, Carey became human. Before all this, he was just the "King," the irresponsible former footballer, the philanderer who allegedly glassed his model girlfriend. A man who drank too much, slept with his best mate's wife, kicked cops and snorted cocaine to make it all go away. . . . Perhaps not in Carey's case, but in general we are far too hard on footballers. Especially the superstars. As a society, we need to show more empathy because at the moment we are demanding too much.

Other commentators were skeptical, accusing Carey of being evasive (Dunn, 2008), with Denton subsequently stating that he was "in denial" (AAP, 2008). *The Truth Hurts* documented Carey's abusive childhood, drug and alcohol benders, contemplation of suicide, therapy, and the fundamental importance of his daughter in his life. The book was dedicated to Ella ("Who, without knowing it, has been my savior—and the reason why I wrote this book"), and contained an evocative image of them on her second birthday with the caption, "My future." The book also elicited some sympathy, particularly with respect to Ella being his redeemer, but like the television interview, also invoked cynicism and disparagement:

> Wayne Carey's new book is sold as an attempt to rebuild his reputation but all it has built is another story on his reputation for hurting people. First betray them, and then turn a buck by telling just how you betrayed them. Win, win for Carey. Lose, lose for his victims. (Morrell, 2009)

> Wayne Carey's done it. Ben Cousins is filming it. Andre Agassi is about to release it. Sport stars are lining up to tell us that they are flawed characters, who succumb to vices like any other vulnerable people. The most fascinating thing about all this is that these sportsmen presume we are interested. That was not their consideration when they were off the planet. But they are now shoving down our throats all manner of personal detail that they previously said we had no right to know. . . . Carey and Cousins . . . appear just to be feeling sorry for themselves and not much else. (Smith, 2009)

Furthermore, in his "tell-all" book every *mea culpa* ("I've only got myself to blame," Carey, 2009, p. 113) was counteracted by exculpations ("There was no escaping the DNA I inherited," p. 69), unexplained events ("I was also drawn towards [Kelli Stevens] in a way that I really can't explain," p. 203), and vivid

examples of the narcissistic, misogynistic, infantile, and alcohol-fuelled culture of the AFL:

> North Melbourne came to the rescue by sending over Judy Francis, a long-time volunteer. . . . Judy would come around and do the cooking. . . . We . . . would have girls coming in and out of the house, dirty dishes everywhere and mess all over the floor. (pp. 80–81)

> One of the secrets of our success was beer . . . alcohol played a big part in our social lives. It was a pretty blokey scene. Some of us would drink 20 or 30 pots after a Friday-night game . . . as long as we were training the house down and winning games . . . powers-that-be at the Kangaroos seemed happy to turn a blind eye to all but the worst excesses. (p. 101)

> It got to the stage where, if I wanted, I could be with two, three or four women, in the one night. Sometimes it was the women doing the pursuing; they were almost predatory at times in the way they hunted down their prey. (p. 191)

On one hand, Carey is explicit about the relationship between football culture and his off-field behavior, inferring that they were inseparable (he constantly refers to his football friends, coaches, and teammates as "family"). On the other hand, he tries to distance himself from responsibility by highlighting that his actions were not transgressive so much as both inevitable and a "normal" aspect of footballers' everyday lives. For the consuming public, this tension between public confessions and insouciance toward football's antisocial culture served to undermine Carey's stated intentions—that he was genuinely repentant and determined to make amends—and put the emphasis on "performance" as opposed to "contrition."

Most commentary became primarily about how Carey (and by extension men within football culture) should have behaved, and what appropriate consequences, beyond legal, personal, and professional, he should face. Thus, Carey's actions and confession facilitated numerous discussions about masculine conduct on and off the field.

But while journalists such as Wilson and Smith dismissed him, the AFL fraternity was more forgiving. (As a meritocracy, football allows even a fallen hero to retain his peerless status.) In 2008 Carey was named the greatest ever player in a book released by the AFL to celebrate the sesquicentenary of Australian Rules Football. The following year he was inducted into the AFL Hall of Fame, after previously failing the "charter character." In 2011 Carey was voted the greatest player of the modern era by a panel of his contemporaries; he announced his return to football in a "legends" game and the possibility of coaching and playing with a district team. According to an account of his participation in the legends match:

"King" has 'em swooning: Everyone wanted to see Wayne Carey in action but the King was quite quiet. . . . But Carey is still a huge hit with the fairer sex. The young women were swooning at how fit and good his body looked. (Confidential Reporters, 2011)

However, there were mixed reactions to Carey's prospective return to football with bloggers posting items like:

I can't imagine anyone would want to follow this guy. He may have footy brains, but coaches need to be respected. Carey doesn't know the meaning of team. He ripped apart a football team in sleeping with Stevens' wife. No leader.

yesterdays (sic) man, the game has passed him. Ego and drugs not a good mix at any club, like Fevola, no one would touch him.

Maybe he should start with a women's team first, and see how that goes.

Lock up your wives. (Sheahan, 2011)

Given such responses, it is difficult to see Carey parlaying his sporting capital into substantive, off-field redemption, regardless of how well he eventually plays or coaches. Short of engaging in behavior that is seen as genuinely altruistic—for example, emulating Sir Ian Botham, who has earned broad admiration after his controversial cricketing career by raising millions for benevolent organizations—we have the interesting situation of Carey's celebrity-commodity status outweighing his sporting hero one. So, while public interest in Carey as a once-prominent footballer is still there, it is his identity as a former drug and alcohol abuser with a purported history of violence toward women (which Carey has repeatedly denied in his autobiography), and as someone who, while individually outstanding on the field, is not a team player, that most resonates. Redemption, for Carey, is only possible within the cultural formation that originally elevated him—football—and which continues to construct a palatable identity through which the public can consume and remember him.

"Forgive Them: They Know Not What They Do"

Since its inception in 1990, the AFL has become a formidable industrial cartel with plans for global expansion (Gullan, 2011; Kelly & Hickey, 2010). However, in marketing the AFL brand, executives have relied on stars, who, like most celebrities, are scrutinized for the slightest transgressions by 24/7, scandal-driven media and their complicit, voyeuristic audiences (the phone hacking scandal that has engulfed News Corp epitomizes this nexus of

production and consumption). Returning to Turner's notion of the representational and discursive perspectives of celebrity, the Carey scandal articulated *some* public disenchantment with the antisocial behavior of a *few* AFL stars. This is consistent with findings from the recent *Being Australian* study according to the following report:

> Participants expressed disgust that bad behavior by sports stars was overlooked or even celebrated in Australia simply because of their sporting achievements and hero status. Australians may recognize the cricketing talent of a Shane Warne or the football prowess of a Brendan Fevola or Ben Cousins, but they are unwilling to invest them with any respect. (West, 2011)

Yet neither such resentment nor the demonization of Ablett, Carey, Cousins, and Fevola is likely to translate into any substantive threat to the AFL either as an industry or as an androcentric cultural formation. On the contrary, the AFL continues to be both a popular and lucrative commodity despite a litany of scandals (Hooton, 2011; Stevenson, 2010). Since scandals are driven by moral binaries, they have conservative tendencies that harken back to a golden age (that never existed), and sports are particularly ripe for nostalgic impulses (Howell, 1991). For example, despite intimations of structural causes (e.g., Carey's minders and yes-men), a strong leitmotif in coverage of Carey, along with Ablett, Cousins, and Fevola, was pleas for sportsmen to be better role models. Even the more insightful sports journalists like Patrick Smith (2009) invoked this shibboleth: "When Carey was at his *worst* [emphasis added] he said he was not a role model."

This simplistic and individualistic storyline is consistent with other studies of sex scandals involving Australian footballers. Misogyny and violence against women are framed as aberrant acts by *individual* men rather than a "logical" outcome of *institutionalized* relations of power between men and women in sports (Mewett & Toffoletti, 2008; Philadelphoff-Puren, 2004; Rowe, 2010; Toffoletti; 2007; Waterhouse-Watson, 2007, 2009). Another conservative narrative was a preoccupation with Carey, Cousins, and Fevola seeking treatment for their various "addictions," which also underpinned media narratives of scandals surrounding Tiger Woods and soccer star, Ryan Giggs (Furedi, 2011; Hyde, 2010; Wente, 2010). Speaking more generally about addiction as a "cultural fetish," Furedi argued that:

> Western society has become hooked on addiction because it finds it difficult to imagine that people can be the authors of their destiny. It is therefore drawn towards a fatalistic interpretation of human behaviour. The idea that people "can't help it" or are "victims of their emotions" is really an abandonment of the standard of accountability. . . . Through its devaluation of the idea of moral independence, the medicalization of bad habits diminishes the human capacity for self-determination.

Moreover, scandals are fleeting phenomena, so transgressions can readily be expunged amidst sporting glory (McKay, Hutchins, & Mikosza, 2000; Rowe & McKay, 2011). Hence Dubecki (2008) alluded to the "forgive-and-forget culture, not only of AFL football but Australian sport in general."

Conclusion

Sports continue to be an obdurate and resilient, male, homosocial, cultural formation (McKay, Emmison, & Mikosza, 2009; Rowe & McKay, 2003). For instance, the AFL has instituted programs designed to cultivate respectful behavior toward women by its players and tried to recruit more female executives. However, these initiatives coexist with incidents like AFL identity, Sam Newman, performing any number of blatantly misogynist, homophobic, and racist stunts on *The Footy Show* (Brooks, 2000), most recently with a lingerie-clad mannequin that resembled Caroline Wilson, chief football writer for *The Age* newspaper in Melbourne (Deveny, 2007; Hutchison, 2008; Lane, Perkins, & Blake, 2008). Peter Costello, a former conservative federal treasurer and supporter of Melbourne club Essendon, recently wrote in a leading Melbourne daily that, "Any right-thinking parent would quake with fear to hear that footballers were coming to their daughter's school to give a little bit of inspiration" (Costello, 2011a). In reply to a barrage of strong criticism, Costello (2011b) unrepentantly condemned the AFL for washing its hands of player-manager, Ricky Nixon, who was video-recorded in his underwear in a hotel room with a 17-year-old girl (Stuchbery, 2011). Costello noted that, "A number of the players who passed through the Nixon stable developed drug problems—Ben Cousins, Wayne Carey and Gary Ablett."

The scrutiny that sports stars are subjected to on and off the field means that their status as celebrity-commodities is only likely to increase, allowing for more opportunities for celebration and exploitation. Complicit in this is the sports star who, aware of the mass-media cycle that starts with celebration and ends with redemption, will seek new ways to ensure their cultural, media, and corporate relevance, performing on or off the field using all tools—from defiance to contrition—to maintain their visibility and cultural purchase (Turner, 2007, p. 197). The best illustration of this in Carey's saga is in the ironic "acknowledgments" in his book, *The Truth Hurts*, where he thanks Nixon and his former manager, Anthony McConville, for "managing my affairs, and sometimes, my life." This neatly encapsulates the iteration of celebrity commodification and the continuous cycle of celebration and redemption by

placing the fallen sports star firmly back within a homosocial formation that fosters and protects their investment.

References

AAP. (2008, March 28). Wayne Carey is in denial, Denton says. Retrieved from http://news.ninemsn.com.au/national/418770/wayne-carey-is-in-denial-denton-says

Bedo, S. (2009, September 19). Wayne has ex climbing the wall. *Gold Coast Bulletin*. Retrieved from http://www.goldcoast.com.au/article/2009/09/19/138975_gold-coast-news.html

Brooks, K. (2000). 'More than a game': *The Footy Show*, fandom and the construction of football celebrities. *Football Studies, 3*(1), 27–48.

Carey, W. (2009). *The truth hurts*. Sydney, Australia: Pan Macmillan.

Confidential Reporters. (2011, July 6). Victoria pip All-Stars in E. J. Whitten Legends match. *Herald Sun*. Retrieved from http://www.heraldsun.com.au/sport/afl/vics-pip-all-stars-in-ej-whitten-legends-match/story-e6frf9jf-1226088441095

Costello, P. (2011a, February 16) Hard to be charitable about sports stars' philanthropy. *The Age*. Retrieved from http://www.theage.com.au/opinion/society-and-culture/hard-to-be-charitable-about-sports-stars-philanthropy-20110215-1av1r.html#ixzz1RNOgLdtS

Costello, P. (2011b, March 2). Big men fly into a fury at those who dare question the AFL. *The Age*. Retrieved from http://www.theage.com.au/opinion/society-and-culture/big-men-fly-into-a-fury-at-those-who-dare-question-the-afl-20110301-1bd44.html

Deveny, C. (2007, June 16). Bankrupt orgy of male chauvinism. *The Age*. Retrieved from http://www.theage.com.au/news/tv--radio/bankrupt-orgy-of-male-chauvinism/2007/06/14/1181414462054.html

Dubecki, L. (2008, February 2). Carey and the forgive-and-forget culture. *The Age*. Retrieved from http://www.theage.com.au/news/opinion/carey-and-the-forgiveandforget-culture/2008/02/01/1201801032986.html

Dunn, E. (2008, March 28). Carey ducks, weaves in Denton interview. *The Sydney Morning Herald*. Retrieved from http://www.smh.com.au/articles/2008/03/27/1206207302482.html

Enough Rope. (2008, March 31). Wayne Carey. Retrieved from http://www.abc.net.au/tv/enoughrope/transcripts/s2201719.htm

Football Fans Against Sexual Assault (FFASA). (2005, February). *Towards champions: A better culture, a better game*. Submission to Australian Football League and National Rugby League. Retrieved from http://fulltext.ausport.gov.au/fulltext/2005/ffasa/Towards%20Champions-summary.pdf

Furedi, F. (2011, June 22). Is Ryan Giggs a Lothario or a sick man in need of help? *Spiked*. Retrieved from http://www.spiked-online.com/index.php/site/article/10628/

Gullan, S. (2011, July 7). Aussie rules dreams of going global. *The Courier-Mail*. Retrieved from http://www.couriermail.com.au/ipad/aussie-rules-dreams-of-going-global/story-fn6ck6f9-1226089200681

Halloran, J. (2008, April 5). Worlds should not collide when stars fall from grace. *The Sydney Morning Herald*. Retrieved from http://www.smh.com.au/news/sport/worlds-should-not-collide-when-stars-fall-from-grace/2008/04/04/1207249454736.html

Hinds, R. (2008, February 2). Wayne's World won't go into receivership. *The Sydney Morning Herald*. Retrieved from http://www.smh.com.au/news/sport/waynes-world-wont-go-into-receivership/2008/02/01/1201801033719.html?page=fullpage

Hooton, A. (2011, March 21). Andrew Demetriou: the goal-kicker. *Brisbane Times*. Retrieved from http://www.brisbanetimes.com.au/afl/afl-news/andrew-demetriou-the-goalkicker-20110321-1c34a.html

Howell, J. (1991). 'A revolution in motion': advertising and the politics of nostalgia. *Sociology of Sport Journal, 8*(3), 258–271.

Hutchison, T. (2008, May 3). Boys will be boys is not good enough. *The Age*. Retrieved from http://www.theage.com.au/news/opinion/boys-will-be-boys-is-not-good-enough/2008/05/02/1209235151933.html

Hyde, M. (2009, December 11). Forget moralising golf nuts. Silence is Tiger's most exciting statement yet. *The Guardian*. Retrieved from http://www.guardian.co.uk/commentisfree/cifamerica/2009/dec/11/silence-tigers-most-exciting-statement

Hyde, M. (2010, February 24). Will Tiger be on his game after rehab? *The Guardian*. Retrieved from http://www.guardian.co.uk/sport/blog/2010/feb/25/tiger-woods-sex

Kelly, P., & Hickey, C. (2010). Professional identity in the global sports entertainment industry: Regulating the body, mind and soul of Australian Football League footballers. *Journal of Sociology, 46*(1), 27–44.

Kent, M. (2008, February 3). Men behaving badly. *The Age*. Retrieved from http://www.theage.com.au/articles/2008/02/02/1201801098929.html

Kogoy, P. (2006, February 24). Love-rat Carey splits from patient wife. *The Australian*, p. 5.

Lane, S., Perkins, M., & Blake, M. (2008, May 1). Nine deaf to AFL's most powerful women over *Footy Show* sex code. *The Age*. Retrieved from http://www.attitude.com.au/attitude-articles/2008/5/1/nine-deaf-to-afls-most-powerful-women-over-footy-show-sex-code/

Le Grand, C. (2002, March 16). Cost of life in Wayne's world. *The Australian*, pp. 1, 6.

Masters, R. (2004, March 24). A tough ask, juggling egos and economics. *The Sydney Morning Herald*. Retrieved from http://www.smh.com.au/articles/2004/03/23/1079939649814.html

McGrath, N. (2010, October 12). Boy George: 'Jail's like school but you can't leave.' *The Guardian*. Retrieved from http://www.guardian.co.uk/music/2010/oct/12/boy-george-interview

McKay, J., Emmison, M., & Mikosza, J. (2009) Lads, larrikins and mates: Hegemonic masculinities in Australian beer advertisements. In L. A. Wenner & S. J. Jackson (Eds.), *Sport, beer, and gender: Promotional culture and contemporary social life* (pp. 163–180). New York, NY: Peter Lang.

McKay, J., Hutchins, B., & Mikosza, J. (2000). 'Shame and scandal in the family': Australian media narratives of the IOC/SOCOG scandal spiral. *Olympika: The International Journal of Olympic Studies, IX*, 25–48.

McKay, J., & Roderick, M. (2010). 'Lay down Sally': Media narratives of failure in Australian sport. *Journal of Australian Studies, 34*(3), 295–315.

Mewett, P., & Toffoletti, K. (2008). Rogue men and predatory women. Female fans' perceptions of Australian footballers' sexual conduct. *International Review for the Sociology of Sport, 43*(2),165–180.

Morrell, S. (2009, October 26). Carey book just adds to the pain. *Herald-Sun.* Retrieved from http://www.news.com.au/opinion/carey-book-just-adds-to-the-pain/story-e6frfs99–1225791172346

Philadelphoff-Puren, N. (2004). Dereliction: Women, rape and football. *Australian Feminist Law Journal, 21,* 35–51.

Rowe, D. (2010). Attention la femme! Intimate relationships and male sports performance. In L. K. Fuller (Ed.), *Sexual sports rhetoric: Global and universal contexts* (pp. 69–81). New York, NY: Peter Lang.

Rowe, D., & Gilmour, C. (2009). Lubrication and domination: Beer, sport, masculinity, and the Australian gender order. In L. A. Wenner & S. J. Jackson (Eds.), *Sport, beer, and gender: Promotional culture and contemporary social life* (pp. 203–221). New York, NY: Peter Lang.

Rowe, D., & McKay, J. (2003). A man's game: sport and masculinities. In M. Donaldson & S. Tomsen (Eds.), *Male trouble: Looking at Australian masculinities* (pp. 200–216). Melbourne, Australia: Pluto Press.

Rowe, D., & McKay, J. (2011). Torchlight temptations: Hosting the Olympics and the global gaze. In J. Sugden & A. Tomlinson (Eds.), *Watching the Olympics: Politics, power and representation* (pp. 122–137). London, UK: Routledge.

Rule, A. (2008a, February 3). Dark side of the hoon they called the King. *The Age.* Retrieved from http://www.theage.com.au/news/national/dark-side-of-the-hoon-they-called-the-king/2008/02/02/1201801098872.html

Rule, A. (2008b, February 3). Pariah Carey—a life of near hits and many misses. *The Age.* Retrieved from http://www.theage.com.au/news/national/pariah-carey—a-life-of-near-hits-and-many-misses/2008/02/02/1201801098833.html

Schembri, J. (2010, August 23). Ben Cousins doco a warning to the young. *The Sydney Morning Herald.* Retrieved from http://www.smh.com.au/entertainment/blogs/cinetopia/ben-cousins-doco-a-warning-to-the-young-20100823–13ief.html

Sheahan, M. (2011, June 23). Wayne Carey declares his hand for coaching. *Herald Sun,* Retrieved from http://www.heraldsun.com.au/sport/afl/wayne-carey-declares-his-hand-for-coaching/story-fn8ymmuy-1226080923087

Smith, P. (2009, October 29). Addiction to spilling one's guts. *The Australian.* Retrieved from http://www.theaustralian.news.com.au/story/0,25197,26273797–21147,00.html

Smith, P. (2010, March 13). Find a cure for the Fevola virus. *The Australian.* Retrieved from http://www.theaustralian.com.au/news/opinion/find-a-cure-for-the-fevola-virus/story-e6frg6zo-1225840222026

Stevenson, A. (2010, July 10). If only we played the same code. *The Sydney Morning Herald.* Retrieved from http://www.smh.com.au/world-cup-2010/world-cup-news/if-only-we-played-the-same-code-20100709–103z1.html

Stewart, C. (2008, January 31). King Carey falls back to earth. *The Australian.* Retrieved from http://www.theaustralian.news.com.au/story/0,25197,23135648–5012432,00.html

Stuchbery, M. (2011, June 9). Addicted to cheap, sordid scandals. *The Drum.* Retrieved from http://www.abc.net.au/unleashed/2752644.html

Sunday Night. (2011, May 1). Fallen star transcript. Retrieved from http://au.tv.yahoo. com/sunday-night/transcripts/article/-/9306077/fallen-star-transcript/

Toffoletti, K. (2007). How is gender-based violence covered in the sporting news? An account of the Australian Football League sex scandal. *Women's Studies International Forum, 30*(5), 427–438.

Turner, G. (2004). *Understanding celebrity.* London, UK: Sage.

Turner, G. (2007). The economy of celebrity. In S. Redmond & S. Holmes (Eds), *Stardom and celebrity: A reader* (pp. 193–205). London, UK: Sage.

Turner, G. (2010). Approaching celebrity studies. *Celebrity Studies, 1*(1), 11–20.

Turner, G., Bonner, F., & Marshall, P. D. (2000). *Fame games: The production of celebrity in Australia.* Cambridge, UK: Cambridge University Press.

Waterhouse-Watson, D. (2007). All women are sluts: Australian rules football and representations of the feminine. *Australian Feminist Law Journal, 27,* 155–162.

Waterhouse-Watson, D. (2009). Playing defence in sexual assault 'trial by media': The male footballer's imaginary body. *Australian Feminist Law Journal, 30,* 109–129.

Wente, M. (2010, February 19). The road to redemption goes through rehab. *The Globe and Mail.* Retrieved from http://www.theglobeandmail.com/news/opinions/the-road-to-redemption-goes-through-rehab/article1475137/

West, A. (2011, June 25). Who do you think you are? *The Sydney Morning Herald.* Retrieved from http://www.smh.com.au/opinion/society-and-culture/who-do-you-think-you-are-20110624-1gjjh.html

Wilson, R. (2010, April 3). Sinners are grinners. *The Daily Telegraph.* Retrieved from http://www.dailytelegraph.com.au/sport/sinners-are-grinners/story-e6freyar-1225849030608

Spinning Out of Control: Harbhajan Singh, Postcolonial Cricket Celebrity, and the "Revenge Narrative"

David Rowe

In order to fall, sport heroes must first, of course, rise. But this is not always a simple matter of agreement on ascent and descent. What in the eyes of some actors and spectators may be an unequivocal case of disgrace, others may see as triumph, or at least extenuating circumstances bordering on justification. It is important then, as in all cases of interpretation and judgment, to take into account the conditions of transgression and the potentially conflicting readings of them. It is also crucial to acknowledge that movements in levels of esteem are not necessarily inexorable—the idea of redemption, for example, is deeply inscribed into the natural history of the media sport scandal (Rowe, 1994; 1997). This is a process that can be found not only at the level of individual subjects, but also in the wider social sphere. For example, Stanley Cohen (1973), in his renowned, influential work, *Folk Devils and Moral Panics*, described how social problems (such as subcultural violence or drug taking) may be "amplified" by societal responses (articulated through the media, police, judiciary, politicians, and various "moral entrepreneurs") that result in a "moral panic" in a manner that creates "folk devils" who must be dealt with in the interests of social order (see also Critcher, 2003; Thompson, 1998). In most cases, Cohen noted (pp. 202–203), moral panics run out of steam (crises cannot continuously escalate) and folk devils become less threatening with time and maturation, resulting in what he called a process of "de-amplification" (although one, presumably, that is potentially subject to "re-amplification").

An analogous process may be said to occur regarding the amplification and de-amplification of sport celebrity media scandals, when a sudden upsurge of notoriety creates the necessary folk devil and moral panic. For example, the

Tiger Woods "affair" (discussed elsewhere in this book) did not only see him widely condemned in media and public discourse but also provided a global opportunity to address what were presented as crises in the ethics of sportsmen and in the wider gender order (Rowe, 2011a). But the enormous spike in media coverage that caused Woods's public apology for his serial sexual infidelities to lead the main television news bulletins of august national public broadcasters such as the BBC in February 2010 (Thomas, 2010) could not be indefinitely sustained.

Although not of the same order of global magnitude, the subject of this chapter, the Indian cricketer, Harbhajan Singh, garnered enormous media coverage, especially in India and Australia, in early 2008. As is often the case with on-field incidents centered on speech (most notoriously in the case of the Zidane-Materazzi confrontation during the final of the 2006 FIFA World Cup in Germany), the material facts are disputed. But in brief, during the New Year cricket Test match between India and Australia in Sydney, Singh allegedly called Andrew Symonds, a UK-born Australian cricketer of African Caribbean and White parentage, a "monkey" (Rowe, 2011b). If true, this was a gross racial insult (one to which Symonds had claimed he had been subjected, by both Singh and some spectators, during an earlier tour to India), demanding disciplinary action by the cricket authorities. A formal complaint against Harbhajan was made by Australian captain, Ricky Ponting, and he was charged with the offense of "using language or gestures that offends, insults, humiliates, intimidates, threatens, disparages or vilifies another person on the basis of that person's race, religion, gender, color, descent or national or ethnic origin." Of particular note was that this was alleged racial abuse of one cricketer of color by another, unlike, for example, an earlier racial vilification scandal involving the Australian cricketer, Darren Lehmann and the Sri Lankan team (Knox, 2003). Harbhajan was, initially, found guilty and banned for three matches—although this was by no means the end of the story. But before proceeding with the tale of Harbhajan Singh and the "monkey" scandal, it is necessary to introduce him to those who may not know of his celebrity in cricket and to describe his background and rise to cricketing prominence.

The Rise of *Bhajji*

Born into the Punjabi middle class in 1980, Harbhajan Singh, the only male child with five female siblings (Coomber, 2008; "The Renaissance of

Harbhajan," 2001), was expected to take over the family business, a ball bearing and valve factory. Nonetheless, the cultural allure of cricket in India is extraordinary (Majumdar, 2004), and he was encouraged by his father to pursue his interest in the game (Mukhopadhyay, 2010) in the hope that he would become an international cricketer:

> "I was very passionate about playing cricket since childhood. It was my father's dream that I should play cricket. In fact, he was very enthusiastic about my taking to any sport," said Harbhajan Singh.

> "He (father) wanted me to do so well to make his [sic] and the family proud. He wanted me to make Punjab and the entire nation proud. God has been kind to gift me the ecstasy of just doing something I never dreamt of," said Harbhajan. (Nagpal, 2007)

Of ironic significance in this popular media article, which is squarely in the genre of the celebratory "puff piece," is the statement, "Harbhajan believes a person should work hard for his goals. God also tests, but one should be patient in life. It pays in the end" (Nagpal, 2007). The extent of Harbhajan's patience in response to his tests will be elaborated below.

Initially trained primarily as a batter under his first coach, Charanjit Singh Bullar, Harbhajan flourished as a spin bowler after Bullar died and was replaced by Davinder Arora. In 1998, as only a 17-year-old, he made a very early test debut against Australia in Bangalore ("Harbhajan Singh: Timeline," n.d.), but was not a regular in the team for some years due to inconsistent form and injury. He was a regular player and leading spinner in the national team from late 2007 to 2010, but since then his team selection has been irregular. An early sign of attitudinal and behavioral difficulties saw him selected, among intense competition, to train at the National Cricket Academy in Bangalore in 2000, only to be ejected for disciplinary reasons concerning refusal to meet Academy objectives and shirking physical workouts ("Harbhajan's List of Controversies," 2009). Harbhajan (nicknamed "Bhajji" among teammates, local media, and fans), though, claimed that he was expelled for complaining about the lack of nutritious, quality food in the Academy and for tearing up its diet chart in protest (Gupta, 2010). Soon after (with no suggestion of causal linkage), Singh's father died, and he assumed responsibility for family leadership at only 20 years of age (Mukhopadhyay, 2010), leading him to consider discarding a sporting career and even to emigrate to North America in pursuit of menial or manual work that would enable him to repatriate earnings to support his family in Jalandhar. However, within a year he was recalled to the national squad to replace injured spinner, Anil Kumble, after receiving the public support of captain Sourav Ganguly (Gupta, 2010). Due to his volatile

temper, in his debut one-day series in 1998 against Australia, Singh "engaged in a war-of-words with Australian captain Ricky Ponting and was slapped with a fine and a reprimand" ("Harbhajan's List of Controversies," 2009).

Harbhajan Singh's identity and religion as a Sikh in a Hindu-dominated country has complicated his status as a sporting hero, not least given the common typification of Sikhs as easily riled and aggressive. Thus, such media typifications of him as "The hotheaded cricketer—fined six times by the International Cricket Council for conduct violations and once described by cricket columnist Peter Roebuck as an intemperate Sikh warrior" (Ray, 2008), reference the cultural positioning of Sikhs within India in a manner that reflects something of an "outsider" status. This is not only a matter of stereotyping, but also taps into deeply political matters of recent memory, especially the 1984 attack on the Sikh separatists who had used the Golden Temple in Amritsar to store weaponry; the Indian army's storming of the Temple and killing of many hundreds of civilians; the subsequent assassination of Prime Minister, Indira Gandhi, by her Sikh bodyguards, and the hundreds of revenge killings of Sikhs and sacking of their neighborhoods (Khullar, 2009). These terrible events remain close to the surface in Hindu-Sikh relations (the former outnumbering the latter in India by fifty to one), with Sikhs in India (and among their diaspora) still currently petitioning the United Nations Human Rights Commission on grounds of denial of justice (Singh, 2011).

At the same time, Harbhajan Singh is required to negotiate Sikh sensibilities, such as when he caused religious offense in 2006 by appearing in an advertisement endorsing a brand of whisky without wearing his turban ("Harbhajan in 'Hair' Controversy," 2006). Nonetheless, his subordinated minority status is outweighed by the extraordinary celebrity that attaches to professional cricketers in India (not to mention the rewards that have seen the most valued players in the Indian Premier League (IPL) become the most lavishly rewarded sportsmen in the world), and which is often out of proportion to their actual cricketing capabilities (Marqusee, 2008; Rowe & Gilmour, 2009; Srinivasa-Raghavan, 2010). Singh's impressive in aggregate but chequered performance history, though, is consistent with his reputation for feistiness.

The "Sikh warrior" image fits particularly well with the current era of cricket in which India, having thrown off the yoke of imperial domination, is asserting itself as the game's dominant power (Appadurai, 1996; Majumdar, 2004, 2007; Williams, 2001). For many decades, the International Cricket Council (ICC) was controlled by the white, imperial power of England and its white-Anglo settler former colonies, Australia, South Africa, and New Zealand

(see various contributions to Wagg, 2008). However, the late twentieth century "rise of Asia" in the realms of economics and politics registered also in cricket in India, which has used (often ruthlessly) the advantage that comes with its enormous, burgeoning media cricket market to cooperate with its subcontinental peers (Pakistan, Sri Lanka, and Bangladesh), as well as the West Indies, in wresting control of the game from the white imperial center most conspicuously symbolized by the "guardians" of cricket's laws, the Marylebone Cricket Club (MCC) (Mehta, Gemmell, & Malcolm, 2009).

With this Indian political and economic power has come something of an expectation that, on the field of play, its cricketers should be more assertive and aggressive in contrast with the more deferential and passive behavior of their predecessors. That Australia should be the team with which India has had the most intense conflict in recent times is consistent with that nation's aggressive approach to cricket, especially under the captaincy of Stephen Waugh, when the team sought the "mental disintegration" of its opponents (Rowe, 2011b). Thus, the propensity of Singh to match the Australians (and other teams, such as the South Africans) in abrasive style and hostile conduct (on occasion leading to disciplinary action) has been a substantial element of his sporting celebrity. What I call here the *postcolonial revenge narrative* has positioned Harbhajan Singh as a "bad boy" who has helped to make a break between Indian cricket's subaltern history and its hegemonic present. Thus, at the time in 2008 when he became embroiled in conflict with Australian cricketers on their home soil and then was disciplined by the authorities, he was widely seen in India as both heroic and victimized. Ironically, therefore, Harbhajan's popularity—certainly among his country's media—peaked at the very moment that he was being condemned in the Western cricket press as recalcitrant, boorish, and racist. As is shown below, his celebrity rose and fell in different locations and times.

The Temporary Fall of "The Turbanator"

The "monkey" affair precipitated a mediated and sporting "diplomatic incident" involving India and Australia, with outrage expressed by several Australian players and the country's media, and corresponding defense of "The Turbanator" (a nickname used by mainly Western journalists) by elements of the Indian media and leading cricket figures such as Sunil Gavaskar, a former Indian captain and, at the time, Chairman of the ICC Cricket Committee. Gavaskar wrote in the *Hindustan Times* that "Millions of Indians want to know if [it] was a 'white man' taking the 'white man's' word

against that of the 'brown man'" (as quoted in Brown, 2008; "Gavaskar Denies Racism," 2008). Following this allegation of racism in the treatment of Harbhajan, Gavaskar then made an explicit argument in favor of the new postcolonial order in world cricket:

> Gone are the days when two countries, England and Australia, had the veto power in international cricket, even though the dinosaurs may not open their eyes and see the reality. The cricketing world has found that India has no longer a diffident voice but a confident one that knows what is good for its cricket, and will strive to get it. (Gavaskar, as quoted in "Gavaskar Slams Anglo-Australian," 2008)

The ICC Appeals Commissioner, Justice John Hansen, upheld an appeal against the racism finding and banning of Harbhajan (which was downgraded to a finding of using "abusive language"), following a reported compromise behind the scenes. There was also the absence of "smoking gun" proof, and smokescreen claims of cultural difference revolving around the status of the monkey in India as symbolized, for example, by the monkey god, Hanuman. There was also a claimed, Zidane-like mishearing, with Singh supposedly having called Symonds a "teri maki" (a term corresponding to "mother fucker" in Hindi), which might have sounded like "big monkey" to the latter's ears (Pierik, 2008). Merely calling another player incestuous in obscene language, then, was not regarded as among the more serious categories of offense. Hansen stated that Symonds's aggressive behavior contributed to the dispute, although, ironically, his failure to take into account Singh's previous infractions of the Code of Conduct meant that he was only fined, rather than banned, as he should have been under ICC rules when found guilty of the lesser charge. That the Board of Control for Cricket in India (BCCI) had suspended the tour and threatened to fly the team back to India was a clear case of it exercising its muscle in the sport that also influenced the outcome.

Harbhajan Singh, therefore, emerged from the crisis as a victor, his condemnation in the Western press (see, for example, Booth, 2008; Coomber, 2008) represented in the Indian media as historical bias against Indians by a faded white establishment (see, for example, Robinson, 2008). A small number of Indian journalists expressed reservations about this outcome:

> A tidal wave of nationalistic fervour had been wrongly unleashed in the wake of Sydney. Harbhajan, one of India's worst performers in the Australia series and someone with serious anger management issues, had done nothing to deserve such wounded-martyr status. An inquiry compromised by pressure from the Indian board didn't find him guilty of using a racial slur against Andrew Symonds, but it was common knowledge that Cricket Australia had leaned on its players to take a less belligerent stance. The prospect of losing over [AU]$50m in revenue if the Indians

went home meant that all talk of a zero-tolerance policy towards racism remained just that.

It was hugely depressing to see sections of the media and fans alike treating Harbhajan as though he was Bhagat Singh (the freedom fighter and revolutionary who was hanged in 1931) and not an underperforming cricketer with a short fuse who had either abused a fellow professional's mother or called him a Simian (Premachandran, 2008).

Correspondingly, some Western journalists saw an element of "rough justice" in Australian players receiving a little of the treatment that they had meted out to others (Roebuck, 2008), although some, perhaps, were unsympathetic as they were "Western" but not Australian (see, for example, Hopps, 2008).

Singh's fall, though, was not to come from a confrontation with an international opponent, but, later, with an Indian team-mate who was an opponent in the IPL. Less than four months after the confrontation with Symonds in Sydney, at the end of a match in late April 2008 in the Indian Premier League between his club team, the Mumbai Indians, and the Kings XI Punjab, the acting captain, Harbhajan, slapped his national teammate and IPL opponent, Shanthakumaran Sreesanth, in the face as the teams shook hands, reducing him to tears ("Bhajji "Slaps" Sreesanth," 2008). He was banned for the remainder of that IPL season, had a portion of his contract salary withheld, and was given the maximum punishment by the BCCI of a five-match ban from One-Day Internationals. Harbhajan was warned that, given his extensive disciplinary record, any such future misconduct would lead the BCCI to impose a life ban (Lalor, 2008). Although Sreesanth had behaved aggressively to batters during the match, there was no media and player campaign of support for Harbhajan. The resistive postcolonial dynamic that propelled sympathy and even vindication for him against the Australians (themselves formerly colonised by the British) was dissipated—the "war" against outsiders had quickly turned into a "civil" conflict in which nationalist heroism was reduced to selfish petulance.

In a subsequent interview, Harbhajan offered only a qualified apology for any of his actions during his turbulent career. For example:

Whatever happened in Sydney was an instance of making a mountain out of a molehill. They do not like it when people say things about their players, but they are probably the worst when it comes to saying things or doing things to other players. But I am not like those who can listen to abuses and keep quiet. I have come to play, not get abused. If they abuse me, I will give it back to them. . . . First they were talking normally. But when they got personal, I got personal too. But I never said the word that they claimed I did. (as quoted in Gupta, 2010)

In admitting to using unpleasant language to the Australians, Harbhajan was marking out the distinction between his approach and conduct, and that of previous generations of Indian cricketers who did not "give it back to them." As the Indian journalist, Harsha Bhogle, put it:

> Since I was a little child, my abiding memory is of visiting journalists and cricketers coming to India and making fun of us.
>
> We were a country finding our feet, we were not confident, we seethed within but we accepted. The new generation in India is not as accepting, they are prouder, more confident, more successful. (Bhogle, 2008)

Harbhajan has clearly not "seethed within," having to "listen to abuses and keep quiet." The postcolonial revenge narrative can never be permitted to be directed within, especially given the divide-and-conquer strategies of colonial powers. This outsider-insider binary structure is clearly delineated in Harbhajan's reflection on the physical confrontation with Sreesanth:

> I had a fight with him. Whatever happened was wrong on my part. But the coach came and spoke to me. He said I just want you to forget what happened, we will make sure everybody is happy—you are happy, the team is happy, Sreesanth is happy. We are just like a family, we have fights in our family. We need a guy like Gary [Kirsten] to understand that we are not just playing, this is a family kind of a thing. (as quoted in Gupta, 2010)

A certain irony can be detected here in that one white South African (Kirsten) worked to maintain the "family" by soothing its internal conflicts, while another (Procter) had brought it together under external threat by, in Gavaskar's above-quoted words, implicitly taking "the "white man's" word against that of the "brown man." "In Sydney, the opposing person of color (Symonds) was not seen as such—as one close associate of the Indian cricket team stated, "To Indians he is not black. He is just Australian" (as quoted in Coomber, 2008). Symonds's Australianness, then, obscured any potential affinity with Harbhajan and the other Indian players. Harbhajan's consistent defiance (when outer-directed) bolstered his reputation among Indian patriots, while he was condemned as scandalous by those who were not Indians, and who were more accustomed to (and comfortable with) Indian compliance than Indian intransigence. That India could use this incident at the institutional level to remind the traditional powers of their own decline was particularly symbolically rewarding. When Harbhajan slapped Sreesanth in Mohali, though, ammunition was handed to the enemy, and his treasonous conduct could not go unpunished by his compatriots.

Conclusion: After the Fall, the Return

Harbhajan Singh soon "made it back" into favor in Indian cricket. While possessed of probably the worst disciplinary record in the history of the international game (some of which is listed almost proudly in "Harbhajan's List of Controversies," 2009), his talent as bowler and batter, and recognition factor in international cricket, saw him out of the game for only a few months. Coming to attention by being fined for driving his black Hummer without properly displaying a number plate ("Bhajji's Hummer Enters Police Records," 2009), and receiving a notice from the Central Excise and Taxation Department for not paying service tax on his IPL earnings from promotional campaigns for the franchise ("Bhajii Evades Tax," 2011) are fairly routine consequences of cricketing celebrity. Although, in his now-long career, "Bhajji"/"The Turbanator" has gained considerable notoriety in world cricket, it is not possible to analytically interpret the sociocultural significance of his travails without a keen awareness of the contrasting ways in which he can be "read" against the backcloth of a new global cricket order.

This chapter began by referring to Cohen's (1973) significant book, *Folk Devils and Moral Panics*, in proposing a way of understanding the anatomy and rhythm of the celebrity media sports scandal in terms of the emergence (indeed, creation) of the cultural figure of the transgressor who is caught up in an escalating moral anxiety of significant, social proportions. The scandal is amplified, and there are calls for action and other discursive interventions by a range of interested parties. After a period of intense media focus on the celebrity's failings and their impact or symbolic resonance across the social spectrum, there is normally a de-amplification caused by attention exhaustion, although with the possibility of a revival under new circumstances. Harbhajan Singh became, briefly, a folk devil in the Western cricket-following media (which is not confined to the sports pages) when accused of racism and unseemly behavior. Within these discursive constructions he came to symbolize the negative consequences of the changing of the "colonial guard" under postcolonialism (Bale & Cronin, 2003; Malcolm, Gemmell, & Mehta, 2010; Rumford, 2007), when those who were once subaltern become aware of and exercise their newfound dominance. But within the media and public sphere of the non-West, the folk devil more closely resembles the folk hero—flawed perhaps but usefully so.

At this point another leading sociologist comes usefully into the frame—Pierre Bourdieu. In various works including his most famous, *Distinction*, Bourdieu (1984) described and analyzed the embodied dispositions that social actors take on (largely unconsciously) in ways that relate to the structuring

elements of their lives (Tomlinson, 2004). This he called the *habitus*, and it could be reasonably argued that Harbhajan represents, in his embodied conduct on the field of play, a "new" habitus for the Indian cricketer that varies strikingly from the self-effacing and relatively passive demeanor of those from the era when cricket was indeed dominated by the white, imperial center and its white settler colonies. In other words, Harbhajan, with his highly competitive, provocative, and outwardly aggressive approach to cricket came to embody—at least for a significant, conflict-saturated moment on a hot Australian cricket field—a new order of cricket in which the subcontinent made no apology for displaying and using its political and economic might (Gupta, 2004).

With an estimated 80% of world cricket revenue being generated in India, sweet postcolonial revenge could be exacted by (a) taunting once-dominant cricket powers with insouciant demeanor, (b) displaying a willingness to break uncooperative parties financially by cancelling a lucrative tour, and (c) luring opponents' most accomplished players with unprecedented rewards to play in a highly dramatized, "fast food" version of the cricket invented in the West— Twenty20 cricket as practiced in the IPL (Haigh, 2010; Rowe, 2011a). The face of cricket thereby shown to the world is not all that appealing, but it is the face of newly acquired power nakedly exposed. Harbhajan Singh first rose with this power in adversity but fell briefly because he showed that it could be turned against itself. After barely three months of punishment, he was rehabilitated, although with something of a Sword of Damocles life ban prospect if he again slaps a teammate or commits some other infraction which offends the postcolonial revenge narrative governing the rise and fall of contemporary cricket celebrities.

Acknowledgment

The author would like to thank Vibha Bhattarai Upadhyay for her research assistance in the preparation of this chapter.

References

Appadurai, A. (1996). *Modernity at large: Cultural dimensions of globalization*. Minneapolis, MN: University of Minnesota Press.

Bale, J., & Cronin, M. (Eds.). (2003). *Sport and postcolonialism*. Oxford, UK: Berg.

Bhajii evades tax; Central Excise and Taxation Department issues notice. (2011, May 13). *The Economic Times*. Retrieved from http://articles.economictimes.indiatimes.com/2011-05-13/news/29540219_1_central-excise-service-tax-punjab-cricketer (no longer accessible).

Bhajji 'slaps' Sreesanth, makes him cry. (2008, April 26). *The Times of India*. Retrieved from http://timesofindia.indiatimes.com/NEWS/India/Bhajji-slaps-Sreesanth-makes-him-cry/articleshow/2983882.cms

Bhajji's Hummer enters police records. (2009, September 2). *The Times of India*. Retrieved from http://timesofindia.indiatimes.com/sports/cricket/top-stories/Bhajjis-Hummer-enters-police-records/articleshow/4961693.cms

Bhogle, H. (2008, January 31). Why India tired of being little brother. *The Sydney Morning Herald*. Retrieved from http://www.smh.com.au/news/cricket/bharsha-bhogleb/2008/01/30/1201369227877.html?page=fullpage#contentSwap1

Booth, L. (2008, January 7). India choose the wrong time to flex their muscles. *The Guardian*. Retrieved from http://blogs.guardian.co.uk/sport/2008/01/07/india_choose_the_wrong_time_to.html

Bourdieu, P. (1984). *Distinction: A social critique of the judgement of taste*. London, UK: Routledge & Kegan Paul.

Brown, A. (2008, January 14). Sunny slams ref, Aussie motives. *The Sydney Morning Herald*. http://www.smh.com.au/news/cricket/sunny-slams-ref-aussie-motives/2008/01/14/1200159286472.html

Cohen, S. (1973). *Folk devils and moral panics: The creation of the Mods and Rockers*. London, UK: Paladin.

Coomber, J. (2008, January 8). Turbanator's history with Aussies. *Fox News*. Retrieved from http://www.foxsports.com.au/breaking-news/turbanators-history-with-aussies/story-e6frf33c-1111115273134

Critcher, C. (2003). *Moral panics and the media*. Buckingham, UK: Open University Press.

Gavaskar denies racism claim against Procter. (2008, January 17). *The Sydney Morning Herald*. Retrieved from http://www.smh.com.au/news/cricket/gavaskar-denies-racism-claim-against-procter/2008/01/16/1200419885452.html

Gavaskar slams Anglo-Australian 'dinosaurs.' (2008, March 24). *ESPN Cricinfo*. Retrieved from http://content-ind.cricinfo.com/ci-icc/content/story/343691.html

Gupta, A. (2004). The globalization of cricket: The rise of the Non-West. *International Journal of the History of Sport*, 21(2), 257–276.

Gupta, S. (2010, September 14). 'Chappell was a disaster. He was after Sachin. He wanted Sachin to retire.' *Indian Express*. Retrieved from http://www.indianexpress.com/news/chappell-was-a-disaster.-he-was-after-sachin.-he-wanted-sachin-to-retire/681255/0

Haigh, G. (2010). *Sphere of influence: Writings on cricket and its discontents*. Melbourne, Australia: Victory Books.

Harbhajan in 'hair' controversy. (2006, October 7). *The Times of India*. Retrieved from http://timesofindia.indiatimes.com/articleshow/2115208.cms

Harbhajan Singh: Timeline. (n.d.). *ESPN Cricinfo*. Retrieved from http://www.espncricinfo.com/india/content/player/29264.html?index=timeline

Harbhajan's list of controversies. (2009, September 9). *Hindustan Times*. Retrieved from http://www.hindustantimes.com/Harbhajan-s-list-of-controversies/Article1-451911.aspx#

Hopps, D. (2008, January 7). Bowler found guilty but Australia stand condemned. *The Guardian*. Retrieved from http://sport.guardian.co.uk/cricket/story/0,,2236970,00.html

Khullar, M. (2009, October 28). India's 1984 anti-Sikh riots: Waiting for justice. *Time*. Retrieved

from http://www.time.com/time/world/article/0,8599,1931635-1,00.html

Knox, M. (2003, January 27). Lehmann reveals the unwitting racism that infuses Australia. *The Age.* Retrieved from http://www.theage.com.au/articles/2003/01/26/1043533952023. html

Lalor, P. (2008, May 15). BCCI gives Harbhajan Singh final warning. *The Australian.* Retrieved from http://www.theaustralian.com.au/news/harbhajan-facing-life-ban/story-e6frg7mo-111 1116343808

Majumdar, B. (2004). *Twenty-two yards to freedom: A social history of Indian cricket.* New Delhi, India: Penguin.

Majumdar, B. (2007). Nationalist romance to postcolonial sport: Cricket in 2006 India. *Sport in Society, 10*(1), 88–100.

Malcolm, D., Gemmell, J., & Mehta, N. (Eds.). (2010). *The changing face of cricket: From imperial to global game.* London, UK: Routledge.

Marqusee, M. (2008, March 9). Cashing in on cricket. *The Hindu.* Retrieved from http://www.hindu.com/mag/2008/03/09/stories/2008030950020100.htm

Mehta, N., Gemmell, J., & Malcolm, D. (2009). 'Bombay sport exchange': Cricket, globalization and the future. *Sport in Society, 12*(4–5), 694–707.

Mukhopadhyay, A. (2010, November 8). This century is for my dad, says ecstatic Harbhajan. *Hindustan Times.* Retrieved from http://www.hindustantimes.com/This-century-is-for-my-dad-says-ecstatic-Harbhajan/Article1-623669.aspx#

Nagpal, S. (2007, November 12). Cricketer Harbhajan Singh loves the spins of his life. *TopNews.* Retrieved from http://www.topnews.in/cricketer-harbhajan-singh-loves-spins-his-life-25779

Pierik, J. (2008, January 30). Judge says Andrew Symonds to blame in cricket race row. *The Courier Mail* (Brisbane, Australia). Retrieved from http://www.news.com.au/couriermail/story/0,23739,23134165-10389,00.html

Premachandran, D. (2008, April 30). Thuggery is no way to cricket paradise. *The Guardian.* Retrieved from http://blogs.guardian.co.uk/sport/2008/04/30/thuggery_is_no_way_to_cricket.html

Ray, S. G. (2008, May 10). Slap and tickle match. *Tehelka: India's Independent Magazine, 5*(18). Retrieved from http://www.tehelka.com/story_main39.asp?filename=hub100508slap_and.asp

The renaissance of Harbhajan. (2001, November 5). *BBC Sport.* Retrieved from http://news.bbc.co.uk/sport2/hi/cricket/1638947.stm

Robinson, S. (2008, January 7). Race row threatens cricket world. *Time.* Retrieved from http://www.time.com/time/world/article/0,8599,1700917,00.html

Roebuck, P. (2008, January 8). Arrogant Ponting must be fired. *The Sydney Morning Herald.* Retrieved from http://www.smh.com.au/news/cricket/arrogant-ponting-must-be-fired-roebuck/2008/01/07/1199554571883.html

Rowe, D. (1994). Accommodating bodies: Celebrity, sexuality and 'tragic Magic.' *Journal of Sport & Social Issues, 18*(1), 6–26.

Rowe, D. (1997). Apollo undone: The sports scandal. In J. Lull & S. Hinerman (Eds.), *Media scandals: Morality and desire in the popular culture marketplace* (pp. 203–221). Cambridge, UK: Polity Press.

Rowe, D. (2011a). *Global media sport: Flows, forms and futures*. London, UK: Bloomsbury Academic.

Rowe, D. (2011b). The televised sport 'monkey trial': 'Race' and the politics of post-colonial cricket. *Sport in Society, 14*(6), 792–804.

Rowe, D., & Gilmour, C. (2009). Global sport: Where Wembley Way meets Bollywood Boulevard. *Continuum, 23*(2), 171–182.

Rumford, C. (2007). More than a game: Globalization and the post-Westernization of world cricket. *Global Networks, 7*(2), 202–214.

Singh, I. P. (2011, June 28). Sikh bodies to approach UNHRC. *The Times of India*. Retrieved from http://timesofindia.indiatimes.com/india/Sikh-bodies-to-approach-UNHRC/article show/9021171.cms

Srinivasa-Raghavan, T. C. A. (2010, April 17). Economics of honey, flies and IPL. *Business Line*. Retrieved from http://www.thehindubusinessline.com/2010/04/17/stories/2010041750 480800.htm (no longer accessible).

Thomas, L. (2010, February 25). BBC's news coverage of Tiger Woods' apology sparks 'dumbing down' backlash. *Mail Online*. Retrieved from http://www.dailymail.co.uk/news/article-1253598/BBCs-news-coverage-Tiger-Woods-apology-sparks-dumbing-backlash.html #ixzz0jRxYpheR

Thompson, K. (1998). *Moral panics*. London, UK: Routledge.

Tomlinson, A. (2004). Pierre Bourdieu and the sociological study of sport: Habitus, Capital and Field. In R. Giulianotti (Ed.), *Sport and modern social theorists* (pp.161–172). Basingstoke, UK: Palgrave Macmillan.

Wagg, S. (Ed.). (2008). *Cricket and national identity in the postcolonial age: Following on*. London, UK: Routledge.

Williams, J. (2001). *Cricket and race*. Oxford, UK: Berg.

Fallen Sideline Sports Celebrity

The "Bully" and the "Girl Who Did What She Did": Neo-Homophobia in Coverage of Two Women's College Basketball Coaches

Marie Hardin
Nicole M. LaVoi

In March 2007, two high-profile NCAA women's basketball coaches resigned under a cloud of scandal, garnering coverage from media such as ESPN and *The New York Times*. The reason: both coaches were accused of wrongdoing in relationships with players. One was sued by a player and then sanctioned by her university for discrimination; another was confronted by university officials on allegations of an improper sexual relationship.

The similarities in the cases of Rene Portland and Pokey Chatman extend further. The morality tales around the accusations against both coaches—and their subsequent falls from the pinnacle of their profession—simultaneously challenged and reinforced hetero-normative values in women's sports. We explore storylines around the rise and fall of Chatman and Portland through the lens of *neo-homophobia*. We use the term to describe a form of homophobia that, like "new racism," positions discrimination solely in individuals and turns a blind eye to the systematic, institutional discrimination protecting the uneven playing field in sports from groups that challenge entrenched, cultural hierarchies (Hardin, Kuehn, Jones, Genovese, & Balaji, 2009).

Neo-Homophobia in Coverage of Sports

Research has demonstrated that hegemonic ideology about gender roles underpins sports coverage; reinforcement of gender norms may well be the most powerful (ubiquitous yet transparent) function of mediated spectator sports in U.S. culture. Traditional notions of masculinity and femininity

assume heterosexuality; thus, the display of heterosexuality has been an essential component in the gendered mediation of sports (Baird, 2002). The emphasis on heterosexuality (constructing it as the "norm" and other sexualities as deviant) manifests itself in representations of athletes. For instance, the (heterosexual) romances of high-profile athletes are celebrated in popular culture, and female athletes are featured in presentations that emphasize their attractiveness to men (e.g., *Sports Illustrated*'s swimsuit issue).

At the same time, there is no doubt that popular acceptance of alternative sexualities in U.S. culture has increased; public attitudes toward same-sex marriage have evolved to the point that such marriages are legal in some states (Confessore & Barbaro, 2011). In light of social progress on issues of sexuality and sexual identity, it is no surprise that overt, individual expressions of homophobia have become far less common. The same can also be said of individual, public expressions of outright racism in light of the civil rights movement (Hardin et al., 2009). When public figures do express racist views, public condemnation quickly follows; the firing of radio host Don Imus after his infamous 2007 comment about female basketball players—he referred to them as "nappy-headed hos"—is an example of the societal intolerance for individual racist expression.

We suggest—as do many researchers—that racism and homophobia, however, are still part of institutional practices and policies, including those in popular spectator sports (Sage, 2000). Scholars have coined these more subtle, neoliberalist, and powerful manifestations of discrimination—which simultaneously oppress as they deny oppression—as "new racism" (Augoustinos, Tuffin, & Every, 2005). Ferber (2007) pointed to mediated constructions of black athletes as liminal and potentially dangerous as a form of new racism; scholars have critiqued the NBA's implementation of a dress code as reinforcing negative stereotypes about black athletes as irresponsible and as potentially criminal (Bandsuch, 2009).

Research examining the framing of gay and lesbian athletes has similarly found the reinforcement of heterosexism along with denial that such heterosexism exists. One study, for instance, examined columnists' treatment of retired NBA player John Amaechi after he came out of the closet and found that columnists ridiculed players who made homophobic comments but also dismissed Amaechi as a legitimate player and failed to examine institutional homophobia in the NBA (Hardin et al., 2009). Scholars have also pointed directly to practices in sports leagues as reinforcing heterosexism; the LPGA's hiring of a "fashion consultant to promote heterosexual femininity for golfers on the tour" (Burns-Ardolino, 2007, p. 38) and the WNBA's emphasis on uniform styles for its players ("Should they wear dresses? Tunics over shorts?")

are two examples (Baroffio-Bota & Banet-Weiser, 2006, p. 491). Only recently have major media accounts begun to consider homophobia; a 2011 article addressed the practice of "negative recruiting"—using homophobic appeals—in women's basketball. It concluded that such practices have "without question created a toxic atmosphere in the highest-profile women's college sport" (Cyphers & Fagan, 2011, para. 8).

Framing Portland and Chatman

Rene Portland and Pokey Chatman were both familiar names to any fan of women's college basketball in 2007, when both resigned from coaching. Portland had been coaching much longer than Chatman—but Chatman, as coach of a high-ranked team at Louisiana State University, had reached the same elite ranks as had Portland, who spent almost the entirety of her 31-year coaching career at Penn State University ("Rene Portland Biography," 2007).

Portland

Rene Portland, who ended her career with more than 600 wins over 27 seasons at Penn State (only the ninth women's coach to do so), was a player at Immaculata College in the 1970s before starting her career at St. Joseph's and then moving to Colorado for two years ("Rene Portland Biography," 2007). Penn State played in 21 NCAA Tournaments under Portland and advanced to the 2000 Final Four. Portland won five Big Ten championships and two conference tournament titles.

Although she was well known for her winning records, Portland was controversial from early in her career for her "no lesbians" policy, one that was not a secret in intercollegiate ranks, the Penn State community, or the media, for that matter (Newhall & Buzuvis, 2008). In 2006, Jennifer Harris, a player whom Portland dismissed from the team, filed a discrimination lawsuit alleging that Portland did so because she suspected that Harris was lesbian. After Harris reached an undisclosed settlement with the university, Portland resigned (Newhall & Buzuvis, 2008).

Chatman

Pokey Chatman was an All-American point guard for LSU before starting a coaching career as a student assistant at her alma mater. During her 13th season, she took over from head coach, Sue Gunter. As head coach for LSU from 2004–2007, Chatman led the team to three consecutive NCAA Final

Fours (Chatman resigned prior to the 2007 NCAA Tournament. Under direction of interim head coach, Bob Starkey, LSU reached its fourth Final Four with a team that was arguably Chatman's). During her tenure, the team amassed a record of 90-14, and Chatman won numerous regional and national coaching awards ("Pokey Chatman," 2007).

Chatman resigned as head coach at LSU on March 7, 2007, amid allegations of an inappropriate relationship with a former player that began when Chatman was coaching that player. After her resignation from LSU, in August 2007 she signed on as assistant coach of Moscow's Spartak. In 2010 Chatman was named general manager and head coach of the Chicago Sky of the WNBA ("Pokey Chatman," 2011).

Research Strategy

Our goal was to evaluate selected news coverage from the coaching careers of Portland and Chatman to understand how heterosexual and neoliberalist ideology manifested in storylines. We did not seek to analyze all coverage of these coaches but instead chose for analysis coverage from major news outlets, such as ESPN, *The New York Times*, and other influential or high-circulation sources, and from the universities at which they coached. In total, we read 45 stories about Chatman and 50 about Portland, whose career lasted far longer than Chatman's.

Our approach was generally iterative; that is, we went into the project with the expectation that we would encounter neo-homophobia in the narratives about Chatman and Portland, albeit manifested differently (Potter, 1996). We used a method called textual analysis in reading the stories; this approach allowed us to understand that texts (including news stories) are written to be "*persuasive* . . . establishing one version of the world in the face of competing versions" (Gill, 2007, p. 59). We used several observational techniques, such as repetition of key ideas, the use of metaphors and analogies, and the establishment of relationships in the stories, to note themes (Bernard & Ryan, 2009).

The Portland Story

Rise of a coaching crusader

The arrival of Rene Portland at Penn State in 1980—hired by legendary football coach Joe Paterno during his short run as an athletic director—was one

of several key anecdotes used in stories about Portland as she moved the women's basketball program at Penn State from what she called the "dark ages" to a nationally prominent program (Anderson, 1994; Henderson, 1992; Hubbard, 1991, para. 29). The anecdotes, repeated in stories over a period of years, reinforced her as a "crusader" who championed women's sports and managed to "have it all" (Anderson, 1994, para. 21): a husband, children, and a career. From her hiring at Penn State, through her public skirmishes with university officials to gain better playing facilities, to her coaching tactics, Portland was repeatedly referred to as a "fighter"; it was not uncommon to see references to Portland as a "crusader," as "ferocious competitor," or in a "fight" (Anderson, 1994; Henderson, 1992; Hubbard, 1991; Longman, 1991). This lead on a 1991 story about Portland's career was typical of presentations about her:

> Want a fight? Rene Portland will give you one. Try anything that even vaguely suggests her team is being treated like a second-class citizen and she will be in your face like a blocked shot. Give her players a little less respect than they deserve and she will give you an attitude adjustment. (Longman, 1991, para. 1)

Anecdotes about Portland's hiring (she refused the job, then relented after Paterno reportedly met a series of demands), her tirades about her players, and her response after her team was forced to play an NCAA tournament game away from home so the men's team could have the gym (protests ensued at the men's game) were repeated, reinforcing Portland's framing as a crusader. The dominant role of Portland's religious beliefs—she was a Catholic who attended daily mass—was noted (Anderson, 1994; Klein, 2000; McGeachy, 2000; Patrick, 1997).

Emphasis on family

Stories about Portland commonly referred to her family, providing details about her children, her husband, and her mother, who lived with Portland (Henderson, 1992; McGeachy, 2000; Voepel, 2000). Portland's status as a wife and mother was positioned as idyllic: "They are the perfect happy family, perfect for the area known as Happy Valley," wrote one reporter after Portland had her third child (Henderson, 1992, para. 20).

Portland—and those who covered her—presented her familial status as evidence of her success but also as a rationale for her battles on behalf of women. One story, for instance, detailed how Portland's husband, John, accompanied her to games and then quoted her:

I have everything I want. I have a husband, I have three kids, I have a nice house, I drive a nice car. And I have a wonderful job. And you say why do you keep fighting? Well, you have to keep fighting because I want my daughter to be guaranteed those things, not to have to fight for those things. And I want my players to realize that they really can have it all. It's not a man's world. It's not a female's world. It's a world. (Anderson, 1994, para. 21–23)

Champion for women

Portland presented herself—and the storyline was inserted into reporters' narratives uncritically—as a tireless advocate for female athletes. Anecdotes about her demands upon arriving at Penn State and her criticism of the media and the university for inadequate attention to her team were used as evidence (Anderson, 1994; Henderson, 1992; Hubbard, 1991; Longman, 1991). One story characterized her as someone who was "bold and brash and stridently fights for the rights of women in the often-chauvinistic, male-dominated world of sports" (Hubbard, 1991, para. 3). Another writer implied that "Rene's Wrath" (Henderson, 1992, para. 2) awaited any entity that failed to comply with Title IX.

"One incident"

Portland's role as a "role model" for her players was reinforced through the use of anecdotes about her recruiting and her coaching and through quotes from current and former players. However, her discrimination against players she believed were lesbian became public knowledge in the mid-1980s—and was mentioned in several stories in the early and mid-1990s before virtually vanishing until the lawsuit was brought against her in 2005 (Voepel, 2006). Portland's "no lesbians" policy received widespread (although short lived) attention in 1991, when it was discussed in a *Philadelphia Inquirer* article (Longman, 1991). It was acknowledged that the policy was widely known. The story went on to quote players—but only those who "appreciated Portland's stance" because she was, in the words of one, "trying to get the stereotype [of female players as lesbian] erased" (para. 52, 56).

Generally, reporters, such as Hubbard (1991), positioned Portland's discrimination as a "curious" (para. 38) deviation from her more relevant crusade for women's rights, noting "This is one fight she concedes, if only publicly" (para. 41). Another implied that Portland had been a victim—she had been "attacked," he wrote—because of her stance (Henderson, 1992). In a 1994 story recounting highlights of her career, her policy was referred to as an "inci-

dent"—a small blip on a long list of women's-rights causes she championed (Anderson, 1994, para. 40).

Fall of the "bully coach"

The fall of Portland—the public scandal surrounding a lawsuit filed against her by a former player in 2005 and her subsequent resignation from Penn State (Associated Press, 2007a)—was covered through storylines that were both complementary and contrasting to those used during her ascension. Portland was still defined by her familial relationships and as a pioneer for women's basketball but also as a combative personality tainted by homophobia—a lone "bad actor" who needed to be expelled. Her employer, Penn State, was also implicated as an institution that was out of line for having tolerated her homophobia. Even so, the problem of homophobia in women's sports was positioned as marginal.

The good, the bad, and the ugly

As stories about the dismissal of leading scorer, Jen Harris, and her lawsuit surfaced in 2005 and moved into 2006, stories focusing on Portland presented her as a women's sports advocate with a well-known flaw that ultimately hurt a handful of players. Her homophobia was presented using words such as "crusade" or "campaign"—indicating that a sense of morality or justice (however misguided) underpinned it (Hohler, 2006, para. 1; Voepel, 2005, para. 7). Her marriage and family were still sometimes mentioned in descriptive detail, implying relevance to her identity related to the case (Lieber, 2006; "Rene Portland Biography," 2007; "Rene Portland Resigns," 2007; Voepel, 2006).

Portland's background as a player for Immaculata and as someone with a "very important role in the development of women's basketball" (Voepel, 2006, para. 7) figured in lengthy stories about her (Hohler, 2006). Prominent women's basketball writer, Mechelle Voepel, who provided much of the commentary for ESPN, noted Portland's background as an advocate for women's sports (Voepel, 2005, 2006, 2007a, 2007c). Her background was generally used as illustrative of her positioning as "very complex" (Voepel, 2007c, para. 26)—in other words, her good deeds on behalf of the women's sports movement made it difficult to condemn her (Hohler, 2006).

Portland was not depicted sympathetically in some stories, however, as writers detailed her aggressive, combative style (Hays, 2006; Voepel, 2006).

One reporter wrote that "if you're on the receiving end of criticism or sarcasm from Portland, you might find yourself cut to pieces" (Voepel, 2005, para. 18).

The intolerance of a single coach, the tolerance of a single institution

Although the problem of homophobia as extending beyond Penn State was hinted at in some stories (Hohler, 2006), it was generally positioned as a local problem in which Portland and her employer could be squarely blamed. Portland was described as "boorish" (Brennan, 2006, para. 12), a "bigot" (Hays, 2006, para. 6), and a "bully" (Voepel, 2007a, para. 21). Penn State was prominent in most stories, indicted as a party to Portland's anti-lesbian bias (Brennan, 2006; Hays, 2006; Voepel, 2006, 2007a, 2007c). Portland's homophobia was framed as an individual flaw that had been enabled by an institution that was callous, greedy, or incompetent.

Voepel, the most prominent voice for ESPN on the issue, provided a summation of "lessons for women's basketball" in a 2007 column (Voepel, 2007a, para. 23), but none of them involved addressing homophobia. Instead, the lessons focused on managing relationships between coaches, players, and university administrators. Other stories more directly minimized the impact of homophobia; for instance, one article, headlined "Campus reaction is tepid" (Benjamin, 2006) concluded: "Questions linger. And while a few members of the LGBT community ask them, the rest of the Penn State campus continues with its daily business" (para. 14).

This is not to imply that, during the Portland saga, all reporters downplayed homophobia as a problem for female athletes beyond Penn State. One notable attempt was in a *Boston Globe* article by Bob Hohler, in which the author characterized the Portland case as "a watershed chapter in a decades-long struggle to eradicate prejudice that has long festered in the sport" (2006, para. 3).

Generally, however, homophobia was not presented as an issue in women's sports. One writer, for example, argued precisely the opposite: that "homosexuality is a part of women's basketball"—and that "diversity and open minds," while not in Happy Valley, were the norm beyond Penn State (Hays, 2006, para. 11, 14).

The Chatman Story

Rise of an LSU "lifer"

Chatman's entire, record-setting collegiate career was spent at LSU. One reporter wrote, "the word 'Lifer' might have been stamped on her forehead" (Merrill, 2007, para. 1). Based on her history and protégée status, Chatman was considered a "natural" to take over from ailing Hall of Fame head coach, Sue Gunter (*LSUSports.net*, 2004). Facing what is usually a tough transition from assistant to head coach—where roles, responsibilities, and pressure to perform drastically change—in addition to Gunter's illness and Hurricane Katrina, Chatman was praised for her ability to handle the transition (DeShazier, 2006).

Based on comments from colleagues, reporters underscored that the team was in "good hands" with Chatman at the helm (DeShazier, 2006; Patrick, 2005). Chatman was portrayed as someone who could provide "a calming influence, a smooth transition, a 'family' member who could maintain and improve upon the ascension" (DeShazier, 2006). Skip Bertman, LSU Athletic Director, claimed that "Pokey was the perfect person to transition from Sue. It was seamless" (Patrick, 2005).

The team's record, 15–5 in her first year, an unbeaten SEC season, and a first-ever Final Four appearance catapulted Chatman upward in the women's coaching ranks. She won numerous coaching awards in her first two years at the helm (*LSUSports.net*, 2005). The high-level performance of her teams garnered her recognition and helped reporters construct an image of trustworthiness and credibility both on and off the court.

"Small" package, big personality

Demonstrating a trust in Chatman's leadership, the university awarded her a four-year contract extension. In an LSU press release about the extension, Bertman noted that her leadership abilities "both on and off the floor, along with her recruiting talent, continue to make LSU one of the top women's programs in the country" (*LSUSports.net*, 2005).

During her ascension, reporters used comments from colleagues and players to emphasize the popularity of a "small" or "pint-sized" woman who possessed a big personality—a woman who knew the game, was a scrappy fighter, handled herself professionally, made an impact on her players, and rode a Harley-Davidson motorcycle to relax (DeShazier, 2006; Kalec, 2005; Merrill, 2007; NPR, 2006; Patrick, 2005). In a National Public Radio segment of *All*

Things Considered in which the 2006 NCAA Final Four was previewed, reporter, Tandelaya Wilder, portrayed Chatman as an enigma:

> She's got a really cute name, Pokey Chatman, but it certainly doesn't fit her demeanor on court. Pokey Chatman is the tiger of the LSU Tigers. She is their mascot as the coach. She's intense. She's smart. It's fun to watch her pace back and forth on the sidelines arguing calls. (NPR, 2006)

Reporters quoted other coaches, including legendary Tennessee coach, Pat Summitt, and Connecticut coach, Geno Auriemma, praising Chatman's coaching skills and record (DeShazier, 2006; Kalec, 2005). Quotes from players also reinforced how well Chatman was respected and liked. For instance, two-time, All-American LSU player and prized recruit, Seimone Augustus, was quoted saying of Chatman:

> It's easy for people to get the wrong idea about Pokey when you first see her. You can say, "Oh look, she's pretty. Oh look, she's small." But Coach is very intense. She knows what she wants out of a team, and she is going to use her intensity to get it out of them. She's always been like that. (Kalec, 2005)

A picture of Chatman as competent, admired, and beloved was evident in her ascension, but Chatman was never defined or described in relationships with family, in romantic relationships, or even regarding close friends. The only mention of family by reporters was of her mother, Carolyn Fiffie.

The "shocking" fall of a rising star

Based on allegations of "improper" and "inappropriate" conduct with former players stemming from a report filed by LSU colleague, Carla Barry, Chatman's resignation just days before commencement of the NCAA tournament received national attention (Longman, 2007; Lyons, 2007; Merrill, 2007; Varney & Kleinpeter, 2007). Reporters positioned Chatman's resignation as "shocking" (Varney & Kleinpeter, 2007)—in other words, her status as a trustworthy rising star made it problematic to make sense of events and wholeheartedly denounce her. The story appeared and disappeared in a matter of days.

Reporters constructed Chatman's fall as a violation of trust, a series of "bad decisions," and an abuse of power within the coach-athlete relationship (Associated Press, 2007b; Longman, 2007; Merrill, 2007). Skip Bertman, the oft-quoted LSU Athletic Director, was first quoted in *The Times-Picayune* of New Orleans as saying, "The girl did what she did and LSU had no control over that"' (Associated Press, 2007b; Longman, 2007; Voepel, 2007b).

This statement—in which he absolved LSU of any wrongdoing—was quickly picked up by many other media outlets, and the sentiment of bad decision-making was repeated. For instance, in an *ESPN.com* story, a former teammate stated, "Speculation or not, you have choices every day. Sometimes you make good choices, sometimes you make bad ones" (Merrill, 2007). Amidst speculation and rumors of "bad decisions," Chatman was not presented in the stories as meriting due process.

Under a shroud of secrecy and mystery

When news broke of the abrupt departure of a prized alumnus and nationally acclaimed coach, LSU Athletic Director Bertman explained that it was because of her pursuit of unspecified "career opportunities" (Associated Press, 2007b; Longman, 2007)—which quickly became an obvious attempt to cover up a scandalous situation. Bertman admitted that no formal investigation had occurred, but that an informal investigation "might have happened" (Associated Press, 2007b).

After being forced to resign without any evidence concerning due process in news coverage, Chatman made very few public statements and alluded to unfair treatment. In one story, she was quoted: "I had a 20-year career at LSU, and that didn't warrant a 20-minute conversation." She explained her silence as a choice not to "wrestle in the mud with the pigs" (Lyons, 2007). Subsequently, her lawyer, Mary Olive Pierson, revealed that LSU had no policy governing relationships between teachers and students and between coaches and athletes. Following her resignation, Chatman disappeared from the public eye.

Once likeable, now invisible

Only a handful of former and current players came to Chatman's defense in coverage, and when they did, their comments were presented in the same style as a eulogy—with praise for a coach whose fate had already been decided. A few players were quoted, such as All-American LSU center, Sylvia Fowles: "Pokey's always been a great person. . . . No matter what people say, I'm not going to look at her any different" (Associated Press, 2007b).

Ironically, one of the few colleagues who defended Chatman on the record had nothing to lose. Hall of Famer Sheryl Swoopes, retired but considered one of the best in the game had come out of the closet two years prior in a swirl of publicity, eulogized:

Pokey was a role model for a lot of young girls out there, a lot of women who are already head coaches. Whether it's true or not, I still think what she's done, her legacy will be left. She will definitely be missed, not just at LSU, but in the game of women's basketball. (Associated Press, 2007b)

In an *ESPN.com* online article shortly after Chatman's resignation and before the NCAA Tournament, coaches who were interviewed weren't named on the record (Merrill, 2007). One coach bluntly stated why some want to remain anonymous or do not want to discuss Chatman:

We've got a very significant gay element in our game. The reason people don't want to talk about it on the record is because it's not just about the player-coach relationship thing. It's about the gay thing, and that's too much for any of us who value our jobs and value our standing in the women's business. That's too much to have our names attached to. (Merrill, 2007)

As the story lost steam, an article in *The New York Times* following the NCAA Final Four quoted big-name coaches such as Auriemma and Summitt about the impact they thought the Chatman fall would ultimately have: it would fuel negative recruiting, inflame homophobia, scare parents, and reinforce stereotypes of lesbians as sexual predators (Longman, 2007).

And finally—it was in the narrative about Chatman's fall that at least one reporter included speculation about Chatman's off-the-court life. One story quoted a former teammate who "thought Chatman was dating a male chef in Baton Rouge at the time of her abrupt exit" (Merrill, 2007, para. 14–15):

Pokey was on the pink team [the pink team was described as women who date men] as far as we knew. We talked about guys and how fun they were. We would go out and party and have fun and dance with guys and have a great time.

Discussion and Conclusion

The coverage of Portland and Chatman was both strikingly similar and different in ways that ultimately hinged on perceptions of their sexual identities. As they rose, both were depicted as no-nonsense coaches who could thrive in challenging environments and as role models for women's sports. At the same time, they were framed differently: Portland's identity was constructed as tied to her status as wife and mother; Chatman's identity was tied to her history with the institution (LSU). Portland's identity protected her from the critical coverage she warranted early in her career; Chatman's identity failed to help her gain fair-minded, more complete coverage late in her college coaching career.

Neo-homophobia was manifest in narratives about both women in several key ways, but especially in what was *missing* or *concealed*. Missing from the narratives were critical coverage of Portland's discrimination early in her rise, and of a more comprehensive, "due-process" storyline and reporting around the dismissal of Chatman during her fall. Overwhelmingly, neoliberalist rationales were also used in coverage to explain the fall of both Portland and Chatman. For both, the fault was in the *individual* or, in the case of Portland, also in an individual university. The idea that both coaches made bad choices— independent of the environments in which they worked—is a convenient device for blame and makes for uncomplicated storytelling. Neo-homophobia was also manifest in narratives in what was *included* about the two women, *compared to what was missing or concealed*. During the rise and fall of Portland stories including her family and children were ample, while for Chatman family and personal relationships were virtually nonexistent. What was in-cluded and excluded permitted the simultaneous construction and denial of heterosexism and homophobia.

However, each case presented—for those who cared to see them—questions about the wider institution of sports. For instance, what was it about the *environment* in women's college sports that allowed Portland—a known homo-phobe for two decades at a top program—to survive and, indeed, to thrive? Conversely, what kind of system allowed another coach, whose sexuality was revealed by virtue of accusations about relationships with players, to go through arrest, trial, and sentencing in a matter of days—without protest?

Journalists did not ask these questions. Instead, they focused on personali-ties and diminished the issues behind the stories. In doing so, reporters re-duced the issues to a problem of an individual or an institution. Reporters also failed to address the injustices of two women's basketball programs as a result of ideologies at the very heart of institutionalized (intercollegiate) sports.

At face value, the Portland case may seem like the more obvious lesson in the ways neo-homophobia manifests in both positive and negative coverage; the fact that the journalistic establishment was complicit in her ability to abuse players over two decades is damning. But the Chatman case may be even more troubling for what it says about how much homophobia pervades the culture in women's intercollegiate sports. Why did the story of Chatman's reported transgressions flame and then die so quickly? Why did so few speak out on her behalf? A coach interviewed for the story put it plainly: What was taboo were the implications about Chatman's *sexuality*. For a source to speak out on Chatman's behalf or to raise questions about due process would have meant engaging in issues around sexuality and homophobia. For journalists, to cover the story in any kind of depth would have meant acknowledging the idea that

a high-level coach might be lesbian. Instead, Chatman's eulogy was written, she died by disappearing from the public eye—and we quickly moved on. Stereotypes about the lesbian "predator" in sports were not challenged but were instead, unfortunately, reinforced.

New narratives, more truthful stories

Neo-homophobia as a cultural practice is insidious because it allows the values, beliefs, and practices that marginalize sexual minorities to flourish. Neo-homophobia also serves as a device to obscure the truth about our cultural understandings of sexuality. Yet, truth-telling is a critical value for the journalistic establishment in a democracy. We hope that in examining the ways journalists tell the critical stories involving sports, gender, and power, we can encourage media producers to more critically, thoughtfully, and courageously approach such stories. Only in doing so will we definitively address enduring injustices that reinforce the "toxic atmosphere" (Cyphers & Fagan, 2011) that is homophobia in sports.

References

Anderson, S. (1994, February 13). Portland and PSU women's team have come a long way. *Pittsburgh Post-Gazette*, p. D5.

Associated Press. (2007a, March 25). Penn State's Portland makes 'difficult' decision to quit. *ESPN.com*. Retrieved from http://sports.espn.go.com/ncw/news/story?id=2808075

Associated Press. (2007b, May 4). Swoopes: Chatman effect will be difficult to quantify. *ESPN.com*. Retrieved from http://sports.espn.go.com/espn/print?id=2860786&type=story

Augoustinos, M., Tuffin, K., & Every, D. (2005). New racism, meritocracy and individualism: Constraining affirmative action in education. *Discourse & Society*, 16(3), 315–340. doi: 10.1177/0957926505051168

Baird, J. A. (2002). Playing it straight: An analysis of current legal protections to combat homophobia and sexual orientation discrimination in intercollegiate athletics. *Berkeley Women's Law Journal*, 17, 31–67.

Bandsuch, M. (2009). The NBA dress code and other fashion faux pas under Title VII. *Villanova Sports & Entertainment Law Journal*, 16(1), 1–48.

Baroffio-Bota, D., & Banet-Weiser, S. (2006). Women, team sports, and the WNBA: Playing like a girl. In A. A. Raney & J. Bryant (Eds.), *Handbook of sports and media* (pp. 485–500). Mahwah, NJ: Lawrence Erlbaum.

Benjamin, A. (2006, March 26). Campus reaction is tepid. *The Boston Globe*, p. D13.

Bernard, H. R., & Ryan, G. W. (2009). *Analyzing qualitative data: Systematic approaches*. Los Angeles, CA: Sage.

Brennan, C. (2006, April 20). Penn State didn't learn from Duke. *USA Today*, p. C2.

Burns-Ardolino, W. (2007). *Jiggle: (Re)shaping American women.* Lanham, MD: Lexington Books.

Confessore, N., & Barbaro, M. (2011, June 24). New York allows same-sex marriage, becoming largest state to pass law. *The New York Times.* Retrieved from http://www.nytimes.com/2011/06/25/nyregion/gay-marriage-approved-by-new-york-senate.html

Cyphers, L., & Fagan, K. (2011, January 26). On homophobia and recruiting. *ESPN.com.* Retreived from http://sports.espn.go.com/ncw/news/story?id=6060641

DeShazier, J. (2006, April 2). In good hands; Pokey Chatman and Gail Goestenkors have distinctly shaped their teams and gotten excellent results. *Times-Picayune* (New Orleans, LA), p. D19.

Ferber, A. (2007). The construction of Black masculinity: White supremacy now and then. *Journal of Sport & Social Issues, 31* (1), 11–24.

Gill, R. (2007). *Gender and the media.* Cambridge, UK: Polity Press.

Hardin, M., Kuehn, K., Jones, H., Genovese, J., & Balaji, M. (2009). 'Have you got game?' Hegemonic masculinity and neo-homophobia in U.S. newspaper sports columns. *Communication, Culture & Critique, 2*(2), 182–200.

Hays, G. (2006, April 19). Penn St. coach should be packing. *ESPN.com.* Retrieved from http://sports.espn.go.com/espn/page2/story?page=hays/060419.

Henderson, J. (1992, March 22). Portland no powder puff at Penn State. *The Denver Post*, p. 7B.

Hohler, B. (2006, March 26). When the fouls get very personal. *The Boston Globe*, p. D1.

Hubbard, S. (1991, November 26). Penn State's Portland fights for right. *The Pittsburgh Press*, p. C1.

Kalec, W. (2005, February 10). Uneasy rider; LSU's Pokey Chatman is off to the fastest start of any first-year women's basketball coach in the SEC, and she knows the road only gets tougher, starting tonight with No. 5 Tennessee. *Times-Picayune*, p. D1.

Klein, M. (2000, March 25). Sisters on their side: Penn State has a prayer—lots, in fact. *The Philadelphia Inquirer.* Retrieved from http://articles.philly.com/2000-03-25/news/25604667_1_nuns-sisters-penn-state

Lieber, J. (2006, May 26). Portland vigorously defends her integrity and Penn State program. *USA Today*, p. C3.

Longman, J. (1991, March 10). Lions women's basketball coach is used to fighting and winning: Rene Portland has strong views on women's rights, lesbian players and large margins of victory. *The Philadelphia Inquirer*, p. G1.

Longman, J. (2007, April 19). Chatman case raises mistrust during recruiting season. *The New York Times*, p. D1.

LSUSports.net. (2004, April 26). Gunter retires, Chatman named head coach. Retrieved from www.lsusports.net

LSUSports.net. (2005, July 7). Chatman receives new four-year contract. Retrieved from www.lsusports.net

Lyons, L. (2007, August 4). Chatman at home back on the court; Embattled ex-LSU coach resurfaces, says exit wasn't voluntary. *Times-Picayune* (New Orleans, LA), p. D1.

Mandell, N. (2011, May 23). Suns guard Steve Nash appears in video spot advocating for legalizing gay marriage in New York. *New York Daily News.* Retrieved from http://www.nydailynews.com/ny_local/2011/05/23/2011-05-23_suns_guard_steve_nash_appears_in_video_spot_advocating_for_legalizing_gay_marria.html, and http://

articles.nydailynews.com/2011-05-23/local/29595600_1_gay-marriage-lesbian-couples-gay-slurs

McGeachy, A. (2000, March 19). Coach gives care to her no. 1 fan: Penn State's Portland has a second job: Looking after her mother. *The Philadelphia Inquirer*. Retrieved from http://articles.philly.com/2000-03-19/sports/25604618_1_granny-state-coach-rene-portland-retirement-community/4

Merrill, E. (2007, March 31). Chatman mystery continues as LSU rolls into Cleveland. *ESPN.com*. Retrieved from http://sports.espn.go.com/ncw/ncaatourney07/news/story?id=2818123

National Public Radio. (NPR). (2006, April 2). Women's Final Four. *All Things Considered*. Retrieved from http://www.npr.org/series/ncaa-tournament/

Newhall, K., & Buzuvis, E. (2008). (e)Racing Jennifer Harris: Sexuality and race, law and discourse in *Harris v. Portland*. *Journal of Sport and Social Issues, 32*(4), 345-368.

Patrick, D. (1997, March 10). Women's game owes a lot to Immaculata power of early 70s. *USA Today*, p. 12E.

Patrick, D. (2005, March 18). Rookie coach wears legends mantle. *USA Today*, p. C1.

Pokey Chatman bio. (2007, May 16). Retrieved from http://www.lsusports.net/ViewArticle.dbml?DB_OEM_ID=5200&ATCLID=174129

Pokey Chatman bio. (2011). Retrieved from http://www.wnba.com/coachfile/pokey_chatman/index.html

Potter, W. J. (1996). *An analysis of thinking and research about qualitative methods*. Mahwah, NJ: Lawrence Erlbaum.

Rene Portland biography. (2007). *GoPSUSports.com*. Retrieved from http://www.gopsusports.com/sports/w-baskbl/mtt/portland_rene00.html.

Rene Portland's 'hectic life' leads to Final Four. (2000, March 1). *Hays Daily News*. Retrieved from http://haysdailynews.newspaperarchive.com/Default.aspx

Rene Portland resigns as Penn State women's basketball coach [Press release]. (2007, March 22). Retrieved from http://live.psu.edu/story/23062.

Sage, G. H. (2000). Racial inequality and sport. In D. S. Eitzen (Ed.), *Sport in contemporary society: An anthology* (6th ed., pp. 275-291. New York, NY: Macmillan.

Varney, J., & Kleinpeter, J. (2007, March 9). Chatman to leave LSU immediately. *Times-Picayune* (New Orleans, LA). Retrieved from http://web.lexis-nexis.com/universe

Voepel, M. (2000, March 28). Long wait ends for Penn State's coach. *The Kansas City Star*, p. C1.

Voepel, M. (2005, December 9). Presenting facts . . . still seeking answers. *ESPN.com*. Retrieved from http://sports.espn.go.com/ncw/columns/story?columnist=voepel_mechelle&id=2253956

Voepel, M. (2006, April 18). Step in right direction, but so much further to go. *ESPN.com*. Retrieved from http://sports.espn.go.com/ncw/columns/story?columnist=voepel_mechelle&id=2413326

Voepel, M. (2007a, February 6). Penn State settlement leaves unsettling feeling. *ESPN.com*. Retreived from http://sports.espn.go.com/ncw/columns/story?columnist=voepel_mechelle&id=2755832.

Voepel, M. (2007b, March 9.) LSU bungles Chatman saga. *ESPN.com*. Retrieved from http://sports.espn.go.com/ncw/columns/story?columnist=voepel_mechelle&id=2792714

Voepel, M. (2007c, March 22). Resignation should spark time of healing for PSU. *ESPN. com*. Retrieved from http://sports.espn.go.com/ncw/columns/story?columnist=voepel_mechelle&id=2808469

Coaches Gone Wild: Media, Masculinity, and Morality in Big-Time College Football

Michael L. Butterworth

To me, the coaching profession is one of the noblest and most far-reaching in building manhood. . . . To be fair-minded . . . to deal justly . . . to be honest in thinking and square in dealing . . . not to bear personal malice or to harbor hatred against rivals . . . to be the sportsman and gentleman at all times . . . these should be the ideals of the coach. (Amos Alonzo Stagg, as cited in Telander, 1996, p. 81)

Few figures in sports are as idealized as the coach. Coaches are celebrated in American culture as consummate leaders, molders of men, and models of success. Especially in college sports, they are granted a degree of authority that can be described as a hybrid of father figure and chief executive officer. Sports media feed off of coaching vernacular for catchy quotations, hire old coaches as expert analysts, and promote an economy of high-priced contracts, shoe deals, and books. A quick review of the volumes "authored" by college football coaches, for example, might suggest that coaches are uniquely gifted in the arts of athletics, business, parenting, politics, and religion. Titles commonly invoke terms such as "champion," "game of life," and "winning" (Bowden & Schlabach, 2010; Carroll, Roth, & Garin, 2010; Holtz, 1998; Saban & Curtis, 2005; Tressel & Fabry, 2008). The book publishing industry alone would appear to confirm that our best hope for shaping the young leaders of tomorrow is to entrust them to the ever-virtuous fraternity of football coaches.

Justified by their location in institutions of higher learning, college football coaches are given great latitude, presumably because "athletic competition fosters learning for life, training for leadership, the ability to work in teams, competitiveness, self-control, and discipline" (Shulman & Bowen, 2001, p. 3). Nevertheless, the coaches whose books I have cited above—Bobby Bowden, Pete Carroll, Lou Holtz, Nick Saban, and Jim Tressel—have all, in spite of their purported moral superiority and documented success on the field, been accused or found guilty of violating National Collegiate Athletic Association

(NCAA) rules or the guidelines of their respective universities. Thus, these coaches reveal a paradox that is increasingly common in contemporary sports: created by the sports media as objects of admiration when they succeed, these individuals are subsequently marked as objects of condemnation when they succumb to scandal. Rather than see such narratives merely as products of a fickle mass media marketplace, we would be wise to consider the cultural tendencies revealed by sports media coverage. In Whannel's (2002) words, "as the intensity of media coverage of sport has increased, and as the sporting star system has become central to the media sports industry, the images of sport stars become the point of convergence of social anxieties over morality and masculinity" (p. 1). Although Whannel's focus is on celebrity athletes, similar anxieties are in play when the behavior of celebrity coaches appears to exceed the normal boundaries of vigorous masculine leadership.

In late 2009, three head coaches—Mark Mangino at the University of Kansas, Mike Leach at Texas Tech University, and Jim Leavitt at the University of South Florida—were all terminated for behavior toward players deemed to be either emotionally or physically abusive. Mangino faced numerous allegations of verbally berating his players, especially by mocking the culture and identity of African American players. Leach allegedly ordered one of his players—Adam James, a reserve player whose father, Craig James, was a star running back at Southern Methodist University in the 1980s—to be locked in an electrical closet during practice. And Leavitt was charged with having slapped a player during halftime of a game, presumably as a means of motivating his team after a lackluster first half of play.

Reflecting on the fates of these coaches, sportswriter Erik Brady (2010) lamented, "Once upon a time, coaches were respected and revered as pillars of their communities. The best of them sported images as never-flinching captains of their ships—flinty-eyed eminences who were tough but fair. You could trust your kids with them" (para. 1). Brady's sentiments were shared widely across the sports media, many of which were surprised to see that their celebrated paragons of virtue and leadership were evidently abusing their authority as coaches. As I argue in this chapter, however, Mangino, Leach, and Leavitt should not be viewed as unusual; rather, they are the logical products of a college football culture that has been built upon, and continues to valorize, a mythology of white masculine leadership.

More than simply a product of tough practices and motivational speeches, this mythology is also a product of persistent practices in sports media that capitalize both on the celebration of masculine authority and the vilification of those who fail to observe the limits of such authority. To make sense of this paradox, I begin with a discussion of hegemonic masculinity as a theoretical

concept, giving specific attention to the coach as an expression of "the cultur-ally idealized form of masculine character" (Connell, 1990, p. 83). Next, I examine how mainstream sports media constructed Mangino, Leach, and Leavitt as exemplars of hegemonic masculinity and assess the same media's inability to acknowledge their own complicity in each coach's downfall. I conclude, then, with some critical observations about hegemonic masculinity and American sports media.

Hegemonic Masculinity and the Valorization of Coaches

The mythology embodied by college football coaches can be appropriately theorized in terms of hegemonic masculinity. Connell (1987) developed this concept as a way to critique the dominant constructions of gender that constrain heterosexual men and subordinate women and gay men. Men who conform to the standards of hegemonic masculinity demonstrate strength, power, and control; meanwhile, those who do not embrace these characteristics risk being marginalized in society. While media scholars have attended to hegemonic masculinity in popular media such as film and television (Atkinson & Calafell, 2009; Hanke, 1990, 1998; Vavrus, 2002); Connell (1987) argued that "images of ideal masculinity are constructed and promoted most systematically through competitive sport" (pp. 84–85). Building on Connell's foundation, Trujillo's (1991) study of baseball pitcher Nolan Ryan outlines the principal features of hegemonic masculinity, especially as they are constituted in and by media portrayals of sports: "(1) physical force and control, (2) occupational achievement, (3) familial patriarchy, (4) frontiersmanship, and (5) heterosexuality" (p. 291).

In addition to these characteristics, hegemonic masculinity also implies an ideal of *whiteness*. Communication and media scholars increasingly have recognized the influence of white identity, including in sports (Butterworth, 2007; Grano & Zagacki, 2011; Griffin & Calafell, 2011; McDonald, 2010). As I have argued elsewhere, analyses of media coverage of events such as the 1998 home run race between Mark McGwire and Sammy Sosa reveal "the extent to which whiteness is a taken-for-granted norm in discussions about race and how sports media produce and perpetuate a discourse that privileges white-ness" (Butterworth, 2007, p. 229). In their critique of National Basketball Association (NBA) Commissioner David Stern's unilateral decision to impose a dress code on his league's players, Griffin and Calafell (2011) contended that Stern defaulted to underlying norms that privilege conventions of white culture. Although Stern justified his actions based on the need to appease

corporate sponsors and impose order over the game, the dress code can be understood as "symbolic of the desire to control and dilute the expression of blackness according to white norms" (Griffin & Calafell, 2011, p. 128).

Much as a commissioner may exercise control over the players in his league, a head coach exercises control over his players. Indeed, football coaches routinely demonstrate the characteristics of hegemonic masculinity through their behavior on the sidelines during games, communication with media, and, perhaps most importantly, in their relationships with the players themselves. Both college and professional football history are replete with stories of coaches who push their players to emotional and physical limits, all in the name of building "character," "discipline," and "teamwork." Perhaps most representative of this mythology is Paul "Bear" Bryant, best known as the long-time coach at the University of Alabama. Before moving on to Tuscaloosa, however, Bryant was the head coach at Texas A&M, where he is described in the book, *The Junction Boys*, as subjecting his players to temperatures of over 100 degrees, depriving them of water, ignoring injuries, and physically attacking selected individuals. Despite grueling practices, one former player is grateful to his coach for teaching him "character" and praises Bryant as his "hero" (Dent, 1999, p. xi).

Bryant represents a pervasive image in college football mythology. Although the extreme physical tests he forced his players to endure are no longer the norm, the degree of authority and discipline embedded in those tests remains. In fact, as Whannel (2002) contended, the commonly held belief that contemporary culture is too often characterized by moral relativism and a decline in authority yields sports media narratives that seek "figures who will epitomize moral correctness" (p. 5). Yet sportswriter and former Northwestern University player Rick Telander questions our culture's admiration for these models of leadership. As he wrote:

> Far from socializing players, coaches all too often shape them into young men with warped perspectives on obedience, morality, and competition who are often unable to function appropriately in the real world—that is, any world without football at its epicenter—until they learn new methods of behavior and thought. (Telander, 1996, p. 86)

He goes so far as to suggest that coaches willingly manipulate their players and that they "have become experts at brainwashing, at keeping their players up in the air, subservient, thankful for the simplest of rewards" (p. 90).

The degree of influence coaches have over players raises serious ethical questions. If coaches are supposed to embody hegemonic masculinity—and motivate their players to achieve the same standard—then what lines are there to demarcate the difference between intensity and insanity? When Ohio State

University coach Woody Hayes punched an opposing player during a 1978 bowl game, his aggression was almost universally interpreted as excessive. Yet when Oklahoma State University coach Mike Gundy berated a sportswriter in 2007 by hollering, "I'm a man!" he became an Internet sensation and was defended by many who saw his tirade as evidence of support for his players. Of course, Gundy's explosion made for good television, and it thus serves as a reminder that sports media often find boorish behavior acceptable so long as it is entertaining. The lines between authority and deference, and entertainment and abuse are further blurred by stark racial divisions present in college football. According to the most recent Institute for Diversity and Ethics in Sport Racial and Gender Report Card (Lapchick, Hoff, & Kaiser, 2010), over 45% of Division I football players are African American. Meanwhile, just over 5% of head coaches are African American. Thus, the combination of college football mythology, cultural norms of hegemonic masculinity, and the underlying privileging of whiteness, all of which are filtered through the lens of mainstream sports media, inevitably lead to the kinds of controversies that were associated with Mark Mangino, Mike Leach, and Jim Leavitt.

Three Coaches on the Rise

Upon initial review, it might appear that apart from being college football coaches, there is little that Mark Mangino, Mike Leach, and Jim Leavitt have in common. Leach, in particular, has a well-established reputation among sports media as an eccentric. As his own agent has said of him, "He's so different from every other football coach it's hard to understand how he's a coach" (Lewis, 2005, p. 3, para. 1). ESPN's Mark Schlabach (2008) noted that Leach's interests in pirates, art, and other non-football subjects distinguish him from his fellow coaches, and that his reluctance to devote his entire life to coaching means he "isn't like most of his colleagues in a profession dominated by millionaires and workaholics" (para. 10). He was also a contrarian as a coach, and his innovations in the spread offense made Texas Tech an exciting and suddenly competitive program. Historically, Texas Tech has enjoyed modest success in football. Under Leach, the team reached a postseason bowl game in nine of his 10 seasons and finished in the final season Top 25 rankings in five of his final six seasons. When the Red Raiders stunned the top-ranked Texas Longhorns in 2008 en route to an 11–1 regular season, it was easy to see why Leach had become one of the rising stars in college football. He was unconventional, quotable, and individualistic, and his wide-

open offensive philosophy made him an ideal cowboy figure in the Old West landscape of Lubbock, Texas.

Mark Mangino and Mike Leach coached together, in 1999, as part of Bob Stoops's staff at the University of Oklahoma. In 2002, Mangino became the head coach at the University of Kansas, a school much better known in sporting circles for its success in men's basketball. In the late decades of the twentieth century, Kansas often struggled in football, a fact that made Mangino's success that much more notable. He was able to lead the team to postseason bowl appearances in two of his first four seasons and, in 2007, the Jayhawks finished the regular season 11–1. Mangino won several national coach-of-the-year awards, and Kansas completed the season with an Orange Bowl victory over Virginia Tech. While Leach received recognition for lecturing his players about pirates (Lewis, 2005), Mangino was praised for developing a "character-building program" that included community service activities and an emphasis on preparing student-athletes for nonathletic careers (Mitchell, 2004, para. 9). Thus, consistent with college football mythology, Mangino was a success not only because he was building a winning program on the field but because he was developing young men of character off of it.

Prior to joining the coaching staff at Oklahoma, Mangino was an assistant at Kansas State University. Also on that staff was Jim Leavitt, who left to become the head coach of the University of South Florida in 1996, one year before the program's debut season. From 1997 to 2009, Leavitt was the only coach South Florida had known, thus making his achievements perhaps the most remarkable of these three coaches. In twelve years, Leavitt took the Bulls from Division I-AA (now Football Championship Subdivision), to Conference USA in Division I-A (now Football Bowl Subdivision), to the Big East, one of only six automatic qualifying conferences for the Bowl Championship Series. In 2007, South Florida was ranked as high as second in the nation, before finishing with a 9–3 record. Like his counterparts at Texas Tech and Kansas, then, Leavitt was credited with taking a team with a low profile—or, in this case, *no* profile—and turning it into a winning program. He did so, moreover, by notoriously wearing his emotions on his sleeve. As his former boss at Kansas State, Bill Snyder, said of him, "He's wired different than most people, like he's walking around with his finger in a light socket" (Auman, 2006, para. 11). Leavitt himself acknowledged that Snyder, who turned Kansas State from a perennial loser to an annual contender in the 1990s, inspired his all-encompassing approach at South Florida. "[Snyder's] whole world was that program," said Leavitt. "That's why I'm so emotional about this; it's my whole life. I want this program to be established" (Auman, 2006, para. 8–9).

Although different in personality and circumstance, Leach, Mangino, and Leavitt shared certain characteristics that made them ideal success stories within the mythic logic of sports. In particular, they were models of white, masculine authority, whose character and leadership enabled them to transform previously irrelevant programs into viable, national powers. This narrative was especially appealing to sports media outlets eager to spotlight successful models of leadership in an era of declining authority and discipline (Whannel, 2002). It also so neatly articulates with the broad myth of the American Dream that the rise of these coaches seems to be a Hollywood invention. Yet the individualistic, work-hard-and-you-will-succeed ethos of these coaching stories is commonplace in the world of sports. As Nixon (1984) summarized, "Sport is an appropriate vehicle for testing the ideology of the American Dream because the legitimizing beliefs of the sports institution mirror basic tenets of the American Dream. The American Dream conjures up images of 'rags to riches' success stories, of self-made men, and of virtuous achievement by sweat and hard work being duly rewarded" (p. 25). Indeed, the control, success, and individualism demonstrated by these coaches made them sports media celebrities and also appeared to validate the mediated construction of hegemonic masculinity. So much so, in fact, that the latest treatise espousing the virtues of coaching as a model for life comes from none other than Mike Leach (Leach, 2011), whose book, *Swing Your Sword: Leading the Charge in Football and Life*, was published in July of 2011.

Three Coaches Gone Wild

Given their collective success, it is surprising that Mangino, Leach, and Leavitt all lost their jobs within five weeks of one another. On December 3, 2009, Mangino resigned from the University of Kansas and accepted a $3 million settlement after a university investigation into allegations from former players who had "described insensitive, humiliating remarks they claim he made to them during games or practice, often in front of others" (Berkowitz & Carey, 2009, para. 4). Because of the settlement, the details of the university's investigation will not be released. However, several former players publicly commented on the allegations by suggesting that Mangino had a history of being verbally abusive. ESPN's Joe Schad reported a range of comments, including those that detailed Mangino's propensity to use personal information to embarrass players in front of their teammates. One player, whose father struggled with alcoholism, was admonished, "Are you going to be a lawyer or do you want to become an alcoholic like your dad?" (Schad, 2009,

para. 8). Another reported that the coach was prone to "run up to a player and push a player" (Schad, 2009, para. 12). These motivational tactics, of course, seem relatively consistent with the mythic image of the coach, and not surprisingly, there were some who felt the players' complaints were misguided. One sportswriter sardonically quipped, "[Mangino] was forced to resign because he—and this is hard to even type—said 'hurtful' things to, like, linebackers" (Tucker, 2010, para. 4). Mangino also received support from his fellow coach, Mike Leach, who concluded that "Nobody truly knows what went on in Kansas. But my suspicion is Mark's in the middle of a witch hunt, which is unjustified" (Townsend, 2009, para. 6).

If based only on the two comments cited above, perhaps Leach's defense would be plausible. But what is especially troubling about the allegations against Mangino is the extent to which the coach apparently used his authority as a figure of *white* masculinity in particular to control his African American athletes. Several players noted their coach's threats to send them back to their "homies" or "hood" if they were not more disciplined. One player in particular, whose younger brother had been shot in the arm, was told after dropping a pass, "If you don't shut up, I'm going to send you back to St. Louis so you can get shot with your homies" (Schad, 2009, para. 6). Very quickly after these allegations were made, the university launched the investigation that led to Mangino's resignation and the $3 million settlement. Despite what appears to be damning evidence, Mangino defended his behavior. In an interview with Sports Radio 610 in Kansas City, he explained:

> We are sending kids out into the world prepared. But I can't do the work of some parents, what they should have done before [the players] got to me. Some of these guys are bitter, they are bitter and [the allegations] are about that. There are some things that happen for 18 years of their lives that I can't change in four years of college. Can't do it. Can't change their behaviors, can't change their attitudes. ("Mangino Defends," 2009, para. 3-4)

These words reflect the deeply held belief that coaches are teachers, mentors, and even father figures. Yet, Mangino's comments display surprisingly little empathy for his players, many of whom do come from disadvantaged backgrounds. By using language that pathologizes the "hood," and making statements that show contempt for African American culture, Mangino indeed crosses the line between discipline and abuse.

Leavitt's demise at South Florida unfolded in similar ways to the fall of Mangino. *AOL Fanhouse.com* originally reported that at halftime of a November 2009 game against conference rival Louisville, Leavitt entered the locker room and, in a fit of motivational frenzy, grabbed reserve player Joel Miller by the neck and twice struck him in the face. After the story broke, Miller denied

that his coach had hit him, insisting that he had merely grabbed the player by the shoulders. "I don't think anything should happen to him," he said. "Me and Coach Leavitt are fine. People can say different things, but he only grabbed my shoulder pads to motivate me because he's a passionate guy" (Auman, 2009, para. 3). Miller's defense of Leavitt recalls Telander's concerns about the influence coaches have over their players. As he explained, "A football player's sense of achievement, manhood, and self-esteem are so closely bound up in his on-field performance and acceptance by the coach that he will do almost anything to get the coach's approval, including injuring himself or others if the coach so desires" (Telander, 1996, p. 117).

Was Joel Miller lying in order to protect the coach he wished to please? As in Mangino's case, Leavitt reached an agreement with South Florida resulting in a $2.75 million settlement but preventing any public disclosure of the university's findings during its investigation of the Louisville incident. According to the official statement, the nondisclosure condition should not be "construed as an admission by USF or Leavitt of any liability, wrongdoing or unlawful conduct whatsoever" (Auman, 2011, para. 13). Nevertheless, after making the initial denial, Miller later acknowledged that he had "covered it up" to protect his coach. He continued,

> Playing football, growing up, you're taught that your head football coach is like a father figure. . . . When he came over to me that day and grabbed me and hit me . . . I wasn't going to lash out at my head football coach. You just don't do that as a player. (Brady, 2010, para. 18)

Meanwhile, local sports media covering Leavitt during his tenure seemed unsurprised by the allegations in the first place. As John Romano (2009) of the *St. Petersburg Times* summarized, "If you've ever seen Leavitt act like a madman on the sideline, it would not be a stretch to imagine him losing control in a locker room. On the very night of this accusation, Leavitt bloodied his face by headbutting a player who was wearing a helmet" (para. 14). Suddenly, the very traits that made Leavitt a model of hegemonic masculinity now revealed him to be "a little unhinged" (Romano, 2009, para. 15).

If Leavitt was ultimately undone by the very thing that had made him so admired up until 2009, then Mike Leach perhaps revealed himself to be much more like conventional coaches than many had believed. Hegemonic masculinity insists on control, and Leach's reactions to the controversy that cost him his job suggest how important this was to him. The circumstances surrounding Leach remain entangled in the courts, but the basic elements of the story were widely reported. The Texas Tech coach was accused of having one of his players, Adam James, isolated in an electrical closet—also reported as an

equipment shed—when James was unable to practice because he had sustained a concussion. James's father, former star running back, Craig James, became an outspoken critic of Leach, and both sides accused the other of serious character flaws. In the end, Texas Tech officials fired Leach on December 30, 2009, stating, "His contemporaneous statements make it clear that the coach's actions against the player were meant to demean, humiliate and punish the player rather than to serve the team's best interest. This action, along with his continuous acts of insubordination, resulted in irreconcilable differences that make it impossible for Coach Leach to remain at Texas Tech" (Evans & Thamel, 2009, para. 3).

Numerous reports suggest that Leach had a tenuous relationship with the Texas Tech administration and that the James incident provided the necessary justification to fire him. This may well be the case, but it is all the more troubling given the university's support for men's basketball coach, Bob Knight, whose infamous temper led to his controversial termination from Indiana University in 2002 (Weiss, 2010). Knight, of course, commonly displayed many of the same characteristics of hegemonic masculinity that are associated with football coaches: authority, control, and discipline. That Leach was also invested in these traits is evidenced by his reaction to the situation involving Mark Mangino. As he said of the players accusing Mangino of emotional abuse, "Heaven forbid somebody should ask the guys to pay attention and focus in and, for the sake of all his teammates and coaches and everybody else, pay attention. Well, there's different ways to ask a guy to do that, and sometimes after you've asked him a number of times you raise the bar" (Townsend, 2009, para. 25).

The simultaneous development of these three stories prompted numerous conversations about the culture of college football. Shortly after each coach had been fired, many coaches gathered in Orlando at the annual American Football Coaches Convention. Outgoing president of the group, Dick Tomey, concluded, "I don't think you can paint everybody with the same brush. . . . Those incidents are isolated" (O'Toole, 2010, para. 11). Sportswriters, however, sensed a potential culture change. Jonsson (2010), for example, noted, "The rapid-fire ousters of some of college football's most winning coaches have made college athletics the latest bellwether over the direction of American sports culture" (para. 1). Townsend (2009) pointed out that "players and players' parents are far less tolerant of what once were accepted motivational or disciplinary coaching tactics" (para. 22). Meanwhile, Montgomery (2010) simply declared the firings a product of "cultural progress" (para. 7). If, indeed, the decisions to fire Mangino, Leavitt, and Leach were indicative of a cultural shift in college football, then perhaps there is an opportunity to

reconsider the standards of hegemonic masculinity. Before we conclude that the coach-as-disciplinarian has been relegated to the past, however, it is worth reflecting on the common cycles that characterize sports media coverage of controversy.

Conclusion:
Hegemonic Masculinity and Sports Media Ritual

Although academic studies of sports and sports media have demonstrated the pervasiveness of hegemonic masculinity, it is important to recognize that what counts as hegemonic masculinity has the potential to change over time. Miller (2001), for example, pointed out that the growing efforts to market male athletes as figures of beauty—David Beckham, Tom Brady, etc.—"has destabilized the hegemonic masculinity thesis" (p. 52). Nevertheless, it is evident that the standards of hegemonic masculinity remain deeply embedded in mainstream sports coverage, especially given sports media's propensity to cultivate mythologies of heroism, leadership, and masculinity (Butterworth, 2007; Chidester, 2009; Hardin, Kuehn, Jones, Genovese, & Balaji, 2009). Given such tendencies, it is important to spotlight the ritualistic nature of these narratives. As Olsen (2003) pointed out, sports media often place a disproportionate emphasis on creating "characters" and exploiting moments of drama. In the cases of Mike Leach, Jim Leavitt, and Mark Mangino, it is clear that writers and commentators were eager to promote these coaches as exemplars of rugged individualism, fierce competitiveness, and moral courage. Especially because these coaches ran successful programs, behaviors that might have been questionable were instead reflections of men who excelled at being a "maverick" or showing "intensity." With the support of fan bases delighted with on-field success and sports media portrayals that made them celebrities and exalted them as superior leaders, is it any wonder that Leach, Leavitt, and Mangino would consider themselves definitive figures of authority?

To suggest that sports media coverage cultivated hegemonic masculinity and *enabled* the poor behavior of these coaches is not to suggest that sports media *caused* this behavior. Rather, it is to suggest that media images and representations serve as important rhetorical devices in a culture that places a high value on sports. In other words, the way terms such as "authority," "discipline," and "leadership" are discussed in sports media have a significant impact on our broader understanding of those terms. Why else would so many coaches, especially in football, be expected to author book after book instructing the rest of us about winning in the "game of life?" This analysis of hege-

monic masculinity in the coverage of Leach, Leavitt, and Mangino, therefore, is a reminder that sports media exercise tremendous influence over our images of heroism and leadership in contemporary celebrity culture.

As invested as sports media were in the promotion of Leach, Leavitt, and Mangino, they were also quick to chastise them for inappropriate behavior. In this way, the real arbiters of moral authority in sports appear to be the columnists and talk show hosts who quickly decried the antics of those celebrity coaches they once praised. This propensity provides some closure to the ritual, allowing members of the sports media to distance themselves from the figures of their own construction. However, even those columnists who suggest that college football culture is changing fail to acknowledge their own complicity in that culture. Thus, so long as sports media make celebrities of college football coaches and subscribe to the mythology that these men are unique vessels of moral authority, the next rise-and-fall ritual is likely just a matter of time.

References

Atkinson, J., & Calafell, B. (2009). Darth Vader made me do it! Anakin Skywalker's avoidance of responsibility and the gray areas of hegemonic masculinity in the *Star Wars* universe. *Communication, Culture & Critique, 2*(1), 1–20.

Auman, G. (2006, September 23). Today, Leavitt's past looms in distance. *St. Petersburg Times.* Retrieved from http://www.sptimes.com/2006/09/23/Sports/Today__Leavitt_s_past. shtml

Auman, G. (2009, December 17). Player: Leavitt didn't hit me. *St. Petersburg Times.* Retrieved from http://web.lexis-nexis.com/universe

Auman, G. (2011, January 12). Leavitt, USF cut a deal. *St. Petersburg Times.* Retrieved from http://web.lexis-nexis.com/universe

Berkowitz, S., & Carey, J. (2009, December 17). Mangino gets $3 million settlement. *USA Today.* Retrieved from http://web.lexis-nexis.com/universe

Bowden, B., & Schlabach, M. (2010). *Called to coach: Reflections on life, faith, and football.* New York, NY: Howard Books.

Brady, E. (2010, January 20). College discredits adding up: Misconduct, mercenaries put coaching in dim light. *USA Today.* Retrieved from http://web.lexis-nexis.com/universe

Butterworth, M. L. (2007). Race in 'the race': Mark McGwire, Sammy Sosa, and heroic constructions of whiteness. *Critical Studies in Media Communication, 24*(3), 228–244.

Carroll, P., Roth, Y., & Garin, K. (2010). *Win forever: Live, work, and play like a champion.* New York, NY: Portfolio.

Chidester, P. J. (2009). 'The toy store of life': Myth, sport and the mediated reconstruction of the American hero in the shadow of the September 11th terrorist attacks. *Southern Communication Journal, 74*(4), 352–372.

Connell, R. W. (1987). *Gender and power: Society, the person, and sexual politics.* Stanford, CA: Stanford University Press.

Connell, R. W. (1990). An iron man: The body and some contradictions of hegemonic masculinity. In M. A. Messner & D. F. Sabo (Eds.), *Sport, men, and the gender order: Critical feminist perspectives* (pp. 83–95). Champaign, IL: Human Kinetics.

Dent, J. (1999). *The junction boys: How 10 days in hell with Bear Bryant forged a champion team at Texas A&M.* New York, NY: Thomas Dunne Books.

Evans, T., & Thamel, P. (2009, December 31). *New York Times.* Retrieved from http://lexis-nexis.com/universe

Grano, D. A., & Zagacki, K. S. (2011). Cleansing the superdome: The paradox of purity and post-Katrina guilt. *Quarterly Journal of Speech, 97*(2), 201–223.

Griffin, R. A., & Calafell, B. M. (2011). Control, discipline, and punish: Black masculinity and (in)visible whiteness in the NBA. In M. G. Lacy & K. A. Ono (Eds.), *Critical rhetorics of race* (pp. 117–136). New York, NY: New York University Press.

Hanke, R. (1990). Hegemonic masculinity in *Thirtysomething. Critical Studies in Mass Communication, 7*(3), 231–248.

Hanke, R. (1998). The 'mock-macho' situation comedy: Hegemonic masculinity and its reiteration. *Western Journal of Communication, 62*(1), 74–93.

Hardin, M., Kuehn, K. M., Jones, H., Genovese, J., & Balaji, M. (2009). 'Have you got game?' Hegemonic masculinity and neo-homophobia in U.S. newspaper sports columns. *Communication, Culture & Critique, 2*(2), 182–200.

Holtz, L. (1998). *Winning every day: The game plan for success.* New York, NY: HarperCollins.

Jonsson, P. (2010, January 8). Jim Leavitt fired: Is the era of the coach-king over? *Christian Science Monitor.* Retrieved from http://web.lexis-nexis.com/universe

Lapchick, R., Hoff, B., & Kaiser, C. (2010). The 2010 racial and gender report card: College sport. The Institute for Diversity and Ethics in Sport. Retrieved from http://www.bus.ucf.edu/documents/sport/2010-college-rgrc.pdf

Leach, M. (2011). *Swing your sword: Leading the charge in football and life* (B. Feldman & S. Mahoney, Eds.). New York, NY: Diversion.

Lewis, M. (2005, December 4). Coach Leach goes deep, very deep. *The New York Times Magazine.* Retrieved from http://www.nytimes.com/2005/12/04/magazine/04coach.html?pagewanted=3

Mangino defends his tactics, program (2009, November 20). *ESPN.com.* Retrieved from http://sports.espn.go.com/ncf/news/story?id=4672600

McDonald, M. G. (2010). The Whiteness of sport media/scholarship. In H. L. Hundley & A. C. Billings (Eds.), *Examining identity in sports media* (pp. 153–172). Thousand Oaks, CA: Sage.

Miller, T. (2001). *Sportsex.* Philadelphia, PA: Temple University Press.

Mitchell, D. (2004, February 24). Mangino stresses character among football players. *LJWorld.com.* Retrieved from http://www2.ljworld.com/news/2004/feb/24/mangino_stresses_character/

Montgomery, B. (2010, January 13). Football now faces a changing culture. *St. Petersburg Times.* Retrieved from http://web.lexis-nexis.com/universe

Nixon, H. L. (1984). *Sport and the American dream.* New York, NY: Leisure Press.

Olsen, R. (2003). Fifty-eight American dreams: The NBA draft as mediated ritual. In R. S. Brown & D. J. O'Rourke (Eds.), *Case studies in sport communication* (pp. 171–200). Westport, CT: Praeger.

O'Toole, T. (2010, January 14). BCS coaches' year of living dangerously. *USA Today*. Retrieved from http://web.lexis-nexis.com/universe

Romano, J. (2009, December 15). Fiery coach can learn from cautionary tale. *St. Petersburg Times*. Retrieved from http://web.lexis-nexis.com/universe

Saban, N., & Curtis, B. (2005). *How good do you want to be? A champion's tips on how to lead and succeed at work and in life*. New York, NY: Ballantine Books.

Schad, J. (2009, November 20). Ex-players: Coach said 'hurtful' things. *ESPN.com*. Retrieved from http://sports.espn.go.com/ncf/news/story?id=4669621

Schlabach, M. (2008, May 7). Eccentric Leach ready to lead Red Raiders to ultimate treasure. *ESPN.com*. Retrieved from http://sports.espn.go.com/ncf/columns/story?columnist=schlabach_mark&id=3385098

Shulman, J. L., & Bowen, W. G. (2001). *The game of life: College sports and educational values*. Princeton, NJ: Princeton University Press.

Telander, R. (1996). *The hundred yard lie: The corruption of college football and what we can do to stop it*. Urbana, IL: University of Illinois Press.

Townsend, B. (2009, December 31). Zero tolerance for tough coaches. *Dallas Morning News*. Retrieved from http://web.lexis-nexis.com/universe

Tressel, J., & Fabry, C. (2008). *The winners manual: For the game of life*. Carol Stream, IL: Tyndale.

Trujillo, N. (1991). Hegemonic masculinity on the mound: Media representations of Nolan Ryan and American sports culture. *Critical Studies in Media Communication, 8*(3), 290–308.

Tucker, N. (2010, January 1). For crying out loud, what's with college football? *The Washington Post*. Retrieved from http://web.lexis-nexis.com/universe

Vavrus, M. D. (2002). Domesticating patriarchy: Hegemonic masculinity and television's 'Mr. Mom.' *Critical Studies in Media Communication, 19*, 352–375.

Weiss, D. (2010, January 3). NCAA looking for kinder, gentler head coaches. *New York Daily News*. Retrieved from http://web.lexis-nexis.com/universe

Whannel, G. (2002). *Media sport stars: Masculinities and moralities*. London, UK: Routledge.

Faking It: Dean Richards, Rugby Union, and Harlequins at the Bloodgate

Kevin Young
Michael Atkinson

In 2009, an incident occurred in British rugby union that would tarnish the public image of a player, a coach, and the sport. Dubbed *Bloodgate* by media pundits, the scandal symbolized how on-field cheating had become institutionalized not only in rugby but in elite sport all over the world. This chapter uses British media reports to understand how Bloodgate could have occurred, was discursively framed, and was reacted to by those involved and others watching the scandal unfold. Using figurational notions of the *civilizing process* and the *master emotion of shame* (Elias, 1978; Kilminster, 2007), the chapter demonstrates how the media identified the main culprit in the Bloodgate scandal as being the ethos of modern professional rugby rather than any specific individual per se. It also considers the historical shift in the value structures and emphases of rugby union towards a cultural form conducive to institutionalized cheating and corruption.

Bloodgate: Anatomy of a Rugby Scandal

On April 12, 2009, at rugby union's Heineken Cup quarter-final involving Harlequins (of London, England) and Leinster (of Ireland), Harlequins' player, Tom Williams, appeared to sustain an injury as blood gushed from his mouth with just minutes remaining in the game. The incident permitted Harlequins to make a "blood substitution," allowing Nick Evans to come on to the field. At this point of the game, Harlequins would normally not be allowed to make a player replacement; a "blood substitution" was the only possible means of getting Evans (a recognized kicker and potential game-winner) onto the field. After TV cameras captured Williams coyly winking at his teammates as he left the field

with an improbable stream of blood pouring from his mouth, the officials of European Club Rugby (ERC) announced several days later that they would investigate the incident.

On July 2, 2009, both Harlequins and Williams were found guilty of feigning the injury in order to allow for the substitution. The inquiry revealed Williams had removed a blood capsule from his sock and burst it open in his mouth to create the effect of "substitutable" facial bleeding. It was further discovered that, with help from team doctor, Wendy Chapman, Williams had cut his own lip after the match to enhance a cover-up. Williams was banned for one year, while the Harlequins were fined 250,000 euros. Harlequins' coach, Dean Richards, club doctor, Wendy Chapman, and team physiotherapist, Steph Brennan, were all initially cleared of any involvement in the scandal.

However, on August 17, 2009, Williams disclosed previously hidden information implicating his coach and team medical staff. Consequently, Williams's ban was reduced to four months and the club fine increased to 300,000 euros. Brennan received a two-year suspension from rugby, and Dean Richards was banned from coaching rugby in any European competition for three years. These sanctions were assessed after it was discovered that Richards had previously been involved in four similar incidents. Williams's testimony painted a picture of Richards as an overbearing bully-dictator who plotted the fake injury and subsequent cover-up. The player commented that the act was consented to out of fear of his coach. Meanwhile, Richards deflected responsibility to pressures and obligations he faced as a coach, insisting that cheating (including faking injuries) was a common practice in rugby.

The punishments for involvement in Bloodgate were broadly viewed by fans as the harshest sanctions ever handed down in professional rugby. In addition to extensive media coverage, the machinations of Bloodgate were publicly disseminated in a report by the ERC that did, in fact, suggest that cheating was far from uncommon in the sport and had involved players, coaches, and medical staff at Harlequins and other clubs. Richards eventually admitted to organizing the episode but rarely veered from the rationalization that he had acted in accordance with contemporary trends of the game. The scandal also pointed to the need to contextualize contemporary manifestations of on-field deviance against the longer-term, processual development of the sport from an amateur to a hyper-professionalized cultural form.

Dean Richards: The Rise and Fall of a Rugby Icon

Just who *fell*, however, as a result of Bloodgate, and which supposed heroes were dislodged from positions of reverence and prestige in rugby? What is far from unambiguous in media coverage of Bloodgate is who emerged as victims or villains in the scandal.

Perhaps the first person perceived as "victim" in the scandal was Tom Williams himself, the player responsible for faking the blood injury. Williams was widely deemed to be under the complete control of his club and his highly regarded, but daunting, coach, Dean Richards—as is often the case in coach-player abuse scenarios (Stirling & Kerr, 2009). Consequently, the tone of many media accounts assumed Williams was victim to a coercive and tyrannical coach. In such reports, Williams was viewed as simply following Richards's orders, and unfairly "taking the fall" for the Bloodgate scandal which clearly involved many persons at many levels:

> Harlequins will support Williams in an appeal against the length of his one-year ban from the game, with the winger widely seen as the victim and carrying the can for senior club officials behind the ruse designed to win a place among the game's elite. Williams's evidence is expected to show that he was instructed to carry a small phial of blood in his sock. (Eason, 2009).

> Williams is in an invidious position. He surely could not have acted alone, nor could he realistically have refused the instruction to chew on the phial. The ERC judgment is unsatisfactory in that, either way, a miscarriage of justice has taken place. (Souster, 2009b)

> Damian Hopley, chief executive of the players' union, said the case demonstrated that players can be vulnerable to unscrupulous coaches. Williams was pressurized to lie in the original case before deciding to reveal the depths of the cheating culture at Harlequins. (Kelso, 2009b)

Thus, attention turned to Dean Richards as the principal "fallen hero" in the emerging Bloodgate scandal. With no place to go but down, Richards's own illustrious career as a player and coach perhaps set him up for such a fall. Few players shared his credentials at club or national level. Indeed, Richards had been widely considered the world's best player (in his position) at the apex of his career. Among numerous other accolades, Richards had won the Calcutta Cup (1987), had been instrumental in successful national tours of Australia (1988), Romania (1989), Argentina (1990), and Canada (1992, 1994), in addition to having had multiple successes in the European Five Nations Cup (now known as the Six Nations). In 1996, Richards fully retired from rugby, but two years later began his coaching career with Leicester Tigers Rugby Club. During that period he won four premiership titles, and two Heineken Cup trophies. In 2004, after

several successful seasons as head coach of the Tigers, Richards was dismissed following a period in which the team slumped.

Despite the multiple successes that had led to his demigod status in the world of rugby and in the midlands city of Leicester in particular, Richards was no stranger to controversy or reprimand. Alongside his notable accomplishments on the field sat a number of altercations with authority. For example, after one Calcutta Cup victory against Scotland, he was caught with opponent, John Jeffrey, disrespectfully kicking the much-revered trophy. While the England star was "slapped on the wrist" with a one-game ban, his accomplice was given a much stiffer six-month ban. In 1995, he was the first player in the English rugby union to be suspended under a new "totting-up" rule with regard to accumulated yellow cards. Indeed, Richards's on-field career had frequently been marred by violent incidents such as stamping and punching.

For all of this, and despite becoming widely viewed as the principal *offender* in Bloodgate, Richards was also variously portrayed as a *victim* of the demanding and increasingly rationalized world of modern rugby. Much like Williams, numerous media commentators characterized him as a scapegoat for larger ethical problems and moral ambiguities in the sport brought on by hyper-professionalism and consumerism. Much of the media coverage tapped into sociological "contextual factors" that were related to the broader culture of coaching and for which no one individual could fairly be held responsible. In partly exonerating both Williams and Richards, the media widely critiqued the enormous pressure on players and coaches to perform and win:

> speaking in detail about Bloodgate for the first time, Skinner claims he has seen blood capsules used by other clubs and that Richards' suspension was far too severe. (Peters, 2010)

> They must not be allowed to vilify Richards and place all blame on his shoulders. Richards was a brilliant coach but he was not a unique force or a unique culture. The problem is with the game, not the man, and the RFU's task force must start the process of restoring its moral compass. (Ruddock, 2009)

> Dean Richards is a man conditioned by his sport to cheat. (Pearson, 2009).

In what follows, we review how the media framed Richards's fall from rugby grace as a deviant, but perhaps understandable, offshoot of the sport's corrupt professionalization. Using an Eliasian theoretical framework, we consider common, thematic portrayals of Richards and the sport in the ensuing debates about Bloodgate, and how the case represented an emerging moral panic as well as a series of often contradictory viewpoints regarding the root cause of corruption in rugby.

Professional Rugby's March Toward Bloodgate

These are troubling times for rugby union. The image of the game has been besmirched like never before. (Souster, 2009b)

The publicity surrounding the fall-out has damaged the sport severely. (Rajan, 2009)

Rule changes alone will not restore the game's reputation or repair its broken culture. (Ruddock, 2009)

To understand why the media and those involved in professional rugby reacted the way they did to Bloodgate, we apply Elias's (1978) notion of the civilizing process. From this perspective, in order to make sense of contemporary practices such as those at the center of the Bloodgate scandal (and how perpetrators of cheating are understood and publicly shaped in media discourses), we must examine their historical emergence. Specifically, in order to gain a clear understanding of the media reaction to the Bloodgate scandal, it is important to understand the historical splintering between the amateur era of rugby and the modern professional game—i.e., how the sport has undergone what figurationalists call the prototypical "sportization process" (Elias & Dunning, 1986; Dunning, 1999).

Throughout the coverage of Bloodgate, there was a clear distinction drawn between the modern era of professionalism in rugby and the amateur ethos that once underpinned the game. In media accounts of Bloodgate, professionalism was defined in terms of a winning-at-all-costs mentality and an obsession with revenue, commercialization, and image. These characteristics of the professional era are considered to have replaced the amateur, and more "gentlemanly," ethos that defined the game for so long. As we indicate below, the media contributed to a form of moral panic in distinguishing between the two versions of the game, making it seem as though professionalism was or is fundamentally at fault for compromising the rugby culture and consolidating cheating and other forms of deviance as institutional problems.

For figurationalists, such discourses regarding a collapse of rugby ethics and practices should be understood as part of a long-term historical process. As has been widely recorded in the sociology of sports literature, during industrialization in Great Britain a once unruly folk game transformed into a more "civilized" form (Dunning & Sheard, 2005; Elias & Dunning, 1986), and during this time an amateur ethos became woven into the fabric of the game. During the great changes of industrialization, rugby "grew more 'civilized' in at least two senses: players began to be required to exercise more self-control, and some of the wilder features began to be eradicated or subject to more stringent control" (Dunning & Sheard, 2005, p. 57). According to Elias (1978), such a movement

toward self-control in mimetic social practices involving forms of aggression are hallmarks of the civilizing process. These characteristics are essential to amateurism, where a reckless desire to win at all costs is not culturally "wanted" (Atkinson & Young, 2008), legitimate, or respected. Under amateur codes, one plays for the emotional thrill or joy of merely participating.

Today, the era of athletic amateurism in sports is often viewed in a nostalgic (even melancholic) fashion, with the media describing earlier sports phases and cultures in romantic ways concerning values such as fair play, playing the sport for intrinsic rewards, the cultivation of positive character traits in players (such as sportspersonship, discipline, and leadership), and players possessing high levels of self-control. Such an amateur ethos, however stereotypical, contrasts starkly with the current era, and image, of professionalization—where greed, disregard for fair play, and an attitude of winning above all else predominate: "Nostalgia confronts us every day from our longings for the 'good old days' to our sense of insecurity in a world changing faster than many of us can comprehend" (Nauright & Chandler, 1996, p. 227).

Nostalgia is also a key component of the way the media framed Bloodgate. Frequently, journalists used the scandal to sharply contrast the historical ethics of amateur and early professional (read *civilized*) rugby and the ongoing *decivilizing* of rugby in the era of hyper-professionalism. The shift in rugby and its associated cultural trappings during industrialization from an amateur to a professional ethos represents an ideal example of how *sportization* occurs as part of long-term civilizing trends (Dunning & Sheard, 2005). As part of the "civilizing" (or modernizing) transformation towards hyper-competitive, organized, and professional sports cultures, unintended consequences inevitably arise—including offshoots of professional competition such as cheating. As the culture of rugby union in the UK and elsewhere is increasingly driven by formalization, hierarchical organization, and hyper-competition, the possibility of the sport *decivilizing* becomes more likely.

Having acknowledged the general context for thinking about versions of rugby and sports culture, we now review several of the main themes emerging from media discourses around Bloodgate. Such themes, we contest, are linked to broader public and media critiques about how the proliferation of cheating in the sport is a manifestation of an unintended, de-civilizing spurt produced by long-term professionalizing processes.

Staring Corruption in the Face: From Scandal to Panic

Notable in British media coverage of Bloodgate was the way the media framed the *offenders* involved in the original incident. It would be easy to simply look at the situation and claim that Dean Richards and Tom Williams were the single individuals responsible for the actions taken but also considered was the broader social context regarding moral behavior and ethical leadership (Sheridan, 2003). Commentators moved the emphasis away from the actions of individuals to the culture of professional modern rugby where "scandalous activity" appears inevitable (Connor & Mazanov, 2010):

> Cheating in Rugby: Dean Richards is not alone. (Pearson, 2009)

> Now it stands as a moment of considerable consequence: what began with blood on a player's face has ended with blood on the hands of a fine rugby club and its coaching staff. (Walsh, 2009)

> The Harlequins case reveals the pressure support staff are under to produce results, be that for the vindication of the coach or the profit and loss margins of the Chief Executive. It reveals the ERC's desire to protect the credibility of a competition (and sponsors) only when they are faced with a situation as ludicrous as a chartered physiotherapist purchasing fake-blood in a joke shop with intent to supply. The verdict, and the punishments bestowed, do nothing to deter the real cynicism that permeates our game. The gouging, the collapsed scrums, the tampering of lineouts, killing the ball . . . the list goes on. (Pearson, 2009)

Throughout Bloodgate coverage, professionalism was unilaterally scorned as prioritizing winning above all else. In this sense, performance and outcome are seen as central to the game's moral order, and "competitors are seen as merely obstacles to be overcome rather than as fellow participants and persons" (Simon, 1991, p. 31). At every opportunity, the media emphasized the fact that winning is the ultimate goal in professional rugby and comes with glory and, of course, material success. From a utilitarian perspective, cheating, including faking blood injuries, is rational and, indeed, "makes sense" according to media discourses:

> One is left to ask: is this where the win-at-all-costs mentality of professionalism is taking us? It is an uncomfortable truth that the sport at the highest level now has to confront. The Williams case is the latest and most serious manifestation of that trend. The question is whether this was a one-off or an example of something more widespread. (Souster, 2009b)

> The response to Williams will tell us much about the sincerity of rugby's supposed fraternity in the professional era. That spirit was demonstrated in the early hours of Tuesday morning at the hotel bar—where else?—when a member of the appeal committee commiserated with Richards hours after ending his career. It didn't take a first XV of

lawyers to point out that the former England great has done grave, perhaps irreparable damage, to the credibility of that brotherhood. (Kelso, 2009a)

Central to any discussion of the impact of professionalism on the game is the theme of consumerism. Bloodgate thus became couched in such terms as pressure to generate profit and commercial success, especially through victory on the field of play. As Chandler and Nauright (1999, p. 166) argued, "changes in the game of rugby union have not been so much a shift from amateurism to professionalism, but a transformation from a co-operative organization to a commercial enterprise." Such a view was mirrored in media accounts:

> The Harlequins case reveals the pressure support staff are under to produce results, be that for the vindication of the coach or the profit and loss margins of the Chief Executive. (Pearson, 2009)

> The severity of the judgment taken against Harlequins, Dean Richards, Tom Williams and Steph Brennan is not out of a desire to protect the integrity of the game, but out of a need to placate sponsors in a buyers market. (Pearson, 2009)

> Of course, that is what it all comes down to. Money. Cash begets pressure begets a bending of the rules. Competitors, and the viewing public, are becoming desensitised to cheating. (Smith, 2009)

Throughout such media critiques of consumerist ethics in rugby, there was a creeping sense of (moral) panic and crisis in sports. Widely examined in the sports violence literature (e.g., Hall, 1978; Young, 1986), media-generated moral panics can be described as a "mobilization of collective fears and anxieties, amplified and sensationalized through the media and focused in relation to a symbolic other, a folk devil, that ultimately serves processes of societal control through the policing of collective moral boundaries" (Cottle, 2006, p. 413). Sports journalists in the UK and elsewhere have emphasized that the shift from amateur to professional ethos is creating a game that can no longer be understood as fair or just. The Bloodgate scandal perfectly represented such a problem. Periodic "moral panics" seemingly serve to focus collective solidarities, often set against a backdrop of historical change and in relation to a social field structured by power relations (Cottle, 2006). In this case, there was a collective solidarity against the actions (principally those of Richards) taken in the Bloodgate scandal. Yet, through the media's description of the institutionalization of cheating, the win-at-all-costs mentality, and the greed of modern consumerism in sports, the media depicted the ultimate "folk devil" as professional rugby itself:

> Paul Ackford, the former . . . rugby correspondent, wrote that rugby was "morally bankrupt". Ackford was outraged not just by the incident at the end of the Leinster game which has since escalated into Bloodgate, but also by a series of disparate events

that had sullied the game. They ranged from cheating to sexual assault, rule tinkering to coach sacking but they added up to his glum conclusion: rugby had lost its moral compass. (Ruddock, 2009)

The hard facts are chilling and yet unsurprising. Cheating has become endemic in sport to the point where we even have accepted forms of it. (Smith, 2009)

The case—dubbed 'Bloodgate'—is a shocking reminder of the way that winning in pro sports—any pro sport—is now all that matters. Forget about sportsmanship, fair play and just plain honesty, they are forgotten concepts. (Gardner, 2009)

Thus, what is striking about the case of cheating in rugby, and the media-led moral panic surrounding the Bloodgate controversy in particular, is how the individual participants involved were ultimately excused of their wrongdoings and the onus of responsibility was placed on a broader sports culture mired in corruption.

Yet, at other times, media accounts of Bloodgate also underlined how players or coaches do not act without *agency* in the cheating process and how they participate in deviant and illegal acts with clear intent, fully aware of the possible ramifications. This was again a key element in the Bloodgate scandal—as the suffix "gate" (implying deliberate conspiracy) associated with media-led labeling of the scandal suggested:

Dean Richards the "central control" of Bloodgate scandal. ("Dean Richards," 2009)

Disgraced former England hero was kicked out of the sport after masterminding a fake blood injury during a crucial Heineken Cup quarter-final against Leinster. (Moore, 2009)

The Harlequins case is a more worrying development. It suggests clear premeditation on the part of the club at management level. (Souster, 2009b)

Harlequins, a celebrated club, led by Dean Richards, an icon of the English game, systematically cheated their opponents in the most pre-meditated, cynical way imaginable. (Kelso, 2009a)

When coaches and players are portrayed as conspirators, a further element of de-civilization in rugby surfaces. With direction from coaches like Richards, it was broadly argued, cheating becomes normalized by players. It becomes a part of the subculture, and is seen as simply a part of the ethos of the sport; something to be understood and acted on but never acknowledged or discussed openly. This adds to the sense of moral panic created by the media, with cheating depicted as so widespread, and so ingrained in the sport's culture, that it becomes inescapable:

The document rips the lid off institutionalized cheating which Quins' players and medical staff say is prevalent throughout the Premiership. (Ackford, 2009)

The game's authorities cannot pretend that Bloodgate was a one-off affair—cheating and rule-bending are commonplace. (Ruddock, 2009)

Harlequins' cheating was not an isolated case, but it was caught and then it was compounded by the institutionalized cover-up. (Ruddock, 2009)

Clearly people will cheat, chance their arm and when the referee's not looking even swing a fist. I'd certainly forgive the player, bar the wink. I'd even have some degree of sympathy for Dean Richards for all he was doing was cheating. And as the tongue-in-check sporting adage goes, 'If you're not cheating, you're not trying.' (Toland, 2009)

However, complicating media attention paid to the supposed link between professionalism in rugby and cultures of cheating, Tom Williams's performance as a player was frequently considered separately from the act of cheating per se in the Bloodgate scandal. Indeed, in many respects, and perhaps a reflection of his past accomplishments, honors, and otherwise "clean record," Williams was granted a veritable "free pass" in much of the ensuing media coverage: "'He is a player of unquestionable character,' Hopley said. 'His performances for Harlequins demonstrate an excellent work ethic and his disciplinary record—one yellow card following persistent team infringements in seven years as a professional player—speaks for itself'" (Souster, 2009a).

As further evidence of contradiction, many journalists took the opportunity to underline the inconsistencies and hypocrisy at work in the way rugby officials meted out punishments for unwanted behaviors:

Then there are the thugs and gougers. Schalk Burger gets eight weeks for "making contact with the eye area" of Luke Fitzgerald, Williams gets 12 months for bad acting and a mindless wink. Where, his supporters ask, is the justice in that? (O'Brien, 2009)

The logic was impossible to refute: in a game which gives eight-week bans to players who poke their fingers in an opponent's eyes, how could a player be given 12 months for agreeing to his club's request/demand that he feign an injury? It is now clear the ERC's disciplinary panel was incensed by Harlequins' refusal to admit they had been party to anything underhand and the severity of Williams' sentence was a clear reflection of that. (Walsh, 2009)

Of the individuals involved, while Williams (the player) was punished and fell temporarily from grace, Richards (the coach) emerged in media accounts as the central pariah of the incident, eventually leading even rugby's strongest apologists to more seriously ponder the moral status of the game. Richards's character and his seminal role in the Heineken Cup scandal would come to represent not only a lack of coach and player integrity in the modern version of

the sport but also a culture entirely sullied by market forces, competitive logics and so-called "professional" practices.

Fallout: On the Other Side of Bloodgate

In addition to outlining, often contradictorily, the victims and villains of Bloodgate, media accounts underscored Dean Richards's fall from grace and the wider fallout from the scandal. First, although those deemed to have been involved in Bloodgate received lengthy bans and fines, commentaries about the damage control in rugby union highlighted the ultimate punishment for the event as the shame that had fallen upon the team, the players, and especially, Dean Richards. Elias (1978) described shame as a *master emotion* in the social control process. Media depictions of the scandal promulgated shame as the final sanction for offenders:

> The air had barely cleared and the sport taken a deep breath than Richards was on his way, shame-faced, to the exit. (Eason, 2009)

> Richards, once revered for his professionalism, resigned in disgrace on 8 August. (Rajan, 2009)

> Dean Richards' reputation has been burnt to a cinder by the Bloodgate controversy. (Jones, 2009)

> It has cost Dean Richards his position as director of rugby and made a laughing stock of a club that prides itself on high standards. (Walsh, 2009)

Clearly, the Bloodgate scandal brought the prevalence of institutionalized cheating in rugby union to the forefront. Although there may be few positive dimensions to any such scandal, the possibility of a fresh beginning for the sport and a new era of transparency in professional rugby became one of the concluding themes in media discourses. As figurationalists would suggest, such transparency contains the potential for *re-civilizing* the various subjects and settings involved: "Conformity to these standards is psychologically underpinned by fears of arousing disagreeable associations such as shame. . .socially appropriate behavior later becomes automatic for the individual" (Kilminster, 2007, p. 89).

Many media commentaries echoed this view. By demonstrating how much shame had been associated with the scandal, journalists suggested that others could be deterred from committing similar acts:

> The Bloodgate affair has led to a refreshing openness in rugby. (Kitson, 2009)

Tom Williams' testimony seems to have triggered a rush of plain-speaking common sense. Long may it continue. (Kitson, 2009)

Telegraph Sport can disclose that the RFU and the International Rugby Board are already discussing a number of measures intended to prevent cheating in future, including the introduction of independent doctors or match commissioners for professional matches. (Kelso, 2009a)

Amongst the headline tales of deceit, subterfuge and backstabbing for sporting advantage, one of the most interesting themes which came out of these scandals was the apparent increasing recognition of an unwritten whistle-blowing policy by the sporting regulators involved. (Walters, 2010)

By highlighting one case in a very public way, "Bloodgate" could scare off other potential cheats. (Rajan, 2009)

Conclusion

Mass mediations of social events in sports like Bloodgate do not, in and of themselves, have the power to define the nature of a sports culture, create its norms, or forever alter standards of play in the game. However, such mediations (which, we must remember, are always heterogeneous rather than uniform) point to prevailing values and discourses regarding the anxieties and concerns that insiders and outsiders share about the interplay between so-called "wanted" forms of violence, aggression, and even "foul play" in sports (see Atkinson & Young, 2008) and less tolerable and shame-producing violations in a given sport. The mass mediation of Dean Richards's fall from rugby grace illustrates how one of the most difficult practices in selling modern contact sports is finding the perfect balance between civilized or mimetic violence (Elias & Dunning, 1986) and the social control of unwanted (de-civilized) forms of "social deviance." Indeed, sports like rugby now struggle to provide a socially exciting and significant set of "civilized" tension-balances within the game around highly competitive or aggressive acts—such practices and processes are indeed complicated by outside commercial trends influencing leagues, coaches, and players to push the envelope of "fair [mimetic] play" and win at all costs attitudes.

Clearly, the hyper-professionalism, ethics of consumption, and subcultures of cheating in rugby are not unique. Across hyper-masculine, professional sports cultures worldwide there is a pervasive ideology of risk-taking and deviance (such as cheating) as a dangerous, but prized and rewarded, masculine activity (Atkinson & Young, 2008). While many in the media nostalgically lament the loss of a "gentle*manly*" code of honor and integrity in sports like rugby and attribute its

demise to hyper-professional trends, what is more interesting to us, sociologically, is how cheating (like other forms of social deviance) may be reconciled among athletes as an acceptably *masculine* practice. While Richards, like Williams, would be portrayed as a rogue and scoundrel in mediated accounts of Bloodgate, his actions are almost always rationalized as an unintended part of a sports culture where men must simply "do what they have to do" in order to win. In this way, and again paradoxically, while Richards is "guilty" and should feel shame, he was simultaneously portrayed by the media as an effigy of a sports culture battling with de-civilizing spurts where "old codes" and traditional mechanisms of social control (like shaming) offer less relevance.

In sum, media accounts of the etiology and outcomes of Bloodgate draw our attention to the multilayered and contradictory pushes and pulls regarding a culture of corruption in modern day hyper-professional sport. Figurational sociology helps us understand how Richards's actions are products of interwoven, long-term, historical processes within and outside of the sport, including commercialization, professionalization, and globalization. The case study of Bloodgate further illustrates how, in Dunning's (1999) and Elias and Dunning's (1986) terms, the sportization process is never a *fait accompli*. Sportization is an ongoing and multidirectional process, in which the rise, and subcultural normalization of, cheating in sports cultures signals an important sociogenic shift. Bloodgate, and the sport of rugby more generally, merely represent one example of such long-term shifts in a global sport culture widely characterized by power struggles and crisis, often played out dramatically in the popular media.

References

Ackford, P. (2009, August 29). Bloodgate: Scandal opens the doors to a world of sinister practice in rugby. *The Telegraph*. Retrieved from http://www.telegraph.co.uk/sport/rugbyunion/club/6106177/Bloodgate-scandal-opens-the-doors-to-a-world-of-sinister-practice-in-rugby.html

Atkinson, M., & Young, K. (2008). *Deviance and social control in sport*. Champaign, IL: Human Kinetics.

Chandler, T., & Nauright, J. (Eds.). (1999). *Making the rugby world: Race, gender, commerce*. London, UK: Frank Cass.

Connor, J. M., & Mazanov, J. (2010). The inevitability of scandal: Lessons for sponsors and administrators. *International Journal of Sports Marketing and Sponsorship, 11*(3), 212–220.

Cottle, S. (2006). Mediatized rituals: Beyond manufacturing consent. *Media, Culture and Society, 28*(3), 411–432.

Dean Richards the 'central control' of Bloodgate scandal, ECB [sic] appeal hearing notes reveal. (2009, September 2). *Mirror*. Retrieved from http://www.mirror.co.uk/sport/rugby/2009/09/02/dean-richards-the-central-control-of-bloodgate-scandal-ecb-appeal-hearing-notes-reveal-115875-21642417/

Dunning, E. (1999). *Sport matters: Sociological studies of sport, violence, and civilization.* London, UK: Routledge.

Dunning, E., & Sheard, K. (2005). *Barbarians, gentlemen, and players: A sociological study of the development of rugby football.* London, UK: Routledge.

Eason, K. (2009, August 10). Dean Richards exit in 'bloodgate' scandal leaves a deep wound. *The Times.* Retrieved from http://www.timesonline.co.uk/tol/sport/rugby_union/article6789254. ece

Elias, N. (1978). *The civilizing process.* Oxford, UK: Basil Blackwell.

Elias, N., & Dunning, E. (1986). *Quest for excitement: Sport and leisure in the civilizing process.* Oxford, UK: Basil Blackwell.

Gardner, P. (2009, August 20). 'Bloodgate' takes pro sports to new low. *Soccer America.* Retrieved from http://www.socceramerica.com/article/33742/bloodgate-takes-pro-sports-to-new-low. html

Hall, S. (1978). The treatment of football hooliganism in the press. In R. Ingham (Ed.), *Football hooliganism: The wider context.* London, UK: Inter-Action Inprint.

Jones, C. (2009, September 2). 'Bloodgate': The final damning of Dean Richards. *London Evening Standard.* Retrieved from http://www.thisislondon.co.uk/standard-sport/article-23739236-bloodgate-the-final-damning-of-dean-richards.do

Kelso, P. (2009a, August 19). Bloodgate: Worst yet to come for Harlequins and Dean Richards. *The Telegraph.* Retrieved from http://www.telegraph.co.uk/sport/rugbyunion/club/6051364/Bloodgate-worst-yet-to-come-for-Harlequins-and-Dean-Richards.html

Kelso, P. (2009b, September 2). Bloodgate: Dean Richards had 'central control', says judgment of ERC hearing. *The Telegraph.* Retrieved from http://www.telegraph.co.uk/sport/rugbyunion/club/6125863/Bloodgate-Dean-Richards-had-central-control-says-judgment-of-ERC-hearing.html

Kilminster, R. (2007). *Norbert Elias: Post-philosophical sociology.* London, UK: Routledge.

Kitson, R. (2009, September 9). The Bloodgate affair has led to a refreshing openness in rugby. *The Guardian.* Retrieved from http://www.guardian.co.uk/sport/blog/2009/sep/09/guinness-premiership-bloodgate-harlequins

Moore, M. (2009, September 3). Bloody cheat: Dean Richards' career is on the scrapheap after he was exposed as the lying, cheating power behind the Bloodgate scandal. *The Sun.* Retrieved from http://www.thesun.co.uk/sol/homepage/sport/rugby_union/2619567/Dean-Richards-has-been-exposed-as-the-dominant-personality-in-Bloodgate-scandal.html

Nauright, J., & Chandler, T. (Eds.). (1996). *Making men: Rugby and masculine identity.* London, UK: Frank Cass.

O'Brien, J. (2009, July 26). Williams takes hit for Harlequins' bloody mess. *Independent.ie.* Retrieved from http://www.independent.ie/sport/other-sports/williams-takes-hit-for-harlequins-bloody-mess-1841507.html

Pearson, C. (2009, September 2). Cheating in rugby: Dean Richards is not alone. *Eskimo Rugby.* Retrieved from http://eskimorugby.wordpress.com/2009/09/02/CHEATING-IN-RUGBY-DEAN-RICHARDS-IS-NOT-ALONE/

Peters, S. (2010, April 17). Skinner: Dean's bloody great. *News of the World.* Retrieved from http://www.newsoftheworld.co.uk/sport/786345/HARLEQUINS-skipper-Will-Skinner-insists-disgraced-Bloodgate-coach-Dean-Richards-would-be-welcomed-back-into-rugby-with-open-arms.html (no longer accessible).

Rajan, A. (2009, August 28). The big question: how severely has rugby union been damaged by 'Bloodgate'? *The Independent.* Retrieved from http://www.independent.co.uk/sport/rugby/ rugby-union/news-comment/the-big-question-how-severely-has-rugby-union-been-damaged-by-bloodgate-1778287.html

Ruddock, A. (2009, August 30). Cheating heart of rugby has to change. *Independent.ie.* Retrieved from http://www.independent.ie/sport/rugby/cheating-heart-of-rugby-has-to-change-1873288. html

Sheridan, H. (2003). Conceptualizing 'fair play': A review of the literature. *European Physical Education Review, 9*(2), 163–184.

Simon, R. L. (1991). *Fair play: Sports, values, and society.* Oxford, UK: Westview Press.

Smith, J. (2009, September 29). Sporting scandals indicate cheating epidemic. *The Sport Review.* Retrieved from http://www.thesportreview.com/tsr/2009/09/sporting-scandals-indicate-cheating-epidemic/

Souster, M. (2009a, July 22). Players' union jumps to Tom Williams's defence. *The Times.* Retrieved from http://www.timesonline.co.uk/tol/sport/rugby_union/article6722499

Souster, M. (2009b, July 23). Rugby union on the slippery slope from moral high ground. *The Times.* Retrieved from http://www.timesonline.co.uk/tol/sport/rugby_union/article6723992

Stirling, A. E., & Kerr, G. A. (2009). Abused athletes' perceptions of the coach-athlete relationship. *Sport in Society, 12*(2), 227–239.

Toland, L. (2009, September 9). Medics worst offenders in Bloodgate scandal. *The Irish Times.* Retrieved from http://www.irishtimes.com/newspaper/sport/2009/0904/1224453821856. html

Walsh, D. (2009, August 9). Dean Richards: Blood on the carpet. *The Times.* Retrieved from http://www.timesonline.co.uk/tol/sport/rugby_union/article6788768.ece

Walters, J. (2010, March 10). Crashgate and Bloodgate: The rise of whistleblowing policies in sport? *Monday Business Briefing.* Retrieved from http://www.thefreelibrary.com/Crashgate+ And+Bloodgate:+The+Rise+Of+Whistleblowing+Policies+In+Sport%3F-a0220789936 (no longer accessible).

Young, K. (1986). 'The killing field': Themes in mass media responses to the Heysel Stadium riot. *International Review for the Sociology of Sport, 21*(2–3), 253–266.

Who's Sorry Now? Sportscasters Falling from Grace, Saving Face

Heather L. Hundley

During sporting events, attention is typically given to athletes as they jump higher, run faster, and demonstrate amazing athletic abilities. Indeed, they are the stars of the show. As supporting cast members, sportscasters relay information, provide statistics, describe the plays, and contribute to athletes' star status. Yet, almost every fan has an opinion about these commentators, and in some cases they become acclaimed in their own right.

Basketball fans, for instance, not only recall Kareem Abdul Jabbar's phenomenal career but Chick Hearn's 42-year, play-by-play broadcasting with the Los Angeles Lakers. Similarly, baseball fans witnessed Cal "Iron Man" Ripkin's 2,632 consecutive game playing streak. Yet, Vin Scully has provided Dodger play-by-play for an unprecedented 62 seasons, longer than any other broadcaster in history. Clearly, there is no comparison between athletes and announcers. With the onslaught of age and the daily rigors of strength training, practice, and performance, athletes' bodies eventually fail them. Whereas for broadcasters, as long as they maintain their wits they seemingly can continue their careers indefinitely.

Like athletes, broadcasters are no less exempt from falling from grace. Many times when public figures fall from grace it is due to their actions; however, when sportscasters fall, it is primarily because of their words. In the past 30 years, this has never been more obvious as media consumers witness racist, sexist, and homophobic commentary from broadcasters talking about sports and athletes. While the reasons may vary as to why this occurs (heightened sensitivities, political correctness, prolific media coverage), the reactions differ widely. In fact, responses from a slip of the tongue can emerge from the source (broadcaster), the organization of employment (television network), the person(s) targeted (athlete, ethnic group), and the general public.

Sports Broadcasting

Scholars have taken interest in sports in the past 30-plus years (cf. Bryant, Comisky, & Zillman, 1977; Hundley & Billings, 2010; Lapchick, 1996; Wenner, 1989). In terms of sports broadcasting, scholars have recognized that most announcers are white and male (Eastman & Billings, 2001; Messner, 2002) and probably predominantly heterosexual. The majority of research focuses on gender and racial bias in sportscasting. More recently an examination of homophobia was explored (Hardin & Whiteside, 2010). Even though "sport in the US is the one area of public life where racism is least tolerated" (Reid, 2007, p. 6), several scholars argue that sportscasters implicitly connote racist and sexist stereotypes.

Racism is found in sports commentary (Denham, Billings, & Halone, 2002), photographic sports images (Goss, Tyler, & Billings, 2010), sports magazines (Byrd & Utsler, 2007), and athletes featured in advertising (Dufur, 1998). Most of the research compares black and white athletes. Eastman and Billings (2001) posited that "negative racial stereotyping is prevalent in the media, specifically with sports reporters and editors" (p. 184).

As for research examining sexism in sportscasting, it was no different. Repeatedly scholars claimed that female athletes were trivialized compared to their male counterparts (Daddario, 1998; Shifflett & Revelle, 1996). Indeed, the literature finds female athletes and women's sports are reported on quite differently than male athletes and men's sports.

While the literature has focused on *implicit* forms of racism and sexism, *explicit* forms of racism, sexism, and homophobia have gone unnoticed in academia and are major contributors to broadcasters falling from grace. Therefore, this chapter examines eight overt instances of broadcasters making explicit statements revealing racism, sexism, and homophobia in sports.

Apologia

When broadcasters make offensive remarks, they generally lose their credibility and respect, qualities that for announcers, are valuable commodities. As a result, they must attempt to regain their image or reputation. Thus, to frame this analysis, the rhetorical construct of *apologia* is employed. Apologia is particularly appropriate since it is defined as "a recurring type of discourse designed to restore face, image, or reputation after alleged or suspected wrong-doing" (Benoit & Brinson, 1994, p. 75). Rhetorically speaking, apologia is a particular genre of discourse characterized

by "the recurrent theme of accusation followed by apology," and apology is a "verbal self-defense" (Ware & Linkugel, 1973, pp. 274–275). This rhetorical form can be individually (Theye, 2008), organizationally (Jerome & Rowland, 2009), or nationally based (Hatch, 2006).

This area of study may include preemptive apologia (Mueller, 2004), a single speech act (Ling, 1970), a series of speech acts (Kramer & Olson, 2002), and antapologia—the response to the apologia (Stein, 2008). Since broadcasters, particularly play-by-play announcers, must "inform and entertain . . . as events transpire in front of them . . . often without the time to choose words carefully" (Rada, 1996, p. 232), preemptive apologia is inappropriate. Instead, this chapter aligns with Kramer and Olson (2002) who suggested that critics ought to explore "the evolution of rhetorical accusations and multiple self-defense speech acts" (p. 349) that comprise apologia. Thus, in viewing broadcasters' fall from grace as a narrative (Theye, 2008), a variety of apologia strategies, and their relative success, as well as antapologia responses, are examined. While apologetic responses from the targeted people varied, employer responses were consistent. Across cases, second chances were given to broadcasters. As Lipsyte (1997, p. 13) noted, although "a player could be more quickly forgiven for a transgression than an 'interpreter' of events . . . sports, after all, is about second chances, coming back from all the bad bounces of life, from knee injuries to rape convictions."

Just like Sticks and Stones, Words Can Hurt

Table 1 (see p. 317) provides an overview of circumstances to familiarize readers with the sportscasters' fall from grace. For instance, during a telecast of Dallas Cowboys and Washington Redskins, Howard Cosell exclaimed, "That little monkey gets loose, doesn't he?" when observing the Redskins' wide receiver, Alvin Garrett, break free of Cowboys' Joe Gibbs. Jimmy "The Greek" Snyder's fall occurred when he opined to a local television reporter, "The black is a better athlete to begin with, because he's been bred to be that way . . . this goes all the way to the Civil War when, during the slave trading, the owner, the slave owner, would breed his big woman so that he would have a big black kid." Ben Wright's fall began when he told a *Wilmington News Journal* writer, "Let's face facts here. Lesbians in the sport hurt women's golf. They're going to butch the game, and that furthers the bad image of the game. Women are handicapped by having boobs . . . their boobs get in the way." In 1997, after being charged with forcible sodomy (felony), assault, and battery charges (misdemeanor), Marv Albert fell from grace when he pleaded guilty

after a four-day trial to the misdemeanor. During the brief trial, the public learned of Albert's personal preferences, such as his proclivity for three-way, masochistic sex with strangers and wearing women's lingerie. Rush Limbaugh fell from grace during the ESPN *Sunday NFL Countdown* when he shared his belief that Philadelphia Eagles quarterback, Donovan McNabb, was overrated: "I think the media has been very desirous that a black quarterback do well. They're interested in black coaches and black quarterbacks doing well. I think there's a little hope invested in McNabb and he got a lot of credit for the performance of his team that he really didn't deserve." Fox Sports analyst Steve Lyons began his fall when he inappropriately commented on Los Angeles Dodgers' Shawn Green's decision not to play on Yom Kippur: "He's not a practicing Jew. He didn't marry a Jewish girl. And from what I understand, he never had a bar mitzvah, which is unfortunate because he didn't get the money." A decade later he made fun of a Mets fan for wearing corrective lenses. The following week the fall continued when he commented on guest analyst Lou Piniella, who was speaking Spanish: "Lou's habla'ing some Espanol there, and I'm still looking for my wallet." Radio shock jock, Don Imus, fell from grace when he engaged in a conversation with the show's executive producer regarding Rutgers' women basketball team saying, "That's some rough girls from Rutgers. Man, they got tattoos. That's some nappy-headed ho's there, I'm going to tell you that." Golf Channel anchor Kelly Tilghman fell from grace when she responded to co-anchor Nick Faldo's joking comment that the only way for competitors to beat Tiger Woods was to "gang up [on Woods] for a while" to which Tilghman retorted, "Lynch him in the back alley."

Of these eight instances, seven were uttered by white men while the remaining one was from a white female (see Table 1). Five of the comments were completely racially motivated; another was about race and gender, another about gender and sexual orientation, and the remaining instance was about sexual exploits. In terms of race, five of the six broadcasters made comments directed towards black athletes and the other broadcaster insinuated Mexican and Jewish cultures. The gendered comments were about female athletes, and the comment about sexual orientation referred to lesbians.

Sometimes It's Hard to Say I'm Sorry: Five Forms of Apologia

Like Hatch (2006), rather than examining the traditional, apologetic discourse of image restoration, this analysis expands from the rhetor's self-interest to apologia narratives, including the antapologia speech acts. In some cases the

Table 1: Overview of Broadcasters' Fall from Grace

Broadcaster	Date	Content	Medium	Apologized	Consequence
Howard Cosell	9/5/83	Racial	ABC's *Monday Night Football*	No	Quit at end of season/contract
Jimmy "The Greek" Snyder	1/15/88	Racial	Spoke to Washington, DC WRC-TV Channel 4 reporter.	Yes; the next day	Fired
Ben Wright	5/12/95	Sexist; Homophobic	*Wilmington News Journal*	Yes; three years later	Fired
Marv Albert	1995. Trial in 1997	Sexist	He worked for Madison Square Network and NBC Sports. The trial was public.	Yes; two years later when trial ended	Fired from NBC; quit Madison Square Network; rehired for both
Rush Limbaugh	9/28/03	Racial	ESPN *Sunday NFL Countdown*	No	Quit; went back to national radio
Steve Lyons	10/06	Racial	Fox Sports	Yes; the next day re: Pinella. No re: Green	Fired; rehired
Don Imus	4/4/07	Racial; Sexist	CBS owned WFAN-AM "Imus in the Morning" national radio program; simulcast on MSNBC	Yes; two days later	Fired; rehired
Kelly Tilghman	1/7/08	Racial	Golf Channel	Yes; the next day to Woods, four days later publicly	Two week suspension

offensive remarks were directed to a single person, but more often than not, they were about a particular ethnic group, gender, or sexual orientation. As such, the apologies were simultaneously designed to restore the rhetor's image and heal the community from the transgressions. In this analysis, all five tactics of rhetorical apologia (Benoit, 1995) are evident.

Denial

Denial was used in three cases. For instance, later in his broadcast, after referring to Garrett as a "little monkey," Cosell said, "According to the reporters, they were told that I called Alvin Garrett a little monkey. Nothing of the sort and you fellows know it" (Shapiro, 1983a, p. D6). Despite his denial, *The Washington Post* recorded the game and verified Cosell's words.

In the two other instances, the denials were private affairs. Wright, for example, was quoted during a one-on-one interview that was not recorded, so it was his word against the journalist's word. The day after the story ran in the paper, he sent a message to the LPGA Championship players via a note posted in the DuPont Country Club locker room. In the note he claimed the newspaper contained a "pack of lies and distortion that was attributed to me" and accused the reporter of "dishonest tactics" ("CBS President," 1995, p. P). Furthermore, Wright stated that "not going to fly" was a phrase he did not use and that he never uttered the word "boobs" ("CBS Announcer Denies," 1995, p. F01).

In the third example, Albert claimed the plaintiff made up the whole story. Speaking on Albert's behalf, his attorney said the alleged victim was "a mentally disturbed woman scorned . . . who collects celebrities . . . had become unbalanced, vindictive [and] wanted to get revenge against Marv Albert" (Sisk, Galvin, & Hester, 1997, p. 2).

Evading Responsibility

Evading responsibility was an equally prominent tactic used within the apologia genre, as three broadcasters attempted this strategy. Specifically, Lyons and Tilghman both claimed they were light-heartedly joking. Lyons explained, "If I offended anybody, I'm truly sorry. But my comment about Lou taking my wallet was a joke and in no way racially motivated" (Rubin, 2006, p. 64).

Tilghman was joking and laughing with cohost, Nick Faldo, when she made her comment about Tiger Woods. "I can assure you that there was never any intention to offend anyone. I'm sorry for any misunderstanding" (McLe-

man, 2008, p. 63). Supporters furthered her excuse by disclosing her friendship with Woods, attempting to bolster her claim that the comment was meant in jest. "She and Woods have known each other for 12 years and he recently chose her to host a demonstration of new clubs endorsed by him near his home in Florida" (Thompson, 2008, p. 11).

Rather than chalking it up to a joke, Limbaugh argued, "This is such a mountain out of a molehill. There's no racism here. There's no racist intent whatsoever" (Hiestand, 2003, p. 1A). He also evaded responsibility by blaming the media. "Limbaugh said his comments were directed at the media and were not racially motivated" (Shapiro, 2003, p. A01). Thus, these broadcasters argued that they were not racist, but rather, their intent was misunderstood.

Reducing Offensiveness

While Cosell initially attempted denial and then claimed he did not remember saying it, he quickly changed his rhetorical strategy of apologia by reducing the act's offensiveness through dismissing the racial intonation. "On his radio show aired in New York last night, Cosell said he often used the term 'little monkey' with his grandson and that it was 'not remotely connected to racism'" (Shapiro, 1983b, p. C1).

Similarly, Snyder also used this strategy, claiming that he was not making racist comments. In fact, "The Greek [Snyder] still insists he said nothing wrong" (Shapiro, 1991, p. C3). Three years after the incident, Snyder's attorneys claimed, "To the extent that anything Mr. Snyder said may have been controversial, it was a perhaps inartful explanation of legitimate physiological differences between races, amply supported by scientific data, historical studies and medical opinion" (Shapiro, 1991, p. C3). "I thought I was being instructive," said Snyder, attempting to explain his intent (Solomon, 1988, p. A1), but he only dug himself deeper:

> If what I said offended people, I apologize. I didn't mean for my remarks to come out the way they did. I was trying to emphasize how much harder so many blacks work at becoming better athletes than white athletes. And they work hard because they're hungrier. That many black athletes run faster and jump higher than whites is a fact. (Shapiro, 1988, p. A1)

Promising Corrective Action

Promising corrective action is closely related to a subgenre of apologia—atonement. Atonement is successful through "fully accepting responsibility in public for their actions, demonstrating genuine repentance, taking steps to

heal the breach that has occurred, and demonstrating through public action that the repentance is authentic" (Jerome & Rowland, 2009, p. 396). Since Albert's corrective action was predominantly court ordered, Imus's corrective action appeared more authentic.

Specifically, Albert initially attempted denial; however, after a witness stepped forward with a similar story, his rhetorical approach quickly shifted. Facing the circumstances, Albert pleaded guilty to assault and battery. Then he sought corrective action by checking into a court-ordered treatment center. "In order to earn forgiveness, a person has to admit he did wrong. The forgiveness is coupled with a desire to mend one's ways. Albert apologized. He pleaded guilty. He went into treatment. He admitted his pain. That's the first step toward forgiveness" (Heller, 1998, p. E01).

Imus also engaged in corrective action by meeting with the players to apologize. The Rutgers University president was particularly impressed, since Imus attended a private, three-hour-long meeting with the Rutgers women's basketball team, coach, and players' parents the day after he was fired. "To his credit, Mr. Imus apologized directly and sincerely to coach C. Vivian Stringer, the team and their family members" (Giordano, 2007, p. B01). In doing so, Imus attended the meeting "not as an authority but as a learner and coparticipant in a task larger than himself, requiring both divine grace and the graciousness of those who have been offended" (Hatch, 2006, p. 203).

Mortification

Two broadcasters engaged in the apologia strategy of mortification. One came after attempting denial, whereas the other was conjoined with the rhetorical strategy of taking corrective action. Pointedly, Wright initially denied saying what was attributed to him in the newspaper. Three years later, the truth came out and he admitted to the sexist and homophobic remarks. At that point, his denial changed to mortification. Yet, it was unclear if he was mortified he said offensive comments or mortified that he got caught.

Imus's mortification appeared more authentic as he simultaneously engaged in corrective action. Specifically, the day after Imus spoke ill of the Rutgers women's basketball players, he responded to his own insensitivity. He referred to the incident as "some idiot comment meant to be amusing" (de Moraes, 2007, p. C01). Two days later Imus said, "We want to take a moment to apologize for an insensitive and ill-conceived remark we made the other morning regarding the Rutgers women's basketball team. It was completely inappropriate, and we can understand why people were offended. Our characterization was thoughtless and stupid and we are sorry" (de Moraes, 2007, p.

C01). Also, in attempts to reach out to the players and coach to apologize in person, he appeared on Reverend Al Sharpton's radio show. At that time he "offered no real defense for his statement" and said "I understand there's no excuse for it. I'm not pretending that there is. I wish I hadn't said it" (Carter, Rich, & Cathcart, 2007, p. C1).

Antapologia: Reaction and Response

"Antapologia is important because just as the specific arguments outlined in the attack are likely to provoke specific strategies in the apology, the arguments in the apology are likely to provoke certain types of discursive responses" (Stein, 2008, p. 19). This section examines discursive responses from the targeted person(s) or groups, the media organization, and the general public. Whereas the people toward whom the comments were directed varied in their responses (as to whether offense was taken), employers briefly terminated their relationship with the broadcasters. African American communities demonstrated the most disdain compared to other public segments. Nevertheless, over time, broadcasters were forgiven (but not forgotten) for their discrepancies.

Recipient Response

Broadcasters in these cases all claimed that they never intended to offend anyone. Nevertheless, in five instances individuals were offended. Snyder's comments about black people being "bred" as athletes offended not just the black community, but many people in the country. Wright offended the LPGA, its members, and female golfers in general. LPGA players such as Laura Davis and Patty Sheehan dismissed his comments, while Nancy Lopez said Wright "shouldn't be doing women's golf if he feels that way. Why doesn't he talk about all the men on the tour who fool around on their wives?" (Brodeur, 1995, p. F01). In Albert's case, he clearly hurt the woman he accosted since she filed a lawsuit. When asked if he was insulted by Limbaugh's comments, McNabb said, "Did that upset me? Yeah. It upset a whole lot of people" (Shapiro, 2003, p. A01). McNabb said earlier "it was too late for an apology" (Brookover, 2003, p. A01). Finally, many people were affronted by Imus's radio banter, including the Rutgers women's basketball team, their coach, the university, and the players' families.

In the remaining three cases, the recipients of the derogatory comments either explicitly claimed they were not offended or did not have a platform to

voice their feelings. In speaking about Cosell, for instance, Garrett said, "It doesn't offend me because Howard is always shooting off his mouth. Half the time he doesn't know what he's talking about. I think he looks like a monkey. I guess it would bother me if I heard it in person, but that's Howard" (Shapiro, 1983a, p. D6).

Similarly, Woods did not take offense. Speaking on Woods's behalf, his agent responded, "This story is a non-issue. Tiger and Kelly are friends and Tiger has a great deal of respect for Kelly. Regardless of the choice of words used, we know unequivocally that there was no ill intent" (Wickham, 2008, p. 12A).

Whereas Garrett and Woods discounted the remarks and claimed they were not slighted, Lyons's situation was slightly different. In 2004, Lyons's insensitive comments were directed toward Shawn Green, and a Dodger spokesperson said Green was not offended (Sandomir, 2006). Lyons's remarks in 2006 were directed towards the Mexican culture rather than any one person. As such, nobody from that community voiced offense. Interestingly, when Snyder made derogatory remarks regarding African Americans, several members of the community stood up and voiced their discontent to the media. Yet, when stereotypical remarks were made about the Mexican and Jewish cultures, nobody spoke on their behalf.

Media Response

Organizations are equally concerned with their image and seek to maintain public trust, confidence, and respect. "When the speaker is a sportscaster, when his words are on network television, we scurry to make amends, apologizing, denying, suspending, firing" (Remnick, 1983, p. B2). While most of the media took action, they simultaneously distanced themselves from the situations. Snyder, Lyons, Imus, and Albert were fired; ultimately, Wright did not resign; Tilghman was suspended; Limbaugh quit; and Cosell retired at the end of the season and his contract.

The severity of the offense combined with the broadcaster's record appear to shape the organizational response. That is, Snyder's and Imus's opinions were so outlandish, the media for which they worked seemingly did not have a choice but to take direct action. CBS Sports, for instance, issued a public apology one hour after the Snyder interview aired: "CBS Sports deeply regrets the remarks made earlier today to a news reporter by Jimmy (the Greek) Snyder. We find them to be reprehensible. In no way do they reflect the views of CBS Sports" (Shapiro, 1988, p. A1). After 12 years with CBS Sports' *NFL Today* and having earned between $400,000 and $500,000, he was fired one

day after his gaffe (which coincided with the end of his contract) (Goodwin, 1988, p. 1).

Imus's CBS-owned radio show was simulcast on MSNBC television. The radio station released a statement, "We are disappointed by Imus' actions earlier this week which we find completely inappropriate. We fully agree that a sincere apology was called for" (Guthrie, 2007, p. 3). MSNBC responded by saying, "while simulcast by MSNBC, 'Imus in the Morning' is not a production of the cable network . . . as Imus makes clear every day, his views are not those of MSNBC. We regret that his remarks were aired on MSNBC and apologize for these offensive comments" (de Moraes, 2007, p. C01).

During Imus's two-week suspension, eight sponsors and several guests began withdrawing support from his show, and one of the basketball players filed a lawsuit. "Where television viewers, particularly sports fans, have shown a capacity to forgive the away-from-the-playing-field antics of athletes and other sports figures, sponsors flee when anything tarnishes the programming for which they buy time" (Bruton, 1997, p. A01). CBS eventually fired Imus, and yet eight months later he was back on the air.

Albert worked as an NBA play-by-play broadcaster for NBC and as an announcer for Madison Square Network, making between $1.6 and $2 million. After he plead guilty to the misdemeanor charges, NBC fired him and Albert immediately resigned from Madison Square Network. He had one year left on his contract with NBC but had been announcing games for Madison Square Network for 30 seasons. Ten months later, Madison Square Network hired him back, and 21 months later NBC Sports rehired him as well.

CBS Sports' reaction to Wright's misdeeds was initially different but ultimately ended similarly. Rather than rush to judgment or distance themselves from him, they took him out of the next day's (Friday) broadcast of the golf tournament and called him to New York for investigation. After a five-hour-long meeting, the network backed Wright and issued a statement: "I believe that Mr. Wright made no statements that were disparaging or otherwise offensive to gays or lesbians or the LPGA. . . . [Mr. Wright and CBS Sports]. . . have been done a grave injustice" (Sandomir, 1995, p. 25). By Saturday, Wright was reinstated for the telecast. However, it did not end there. By December of that same year (1995), *Sports Illustrated* reported that "Wright had confided to friends that he did indeed make the comments . . . but they were said off the record" (Harig, 1996, p. 1C). With this new development, after Wright's 23-year tenure with the network, in January 1996, CBS Sports indefinitely suspended him, letting his contract expire—unfortunately, the prior November, CBS had just extended his contract another four years with a 30% salary increase.

Tilghman's situation was drastically different. Rather than firing her, the Golf Channel said, "While we believe that Kelly's choice of words was inadvertent and that she did not intend them in an offensive manner, the words were hurtful and grossly inappropriate. Consequently, we have decided to suspend Kelly for two weeks, effective immediately" (Ferguson, 2008, p. 11). Perhaps her close association with Woods or his dismissal of her comment lessened the repercussion; nonetheless, upon her return to the Golf Channel, viewers witnessed Tilghman's prerecorded apology.

Initially ESPN publicly responded to Limbaugh's televised opinion. In a statement, the network disclosed: "Although Mr. Limbaugh today stated that his comments had 'no racist intent whatsoever,' we have communicated to Mr. Limbaugh that his comments were insensitive and inappropriate. Throughout his career, he has been consistent in his criticism of the media's coverage of a myriad of issues" (Shapiro, 2003, p. A01). However, before ESPN took action against Limbaugh, he resigned. ESPN and ABC Sports said, "We regret the circumstances surrounding this [Limbaugh's resignation]. We believe that he took appropriate action to resolve this matter expeditiously" (Shapiro, 2003, p. A01). Essentially, Limbaugh took swift action, reducing the network's public relations crisis.

Unlike any other network in these cases, ABC did not react or respond to Cosell's gaffe. This may have been due to Cosell's "liberal reputation" (Remnick, 1983, p. B2), staunch position of intent, support by O. J. Simpson, Arthur Ashe, and Muhammad Ali, or the fact that Garrett was not offended. By the end of that season, Cosell allowed his four-year, $6 million contract to expire and he retired.

Sandler (2003, p. S4) suggested a double standard exists—that while athletes make objectionable comments frequently, announcers get fired for it. (However, in the majority of these instances, the broadcasters were reinstated after an "acceptable" period of time.) Rather than being subject to a double standard, broadcasters appear to be more expendable than athletes.

Community Response

Another aspect of antapologia is the public reaction to the apologia. In most circumstances the public seemed more upset than any person or organization; the Lyons and Albert cases were the only exceptions. For instance, for those who made derogatory remarks about African Americans, public outrage was evident. Moreover, community organizations and leaders such as the NAACP, the National Organization for Women, the Women's Media Center, Reverend Jesse Jackson, and Reverend Al Sharpton vocalized their discontent

with broadcasters' comments. The National Association of Black Journalists threatened to picket CBS Radio and MSNBC, Imus's employers. Politicians, including "more than 20 members of Congress and at least two presidential candidates called or [had] written letters to ESPN, some demanding that Limbaugh be fired or resign" (Moore, 2003, p. A19). Irrespective of Cosell's liberal reputation and position on Curt Flood, Tommie Smith, John Carlos, Muhammad Ali, Arthur Ashe, and Jackie Robinson, the Southern Christian Leadership Conference spoke out and demanded an apology. Indeed, much public protest was evident in the media when it came to broadcasters making insensitive remarks about African American athletes.

When Lyons voiced racist remarks about the Mexican and Jewish communities, the media did not report anybody speaking out or protesting—it appears that Fox reacted so quickly by firing him after the game that there was no reaction from the broader public. Years later, he was rehired with little fanfare or protest. There appears to be a differentiation when white broadcasters stereotype African Americans versus Hispanics or Jews.

As for derogatory remarks made toward lesbians, the Gay & Lesbian Alliance Against Defamation released a statement: "It's not women's breasts that get in the way of golfing, it's Mr. Wright's ignorance that gets in the way of quality sports broadcasting. Wright seems to be living in another age—the Stone Age. Without America's lesbian athletes, world-class sports would not exist" (Zavoral & Blount, 1995, p. 1C). Additionally, the Women's Sports Foundation also criticized Wright: "Sexual preference and sexuality have nothing to do with a person's performance as an athlete or professional in any field" (Sandomir, 1995, p. 25).

There was even less public discontent with Albert's indiscretions. Instead, it was more about curiosity, shock, and fascination. People speculated on Albert's innocence or guilt, but after the plea deal was announced, only a couple of articles mentioned Albert's victim (Janofsky, 1997, p. 2; "A Year After," 1998, p. 1C). The articles included comments from the National Organization for Women, the National Coalition Against Violent Athletes, and the plaintiff's attorney, Gloria Allred, who all criticized Albert for his behavior and the media for rehiring him.

Conclusion: Second Chances

Clearly American culture, and particularly sports culture, believes in second chances. Two key factors appear to contribute to forgiveness: regret and time. As long as broadcasters admit guilt and apologize, they can be redeemed. This

is particularly true if redemptive action and authenticity are present. "The bottom line is we are all human and sometimes the individual forgets that—or people around them forget that. What makes people forgiving is that you also take ownership of those imperfections" (Sweets, 1997, p. 1C).

Furthermore, regret cannot be isolated, but rather both parties must engage in the process of apologia. "What is clear is that an apology on its own does not bring about social redemption; rather, redemption is a joint work of the offender and victim coming together in apology, forgiveness, and more" (Hatch, 2006, p. 192). This was especially evident in the Imus situation where the female college basketball players displayed dignity and eloquence by accepting his apology (Reid, 2007, p. 6).

The other major factor contributing to second chances is time. "Time heals all wounds" and while Americans do not forget these memorable blunders, they apparently forgave them. As of this writing, five of these broadcasters are back in the booth, two are deceased, and only one remains banished, suggesting that perhaps golf has less tolerance than football, baseball, and basketball. "The public is more forgiving than the powerbrokers who can keep a fallen figure from returning to the limelite" (Heller, 1998, p. E01).

Despite the increased ratings provided by airing controversial shock jock, Rush Limbaugh, or telecasting Don Imus, the television networks are apparently aware of broadcasters' potential impacts, which transcend sports and influence business practices, future generations, and everyday life (Eastman & Billings, 2001). "Announcers can't excuse themselves by citing the sometimes frenetic pace of live TV. Handling that, after all, is why they get the big bucks" (Hiestand, 1996, p. 2C).

References

A year after sex scandal, Albert will be back on air. (1998, July 16). *St. Petersburg Times*, p. 1C.

Benoit, W. L. (1995). Sears' repair of its auto service image: Image restoration discourse in the corporate sector. *Communication Studies, 46*(1-2), 89-105.

Benoit, W. L., & Brinson, S. L. (1994). AT&T: 'Apologies are not enough.' *Communication Quarterly, 42*(1), 75-88.

Brodeur, J. (1995, May 13). Golf analyst under fire for making derogatory comments. *The Oregonian*, p. F01.

Brookover, B. (2003, October 2). Limbaugh quits ESPN job: Resignation follows comments on McNabb. *The Philadelphia Inquirer*, p. A01.

Bruton, M. (1997, September 26). Albert fired after pleading guilty: The NBC sportscaster accepted a charge of assault and battery, prosecutors dropped one of forcible sodomy. *The Philadelphia Inquirer*, p. A01.

Bryant, J., Comisky, P., & Zillman, D. (1977). Drama in sports commentary. *Journal of Communication, 27*(3), 140-149.

Byrd, J., & Utsler, M. (2007). Is stereotypical coverage of African-American athletes as 'dead as disco'? An analysis of NFL quarterbacks in the pages of *Sports Illustrated. Journal of Sports Media, 2*(1), 1-28.

Carter, B., Rich, M., & Cathcart, R. (2007, April 10). Don Imus suspended from radio show over racial remarks. *The New York Times*, p. C1.

CBS announcer denies controversial comments about LPGA. (1995, May 13). *The Oregonian*, p. F01.

CBS president stands behind Wright. (1995, May 13). *The Charleston Gazette*, p. P.

Daddario, G. (1998). *Women's sport and spectacle: Gendered television coverage and the Olympic Games.* Westport, CT: Praeger.

de Moraes, L. (2007, April 7). Sorry excuses: MSNBC's form apology. *The Washington Post*, p. C01.

Denham, B. E., Billings, A. C., & Halone, K. K. (2002). Differential accounts of race in broadcast commentary of the 2000 NCAA Men's and Women's Final Four basketball tournaments. *Sociology of Sport Journal, 19*(3), 315-332.

Dufur, M. (1998). Race logic and 'being like Mike': Representations of athletes in advertising, 1985-1994. In G. A. Sailes (Ed.), *African Americans in sport: Contemporary themes* (pp. 67-81). New Brunswick, NJ: Transaction.

Eastman, S. T., & Billings, A. C. (2001). Biased voices of sports: Racial and gender stereotyping in college basketball announcing. *Howard Journal of Communications, 12*(4), 183-201.

Ferguson, D. (2008, January 11). Golf Channel view 'lynch him' jibe at Woods as foul play. *The Herald*, p. 11.

Giordano, R. (2007, April 14). Team accepts Imus' apology after long meeting with him. *The Philadelphia Inquirer*, p. B01.

Goodwin, M. (1988, January 17). CBS dismisses Snyder. *The New York Times*, Sec. 1, p. 1.

Goss, B. D., Tyler, A. L., & Billings, A. C. (2010). A content analysis of racial representations of NBA athletes on *Sports Illustrated* magazine covers, 1970-2003. In H. L. Hundley & A. C. Billings (Eds.), *Examining identity in sports media* (pp. 173-194). Thousand Oaks, CA: Sage.

Guthrie, M. (2007, April 7). Imus have been nuts: Radio jock Don Imus apologies for calling Rutgers women hoopsters 'nappy-headed hos.' *Daily News*, p. 3.

Hardin, M., & Whiteside, E. (2010). The Rene Portland case: New homophobia and heterosexism in women's sports coverage. In H. L. Hundley & A. C. Billings (Eds.), *Examining identity in sports media* (pp. 17-36). Thousand Oaks, CA: Sage.

Harig, B. (1996, January 10). Wright dropped by CBS. *St. Petersburg Times*, p. 1C.

Hatch, J. B. (2006). Beyond apologia: Racial reconciliation and apologies for slavery. *Western Journal of Communication, 70*(3), 186-211.

Heller, K. (1998, July 19). A nation's forgiveness: It depends/what you do seems to matter more than what you did. *The Philadelphia Inquirer*, p. E01.

Hiestand, M. (1996, March 4). 'Monkey' comment reverberates. *USA Today*, Sports, p. 2C.

Hiestand, M. (2003, October 2). McNabb: Limbaugh comments 'shocking.' *USA Today*, p. 1A.

Hundley, H., & Billings, A. C. (2010). *Views from the fairway: Media explorations of identity in golf.* Cresskill, NJ: Hampton.

Janofsky, M. (1997, September 28). Marv Albert pleads guilty. *The New York Times*, Sec. 4, p. 2.

Jerome, A. M., & Rowland, R. C. (2009). The rhetoric of interorganizational conflict: A subgenre of organizational apologia. *Western Journal of Communication*, 73(4), 395–417.

Kramer, M. R., & Olson, K. M. (2002). The strategic potential of sequencing apologia stases: President Clinton's self-defense in the Monica Lewinsky scandal. *Western Journal of Communication*, 66(3), 347–368.

Lapchick, R. E. (Ed.). (1996). *Sport in society: Equal opportunity or business as usual?* Thousand Oaks, CA: Sage.

Ling, D. A. (1970). A pentadic analysis of Senator Edward Kennedy's address to the people of Massachusetts, July 25, 1969. *Communication Studies*, 21(2), 81–86.

Lipsyte, R. (1997, October 19). Backtalk: Violence, redemption and the cost of sports. *The New York Times*, Sec. 8, p. 13.

Lupica, M. (2007, April 13). 3 big words: Imus is fired: CBS quiets shock jock, but storm won't go away. *Daily News*, p. 82.

McLeman, N. (2008, January 10). Apology for Tiger 'lynching.' *The Mirror*, p. 63.

Messner, M. A. (2002). *Taking the field: Women, men, and sports*. Minneapolis, MN: University of Minnesota Press.

Moore, A. (2003, October 3). Limbaugh offended America. *The Philadelphia Inquirer*, p. A19.

Mueller, A. G. (2004). Affirming denial through preemptive apologia: The case of the Armenian genocide resolution. *Western Journal of Communication*, 68(1), 24–44.

Rada, J. (1996). Color blind-sided: Racial bias in network television's coverage of professional football games. *Howard Journal of Communications*, 7(3), 231–240.

Reid, T. (2007, April 14). The fall of two American icons who pushed their luck too far. *The Times*, p. 6.

Remnick, D. (1983, December 26). Blunders that rebound on us all. *The Washington Post*, p. B2.

Rubin, R. (2006, October 15). Fox fires Lyons for remarks. *Daily News*, p. 64.

Sandler, J. (2003, October 3). Remarks follow time-honored sports tradition: Slurs 'commonplace': Athletes rarely suffer consequences; others, not so lucky. *National Post*, p. S4.

Sandomir, R. (1995, May 13). Golf: Golf reporter and CBS deny remarks on lesbianism. *The New York Times*, Sec. 1, p. 25.

Sandomir, R. (2006, October 14). Fox fires baseball analyst over ethnic comments. *The New York Times*. Retrieved from http://www.nytimes.com/2006/10/14/sports/baseball/15lyonscnd.html

Shapiro, L. (1983a, September 6). Cosell's remark raises ire. *The Washington Post*, p. D6.

Shapiro, L. (1983b, September 7). Come on, Howard, say you're sorry. *The Washington Post*, p. C1.

Shapiro, L. (1988, January 16). 'Jimmy the Greek' says Blacks are 'bred' for sports: Television interview causes furor. *The Washington Post*, pp. A1, A10.

Shapiro, L. (1991, March 1). The Greek says he's not done, in search of redemption from CBS. *The Washington Post*, p. C3.

Shapiro, L. (2003, October 2). Limbaugh quits TV job under fire: Remarks on NFL's Donovan McNabb spark racial controversy. *The Washington Post*, p. A1.

Shifflett, B., & Revelle, R. (1996). Gender equity in sports media coverage: A review of the *NCAA News*. In R. E. Lapchick (Ed.), *Sport in society: Equal opportunity or business as usual?* (pp. 237-243). Thousand Oaks, CA: Sage.

Sisk, R., Galvin, T., & Hester, J. (1997, September 23). Sordid tale of Marv's sex life: Called fan of three-way and lingerie. *Daily News*, p. 2.

Solomon, G. (1988, January 17). 'Jimmy the Greek' fired by CBS for his remarks. *The Washington Post*, p. A1.

Stein, K. A. (2008). Apologia, antapologia, and the 1960 Soviet U-2 incident. *Communication Studies*, 59(1), 19-34.

Sweets, E. (1997, September 29). Falling from grace: Will the public forgive Marv Albert? It could happen. *The Dallas Morning News*, Today Section, p. 1C.

Theye, K. (2008). Shoot, I'm sorry: An examination of narrative functions and effectiveness within Dick Cheney's hunting accident apologia. *Southern Communication Journal*, 73(2), 160-177.

Thompson, P. (2008, January 11). Presenter faces sack over 'lynch Tiger' jibe. *Daily Mail*, p. 11.

Tollefson, M. M. (2000). 'Anonymous' Joe Klein and *Newsweek*: Individual and corporate apologia. *Qualitative Research Reports in Communication*, 1(3), 58-64.

Ware, B. L., & Linkugel, W. A. (1973). They spoke in defense of themselves: On the generic criticism of apologia. *Quarterly Journal of Speech*, 59, 273-283.

Wenner, L. A. (1989). *Media, sports, & society*. Newbury Park, CA: Sage.

Wickham, D. (2008, January 15). Tiger was too quick to dismiss lynching comment. *USA Today*, p. 12A.

Zavoral, N., & Blount, R. (1995, May 13). CBS defends Wright's comments on lesbians. *Star Tribune*, p. 1C.

Don Cherry and the Cultural Politics of Rock'em Sock'em Nationalism: Complicating the Hero-Villain Binary in Canada

Jay Scherer
Lisa McDermott

And let's not forget Don Cherry, an affectionate target of my father's pen. Once the Boston Bruins coach, now a television commentator, he is known in Canada not least for his outrageous, over-the-top plaid suits—and, in my father's words, for having been hockey's patriotic xenophobe, forever railing against 'chickenshit foreign commies taking away hockey jobs that rightfully belong to our own slash-and-grab Canadian thugs.' These European players, in Cherry's view, insisted on wearing masks, protecting their teeth and otherwise dragging down the game's fine traditions. (Richler, 2002, p. xv)

It is difficult to imagine a more popular yet polarizing figure in Canadian popular culture than the Canadian Broadcasting Corporation's (CBC) enigmatic hockey commentator, Don Cherry. His popularity can be evidenced by the *Canadian Press'* (national wire service) remit to record *Coach's Corner* every Saturday and publish any controversial remarks made by Cherry (Burnside, 2009); his ranking as the 7th greatest Canadian in the CBC's 2004 television special, *The Greatest Canadian*, ahead of Sir John A. Macdonald (Canada's first Prime Minister), Alexander Graham Bell, and iconic hockey player Wayne Gretzky; or his selection as Canada's "Most Beautiful Mind" in a 2005 poll by the right-leaning *National Post*, as Canada's leading public intellectual.

A career minor league hockey player—Cherry played only one National Hockey League (NHL) game—Cherry's modestly successful coaching career drew to a close in 1980, when he was hired as a studio analyst and commentator for the world's longest running sports program, *Hockey Night in Canada* (HNIC). Beginning in 1981, Cherry has hosted *Coach's Corner* during the first

intermission, initially with Dave Hodge and, since 1987, with Ron MacLean. Cherry's pronouncements during this segment, which now regularly extend beyond hockey to include contemporary social and political issues, have become a central part of the rhythm of watching hockey on Saturday night for many "ordinary" Canadian fans.

However, as the opening quote from Noah Richler (son of celebrated but controversial Canadian author, Mordecai Richler) suggests, Cherry's commentary has garnered him a reputation as an "over-opinionated," "outrageous buffoon" and "national embarrassment" ("Communication to the Office," 2003; 2010) in many corners of the country. Still, other constituencies have widely embraced the flamboyantly dressed commentator as a Canadian icon "who gives voice to their own feelings and prejudices" (Gruneau & Whitson, 1993, p. 187). For many, including this online commentator,

> He seems like a national hero because he is. Don Cherry is the best thing going in the hockey media. . . . [H]e never sits on the fence and gives his opinion with incredible authority. He'll either end up being extremely right or very wrong, and most of the time he is right. . . . [T]he best and most controversial part is his nationalism. The infamous anti-Russian rants are his trademark, and only made him more popular over the years. He is behind Canada 100% all of the time no matter what. . . . I could go on about more, including his fashion sense, his support of the troops, and his suggestions for game-changes. . . . Cherry is the Don of the hockey world, LOVE HIM! ("What Makes Don," 2009)

Lauded through this posting (in response to the question: "What makes Don Cherry so special?") are the personal characteristics admired by those Canadians supportive of Cherry's elevated cultural status as a representative of the nation: his championing of a preferred "Canadian" style of aggressive hockey and a related macho-nationalistic self-image, his "tell-it-like-it-is" persona, and his unwavering support and honoring of the Canadian Forces (CF). As the noted Canadian author, journalist, and hockey aficionado, Roy MacGregor (1992a) once remarked, for his supporters Cherry has effectively "become the Prime Minister of Saturday night, a voice . . . so popular that hockey has become the only television sport where the audience goes up during the intermission" (p. A1).

Now in his late 70s, Cherry continues to identify proudly as "the Anglo redneck of all time" (MacGregor, 1993, cited in Gillett, White, & Young, 1996, p. 65). Or, as Knowles (1995) has pointed out, Cherry speaks in a conspicuously performative male, class-coded accent "on behalf of (according to Cherry) the working class guy [who] goes to church, pays his taxes, works all day, (sic) he's the silent majority that never has a voice," (Voisin, 2010) having been run roughshod over by vocal minorities (MacGregor, 1992b), an ines-

capably pejorative term when deployed by Cherry. Yet, despite his self-representation as the voice of the "majority" of "ordinary" Canadians, Cherry readily acknowledges other constituencies for whom he does not speak, including "a lot of mothers and women who don't like" his weekly pronouncements (Brunt, 1987, p. C1), as well as "professors [read 'left-wing pinkos'] and the guys who drink Perrier water and white wine [read feminized males]" (Maki, 1992, p. F1).

Our interest in this chapter is to examine Cherry's use of his CBC platform to voice a range of traditional values and neoconservative, populist ideas: promotional practices that are now habitually articulated by the Right as it debates what it means to be a "true" Canadian in a neoliberal era. That this occurs via the public broadcaster is all the more telling in light of both CBC President Hubert LaCroix's elucidation of its mandate "to ensure that the information we put out is fair and unbiased in everything we do" (Althia, 2010), and the regular incriminations leveled by conservatives against the CBC for having a left-wing bias. Moreover, Cherry's heavily mediated persona, along with hockey's ubiquity more generally, have increasingly become key sites in the cultural war being waged by the Conservative Party (CP) and its leader, Prime Minister Stephen Harper, in an attempt to pin down what it means to be an "ordinary Canadian" and to legitimate particular cultural values emanating from that representation (Scherer & McDermott, 2011).

The connections between hockey and a host of Canadian myths are so familiar that the game's place in national popular culture and its capacity to define an imagined national character are regularly understood as natural extensions of the Canadian psyche and landscape. Still, the meanings attached to the sport of hockey and Canadian identity need to be understood as part of much broader struggles "to define a 'national common sense' not only about such abstractions as democracy and justice, but also about everyday relations between social classes, men and women, work and leisure, asceticism and pleasure" (Gruneau & Whitson, 1993, pp. 252–253). To this end, we argue that Cherry's weekly *Coach's Corner* segment functions as a strategic site to (re)produce "a social hegemony around *what it means* to be an average Canadian individual. He literally coaches our identity" (Ani, 2010) in terms of what he judges to be fundamental Canadian values, which for Cherry are quintessentially represented through hockey. Significantly, Cherry's enduring performance of this version of Canadian-ness is conspicuously neoconservative, individualistic, neoliberal in its entrepreneurial spirit, highly masculinized and sexist. It also comes from, as Knowles (1995) has noted, a "moral and political centre [located] in small-town Canada, where men are

men, boys will be boys, and hockey remains the domain of the (white) male English-Canadian working class" (p. 123).

Of course, none of these ideological meanings can be automatically guaranteed. Furthermore, it is Cherry's polarizing approach to cultural values—and his recalcitrance about moderating his views—that helps to explain the visceral reactions he provokes amongst Canadians. This is a group, McParland (2010) suggested (albeit tongue-in-check), that is increasingly divided not in terms of French versus English, or East versus West, but anti-Don Cherry versus pro-Don Cherry. McParland made this comment in response to the public reaction to a speech Cherry made at the late 2010 inauguration of Toronto's new mayor, where he digressed to lob shots at "left-wing pinkos . . . that ride bicycles" ("Don Cherry's Speech," 2010).

It is against the backdrop of these divisions that we interrogate Cherry's cultural significance in terms of the hero-villain binary logic he elicits from different constituencies of Canadians. We focus on two areas within the Canadian sociopolitical landscape about which Cherry has repeatedly offered polemical commentary: the status of French-Canadians within the nation and military engagements of the CF.

The French Connection

One of the first public instances where Cherry expressed his political views about French-speaking Canadians occurred during the first intermission of the 1998 Winter Olympic Gold Medal game between Russia and the Czech Republic in Nagano, Japan. It was on this occasion that Suzanne Tremblay, the Bloc Quebecois Member of Parliament (the Bloc Quebecois is a federal political party whose primary objective is to promote Quebec's interests with a view to seceding from Canada) drew Cherry's ire after she complained that too many Canadian flags were on display at the Canadian Pavilion.

Ron MacLean (RM): The Member of Parliament from Rimouski complained that the Quebec athletes were under tremendous pressure because there are so many Canadian flags.

Don Cherry (DC): Well. Are they Canadian?. . . . Yeah. They are Canadian. They're under pressure . . . because they're so many Canadian flags. How do you figure that?

RM: Her point is that all this flag waving creates such a sense of expectation that you're supposed to do it for your country . . .

DC: You know what it is. They [all Quebeckers] don't like the Canadian flag. You know it's a funny thing. They don't want the Canadian flag . . . but they want our money. They don't

mind our money. We bail them out and that. They've got the Canadian flag on the dollar. You know I've never seen such a bunch of whiners in my life. First of all we start . . . the whole Olympics on a bad note because there's not enough French at some party we have. And then we pick a French guy [to carry the flag]—some skier that nobody knows about.

RM: No. Jean-Luc Brassard is a gold medal winner from the last Olympics. But he did say it threw out his training . . .

DC: And he complains he doesn't want to do it. And now we have the complaint there's too many Canadian flags around. You know *these people* are the whiners of the. . . . If they want to leave why don't they leave. That's it about that. Now talking about *good* Canadians come on in here. [Cherry and MacLean then introduced four players from Canada's silver-medal winning Women's Hockey Team, all English-speaking Canadians. Emphasis added].

In response to this segment, the CBC's Office of the Ombudsman received two letters in support of Cherry's commentary, and 23 letters of complaint from Canadians who characterized Cherry's remarks as "racist," "offensive," and "intolerable." Other writers took issue with the fact that their tax dollars were paying for Cherry's public invectives. As one Victoria, British Columbia (BC) writer asserted:

Like most Canadians, I do not much care about Don Cherry and what he has to say or what he believes. What I do care about, however, is that Don Cherry not inflict his racist and offensive opinions on my (as citizen, taxpayer) nickel. Please, have Don Cherry apologize and then let him go back to talking about hockey, which is what he's supposed to do. (Isn't it?) ("Communication to the Office," 1998b)

Making sense of Cherry's comments, and the reactions he provoked, requires further contextualization on three fronts. First, in 1995, a provincial referendum occurred in Quebec over whether to secede from Canada and form an independent state. After pleas from federalists and sovereignists alike, the motion was defeated by the narrowest of margins with 49.42% of Quebeckers voting "Yes" versus 50.58% voting "No" to secession. Cherry's comments, arguably, offer an indication of the anger felt in some parts of English-Canadian society—particularly Western Canada—towards French separatists, and more generally provincial power relations and the politicized issue of equalization payments from richer to poorer provinces, with Quebec being on the receiving end of such payments.

Second, Cherry took issue with complaints made by several French-language sports writers leveled at the Canadian Olympic Association (COA) over the lack of French spoken at the welcoming reception for Canadian

athletes. Significantly, several English-language sports writers, as well as then Foreign Affairs Minister Lloyd Axworthy and Heritage Minister Sheila Copps, also raised this concern, further substantiating the French-language press' claims regarding the lack of fair representation of both official languages. In response to these objections the COA publicly apologized for the lack of French.

From Cherry's perspective, however, the COA's response was yet another example of "vocal minorities" figuratively beating the "silent majority" into submission. Cherry's views on the balancing of official languages, and his defense of English as the only "legitimate" Canadian language, however, were already well known through prior incidents, as when he lauded Anglophone residents of Sault Ste. Marie (a city with a significant francophone population) for speaking "the good language" ("The Don Cherry Lexicon," 2011), and when, in 1997, he publicly decried the unfairness of federal government funding of the Alberta Francophone Games, participation in which is restricted to French speakers (Dallaire & Denis, 2000).

Finally, at the 1998 Olympic Games, Cherry also took issue with comments made by the defending moguls champion, Jean-Luc Brassard, who, after finishing a disappointing fourth at the Games, admitted that he regretted having accepted the invitation to be Canada's flag-bearer, as it disrupted his preparations for his event. Brassard had also criticized the COA for "festooning the Canadian quarters in the Olympic village with Canadian flags and for putting up a banner with the words 'Through these portals pass the world's greatest athletes,'" which he felt "showed a lack of respect for the Japanese culture" (Bazay, 1998, p. 4). Ironically, at the heart of Brassard's concerns was the very issue precipitating Cherry's attack on French-Canadians: what it means to be a Canadian. While Cherry's version encompassed a U.S.-style, populist patriotism expressed assertively and unwaveringly, Brassard's interpretation offered a stark contrast: "I think Canada used to be well known for the fact that the people in this country are very humble and have lots of humility. Getting there and seeing so many flags surprised me. I was not used to that" (Bazay, 1998, p. 6). Brassard's perspective was one shared by many Canadians, evidenced by the findings of the CBC Ombudsman, David Bazay (1998): "His [Brassard's] remarks strike me as pretty conventional, old-fashioned Canadian discourse: Let's not behave as if we were Americans; let's be nice, polite, discreet and respectful Canadians abroad; and let's display our true colors on the playing field" (p. 5).

The Cherry-Brassard incident points to the difficulty of attempting to pin down an essentialized understanding of Canadian identity. Still, the *effect* of Cherry's comments served to promote a "narrowly conceived fraction of the

[Canadian] identity portrait" (Dallaire & Denis, 2000, p. 420) that steered the English-speaking majority of Canadians toward a negative view of Francophones regarding their presence and position as a minority group within the Canadian mosaic. These diatribes were far-ranging beyond the Nagano incident. Cherry's lumping French-Canadian hockey players with European ones as "cowards" with "zero heart" caused such public outcry that the CBC instituted a seven-second delay to give producers time to prevent "inappropriate and reprehensible personal" comments ("CBC Puts Cherry," 2004). Cherry's diatribes also worked to consolidate a socially conservative U.S.-style populism, "often insensitive to internal differences" (Knowles, 1995, p. 124), that emerged in Canadian politics in the late 1980s through the Reform Party, which has metamorphosed into the current ruling CP. The Reform Party was widely noted for its rejection of official bilingualism, any special status for Quebec in the Canadian constitution, social conservatism, and a fiscal conservatism committed to eroding the commons.

Cherry was well aware of these broader political developments and consciously promoted these values. As Cherry opined over two decades ago, "I slowly see the middle class is turning right wing. . . . People are just fed up with all the socialism. I think I cater to the right wing of the country. I don't like foreign hockey players. I made a choice. I'm not going to go middle of the road" (Brunt, 1987, p. C1).

By the early 1990s, these nascent political shifts were further solidifying. As MacGregor noted (1992a),

> just as Cherry predicted it would, the world began changing rather dramatically. His opinions began to sound more like the political philosophy of the Reform party—or as he would rather put it, the Reform party began catching up to him. (p. A1)

It is precisely this brand of conservative populism that has become normative within contemporary Canadian society. Understood against this cultural and political backdrop, Cherry's comments about "them," the number of flags at the Canadian Pavilion, the lack of French language at a welcoming reception for the athletes, and mogul skier Jean-Luc Brassard, were/are thus far from benign. Rather, they perform(ed) tangible social and cultural work that finds traction with a particular segment of the population that pines for a past "when Anglo-Canadian sentiments dominated the socio-political landscape unchecked" (Elcombe, 2010, p. 210).

Support the Troops

Cherry's commentating at the 1998 Winter Olympics was also noteworthy on another topic that has become intertwined with his *Coach's Corner* segment, and more generally with the NHL in Canada: military engagements of the CF. During the first intermission of the Canada-Czech hockey game, Cherry voiced his support of the ongoing U.S. efforts against Saddam Hussein, remarks that caught many hockey fans off guard, including this letter writer:

> It is appalling to see knee-jerk political commentary on any CBC program, but it is even more disturbing to see it in such an unlikely venue as the coverage of an Olympic hockey game. . . . Cherry . . . spew[ed] a predictably jingoistic tirade about how ungrateful and critical everyone is until they need American help and how fortunate we all are to have the Americans around to protect us from evil: all the usual claptrap. ("Communication to the Office," 1998a)

In response to his public promotion of an impending U.S. military assault on Iraq, another letter writer complained that: "if the CBC was giving Don Cherry a platform to state his political views during hockey games, the CBC should give others the opportunity to state their political views as well" (Bazay, 1998, p. 6). CBC Ombudsman, David Bazay, agreed with the complainants:

> As the CBC policy book states, in the section on balance, "CBC programs dealing with matters of public interest on which differing views are held must supplement the exposition of one point of view with an equitable treatment of other relevant points of view." So in future the CBC should take the necessary steps to ensure that guest commentators in sports programming who pass judgment on public affairs respect the Corporation's policy which states that "the CBC's concern is to ensure the presentation of a wide spectrum of opinion, particularly when the matter is sharply controversial" (Bazay, 1998, p. 6)

Central to Cherry's conservative populism has been an unwavering endorsement of the military and a "return" to a version of Canadian foreign policy reproducing the geopolitical interests of its closest allies: the US and Britain. Most recently Cherry has utilized his *Coach's Corner* platform to laud various military interventions—including Canada's ongoing role in the U.S.-led "War on Terror"—and to memorialize Canadian soldiers who have died in Afghanistan. For some Canadians, including the following "Letters to the Editor" writer, Cherry's promotion of Canadian soldiers as heroes and his support for a more muscular military presence has led to his own veneration:

> I think Don Cherry is on the mark with a lot of things, one being the tribute to the fallen soldiers. It is obvious that . . . he is sincere about his sadness in their deaths, and his pride in our troops in general. If we had more like Don Cherry this country would have a stronger military, and more pride and respect for our Armed Forces.

Let's see more support for our troops and the military as a whole . . . [and as] a way to show some national pride. (Cooper, 2009)

However, this kind of admiration for Cherry's militarization of hockey is cast against other Canadians for whom such acts are seen as exploitation of the Canadian military in an effort to promote a particular moral vision for the country:

He shows us a version of the military that "plays to win," busts the chops of the foes and grits it out on the plains of Kandahar Province just like the quintessential Canadian hockey player that we should all aspire to be. . . . Cherry dishonors the Canadian Armed Forces by piggybacking on their valor in order to make overt political statements about the essence of what *he* considers is Canadian culture. (Ani, 2010)

What becomes clear, regardless of whether he is seen as a hero or a villain, is that Cherry exists as a central figure in the broader mediated "frame of war(s)" (Butler, 2009) through which Canada's divisive presence in Afghanistan is morally regulated. Despite the CBC ombudsman's rebuke of his inappropriate use of the role of public broadcaster to convey his militaristic, pro-US stance over ten years ago, Cherry has continued to take advantage of this platform to offer an uncontested interpretation of political debates associated with the recent war in Iraq and Canada's presence in Afghanistan. On March 17, 2003, then Prime Minister Jean Chrétien announced that Canada would not participate in Iraqi military operations, a decision that was publicly assailed by Cherry. During a March 22, 2003 episode of *Coach's Corner*, host Ron MacLean, who defended Canada's decision not to join the war, asked Cherry "Why attack Iraq if they have not attacked you?" Cherry responded by scolding MacLean (and other like-minded Canadians) for the "lack of support to our American friends," while lamenting how he "hate[d] to see them go it alone" ("*Coach's Corner* on Iraq," 2003). During the same episode, Cherry also indicted "those jerks [Montreal Canadiens fans] in Quebec [who] boo[ed] the [American] national anthem" prior to a game between the Canadiens and the New York Islanders at the Bell Centre. (It is important to note that the U.S.-led invasion of Iraq—and later Canada's presence in Afghanistan—have been widely critiqued in Quebec where, historically, French Canadians have opposed "Canada's involvement in Anglo-American military operations that they saw as 'imperial adventures'" (Stein & Lang, 2007, p. 71).) For Cherry, though, the actions of those fans were shamefully embarrassing and, in his opinion, "years of pride went down the drain" (cited in Dowbiggin, 2008, p. 124). Of course, one could also argue that Cherry's comments about Habs' fans were but another example of the French-English tension he foments.

Following these outbursts, the CBC received over 1,500 phone calls and emails, as well as complaints to the CBC Ombudsman: 60% were opposed to Cherry's views (Christie, 2003). Cherry and MacLean's political foray was dubbed uninformed and irrelevant by network executives who, again, sternly reminded the duo to restrict their discussions to hockey. The following day Cherry fumed about his treatment on the *Jim Rome Show*:

> You have to realize the CBC is government owned. . . . You have to say the government was against it [the war], and I'm for it, and I'm on a government program. I really thought this could be the end. Our media up here is totally left wing. It's socialist, left wing, pinko, commies. . . . The true Canadians do not feel the way they do in Quebec there. Believe me, the majority of people in Canada love the United States. We know you'd be there to help us and don't think too bad of us. It's just a damn shame [Canadiens fans] had to boo the "Star Spangled Banner" in Quebec. You have to realize, it's Quebec and it's French Canadians. (cited in Dowbiggin, 2008, pp. 125–126)

Here on display was Cherry's full arsenal of essentializing, binary classifications of contemporary Canadian society: true Anglo-Canadians versus French-Canadians; the silent majority versus the vocal minority; biased, socialist (government) media versus "objective" (private) media. Regarding Cherry's characterization of the Canadian media as "socialist," we can only presume the extent to which key players in the Canadian media—where the rate of corporate concentration of media ownership is amongst the highest in the world— would have been bemused by their new, left-wing identity.

While these types of overt, political statements have subsided somewhat in recent years, Cherry has consistently referenced the CF as *heroic* Canadians while promoting a particular vision of Canadian identity and common culture. Canadian readers will be well aware of the sheer volume of images on *Coach's Corner* that articulate the CF with hockey and other gendered elements of national popular culture—pictures of "ordinary" Canadian military "boys" in Afghanistan playing hockey (at times with former NHL players), posing next to the Stanley Cup, or watching telecasts of NHL games. It is, in part, through these familiar images and patriotic themes that the controversial presence of the CF in Afghanistan has been morally regulated and, indeed, depoliticized.

These promotional tactics have, however, not gone entirely uncontested. Most recently, the group, *Hockey Fans for Peace*, was formed in response to Cherry's militarization of HNIC. As one member of the group argued, "*Coach's Corner* has been used to really give a one-sided platform to talk about the war only in full support. And when Don Cherry makes political comments during the hockey broadcast, he's never challenged. . . . I think he's giving a very biased perspective and he's invoking the soldiers as a way of promoting

the war" ("*Coach's Corner* Faces," 2011). Underlining this point, the nationalistic images featured on *Coach's Corner* have been regularly linked by Cherry and conservative politicians to a broader political discourse that encourages Canadians to unquestioningly "support our troops"—a discourse that frames those who raise critical questions about Canadian foreign policy and military involvement in Afghanistan as un-Canadian, and as failing to *support* the troops and their families (see McQuaig, 2007; Scherer & Koch, 2010).

One of the most vocal media critics of these political machinations has been *The Globe and Mail's* television columnist, John Doyle. While perhaps discounting the long-standing associations between hegemonic masculinity, hockey, the military, and Canadian identity, Doyle has consistently challenged Cherry and the CBC for further naturalizing these links in the context of the ongoing militarization of Canadian society and the promotion of a revitalized, conservative political agenda in the new millennium.

> [The] CBC is complicit in the unsubtle shifting of the meaning of hockey in Canadian life—from being emblematic of a culture of survival to an offshoot of the military, with an underlying meaning that has something to do with Canada being a warrior nation. Hockey is a fast, beautiful and thrilling game. Some say that hockey is part of the lifeblood of the Canadian culture precisely because it's about survival on the hard, unforgiving ice in the face of the eternal enemy of the elements. Now it's about soldiers, war, warriors and the acceptance of death after death in war. (Doyle, 2010a, p. R3)

Predictably, the CBC denies any role in this type of ideological shift. As the CBC's director of sports explained in relation to Doyle's critique: "If he thinks we sit around thinking that this is what we want to do with the show, it leaves me lost for words as to how anybody could imagine that that's what we've set out to do" (David Masse, personal communication, July 15, 2010). The network executive did, however, acknowledge the value of Cherry as a promotional tool for the public broadcaster:

> I think when a public broadcaster stops providing an opportunity for different opinions to be heard, they stop being relevant and they become "beige" and they should be shut off. I'm not saying we're endorsing his opinion or not, I'm just saying that public broadcasters need to stay out of the corners and be prepared to allow voices to be heard. (David Masse, personal communication, July 15, 2010)

It is ironic that the CBC would defend Cherry's military promotions based on arguments of presenting diverse opinions on the public broadcaster. This is the very terrain upon which Cherry, and by extension CBC Sports, were rebuked ten years earlier by the CBC ombudsman. It remains, moreover, the very terrain that the two parties refuse to ensure: *Hockey Fans for Peace's*

call "to allow one of its members to debate Cherry during . . . Coach's Corner" ("*Coach's Corner* Faces," 2011) has been rejected by CBC Sports as being an inappropriate "forum for that kind of debate" ("*Coach's Corner* Faces," 2011). Beyond this, we have to question whether the public broadcaster's mandate is to be "colorful" and controversial—like so many other private networks in Canada and the US—or to provide informative, balanced analyses of key political issues. Nevertheless, these kinds of tensions speak volumes about the extent to which the CBC is dependent on Cherry's popularity and subsequent audience ratings within an expansive promotional culture and digital broadcasting landscape.

The deaths of 157 Canadian soldiers in Afghanistan have, of course, cut through the antiseptic depictions of military service that regularly feature on *Coach's Corner*. In these instances, Cherry has publicly mourned each soldier by solemnly providing a brief obituary noting, for example, if they were a hockey player or fan of a particular NHL team. To commemorate Remembrance Day in 2010, for example, Cherry aired a picture of every Canadian soldier killed in Afghanistan alongside images of Canadian professional hockey players who had been killed in other wars and a clip of Canadian soldiers playing hockey in Europe in 1941. In so doing, Cherry simply remarked that: "hockey players and the military are the same . . . just Canadians being Canadian."

It is during each of his memorials, however, that we can witness the implosion of Cherry's binary-informed understandings including his long-standing degradation of French Canadians as being "un-Canadian" whiners. Serving in Afghanistan have been soldiers from the Royal 22nd Regiment, the "Van Doos" (the most famous Francophone regiment in the CF, based out of Quebec City). Since their deployment, a number of the Van Doos have been killed, and, in paying tribute to each of these soldiers, Cherry has been forced to acknowledge an irreconcilable position—his long-standing peevishness towards French Canadians, and the sacrifices made by Francophone soldiers who have died serving their and *his* country in Afghanistan. For Cherry, it is only through military service and through death that these soldiers regain their metaphorical citizenship and can, in turn, be nationally grieved.

Conclusion

In this chapter we have examined how Canadian hockey commentator, Don Cherry, complicates the hero-villain binary often utilized to make sense of popular sports figures. Undoubtedly, Cherry's veneration as a hero amongst

some constituencies of Canadians is directly linked to the thirty-year, public pulpit the CBC has afforded him through his *Coach's Corner* segment. Yet, through this same platform, Cherry has also willingly earned—and embraced—a reputation as "a loud mouth bigot who uses his position to spout his own brand of red neck viciousness disguised as national pride" ("Communication to the Office," 2003).

Throughout our discussion, we have briefly mapped this visceral reaction to Cherry as well as the simultaneous hero veneration and villain denouncement that he provokes across the country in relation to two divisive areas within the Canadian sociopolitical landscape: the status of French-Canadians within the nation, and the military engagements of the CF. Here we have argued that Cherry's *Coach's Corner* segment operates as a key circuit of promotion for a host of conservative values that are part of a much broader, cultural struggle being actively agitated by the CP with a view to normatively shifting the Canadian social and political center to the right. Indeed, it is ostensibly through his weekly commentary that Cherry's self-promotion as an "ordinary, working class guy"—Cherry's HNIC salary is upwards of $800,000 ("Plenty of Cash," 2007), not to mention his other lucrative endorsements— and his advocacy of a particular brand of English-Canadian nationalism and militaristic patriotism have provided tremendous promotional value for the ruling Right as it attempts to solidify further its neoliberal agenda and naturalize what it means to be an "ordinary" Canadian—and necessarily the attendant cultural values emanating from such an imaginary (Scherer & McDermott, 2011).

The final point that we want to emphasize, though, is the role of the media—in this case Canada's public broadcaster—in providing Cherry with an ongoing platform to promote his political vision of the country. For many years now, the CBC has abdicated its own mandate by not allowing alternative viewpoints to be expressed on HNIC, as well as semantically disassociating itself from the effects of Cherry's conservative invective. For example, according to CBC's Head of Media Relations, Jeff Keay, from the Corporation's perspective Cherry "is on contract with *Hockey Night in Canada*, not a full-time employee of CBC. 'His actions have nothing to do with either CBC or *Hockey Night in Canada*, nor will they be presented on the air'" (Doyle, 2010b). Such perfunctory public relations gestures aside, it is important to recognize that, far from the left-wing bias which pro-market ideologues like Cherry and the CP charge the CBC as having, its action (or in this case nonaction) in relation to Cherry's political activism demonstrates its complicity with a host of hegemonic effects associated with the reimagining of the nation. Or, as John Doyle (2010b) has observed: "This isn't just a game, any more than hockey is just a

game. The country is being peddled a right-wing version of itself with dollops of help from the intimidated elites and artsy people who control the CBC. What a brutal black comedy this has become."

References

Althia, R. (2010, May 13). CBC to study whether its news is biased. *Ottawa Sun*. Retrieved from http://www.ottawasun.com/news/canada/2010/05/13/13940056.html

Ani, F. (2010, March 14). The meaning of Don Cherry. *Poli-Text*. Retrieved from http://politext.wordpress.com/2010/03/14/the-meaning-of-don-cherry/

Bazay, D. (1998, March 8). The CBC ombudsman's review of complaints about Don Cherry's comments during the Olympics. *CBC-Radio Canada Office of the Ombudsman Annual Report, 1997–1998*.

Bazay, D. (2004). *Office of the Ombudsman English services annual report, 2003–2004*. Retrieved from http://www.cbc.ca/ombudsman/annual.html

Brunt, S. (1987, January 17). A hoser in paradise: Hockey's hardhat in a high collar, Grapes is exactly what he seems. *The Globe and Mail*, p. C1.

Burnside, S. (2009). The biggest mouth in sports. *ESPN.com*. Retrieved from http://sports.espn.go.com/espn/eticket/story?page=doncherry

Butler, J. (2009). *Frames of war: When is life grievable?* London, UK: Verso.

CBC puts Cherry on 7-second delay. (2004, February 6). *CBCNews*. Retrieved from http://www.cbc.ca/news/story/2004/02/06/cherry040206.html

Christie, J. (2003, March 25). Cherry, MacLean to face music over debate. *The Globe and Mail*, p. S1.

Coach's Corner faces heat for using platform to promote military stance. (2011, January 7). *Ceasefire.ca*. Retrieved from http://www.ceasefire.ca/?p=6747

Coach's Corner on Iraq war riles viewers, CBC. (2003, April 1). Retrieved from http://www.cbc.ca/sports/story/2003/03/24/cherry030324.html

Communication to the Office of the Ombudsman. (1998a, February 23). *Office of the Ombudsman annual report, 1997–1998, Vol. 1*.

Communication to the Office of the Ombudsman. (1998b, March 3). *Office of the Ombudsman annual report, 1997–1998, Vol. 1*.

Communication to the Office of the Ombudsman. (2003, March 25). Re: Don Cherry: Make him go away.

Communication to the Office of the Ombudsman. (2010, December 10). Re: Don Cherry.

Cooper, E. G. (2009, May 2). Two minutes in the box for Wakeham. *Letters to the Editor (The Telegram)*. Retrieved from http://www.thetelegram.com/Opinion/Letters-to-the-editor/2009-05-02/article-1458641/Two-minutes-in-the-box-for-Wakeham/1

Dallaire, C., & Denis, C. (2000). 'If you don't speak French, you're out': Don Cherry, the Alberta Francophone Games, and the discursive construction of Canada's francophones. *Canadian Journal of Sociology, 25*(4), 415–440.

Don Cherry's speech at Rob Ford's inauguration. (2010, December 7). *NationalPost*. Retrieved

from http://fullcomment.nationalpost.com/2010/12/07/don-cherrys-speech-at-rob-fords-inauguration/

Dowbiggin, B. (2008). *The meaning of puck: How hockey explains modern Canada.* Toronto,Canada: Key Porter Books.

Doyle, J. (2010a, October 12). Zip your lips: The folly of disliking Don Cherry. *The Globe and Mail*, p. R3.

Doyle, J. (2010b, December 7). Don Cherry: It's loony-right night in Canada, brought to you by the CBC. *The Globe and Mail.* Retrieved from http://www.theglobeandmail.com/news/arts/television/john-doyle/don-cherry-its-loony-right-night-in-canada-brought-to-you-by-the-cbc/article1827207/

Elcombe, T. (2010). The moral equivalent of 'Don Cherry.' *Journal of Canadian Studies, 44*(2), 194-218.

Gillett, J., White, P., & Young, K. (1996). The prime minister of Saturday night: Don Cherry, the CBC, and the cultural production of intolerance. In H. Holmes & D. Taras (Eds.), *Seeing ourselves: Media power and policy in Canada*, (2ⁿᵈ ed., pp. 59-72). Toronto, Canada: Harcourt Brace.

Gruneau, R., & Whitson, D. (1993). *Hockey night in Canada: Sport, identities, and cultural politics.* Toronto, Canada: Garamond Press.

Knowles, R. (1995). Post, 'Grapes,' nuts and flakes: 'Coach's Corner' as post-colonial performance. *Modern Drama, 38*(1), 123-130.

MacGregor, R. (1992a, March 14). Don Cherry: The prime minister of Saturday night. *The Ottawa Citizen*, p. A1.

MacGregor, R. (1992b, March 29). Grapes of wrath (or grapes of gaffe). *Calgary Herald*, p. F6.

Maki, A. (1992, November 11). No sour grapes. *Calgary Herald*, p. F1.

McParland, K. (2010, December 8). Canada's Don Cherry divide. *NationalPost.* Retrieved from http://fullcomment.nationalpost.com/2010/12/08/kelly-mcparland-canadas-don-cherry-divide/

McQuaig, L. (2007). *Holding the bully's coat: Canada and the U.S. empire.* Toronto, Canada: Doubleday Canada.

Plenty of cash stashed in Coach's Corner. (2007, October 3). *The Edmonton Journal.* Retrieved from http://www.canada.com/edmontonjournal/news/sports/askmatty/story.html?id= e6a743d5-7d40-4fa8-bf89-76a444c7ff9a

Richler, N. (2002). Foreword. In M. Richler, *Dispatches from the sporting life* (pp. ix-xxii). Guilford, CT: Lyons Press.

Scherer, J., & Koch, J. (2010). Living with war: Sport, citizenship, and the cultural politics of post-9/11 Canadian identity. *Sociology of Sport Journal, 27*(1), 1-29.

Scherer, J., & McDermott, L. (2011). Playing promotional politics: Mythologizing hockey and manufacturing 'ordinary' Canadians. *International Journal of Canadian Studies, 43*, 107-134.

Stein, J., & Lang, E. (2007). *The unexpected war: Canada in Kandahar.* Toronto, Canada: Viking Canada.

The Don Cherry lexicon. (2011). *CBC Sports.* Retrieved from http://www.cbc.ca/sports/indepth/doncherry/stories/lexicon.html

Voisin, S. (2010, September 17). Don Cherry on being Canadian, the importance of honesty, and NHL's most passionate player. *Motivated Magazine.* Retrieved from http://

motivatedonline.com/don-cherry-on-being-canadian-the-importance-of-honesty-and-nhl%
E2%80%99s-most-passionate-player/

What makes Don Cherry so special? (2009). Comment by Jason on: *Yahoo! Answers*. Retrieved from http://answers.yahoo.com/question/index?qid=20100413203230AA0Qlr4

What should CBC do with Don Cherry? (2004, February 15). CBC *Digital Archives*. Retrieved from http://archives.cbc.ca/sports/hockey/clips/9682/

PART V

Afterword

Beyond the Failed Sports Hero: Where We All Fall Down

Scott Tinley

"I'm special so long as I keep making touchdowns. When it's over, it's over."
(Gavin Grey in Frank Deford's (2004) *Everybody's All-American*)

The fallen athlete hero is an unnatural event in a natural world. It is the irregular occurrence that spikes the regular arc of an athlete's seemingly perfectly projected career, that lovely trajectory adored by consumers of sport. When the athlete's star implodes, the natural order of our sporting cosmos is upset as they stomp our idealistic dreams.

Through time, the story of the sports hero is often the story of the tenacious individual: a foundational narrative in American history. Sports heroes existed as cultural artifacts with fans sharing in the existential nature of their meaning. We grew up and grew close to the men, women, and their myths. The sports hero was a legendary figure, often of divine ancestry with strength of spirit and favored by the gods. But as we have seen, the depersonalizing of iconic figures—their reduction or transformation into celebrities, pseudo-types, and fallible characterizations of themselves—has caused a deep division in the cultural historicity that constitutes much of our national ideology.

Less than a generation ago, athlete heroes were "conceived in a relativistic or idealistic fashion" (Harris, 1994, p. 3). Of late, however, our relationships with athlete heroes have been twittered into an ambiguous psychosis. Still we are fascinated by the sports hero metaphysically and contextually. When they fall from the dais, we face the self-reflexive realization of Pogo: *we have met the enemy and he is us.*

Deftly woven into this volume's texts are conversations on the ethics of *herodom*, that netherworld of relational capacities where human potential is fully exercised. No fall from grace, it seems, is beyond our lust for exposing the good, the bad, and the ugly sports star. Questions of moral judgment and ethical considerations are linked to our self-analysis and esteem. "It is impossible to speak of ethics," as Klapp suggested, "without getting into the realm of

these socially produced images of the hero, villain, and fool" (1962, p. 17). The link to our mortality is felt as our sports heroes miss a catch, a payment, or a chance to save the planet.

And we ask if modern heroes can no longer save us from our existential angst. But when addressing that pessimistic suggestion—Is the modern hero dead?—Higgs (1982) referred to the sporting kind. "The sports world belies such assertions," he claimed, "here the hero is alive and well. It is not a question of whether . . . but what *type* of hero is popular at any particular time in history" (p. 137, emphasis added). Sport heroes—pseudo, fallen, or flimsy—still offer us a popular vehicle in which to connect gods with mortal men. They provide, as critic Victor Brambert suggested, "a transcendental link between the contingencies of the finite and the imagined real of the supernatural" (Brambert, as cited in McGinniss, 1990, p. 141).

What remains contingent is the use of sports heroes in the paradigm of our existence. Mortality is forever human and the fallen star, if we allow it, offers us a blindingly honest reference. To hold the fallen hero up to the light of societal examination is to turn the lamp on ourselves. "As we tell about heroes," Fishwick noted, "they tell us about ourselves" (1969, p. 1). The star athletes, even as they age and fail, sometimes find themselves being outgrown by a sport they cannot outlive. And through it all, in our role as Great Oz behind the curtain of sport production and consumption, we are confused about our products, prodigies, and projections. We bear witness to that "lazy relationship," as Baudrillard suggested (1994), that reality has to images and representation. Within that laziness, I would argue, is both fear and resistance. Still, we lustily seek hope for our athlete heroes.

What this volume reminds us, as does Shelley, is that while we are the creators of sports heroes, they are our masters. As a kid, I remember watching the great San Francisco Giant center fielder, Willie Mays. As I reflect on his best and worst years, I desperately try to separate their context and their meaning. And when he turned 80 years old in 2011, I did not want to remember at all. I could not get past the fact that if *The Kid* was 80, then I was, uh . . . middle aged.

I suggest that a reader's reflexive engagement with this volume might show that our relationships with fallen athlete heroes can reveal more about ourselves and our social worlds than any one exploration of a single prodigy. The very notion of "the fallen" is perhaps best examined alongside the mediated myths of how and why their narratives resonate so powerfully. For example, why do we hate LeBron James? Is he not a product of our sporting society, honed for greatness and spoon-fed bites of adoration until he actually believed that he was an earthly king? But now, as he has fallen and we project ourselves

onto his royal delusions, the ingratiating ignorance of his immaturity turns our stomachs and our hearts.

Sports and societal intersections are well studied across empirical and popular lines. In our production of sports heroes, we idealize and project our quest for higher selves. Their artistry is ours if only doubted in degrees. Their soaring soul is our own. Like Icarus, we go along for their fabulous ride until a fall is imminent. Then we look for another star upon whom to hitch our next ride.

The country singer, Tom T. Hall, wrote about this tenderfoot communion between artists and their followers in his insightful song, *Last Hard Town*. "They came to see the people that they thought we were and never changed their minds," adding the admission that "what a picker does for others is the thing he's mainly doing for himself" (Hall, 1973). Did we really expect LeBron and Woods and Bonds and Floyd Landis—four athletes of the apocalypse—to take their considerable talents into the realm of altruism? Like Hall's hard-scrabble followers who fail to understand that "angels don't have bourbon on their breath," sports fans' expectations of sports stars are linked to ticket prices and hyperbolic displays of sport-turned-phantasmagoria. We are hard-pressed to change our minds about who (and what) they are and it is even harder to accept what they represent.

The constructed athlete hero rises from the working class found in rock lyrics and sitcoms. We are drawn to their imagined tutelage, however meas-ured or far away. Outfitted in players' jerseys we cannot afford, we pay lip service to the myth of an athletic meritocracy. We submit to the tyranny of youth-centrism and we attempt to find our higher selves in a glossy magazine or in a *lifestyle-lift*. We are back-shot by the naturalistic hegemony of the ages—we are not them, even if they can make us think they are us.

So, in the nadir of a fallen athlete's humanity—an act of "bad judgment," or deselection, or some final physiological revolt—we find our separation from the athlete hero both conflictive and rife with hypocritical sanctimony. The fallen athlete hero enters that negotiated terrain where few followers can fully understand their roles in the arc of the fallen hero's production, consumption, and disposal. We have the luxury of forgetting their presence in immediate history when instead we could empower our own lives through authentic remembering. Too often we stand on the edge of reason and watch them spiral downwards, failing to acknowledge the tether attached to our hearts and minds from childhood.

As we revere our athlete heroes and negotiate their failures, we must con-front them individually, not as an idealistic collective. This phenomenon is more easily comprehended in the fiction of Bouton, DeLillo, Exley, Harris,

Kahn, Malamud, Roth, Shaw, Sillitoe, Shaara, Updike and others, while daily reporting struggles for meaning. With nods as well to Bissinger, C. L. R. James, Michener, Moehringer, and Oriard, the fictional fabrication of the fallen has connected more powerfully than journalistic depictions. The best of these stories tell of the rare birds that lived sporting herodom, fell from on high, and struggled with failure.

Few of us fully understand the perils of such a vaulted existence. Many fallen athlete heroes have surrendered wholly to the pursuit of earthly greatness, only to expose themselves to the terrifying process of public ruination after failed morality or the ravages of physical decline arrive. Having given all for the chance to be king or queen, they suffer in ignominy and clumsy quests to return to greatness. Still, most say they would not change a thing.

This Faustian theme resonates because we, too, are human and make decisions yielding consequences, such as when we sweat over spreadsheets and cost-benefit analyses. When we push the envelope, we know we may fall. Yet, we know no one wins big from just getting out of bed in the morning. Because we tend to play it safe, athletes who take risks and fail captivate us. Because their risk plays on a big stage, we may take special glee when they fall. In their falling, athlete heroes give great pleasure to everyone but themselves.

The tormented baseball great, Darryl Strawberry, once told a reporter that he never had a problem hitting, he had a problem living. We are engaged with the fallen because in their trinity—sod-busting mistakes, mea culpas, and second chance comings—we see the rise, fall, and return cycle that necessarily characterizes the human condition and our own lives. In those shoes, we all ask how can I get back to where I was.

Too often we call for athlete stars to go out on top, to save us the tectonic self-conflict of "what would I do, if I got caught growing pot, photographed in a compromised position, or just losing my mojo?" Failed athletes are often older, unlucky versions of our own dreamed selves. They get caught red-handed while believing the grand lie that they are special and get to go out on top. Those older athletes who deny logic mark the very edge of resistance, tracing the arc from then until now. "I will play until they pull the bat from my cold dead hands," some have said. But are these athletes *truly fallen*, we ask, or just tempting fate, lucky as they milk one more long July of *jouissance?*

It is in the fall from grace that we are given the true measure of a man. To watch a Woods or a Phelps or a McGwire read a slick apologia and to see the rehearsed but unfelt remorse in their eyes is to watch grace mocked in the service of a cereal box cover. To watch a reified Michael Vick talk, act, and play as if recast as some enlightened version of a former self is to witness a

transformation for the ages. How the hero addresses his humanness is more telling than how he displayed his godliness.

There is something pathetically voyeuristic about watching the greats go down hard. *Just let them leave*, but can you just show me the white Bronco chase once more? The greats always take something with them when they go. Like a special guest leaving the party, the air is not as breathable as when their photosynthetic personalities danced across the floor. Our relationships with the fallen athlete are situated in the fluid confines of our malleable memories. When we necessarily ask if their act can ever be separated from their play, we are told "well, that depends."

In the case of playing years beyond greatness, as did Willie Mays, Muhammad Ali and Ricky Henderson, we harken to their brilliant youth because it unfolded on our own youth and hopeful futures. And in the case of the inflicted—the Lou Gehrigs and Roy Campanellas and Arthur Ashes—we are pulled into that aphoristic projection—*there but for the grace of God go I*. Yet, a physiological failing must be distinguished from moral decrepitude. Gehrig fell neither from grace nor history, while Barry Bonds fell into a skeleton outfit hanging in a back closet. Tonya Harding fell to a circus act while Little League World Series phenom, Dominican-born, Danny Almonte Rojas, fell because he was born two years too early.

Some are pushed, some jump, but most, like a falling star, are noticed as their ancient reflection stirs an immediate emotion. Our relationships with fallen sports stars are linked to the shifting sands of cultural ideology. We remember Ali stripped of his title and his best years, lighting the Olympic torch in Atlanta; Smith and Carlos running from death threats after Mexico City '68 and then offered honorary doctorate degrees from their alma maters; Pat Tillman, whose memory was appropriated by the U.S. Army PR machine, now stands as icon of integrity; Big Mark McGwire, not wanting to talk about the past (as if history has no import) is now a coach in St Louis. Sometimes tripping in one era becomes a leg up in another.

What we require of our fallen athletes as payment for their failures is the subjugation of hubris—that essential trait that helped to mold their greatness— or at least the ability to squirrel it away until enough time has passed. How selfish, though, to ask for an athletic lobotomy when it is we, the fans, that feed the fires of empowerment. We have become a society of planned obsolescence and addictive consumerism that becomes a means of "personal empowerment, subversion, or resistance" (Horne, 2006). Thus we might question if we are playing Pontius Pilate, convicting Lance Armstrong in the court of public opinion as we sip scotch and sodas before an Ambien night. While we require athletic victory (reinforcing our national ideology) we also call for a

drug-free sport (in the same voice as we call for a cure for cancer). And in the wake of our diametric demands, I cannot help but wonder if the gold medal winners of the 2024 Olympics are already training in a petri dish at an undisclosed lab. We forget that emerging and effecting social milieus, if not myths, begin and end in the fabric of flesh and bone.

On the rare occasion, an athlete steps off the ledge and is lifted by their chosen elevator. *Sports Illustrated Magazine*'s first Sportsman of the Year (1954), Sir Roger Bannister, the first man to run the mile under 4 minutes, has noted that his contributions to medicine as a leading British neurologist far outweigh his singular four laps around the Iffley Road track on May 6, 1954. Fifty years after his track breakthrough, he confessed in his 2004 biography that his words within were "a farewell to athletics but not to exercise" (Bannister, 2004, p. 210). The reader is necessarily stuck by the grace, confidence, and humanness of this athlete and we ask, "where does this come from and how do we access those traits?"

The fallen athlete narrative resonates because it synthesizes other essential tropes. For the same reason that popular sports films such as *The Natural*, *For the Love of the Game*, and the *Rocky* series are successful, nonsports films such as *The Lion King* and *Star Wars* succeed: they are equal parts hero's journey, aging-star-giving-way-to-youth, and the clichéd *circle of life*. These are not just feel-good films, but religious icons that take the viewer from original sin through heaven's gates, and from playground to paradise with a few really big screwups in between. "For the righteous falls seven times and rises again," Proverbs 24:16 tells us, "but the wicked stumble in times of calamity." And on the other side of failure is institutionalized redemption—Robin Williams in *The Best of Times*, Keanu Reeves in *The Replacements*, Russell Crowe in *Cinderella Man* and *Gladiator*, Paul Newman in *The Hustler*, Kevin Costner in *Field of Dreams* and *Tin Cup*, and everyone in *Major League*. Lest we forget, characters in sports films are offered second chances because other gods have offered them to us.

In my own freshman fame, I sat in the back of a large ballroom on the good ship, *Queen Mary*, fittingly one of the only British luxury transports to avoid being sunk by German U-boats. It was the annual awards dinner for triathletes and I had swapped a seat on the champion's dais to blow off some postseason steam in the back of the room with my peers. What I ended up blowing was thick smoke from a thin joint into the heaving face of the sleeping president of our international governing body. My alcohol-fueled hubris could have brought me a hefty fine, a suspension or a night in jail. But in some simple twist of fate, nothing happened but jaw-dropping shock. Our IGB prez slept on through the thank-you-very-much speeches in the wake of his

Euro-travels and I walked, not redeemed, but lucky—fallen in moral judgment but risen in a pre-*drunkenathletes.com* world. Lucky is as fortune does.

Ultimately, we are connected to the fallen athlete hero under the banner of legacy. Sport is a world of quantifying numbers that define a career but not the person. Our own charitable chips too, are counted on tax returns but can never tell us how we might have left a positive mark in an all too negative world. A fallen athlete can erase a lifetime of records by one bad decision, and then lie about it for years; a man-child we all revered, digging his own grave deeper in the grass upon which his deeds were exalted. Ben Johnson, O. J. Simpson, Marion Jones, Pete Rose, Floyd Landis. . . . The list grows long as does our lust for ubiquitous sports narratives. Legacy matters because it may be one of the last true currencies of cultural value that can increase beyond the grave. *Larga vida a Roberto Clemente, el salvador del pueblo y Gandhi de Puerto Rico.* Roberto Clemente, the great humanitarian from Puerto Rico, fell from the sky but his shining star continues to remind us of what we, too, *have* or *have not* done to erase the pain of suffering for the less fortunate.

Structures of modern society have been foundationally altered in such ways that future generations will not look upon athletes in the same way as they will not look to gods. In our fallen stars, however, we will look *not always* for the despicable act but for how their human choices alter our mutual quest for some authenticity in a simulacra world. And over time, with our best years tethered to our glorified sports stars, we will struggle to rise up through all the failures and find the sweetness and light that the best in sports and life offer. Then we, too, are heroic. It is what we wanted all along.

References

Bannister, R. (2004). *The four-minute mile* (50th anniversary ed.). Guilford, CT: Lyons Press.

Baudrillard, J. (1994). *Simulacra and simulation.* Ann Arbor, MI: University of Michigan Press.

Deford, Frank. (2004). *Everybody's All-American.* Cambridge, MA: Da Capo Press.

Fishwick, M. (1969). *The hero, American style.* New York, NY: David McKay.

Hall, T. T. (1973). Last hard town. On *For the people in the last hard town.* Mercury Records. Retrieved from http://www.metrolyrics.com/last-hard-town-lyrics-tom-t-hall.html

Harris, J. C. (1994). *Athletes and the American hero dilemma.* Champaign, IL: Human Kinetics.

Higgs, R. J. (1982). *Sports: A reference guide.* Westport, CT: Greenwood Press.

Horne, J. (2006). *Sport in consumer culture.* London, UK: Palgrave Macmillan.

Klapp, O. E. (1962). *Heroes, villains and fools: The changing American character.* Englewood Cliffs, NJ; Prentice Hall.

McGinniss, J. (1990). *Heroes.* New York, NY: Simon & Schuster.

Contributors

David L. Andrews (PhD, University of Illinois) is Professor of Physical Cultural Studies in the Department of Kinesiology at the University of Maryland, College Park, and an affiliate faculty member of the Departments of American Studies and Sociology. His research utilizes various theories and methods drawn from sociology and cultural studies in critically analyzing the relationship between broader social structures, and the embodied representations and experiences of contemporary physical culture (including sports, exercise, health, and movement-related practices). dla@umd.edu

Michael Atkinson (PhD, University of Calgary) is Associate Professor in the Faculty of Physical Education at the University of Toronto. Michael's research interests pertain to bioethics in sport cultures, violence and aggression, alternative sports cultures, and the transhuman modification of bodies. He is editor of the *Sociology of Sport Journal* and *Deviant Behavior* and is author of *Beyond the Masculinity Crisis* and *Tattooed: The Sociogenesis of a Body Art*. He is coauthor of *Deviance and Social Control in Sport* (with Kevin Young), author/editor of *Battleground: Sports*, and coeditor of *Tribal Play: Subcultural Journeys Through Sport* (with Kevin Young). michael.atkinson@utoronto.ca

Zoe Avner (MA, University of Bath) is a doctoral student in sociocultural studies of sport at the University of Alberta, Canada, under the supervision of Dr. Pirkko Markula and Dr. Jim Denison. A native of Paris, France, she completed her master's degree at the University of Bath, England in coaching education. Her research interests are in applying the work of Michel Foucault to enhance coaching effectiveness and develop more ethical sporting practices in high-performance sport. avner@ualberta.ca

Becky Beal (EdD, University of Northern Colorado) is an Associate Professor of Kinesiology at California State University, East Bay in Hayward. She has served as an editor for the *Sociology of Sport Journal*, and her work has been published in the *Journal of Sport and Social Issues*, *Sport in Society*, and *International Review for the Sociology of Sport*. becky.beal@csueastbay.edu

Andrew C. Billings (PhD, Indiana University) is Professor and Ronald Reagan Endowed Chair of Broadcasting at the University of Alabama. He has published articles in outlets such as *Journal of Communication*, *Mass Communication & Society*, *Journal of Sport and Social Issues*, and *Journal of Broadcasting & Electronic Media*. He has authored or edited six books, including *Olympic Media: Inside the Biggest Show on Television* (2008). acbillings@ua.edu

Karen Brooks (PhD, University of Wollongong) is a research scholar at the Centre for Critical and Cultural Studies at the University of Queensland in Australia; a weekly columnist with Queensland's leading newspaper, the *Courier Mail*; and author of eight books—fiction and

nonfiction. Her current research focuses on youth, sexuality, media, and popular culture. brookssk@bigpond.com

Toni Bruce (PhD, University of Illinois) is Associate Professor of Critical Studies in Education on the Health and Physical Education staff of the Faculty of Education Sport at the University of Auckland in New Zealand. Her research focuses on issues of gender, race and ethnicity, and national identity, with particular focus on the sports media. She is coeditor of *Sportswomen at the Olympics: A Global Content Analysis of Newspaper Coverage*, and *Outstanding: Research about Women and Sport in New Zealand*. t.bruce@auckland.ac.nz

Michael L. Butterworth (PhD, Indiana University) is Assistant Professor and Chair of the Department of Communication in the School of Media and Communication at Bowling Green State University. His research and teaching focus on the intersection of rhetorical theory, democratic politics, and commercial sports. His work includes the book *Baseball and Rhetorics of Purity: The National Pastime and American Identity During the War on Terror* as well as several essays on the rhetoric of sports which have appeared in journals such as *Communication and Critical/Cultural Studies, Communication, Culture & Critique, Critical Studies in Media Communication*, the *Journal of Sport & Social Issues*, and the *Western Journal of Communication*. mbutter@bgsu.edu

James L. Cherney (PhD, Indiana University) is Assistant Professor in the Department of Communication at Wayne State University. His work on disability issues, sports, and ableist rhetoric appear in the book, *Case Studies in Sport Communication*, and in the journals, *Argumentation and Advocacy* and *Disability Studies Quarterly*. His recent collaborations with Kurt Lindemann include a chapter in the book, *Examining Identity in Sports Media*; analyzing the film, *Murderball*; and a study in the *Western Journal of Communication* examining rehabilitative and gendered communication among Quad Rugby players. jlcherney@wayne.edu

Cheryl Cooky (PhD, University of Southern California) is a joint-appointed Assistant Professor in Health and Kinesiology, and Women's Studies at Purdue University. Her research has been published in the *Journal of Sport and Social Issues, Sociology of Sport Journal, Sociological Perspectives*, and numerous edited volumes focusing on sports and culture. ccooky@purdue.edu

Bryan E. Denham (PhD, University of Tennessee) is Charles Campbell Professor of Sports Communication in the Department of Communication Studies at Clemson University. His scholarship on media portrayals of performance-enhancing drug use in sports has appeared in the *Journal of Sport & Social Issues, Sociology of Sport Journal, International Review for the Sociology of Sport, International Journal of Sport Communication*, and *International Journal of Sport Management and Marketing*. He has authored approximately 50 articles and chapters in scholarly journals and books. bdenham@clemson.edu

Shari L. Dworkin (PhD, University of Southern California) is Associate Professor in the Department of Social and Behavioral Sciences at the University of California, San Francisco UCSF. Her books include *Built to Win: The Female Athlete as Cultural Icon* (with Leslie Heywood), and *Body Panic: Gender, Health, and the Selling of Fitness* (with Faye Linda Wachs). Her journal articles have appeared in the *American Journal of Public Health, Gender & Society, Sociology of Sport Journal, Culture, Health and Sexuality, Journal of Sex Research, AIDS and Behavior*, the *Archives of Sexual Behavior*, and *PLoS Medicine*. shari.dworkin@ucsf.edu

Michael D. Giardina (PhD, University of Illinois) is Assistant Professor of Sport Management at Florida State University. He is the author or editor of a dozen books, including *Sport, Spectacle, and NASCAR Nation: Consumption and the Cultural Politics of Neoliberalism* (with Joshua I. Newman), *Contesting Empire, Globalizing Dissent: Cultural Studies After 9/11* (with Norman K. Denzin), and *Sporting Pedagogies: Performing Culture & Identity in the Global Arena*. He is associate editor of the *Sociology of Sport Journal* and *Cultural Studies, Critical Methodologies*. michael.d.giardina@gmail.com

Bill Grantham (PhD, University of Sunderland; JD, University of California, Berkeley) is an independent scholar and attorney in Los Angeles with a practice in media, entertainment, and intellectual property. His books include *"Some Big Bourgeois Brothel": Contexts for France's Cultural Wars with Hollywood, 30 Years of Television*, and *25 Years of Music*. He has written widely on cultural, policy, and legal issues in the globalization of the film and television industries. grantham.bill@gmail.com

Marie Hardin (PhD, University of Georgia) is an Associate Dean in the College of Communications at Pennsylvania State University. Her work, focusing on issues of diversity and ethics in mediated depictions of sports, has appeared in communications and sports journals, and in edited books. mch208@psu.edu

C. Lee Harrington (PhD, University of California-Santa Barbara) is Professor of Sociology and Affiliate of the Women's Studies Program at Miami University. She is coeditor of the journal, *Popular Communication: The International Journal of Media and Culture*, and coeditor of the recent anthology, *Fandom: Identities and Communities in a Mediated World* (2007), both with Cornel Sandvoss and Jonathan Gray. Her areas of research include media/fan studies, TV studies, and the sociology of law. Her current work (with Denise Bielby) draws on gerontological and media studies theories to explore implications of aging fans/audiences. harrincl@muohio.edu

Heather L. Hundley (PhD, University of Utah) is Professor of Communication Studies and Assistant Dean of the Palm Desert Campus at California State University, San Bernardino. She coedited *Examining Identity in Sports Media* and coauthored *Views from the Fairway: Media Explorations of Identity in Golf* with Andrew Billings. Some of her research appears in *New Media & Society, Communication Reports, Communication Quarterly, Journal of Men's Studies*, and *Journal of Intergroup Relations*. Her work explores critical issues of social justice in sports, media, law, and other venues. hhundley@csusb.edu

Steven J. Jackson (PhD, University of Illinois) is Professor in the School of Physical Education at the University of Otago in New Zealand. He is former president of the International Sociology of Sport Association (ISSA), and his books include: *Sport, Culture and Advertising: Identities, Commodities and the Politics of Representation* (coeditor with David L. Andrews), *Sport Stars: The Cultural Politics of Sporting Celebrity* (coeditor with David L. Andrews), and *Sport and Cultural Diversity in a Globalising World*. His research focuses on globalization, national identity, and media. steve.jackson@otago.ac.nz

Alistair John (MPhilEd, University of Otago) is a Lecturer at Victoria University in Melbourne, Australia. His master's thesis entitled: "Call Me Loyal: Globalisation, Corporate Nationalism, and the America's Cup in New Zealand" examined the contested nature of the America's Cup as a private, corporate-driven sporting event that is organized and marketed under the flag of

nationalism. His research focuses on sport, nationalism, and advertising. ali.john1980@gmail.com

Katherine L. Lavelle (PhD, Wayne State University) is Assistant Professor of Communication Studies and the Director of Forensics at the University of Northern Iowa. Her recent work on sports appears in *Sports Mania: Essays on Fandom and the Media in the 21ˢᵗ Century*. Her work focuses on the intersection of race, nationality, and gender in sports. katherine.lavelle@uni.edu

Nicole M. LaVoi (PhD, University of Minnesota) is Associate Director of the Tucker Center for Research on Girls & Women in Sport in the School of Kinesiology at the University of Minnesota. LaVoi's work focuses on media representations of female athletes and coaches and how decision makers influence media representations and hiring patterns of females in sports contexts. nmlavoi@umn.edu

Kurt Lindemann (PhD, Arizona State University) is Assistant Professor at San Diego State University. His work on performances of gender, identity, and ability in sports communication has been published in *Text and Performance Quarterly*, *Qualitative Inquiry*, and the *Electronic Journal of Communication*. His recent collaborations with James L. Cherney include a chapter in the book, *Examining Identity in Sports Media*; analyzing the film, *Murderball*; and a study in *Western Journal of Communication* examining rehabilitative and gendered communication among Quad Rugby players. klindema@mail.sdsu.edu

Mar Magnusen (PhD, Florida State University) is Assistant Professor of Sport Management in the Department of Health, Human Performance, and Recreation at Baylor University. He is interested in the role of team identification and political skill in organizational behavior, especially as related to recruiting practices. His work has appeared in such journals as *International Journal of Human Movement Sciences* and *Thunderbird International Business Review*. Marshall_Magnusen@Baylor.edu

Pirkko Markula (PhD, University of Illinois) is Professor of Sociocultural Studies of Sport and Physical Activity at the University of Alberta, Canada. She is former editor of *Sociology of Sport Journal*, and her books include *Foucault, Sport and Exercise: Power, Knowledge and Transforming the Self* (with Richard Pringle); *Feminist Sport Studies: Sharing Experiences of Joy and Pain*; *Olympic Women and the Media: International Perspectives*, *Critical Bodies: Representations, Identities, and Practices of Weight and Body Management* (with Sarah Riley, Maree Burns, Hannah Frith, and Sally Wiggins), and *Moving Writing: Crafting Movement in Sport Research* (with Jim Denison). pmarkula@sports.ualberta.ca

Lisa McDermott (PhD, Leeds Metropolitan University) is Associate Professor in the Faculty of Physical Education & Recreation at the University of Alberta. Her research interests include cultural analyses of physical activity and health, and sports and popular culture. Her work has been published in journals such as *Sociology of Sport Journal*, *Leisure Studies*, *International Review for the Sociology of Sport*, and *Journal of Canadian Studies*. lisa.mcdermott@ualberta.ca

Mary G. McDonald (PhD, University of Iowa) is Professor in the Department of Kinesiology and Health, and the Western Program for Interdisciplinary Studies at Miami University. Her articles have appeared in several journals, and she has been guest editor of two special issues of the *Sociology of Sport Journal*, "Whiteness and Sport" and "(Post)Identity and Sport" (with Samantha King). She is coeditor (with Susan Birrell) of *Reading Sport: Critical Essays on Power and*

Representation and has also served as the President of the North American Society for the Sociology of Sport. mcdonamg@muohio.edu

Jim McKay (PhD, The Australian National University) is a research scholar at the Centre for Critical and Cultural Studies at the University of Queensland and former editor of the *International Review for the Sociology of Sport*. His current research focuses on the links among gender, race, sports, globalization, the media, and social inequalities. jmckay2704@yahoo.com

Lindsey J. Meân (PhD, University of Sheffield) is Associate Professor of Communication Studies at Arizona State University. Her work has been published in journals such as *Discourse and Society*, *Sex Roles*, and *Western Journal of Communication*, and she is the coauthor (with Angela Goddard) of the book, *Language and Gender*. lindsey.mean@asu.edu

Toby Miller (PhD, Murdoch University) is Professor of Media and Cultural Studies at the University of California, Riverside. His teaching and research cover the media, sports, labor, gender, race, citizenship, politics, and cultural policy. He is the author and editor of over 30 volumes and has published essays in well over 100 journals and books. His current research covers the success of Hollywood overseas, the links between culture and citizenship, and electronic waste. tobym@ucr.edu

William J. Morgan (PhD, University of Minnesota) is Professor of Occupational Science and Occupational Therapy at the University of Southern California. He is the author of *Why Sports Morally Matter* and *Leftist Theories of Sport: A Critique and Reconstruction* and is the former editor of the *Journal of the Philosophy of Sport*. His current work focuses on normative issues in sports in particular and occupation in general. wjmorgan@usc.edu

Oliver Rick (MS, University of Rhode Island) is a doctoral student at the University of Maryland, College Park, studying in the Physical Cultural Studies program, in the Department of Kinesiology. His research for his MS in Kinesiology focused on the lived experiences of international student athletes. His current work focuses on topics that include sporting celebrity, globalization, and international athletes. orick@umd.edu

David Rowe (PhD, University of Essex) is a Professor on the research staff of the Institute for Culture and Society, University of Western Sydney, Australia, of which he was Director (2006–2009). He has published in many journals, including *International Review for the Sociology of Sport* and *Media, Culture and Society*. His books include *Sport, Culture and the Media: The Unruly Trinity* and an accompanying edited anthology, *Critical Readings: Sport, Culture and the Media*. Among his current research activities is an Australian Research Council-funded project (with Brett Hutchins) concerning the transition from broadcast television to networked media sport. d.rowe@uws.edu.au

Jay Scherer (PhD, University of Otago) is Associate Professor in the Faculty of Physical Education & Recreation at the University of Alberta. His research focuses on the globalization of sport and popular culture, and his articles have been widely published in scholarly journals including *Sociology of Sport Journal*, *Policy Sciences*, *Cultural Studies*, *Critical Methodologies*, *New Media & Society*, *International Review for the Sociology of Sport*, *Sport in Society*, and *Journal of Sport and Social Issues*. jay.scherer@ualberta.ca

Kimberly S. Schimmel (PhD, University of North Carolina-Greensboro) is Associate Professor of the Sociology of Sport and an Affiliate to the Women's Studies Program at Kent State University. She serves on the Editorial Board of the *International Review for the Sociology of Sport* and is a Vice President (2008–2011) of the International Sociology of Sport Association. Her areas of research include the political economy of sports, sports and local/global urban development, and sports and urban politics. Her current work focuses on the securitization or militarization of urban terrain via sports mega-events. kschimme@kent.edu

Michael L. Silk (PhD, University of Otago) is a Reader in the Faculty of Humanities and Social Science at the University of Bath. His research centers on the production and consumption of urban space, the governance of bodies, and the performative politics of identity. His work has been published in journals such as *Media, Culture and Society*, *Organizational Research Methods*, *American Behavioral Scientist*, *Journal of Sport and Social Issues*, *Sociology of Sport Journal*, *International Review for the Sociology of Sport*, *Sport, Culture and Society*, *International Journal of Media & Cultural Politics*, *Journal of Sport Management*, and *Cultural Studies, Critical Methodologies*. m.silk@bath.ac.uk

Scott Tinley (PhD, Claremont Graduate University) is a two-time Ironman Triathlon World Champion and founder of the Institute for Athletes in Retirement and Transition at San Diego State University (SDSU). He teaches sports humanities courses at SDSU and California State University San Marcos (CSUSM), while completing his dissertation on contextualizing athlete transitions. He is the author of *Racing the Sunset: An Athlete's Quest for Life After Sport*. Tinley's interest in fallen heroes stems from an effort to address and explain his own emotional trauma as a result of "falling" from sports. scott@scotttinley.com

Lawrence A. Wenner (PhD, University of Iowa) is Von der Ahe Professor of Communication and Ethics at Loyola Marymount University in Los Angeles. He is editor of the journals, *International Review for the Sociology of Sport* and *Communication and Sport*, and was formerly editor of the *Journal of Sport and Social Issues*. His books on sports include *Media, Sports, and Society*; *MediaSport*; and *Sport, Beer, and Gender: Promotional Culture and Contemporary Social Life* (with Steven J. Jackson). His current work critically engages the moral contours of narrative constructions of gender, race, and ethnicity in promotional culture. lawrence.wenner@gmail.com

Kevin Young (PhD, McMaster University) is Professor of Sociology at the University of Calgary. His research interests bridge criminology and the sociology of sports, and his recent books include *Sporting Bodies, Damaged Selves: Sociological Studies of Sports-Related Injury*, *Sport and Gender in Canada* (with Philip White), *Tribal Play: Subcultural Journeys Through Sport* (with Michael Atkinson), and *Deviance and Social Control in Sport* (with Michael Atkinson). kyoung@ucalgary.ca

Index

-U-

-V-

-Y-

-Z-